phys·i·og·no·my

\ˌfi-zē-ˈä(g)-nə-mē\ *n, pl* -**mies**
[fr. *physiognōmōn* judging character by the features, fr. *physis* nature, physique, appearance + *gnōmōn* interpreter] **1**: the art of discovering temperament and character from outward appearance **2**: the facial features held to show qualities of mind or character by their configuration or expression **3**: external aspect; *also*: inner character or quality revealed outwardly

Physiognomy

The MARK SELIGER Photographs

INTRODUCTION BY **ERIC BOGOSIAN**

DESIGNED BY **FRED WOODWARD**

A BULFINCH PRESS BOOK

LITTLE, BROWN AND COMPANY

BOSTON ★★★★★ NEW YORK ★★★★★ LONDON

[*Dedicated to* MOM, DAD & GRANDMA]

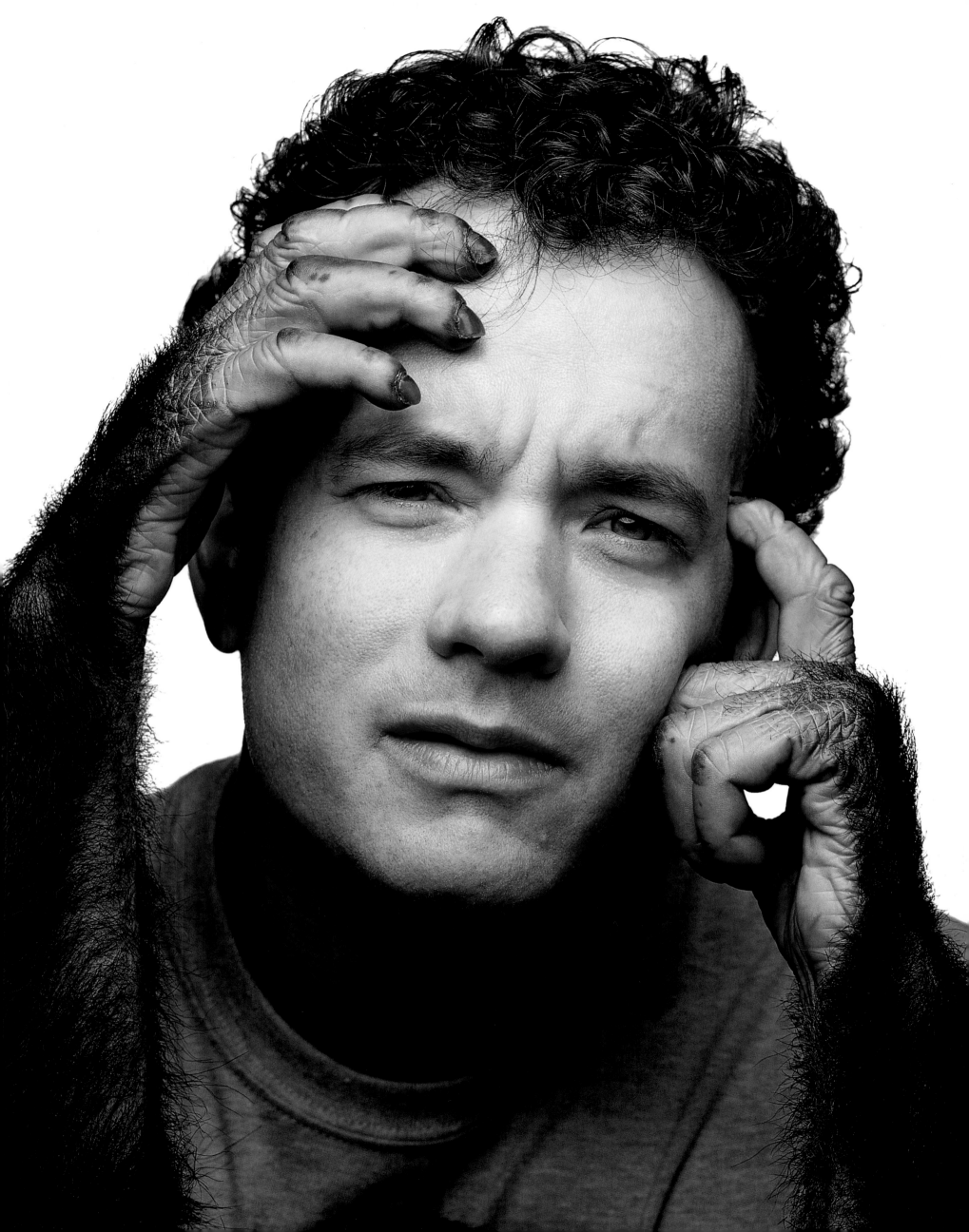

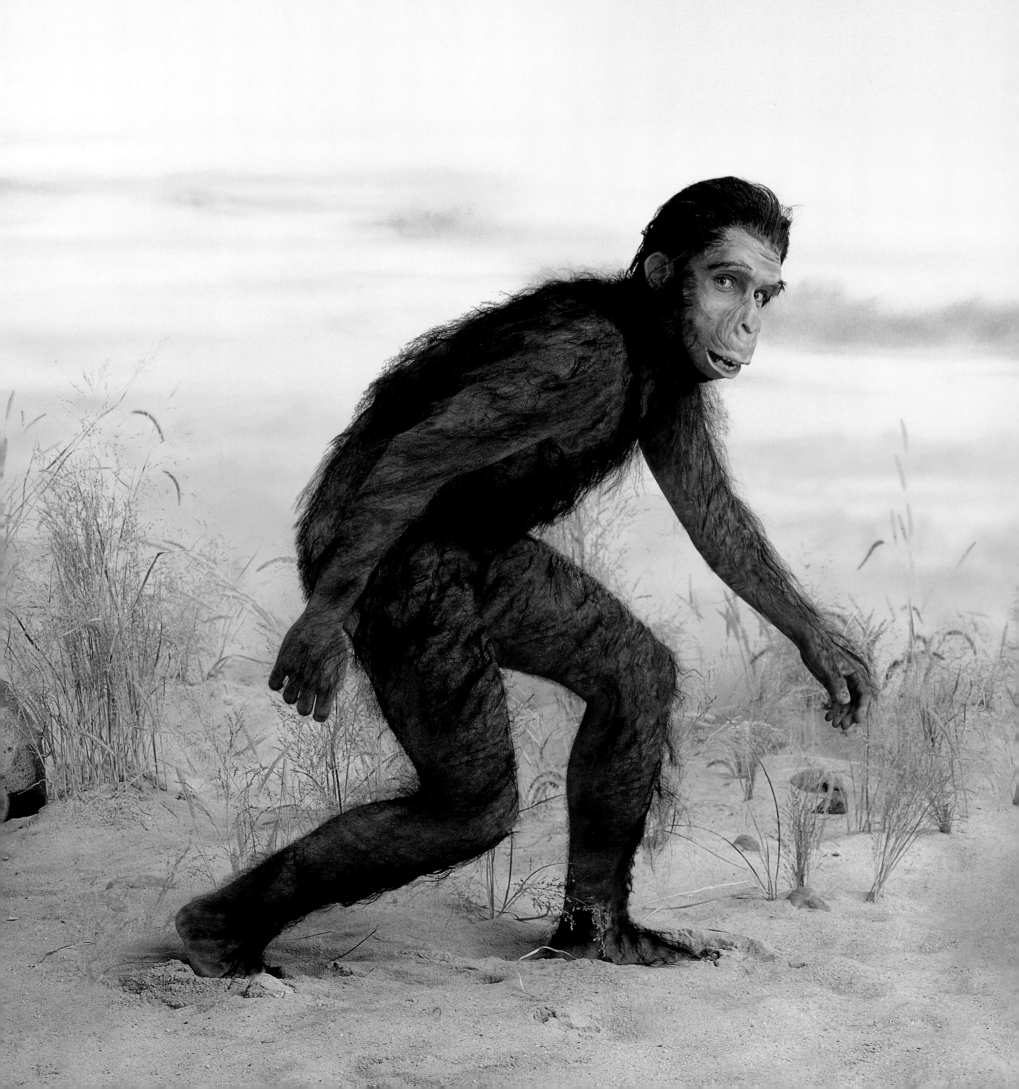

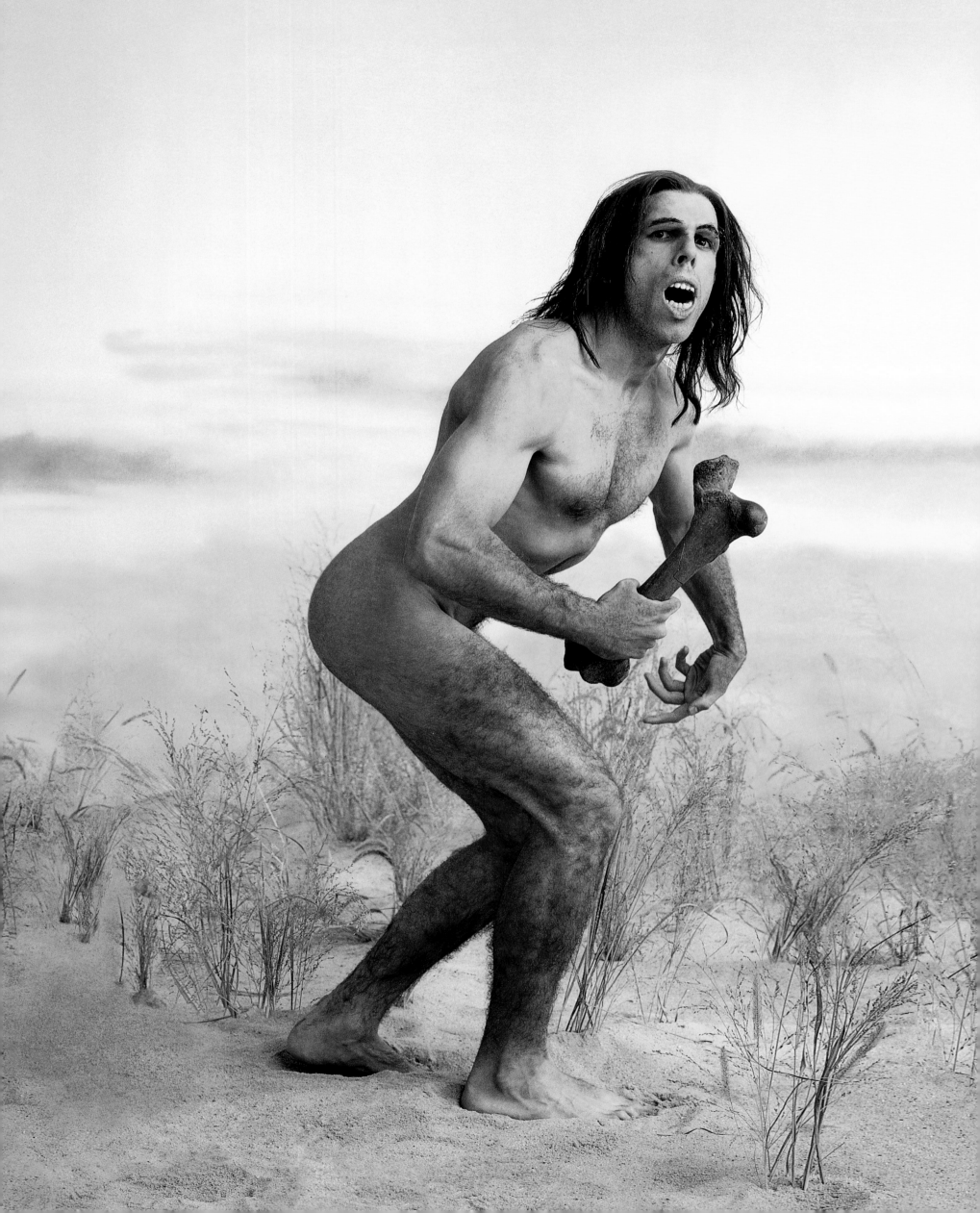

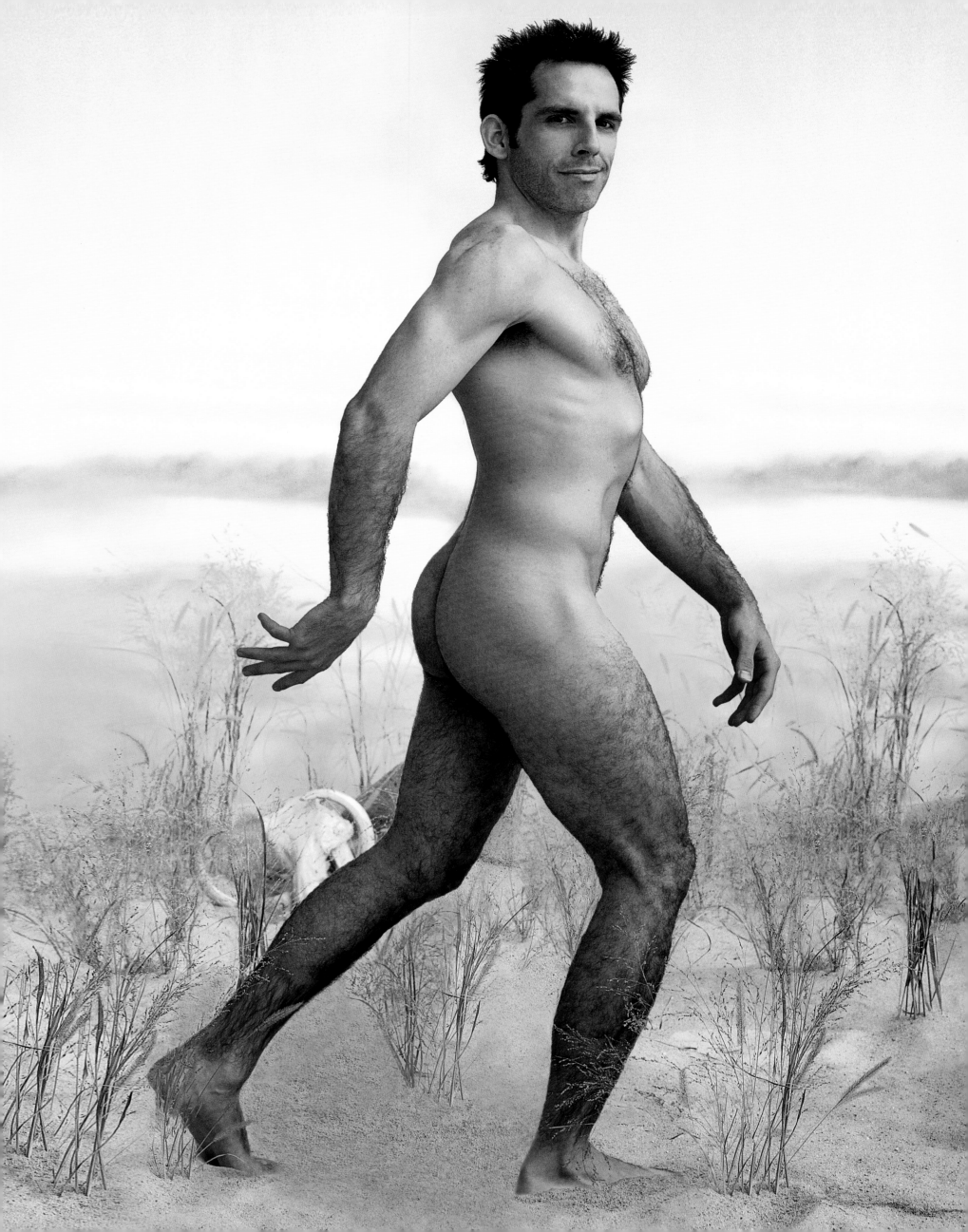

I love to look at faces. When I was ten,

I came to New York to visit the World's Fair and found myself on the corner of Forty-second and Broadway. Growing up in the suburbs, I had never seen anything like the river of humanity flowing past that spot. Each face was different, each face told a story. And the endless stream of faces exerted a tremendous magnetic force upon my imagination. I moved to New York for those faces. And I've not been disappointed.

The cornerstone of our collective imagination is the image of the face. The close-up is mainly why we love movies. Fashion is nothing without bone structure. Music videos are empowered by the physiognomies of everyone from Madonna to Marilyn Manson. And so, in their turn, magazines, television, sometimes even novels (that visage on the cover!) require wonderful faces to live and breathe.

The faces of the celebrated arouse infatuation because somewhere in the depth of those eyes, the turn of that mouth or the crease in that brow is the reflection of a lifetime we all yearn to experience. What have those eyes seen? What have those lips tasted? Regardless of the truth, stars' lives appear huge, filled with delicious treats and intense moments. And if we can't have them, we'll take them vicariously. Because we like to watch.

These people are sexy, famous and rich. They live lives unknown to most of us, lives of first-class cabins and deluxe suites, of gleaming black town cars and breathless entourages. They wear couture, they eat only at the best restaurants, vacation at the most exclusive resorts. They take meetings. They do vast amounts of drugs. They go to posh rehabs. They have mind-bending sex with other, equally gorgeous stars. In short, they have it all.

Mechanically, photography can seem so simple. A finger is depressed, a bulb bursts with light, a moment of exposure is allowed and a picture is taken. Though photos are nothing more than slices of light captured in a bed of chemicals and cellulose, tremendous skill lies in getting a subject to give up the moment. Of all the myriad possibilities, all the moments that

could be caught, the photographer wants to catch the one that would allow us to see his subject in the consummate way. It's as if the photographer were a fisherman in a sea of moments, using his skill to reel in "the big one."

<p align="center">✮ ✮ ✮ ✮ ✮</p>

Mark Seliger, over the past decade, has reeled in untold thousands of big ones from the surging river of our public lives. A connoisseur of the countenance, he has revealed us to ourselves. Or I should say, he has revealed our reigning royalty to ourselves. It seems as if Seliger has shot every rising contender in television, movies and pop music of the Nineties. In fact, I assume the biggest headache in putting together this volume was deciding what to leave out.

Mark has been working with probably the most exciting and talented people out there, obviously having a great time making his photographs. There's a real sense of playfulness exuding from many of these images – the fun comes across. And sometimes his subjects get naked. How cool is that?

Still, for each shoot, a terrible pitfall awaits him: celebrity numbness. Famous people are photographed endlessly. Having experienced dozens of sessions, they inevitably close up like some precious night flower, less and less willing to yield the secret of their eyes and the perfume of their souls. Their precious possession, their face, is their last private treasure and instinctively they shy away from the flash.

The task at hand, then, is daunting. Just as a star is at his or her peak, he or she becomes glazed and dry like a day-old doughnut. Just when everyone wants to see that face more than ever, there's nothing to see. A pair of sunglasses, a fake grin, a frozen stare.

Capturing that ineffable star quality, the charisma that draws us toward him or her, is as difficult as capturing any space launch, any full-tilt combat. Imagine an afternoon of coaxing the Pretty Young Thing, hungover from a two-day champagne and coke orgy, to relax and smile. She's grumpy. She wants

to be alone. She wants to go back to the orgy. And instead she's at this really boring photo call. The photographer, who at this moment would probably welcome the predictability of whizzing bullets and exploding land mines, soldiers on. The masses await the latest portrait of the queen.

Have you ever had the experience of watching a sunset, being transported by the beauty, and snapping a picture only to get it back from the developers looking small and uninspiring? This is what star shooting is like. Celebrities are brilliant moments of nature and just as elusive in their capture. They have something unique, and a photographer has to bag the genuine article. It's like sex – you know when someone's faking it.

<p align="center">✷ ✷ ✷ ✷ ✷</p>

In his quest for the moment, Mark Seliger shakes the tree and gets the apples. Look at these photos and check out the boundless imagination used to bring us what we want. I can't imagine the degree of psychological insight that enables him to maneuver around such hefty personalities. The last mask the star hides behind is the mask of his or her personality, the "public self." Perhaps by helping to create another role for his subjects, Mark charms them into showing their true selves.

So how does Seliger get people as disparate as the Rolling Stones, Howard Stern and President Clinton to strut their stuff? Well, first, he is endlessly inventive, refusing to be pigeonholed. He moves smoothly from super close-up (Sean Penn sucking a cig) to posed kinetic groupings (my favorite is the twisted Norman Rockwell–esque shot of Boy Scouts tying up Drew Barrymore in bondage knots), to energized character moments like Seinfeld impersonating Elvis, to period pieces (Travolta in a luscious, noir-perfect, Forties-style portrait). He uses outdoor light, studio light, manic light. He shoots roughly, smoothly. He'll even go underwater. Just ask Sandra Bullock and Fiona Apple.

He has one objective: Deliver the essence. A perfect example is his portrait of Robin Williams for the cover of *Rolling*

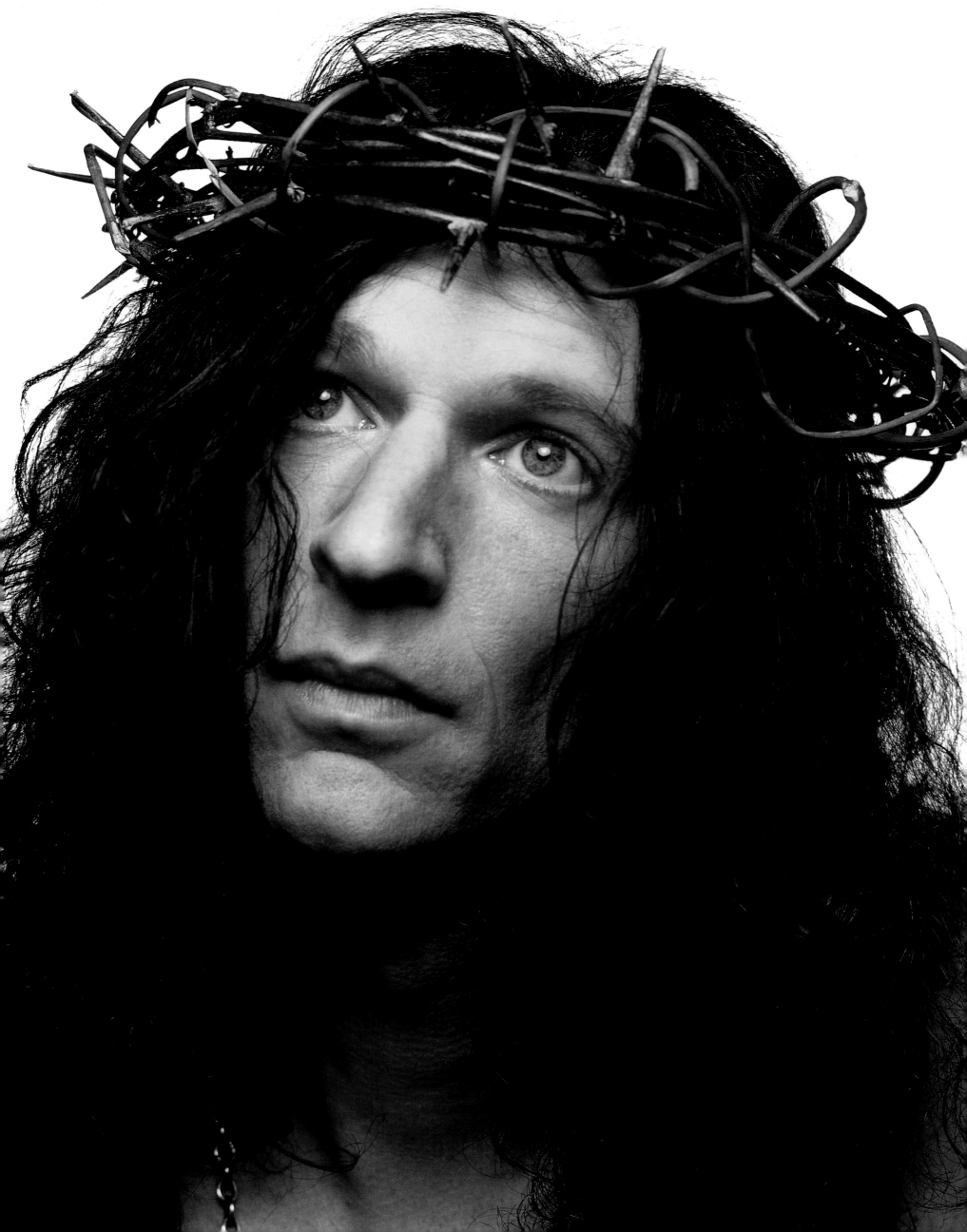

Stone – a classic. Crunched down into an oversized collar, Williams looks comical but anxious, up but down at the same time. He's a little boy in a grown-up's clothing. And this is exactly what Williams is, the sad clown. It's a big bold stroke of a photograph, muscular and centered.

Jenny McCarthy, well known and well exposed for her lascivious sense of humor, is presented here in some sort of Freudian joke. In Seliger's inside-out symbolism, the mustard is orgasming onto the phallic hot dog. And who's squeezing the bottle? Jenny. Incidentally, she looks sexy and hot, not dumb and jokey.

<p align="center">✶ ✶ ✶ ✶ ✶</p>

While I was working on this introduction,
Mark, as usual, was off with a mad, wonderful movie star on a luscious tropical island. He was "hanging out." And he told me how much "fun" it was. But I know Mark. He wasn't there for fun. He was hunting. Hunting the moment. Getting playful, getting the celeb to open up, relax, reveal. He knows we don't want the pose, we want the soul.

Of course, this is a case where the prey wants to be hunted. Because the big news is, stars don't look like stars most of the time. Have you ever met one? They rarely look like "themselves." And they know it. Because stars want their image to be as close to their imagined larger-than-life self as possible, the pressure is on the photographer to do the job. As the photos in this volume testify, Mark Seliger has more than risen to the task.

So dive in. The stars want you to. Enter that precious moment – collected, lit and staged by a master. It's a magical thing when you consider it: a drop of time in which, very briefly, a brilliant entity burning in the firmament was plucked down and frozen for all eternity. No one really knows if the stars are what they pretend to be, but with faces like these, who cares? Let the eyes of these mythical characters reach into you, find you and transport you one more time. And then thank Mark Seliger for his talent. ✶ FEBRUARY 1999

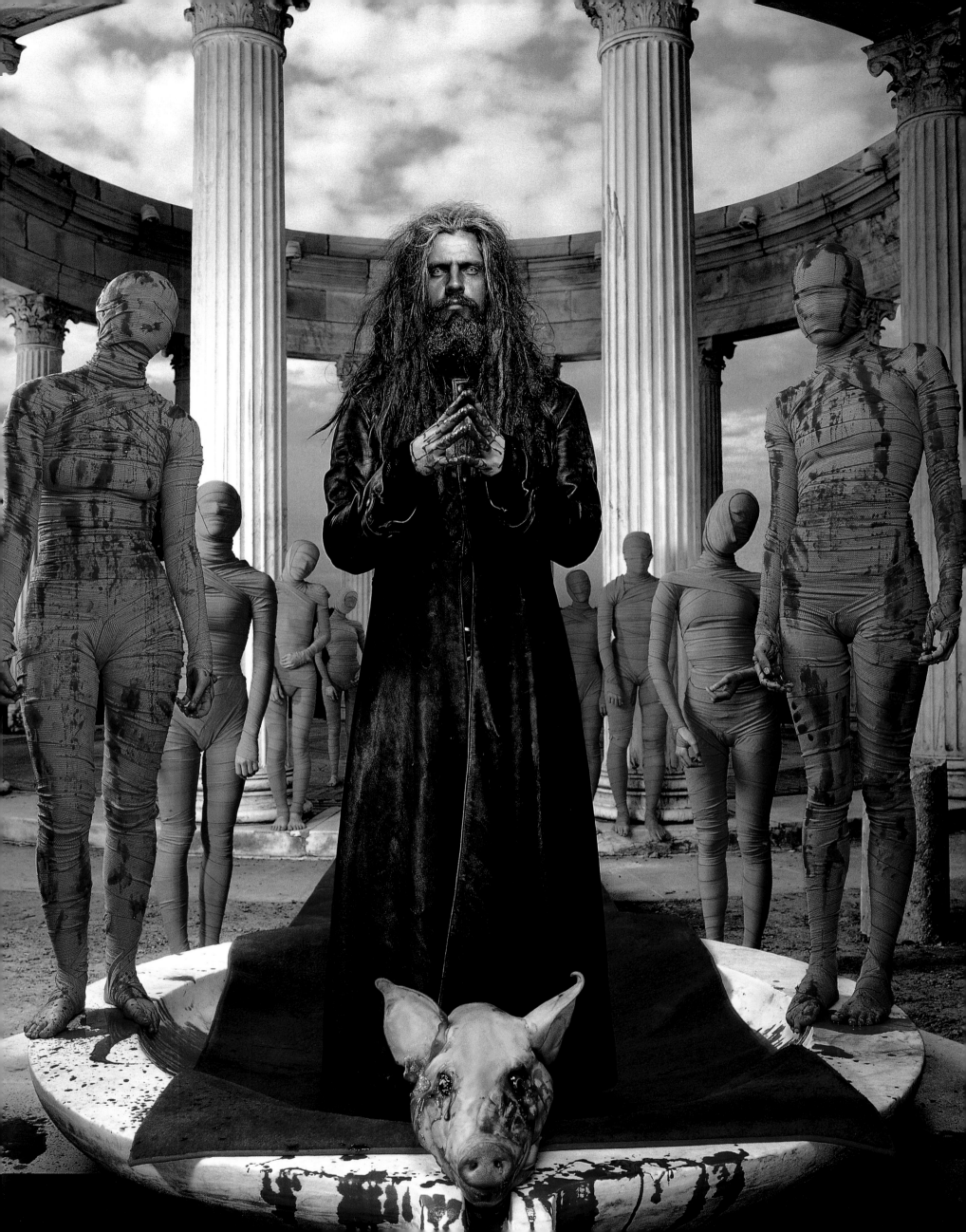

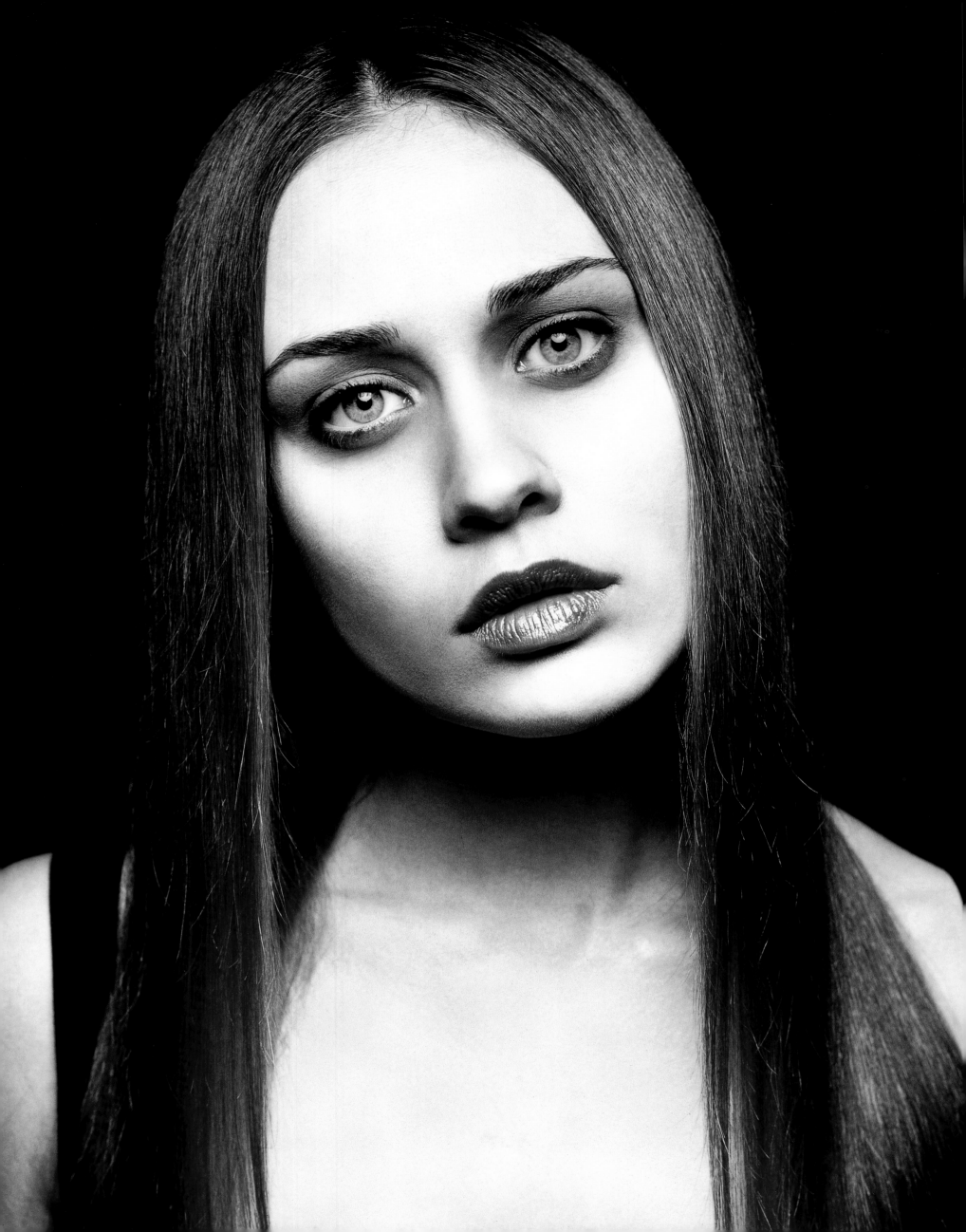

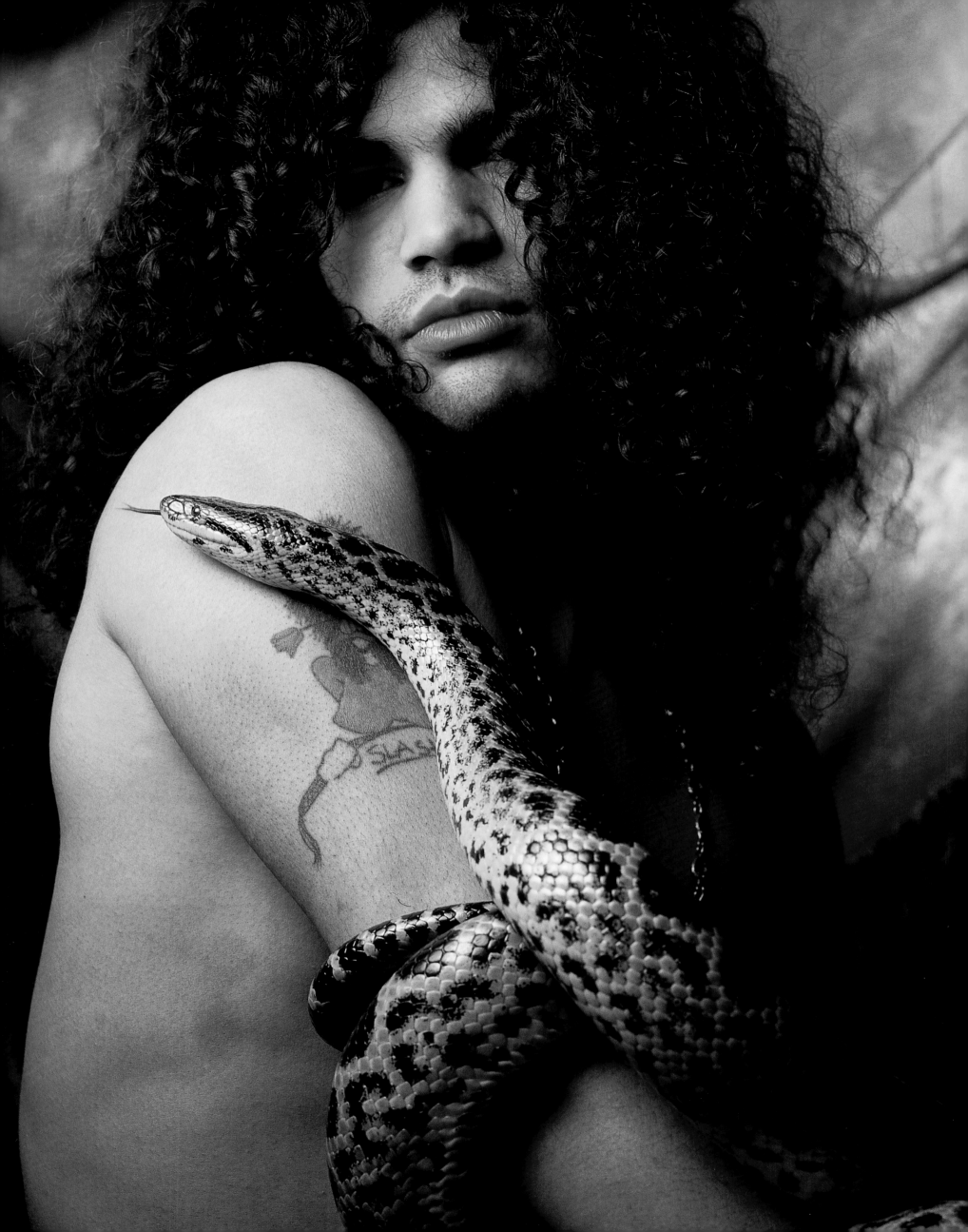

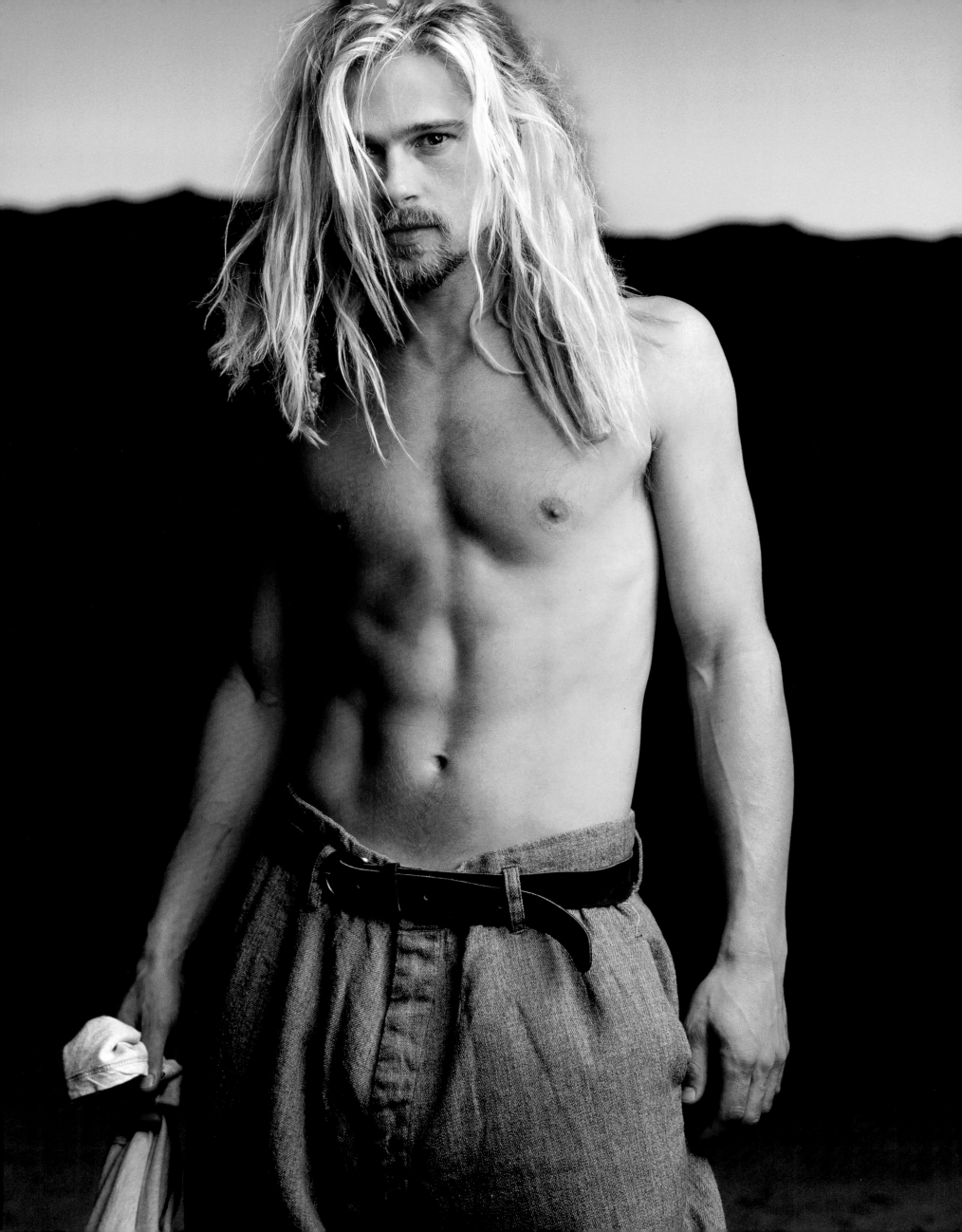

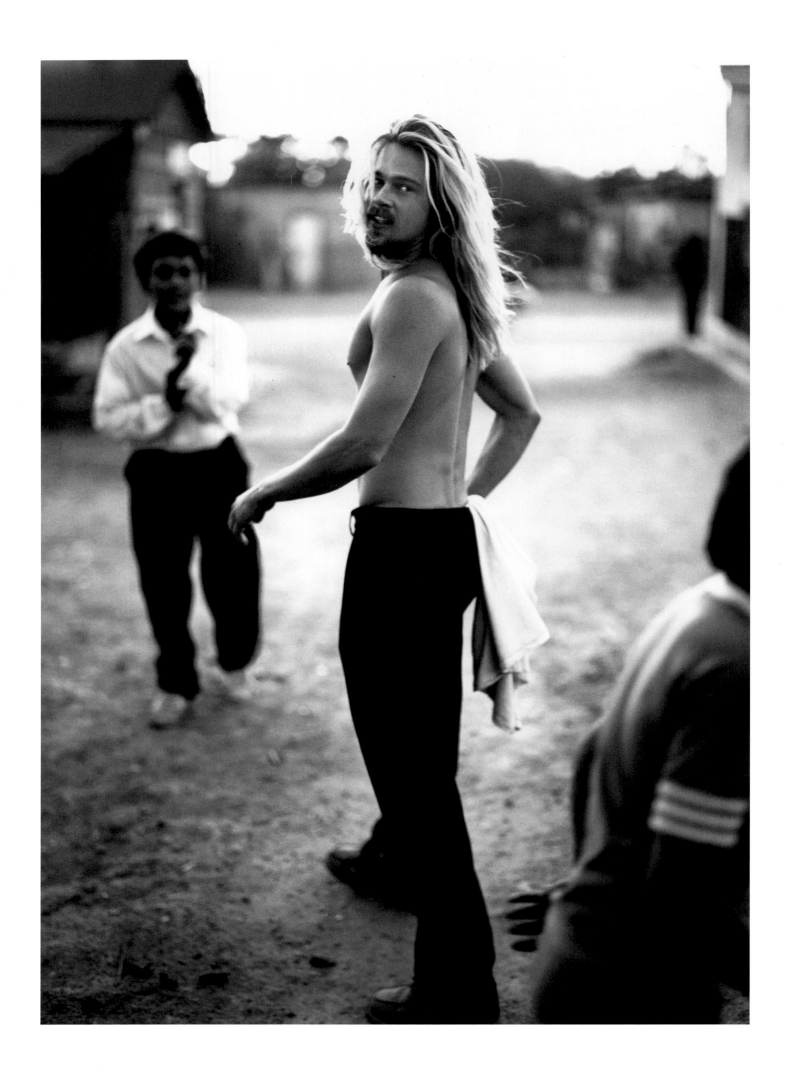

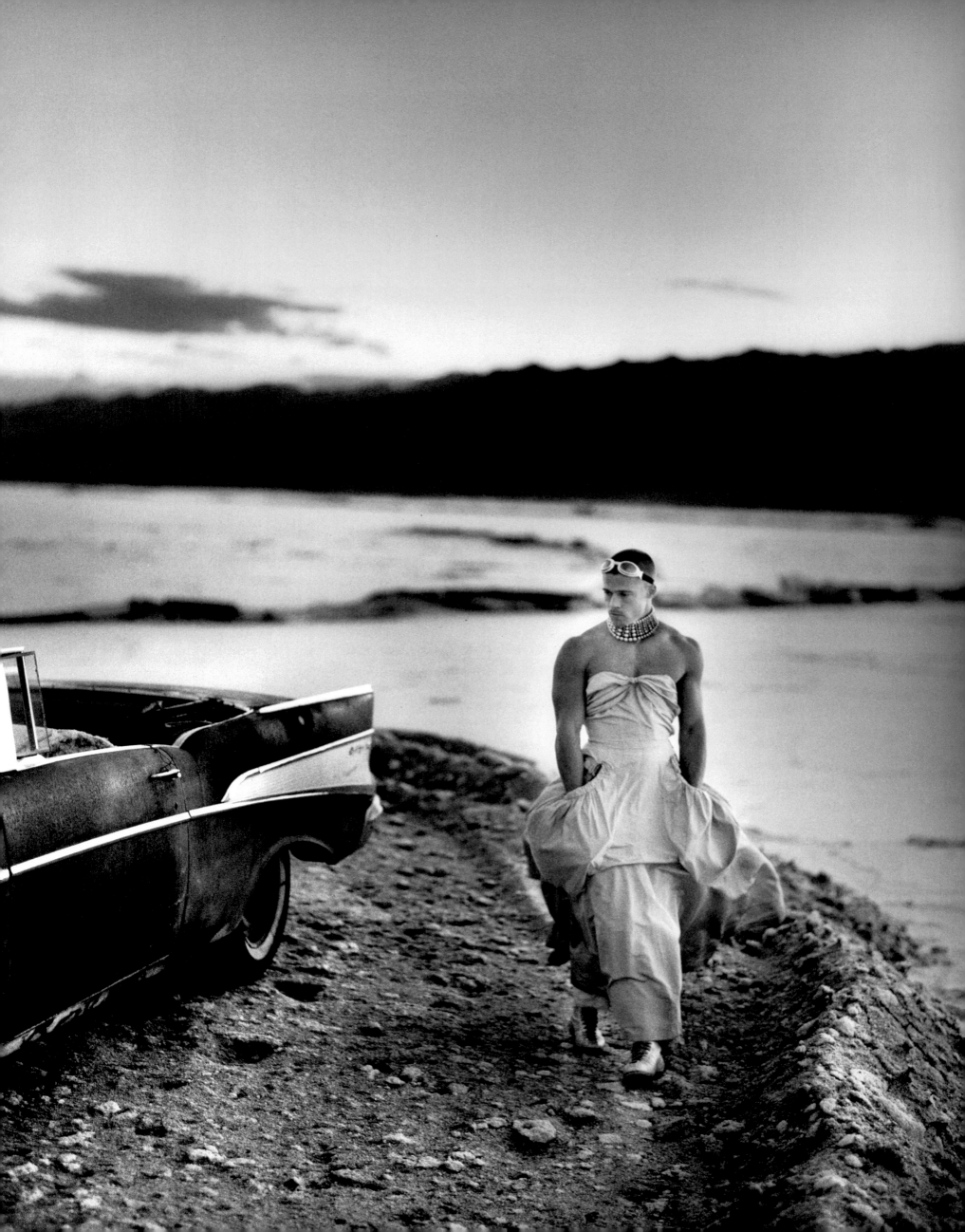

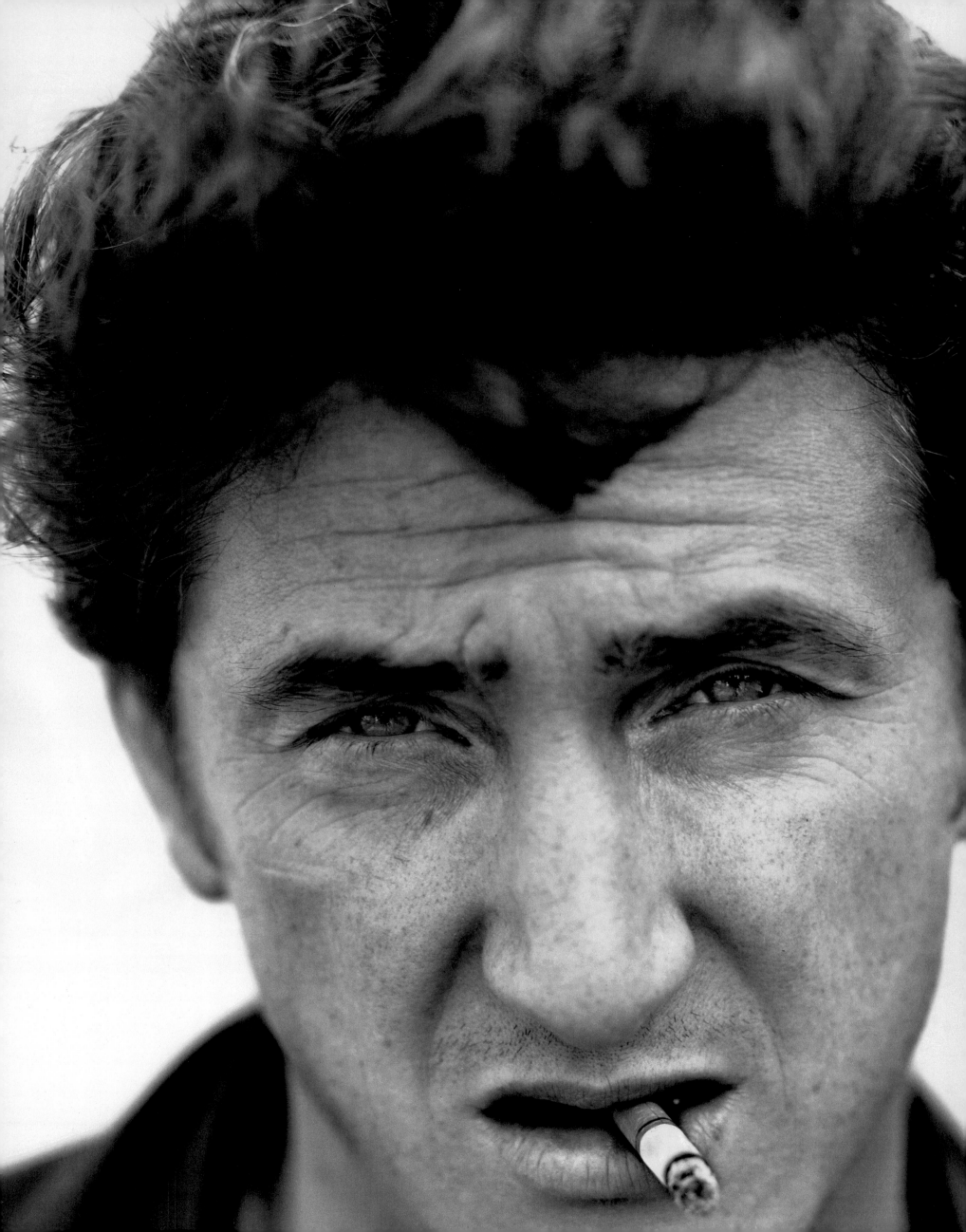

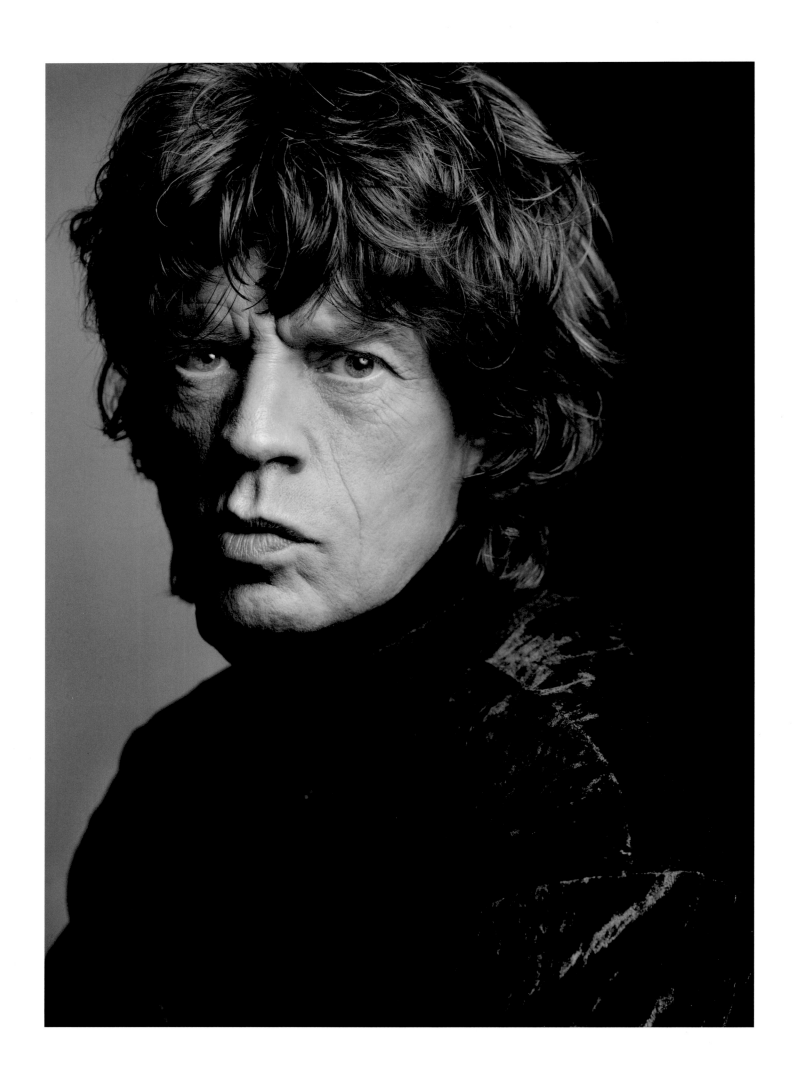

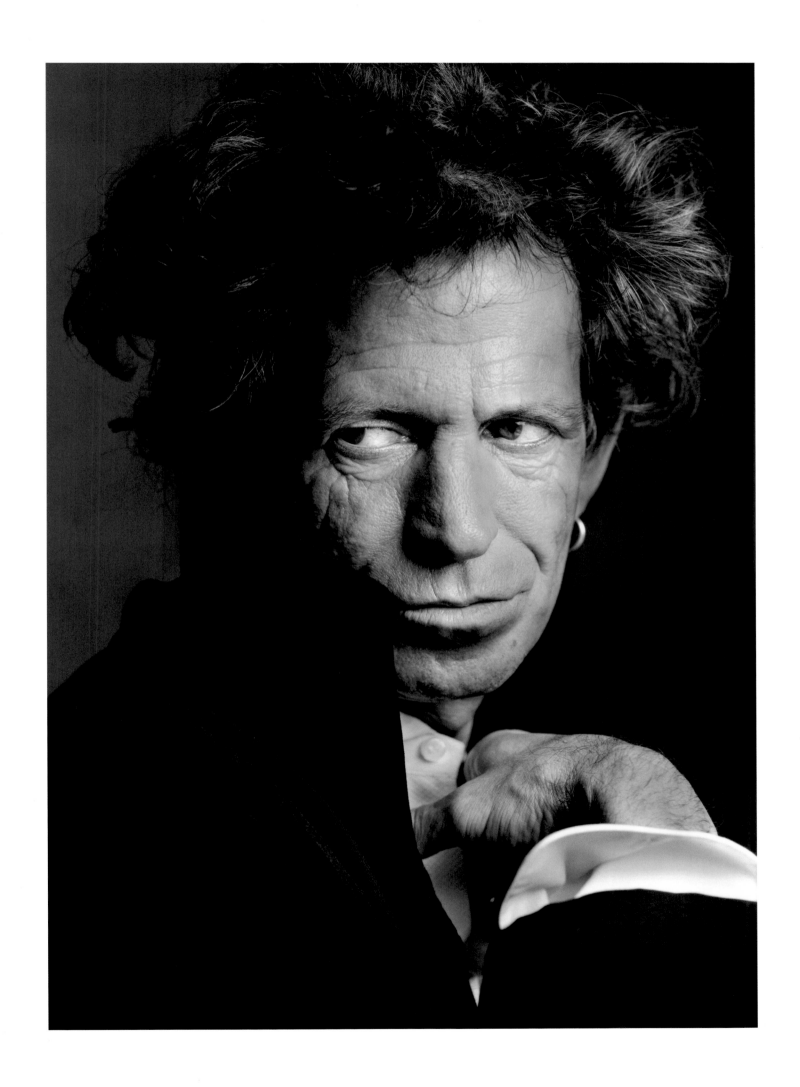

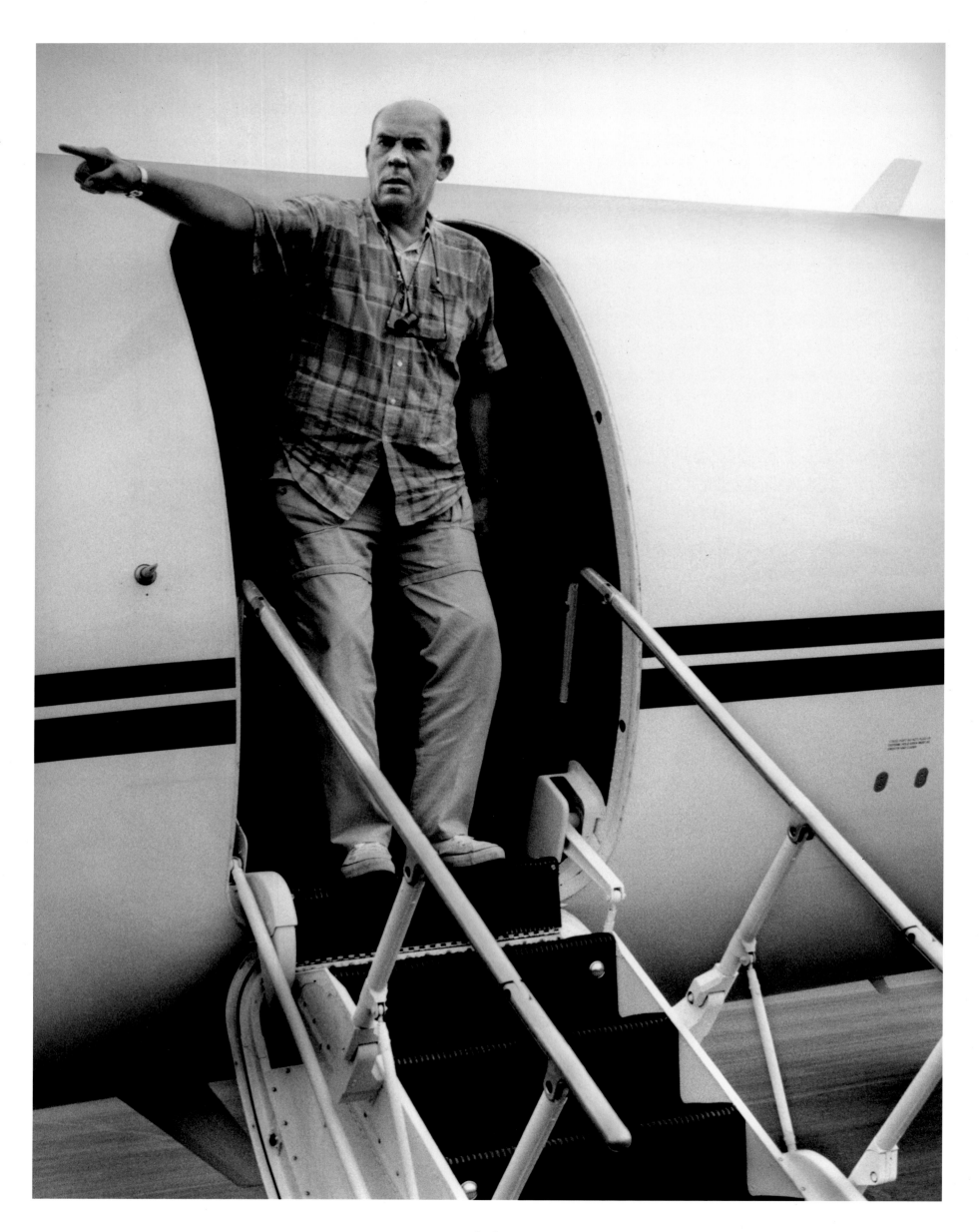

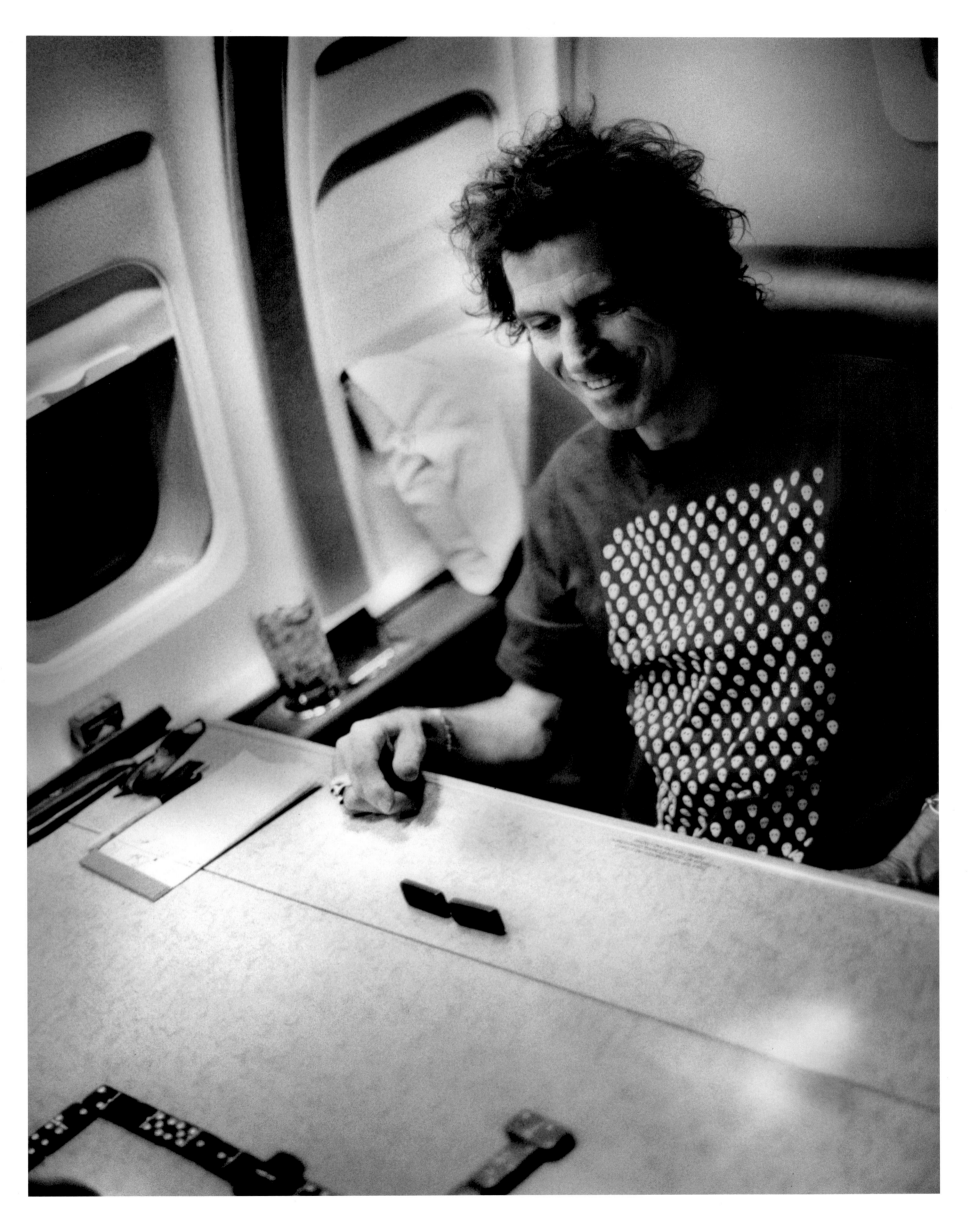

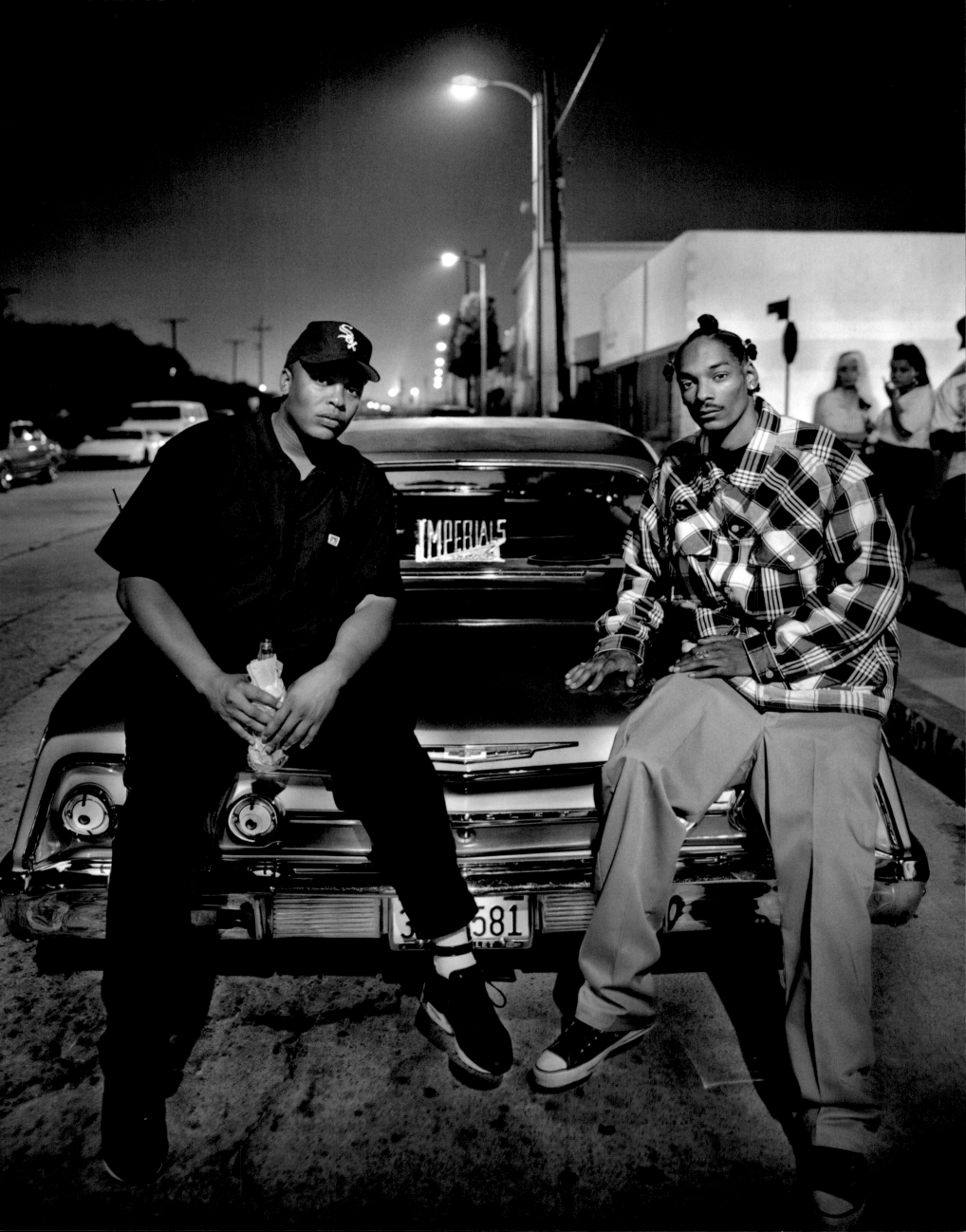

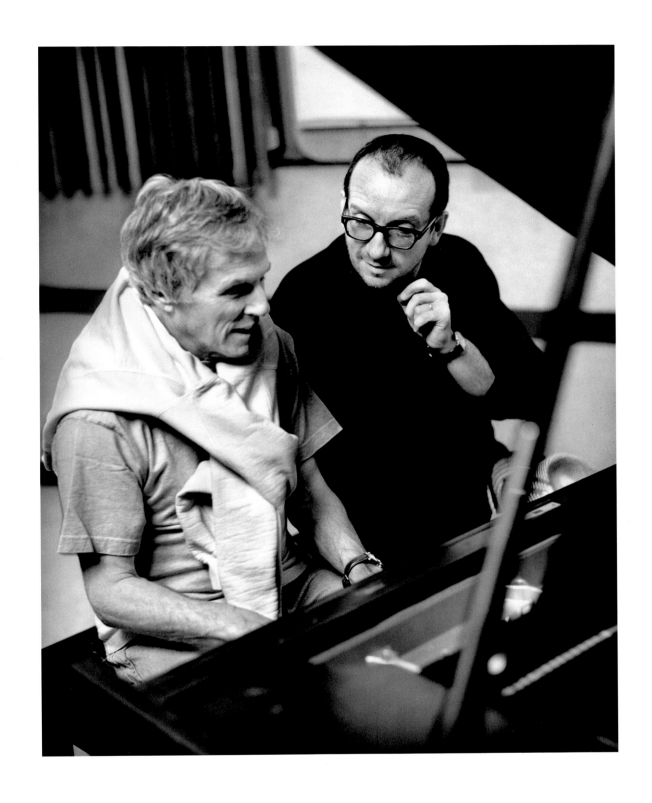

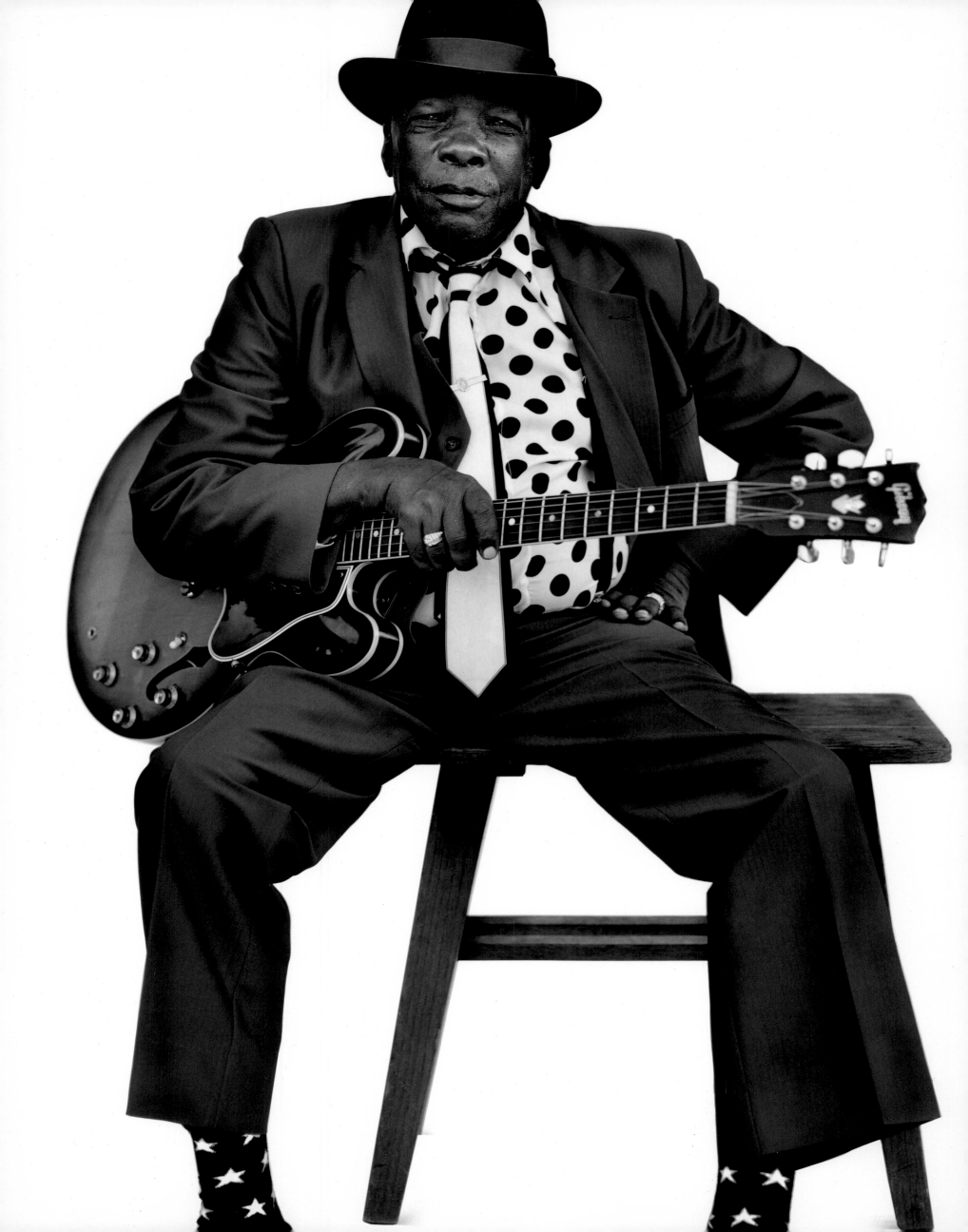

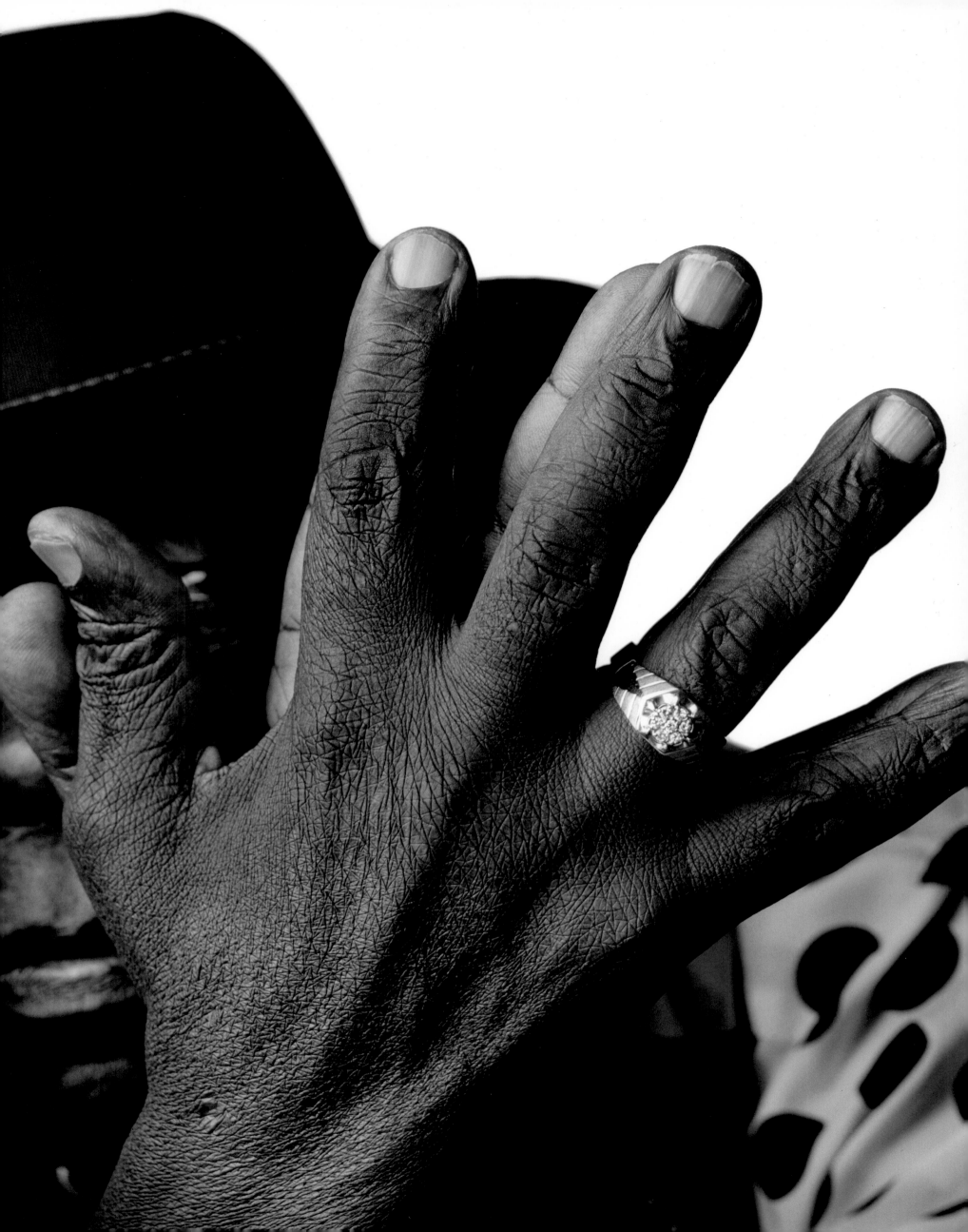

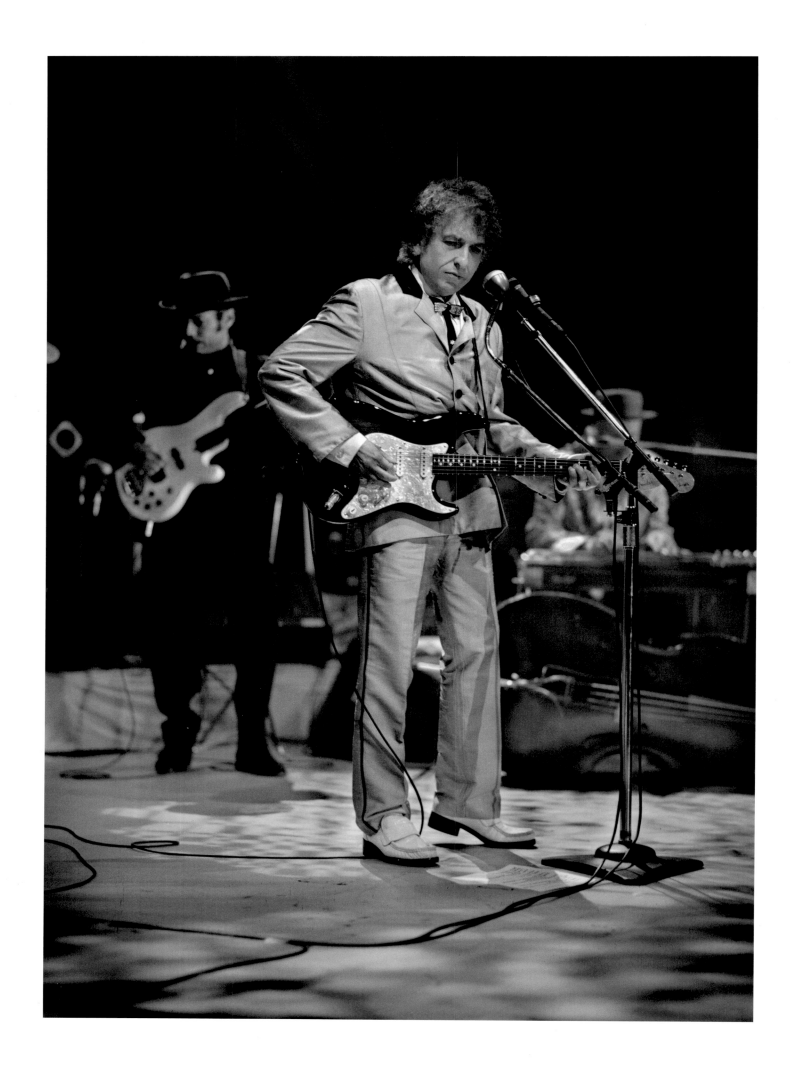

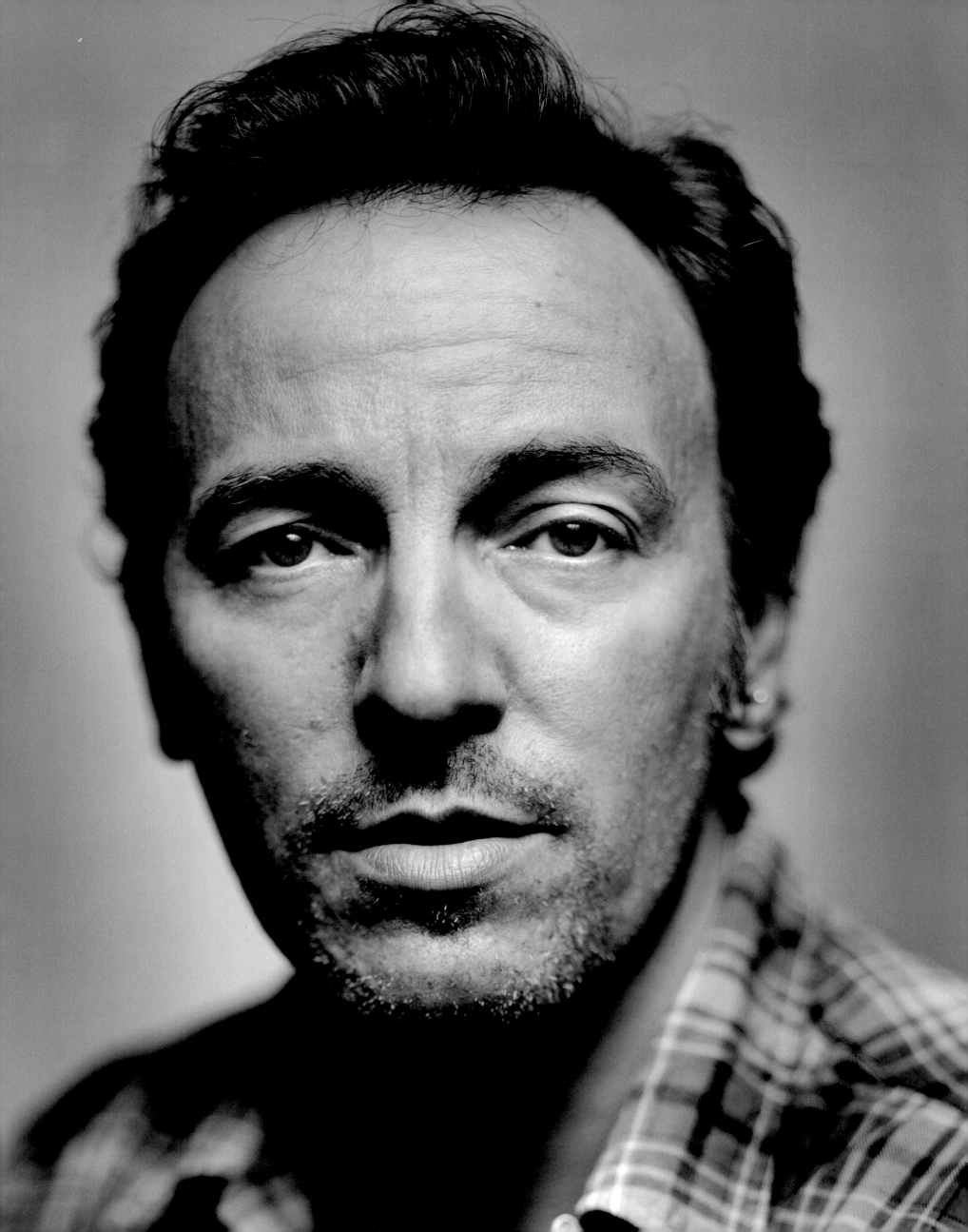

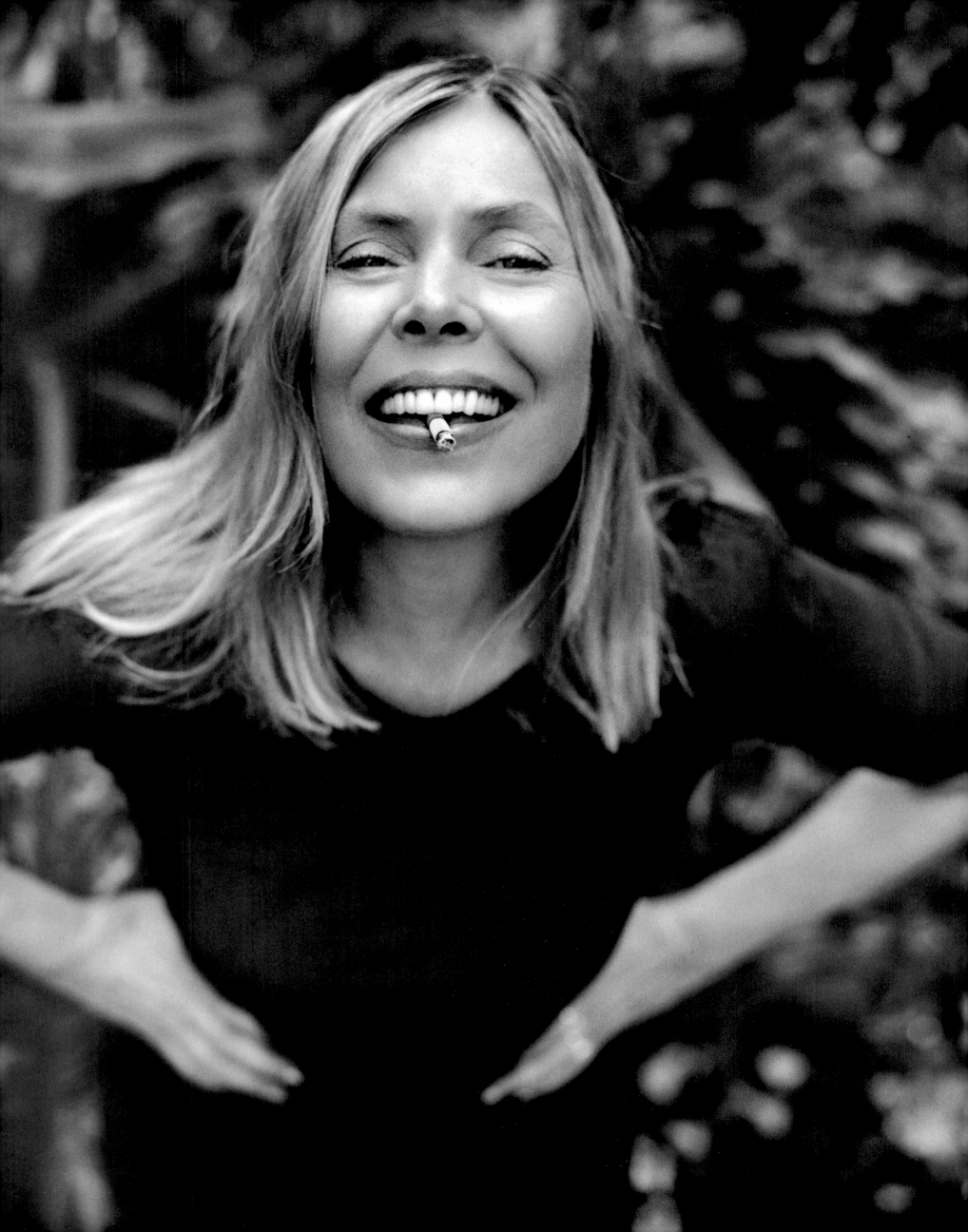

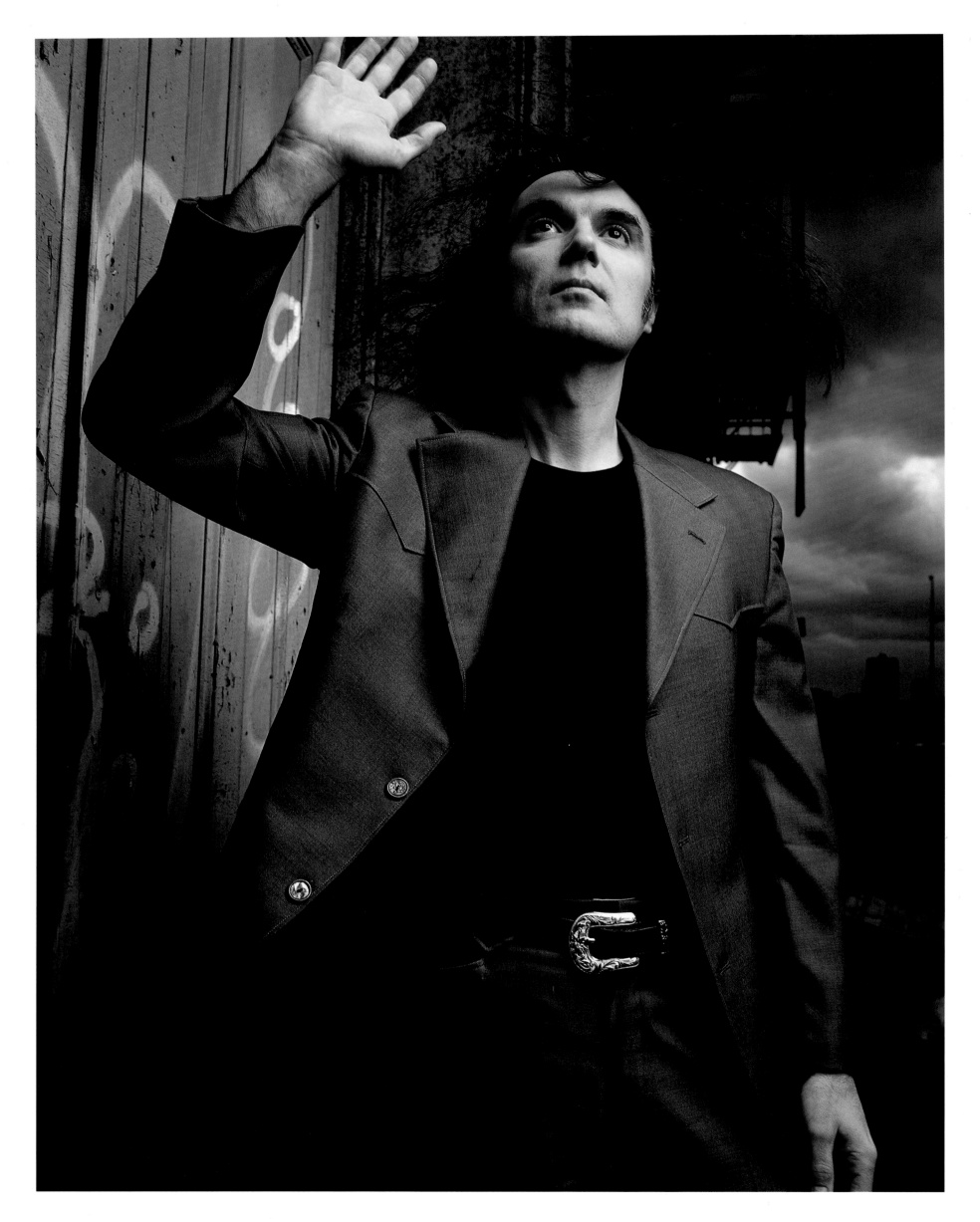

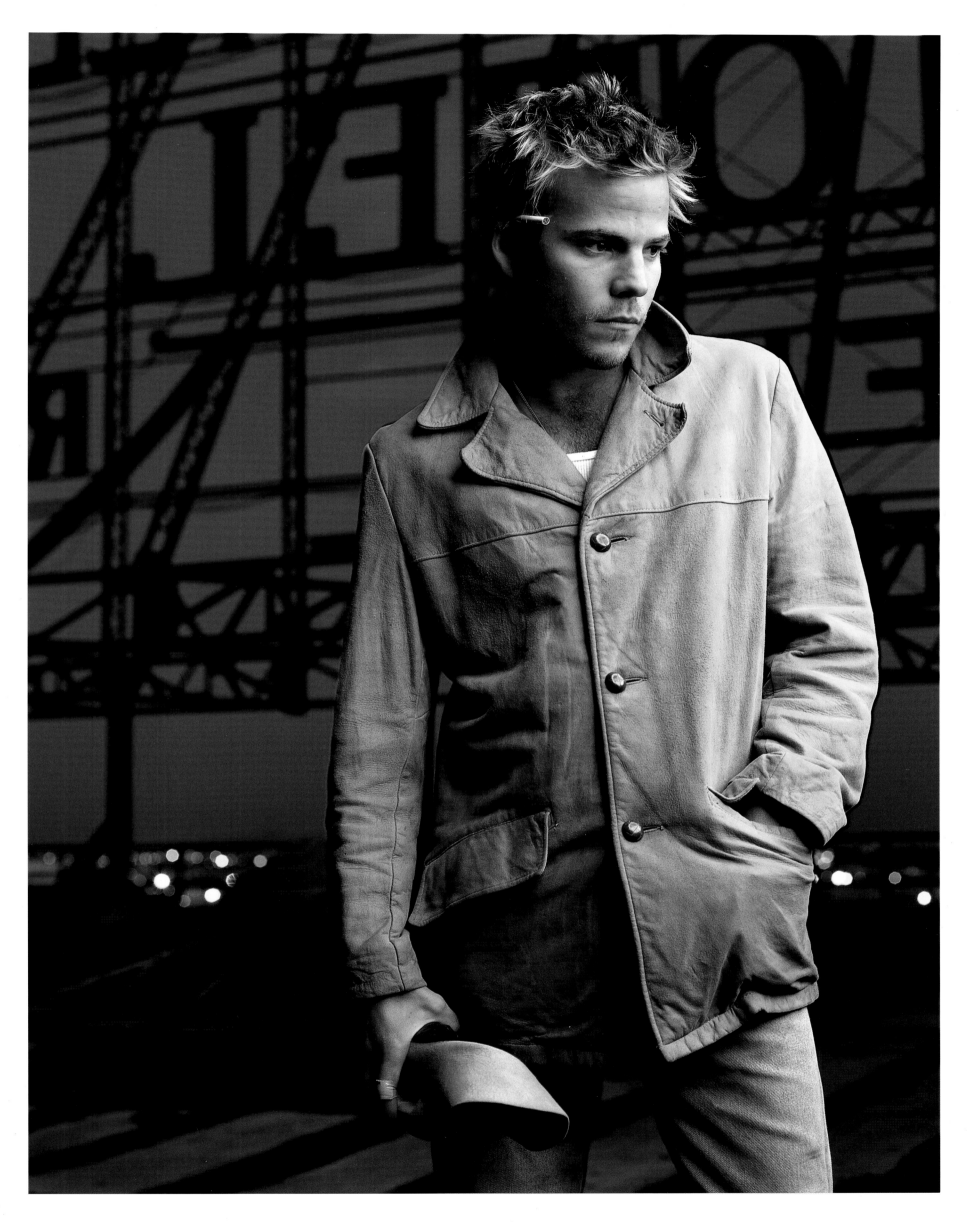

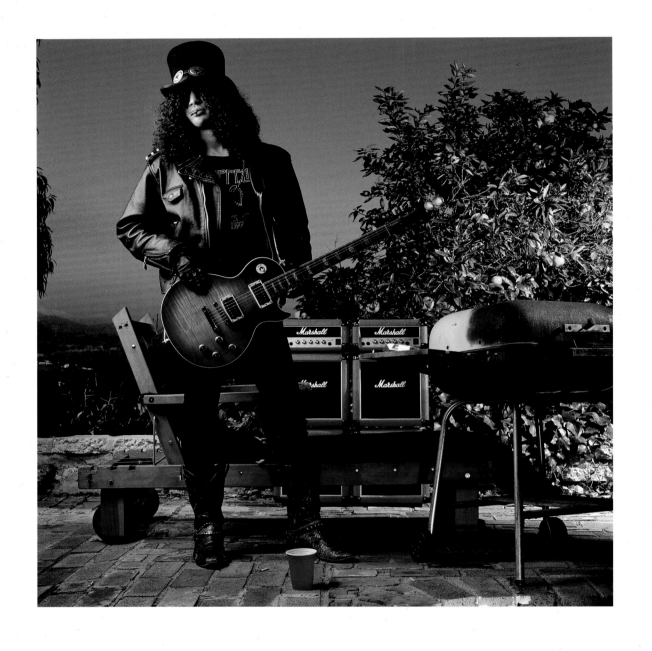

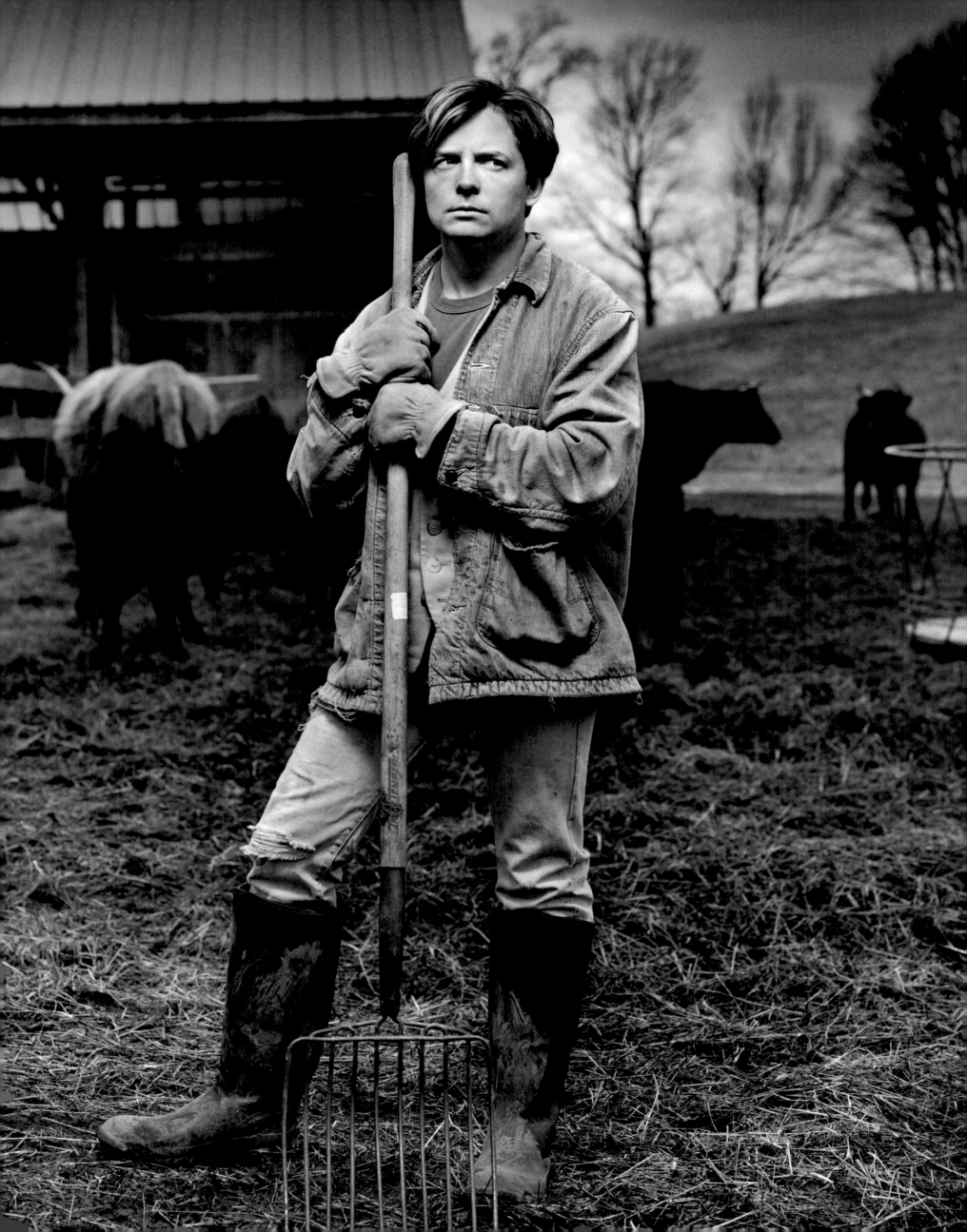

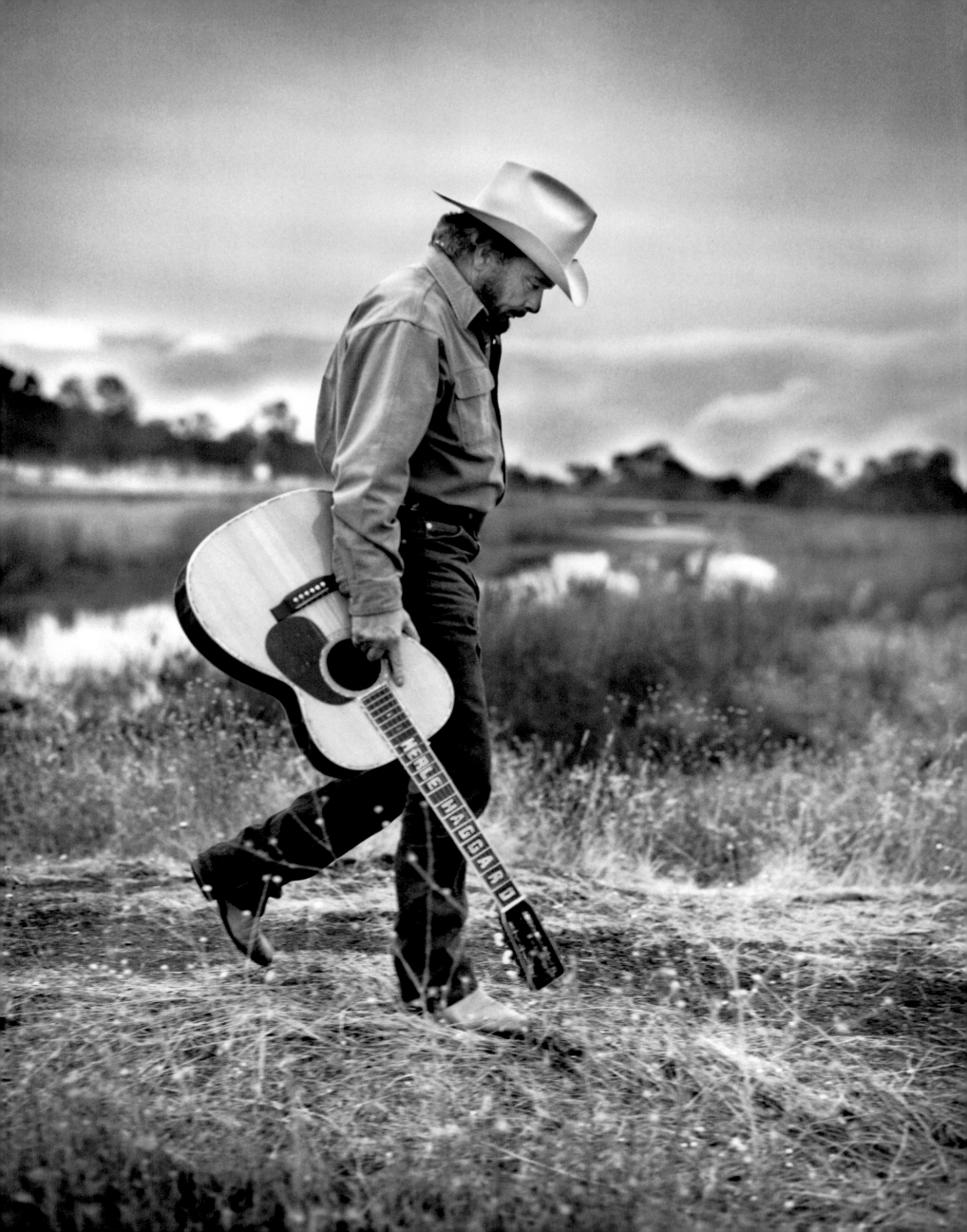

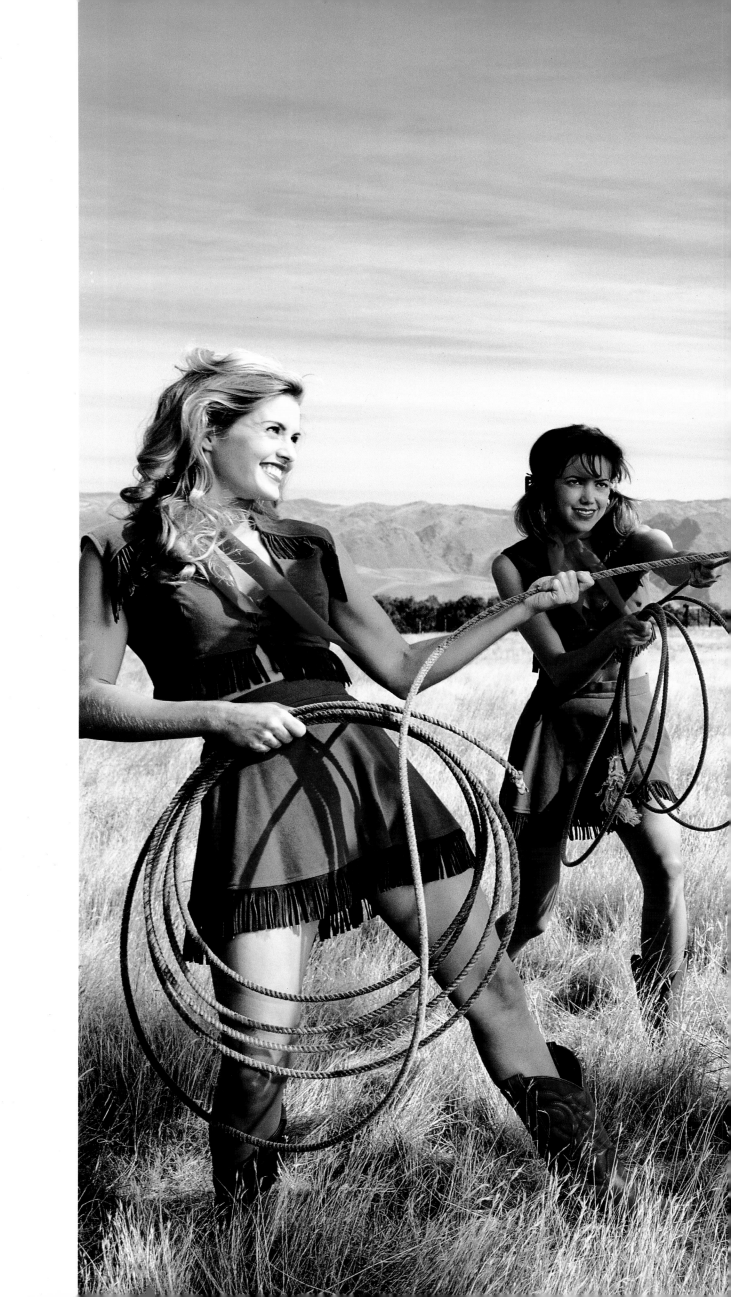

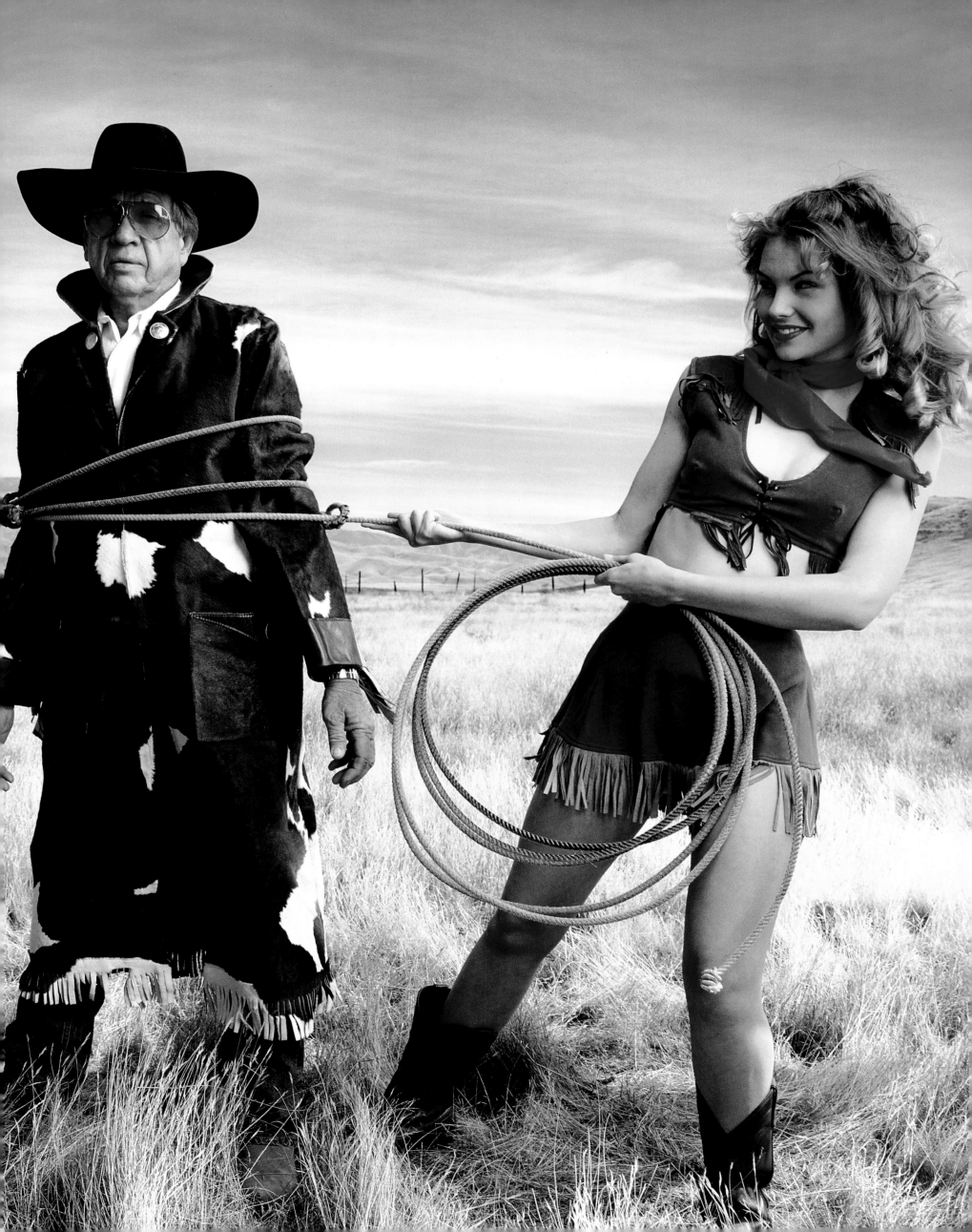

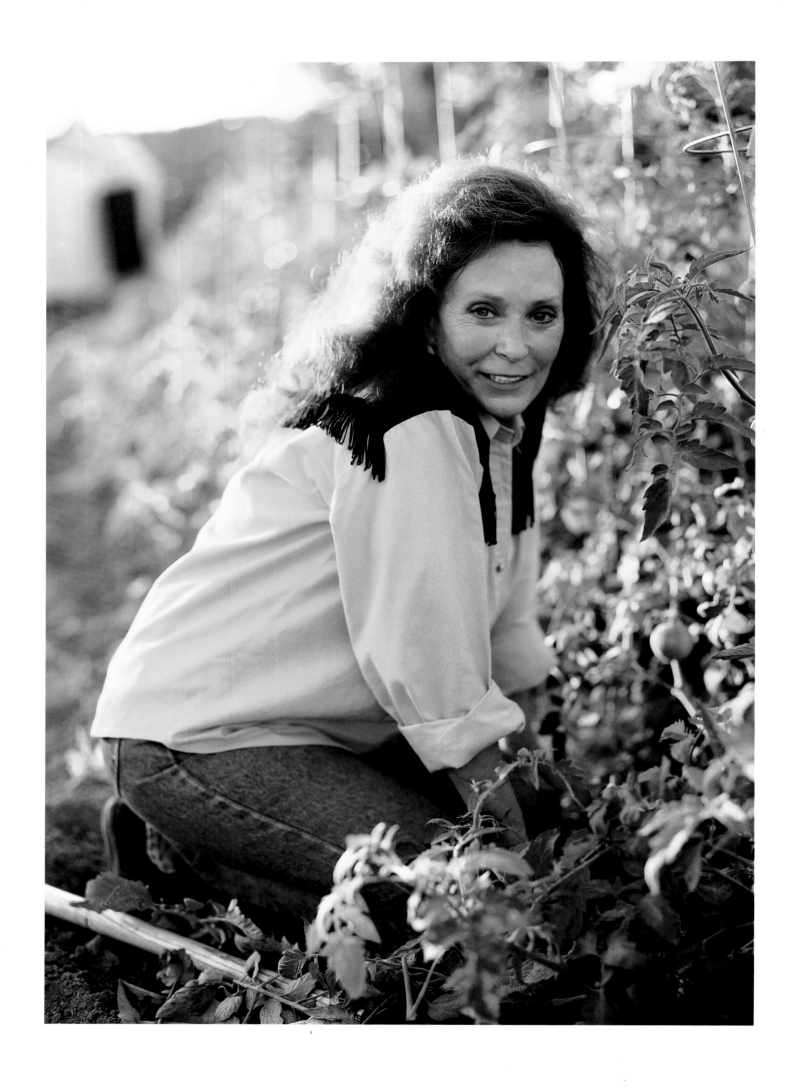

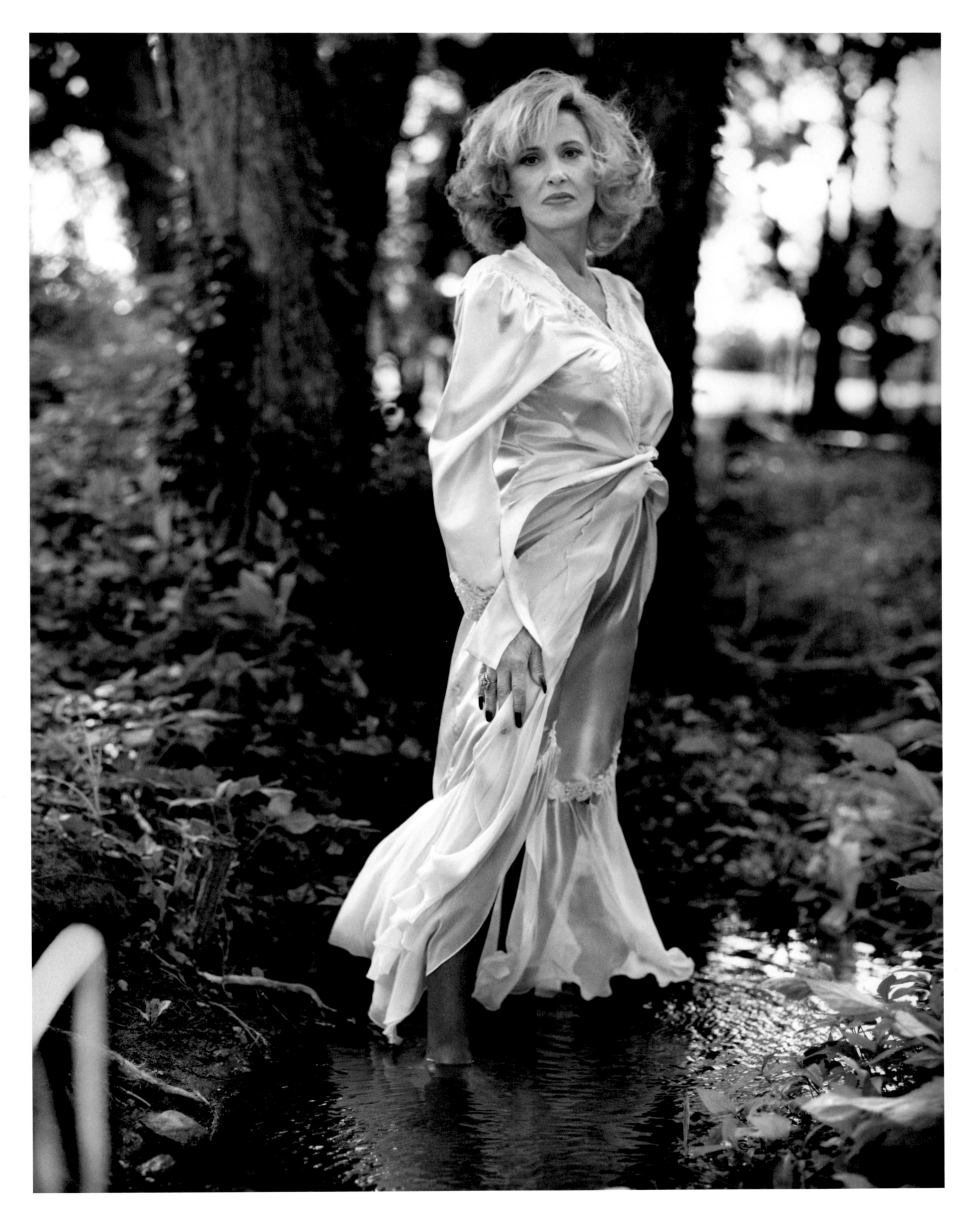

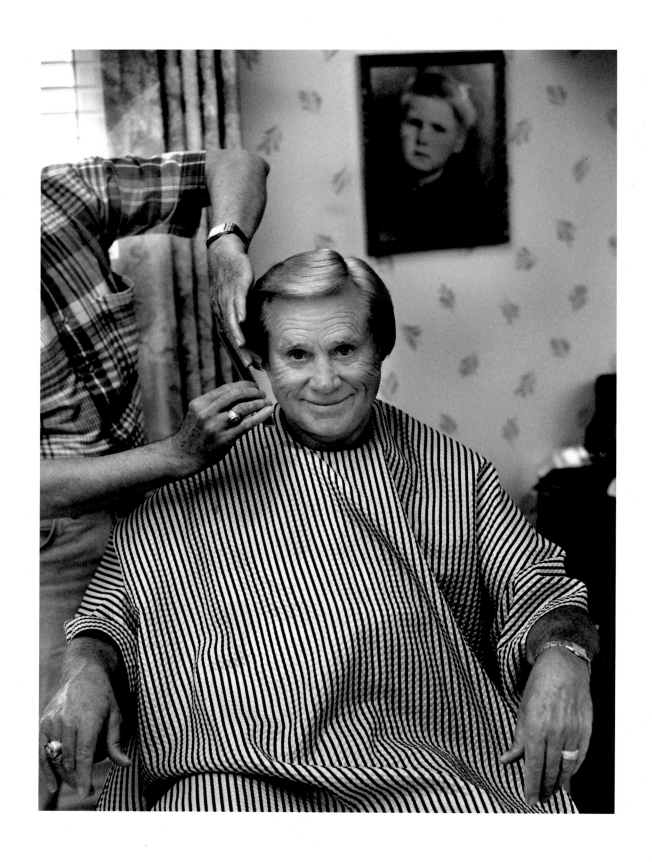

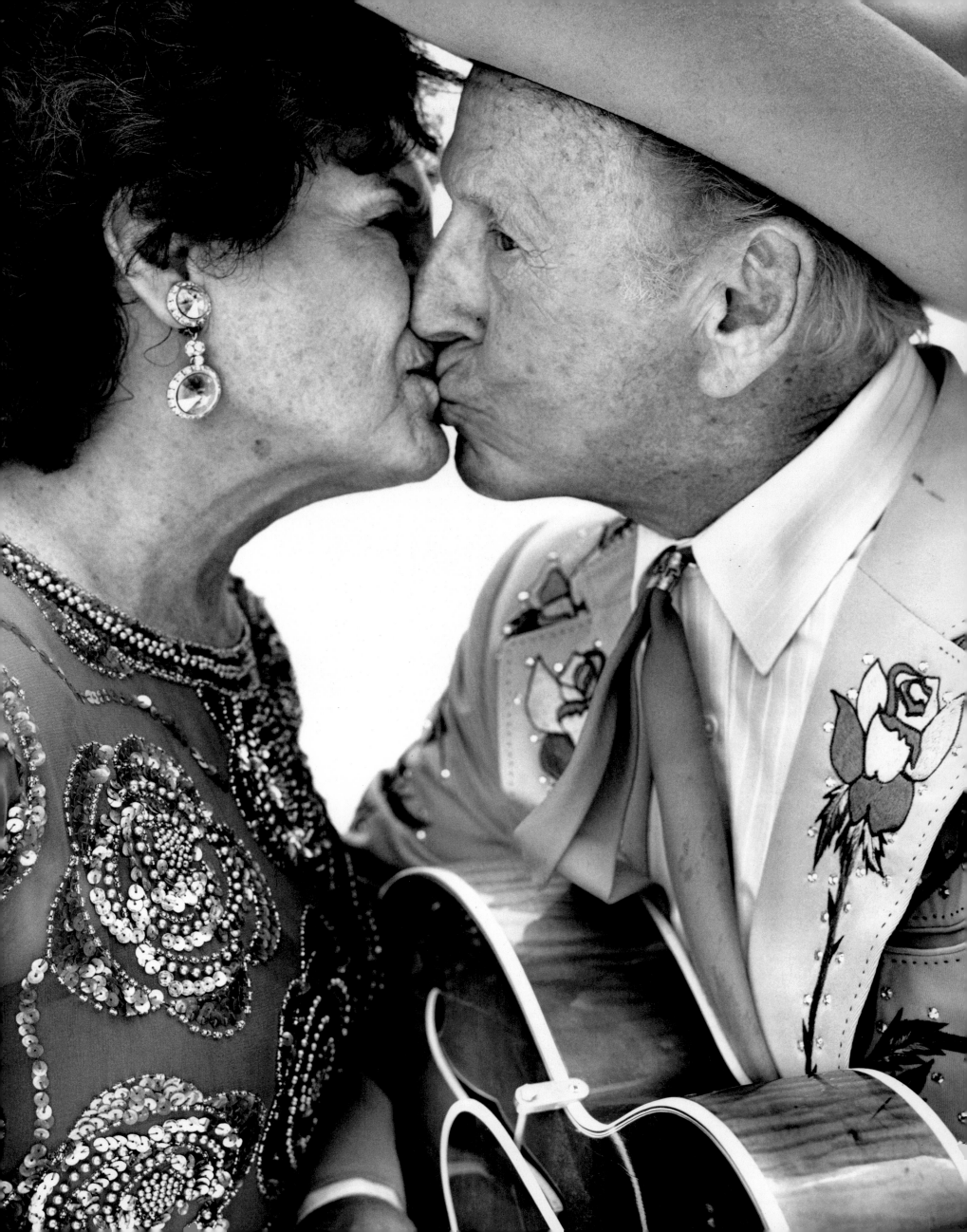

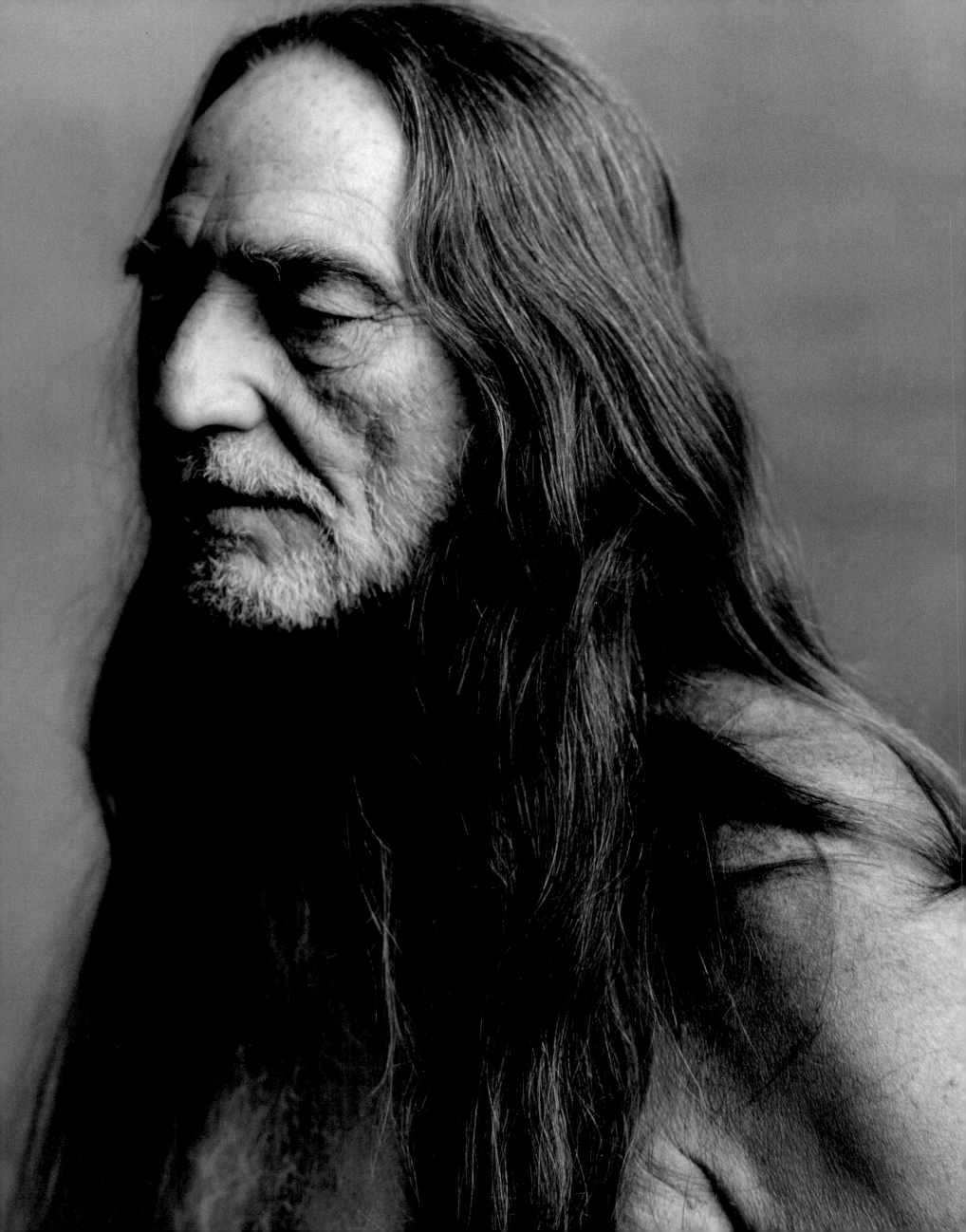

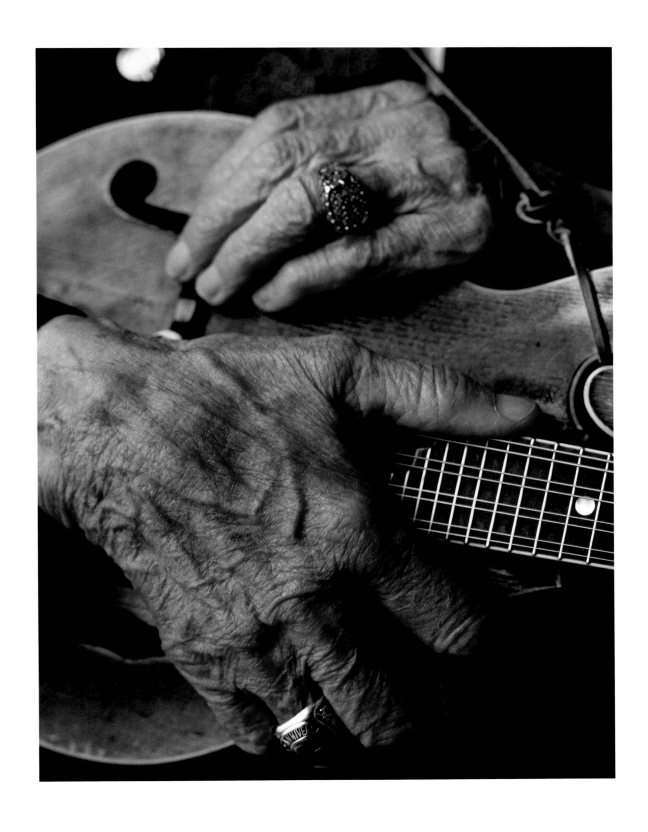

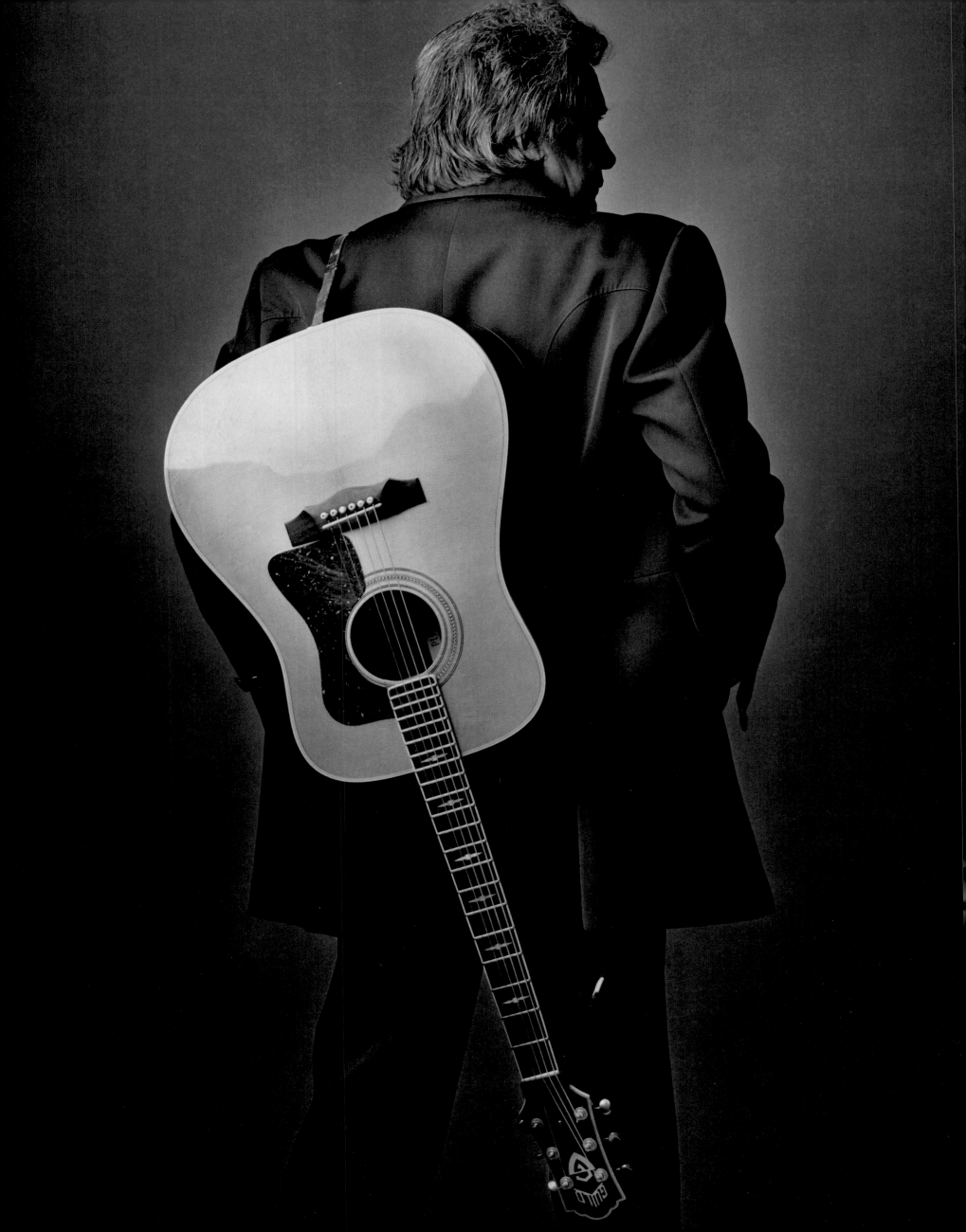

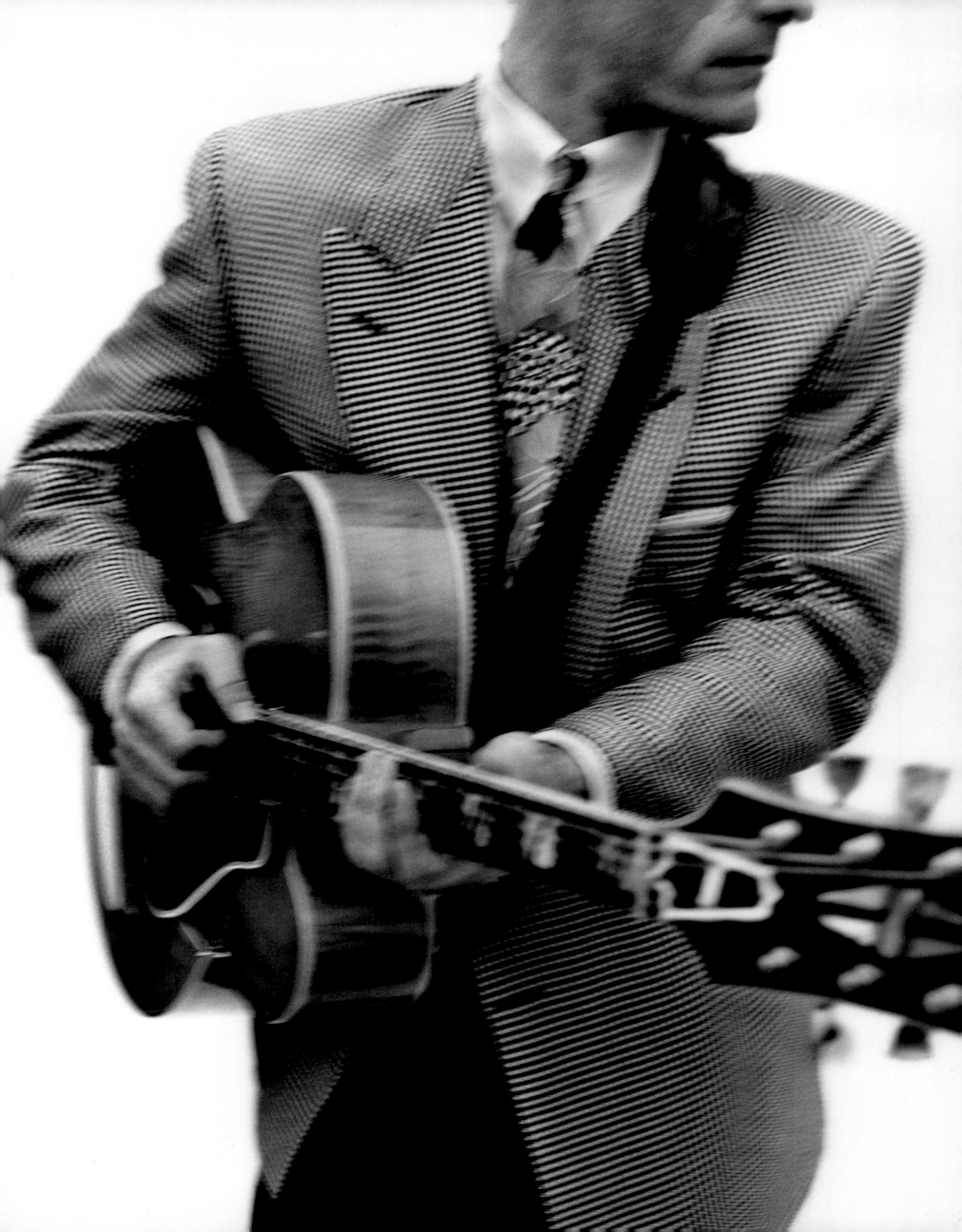

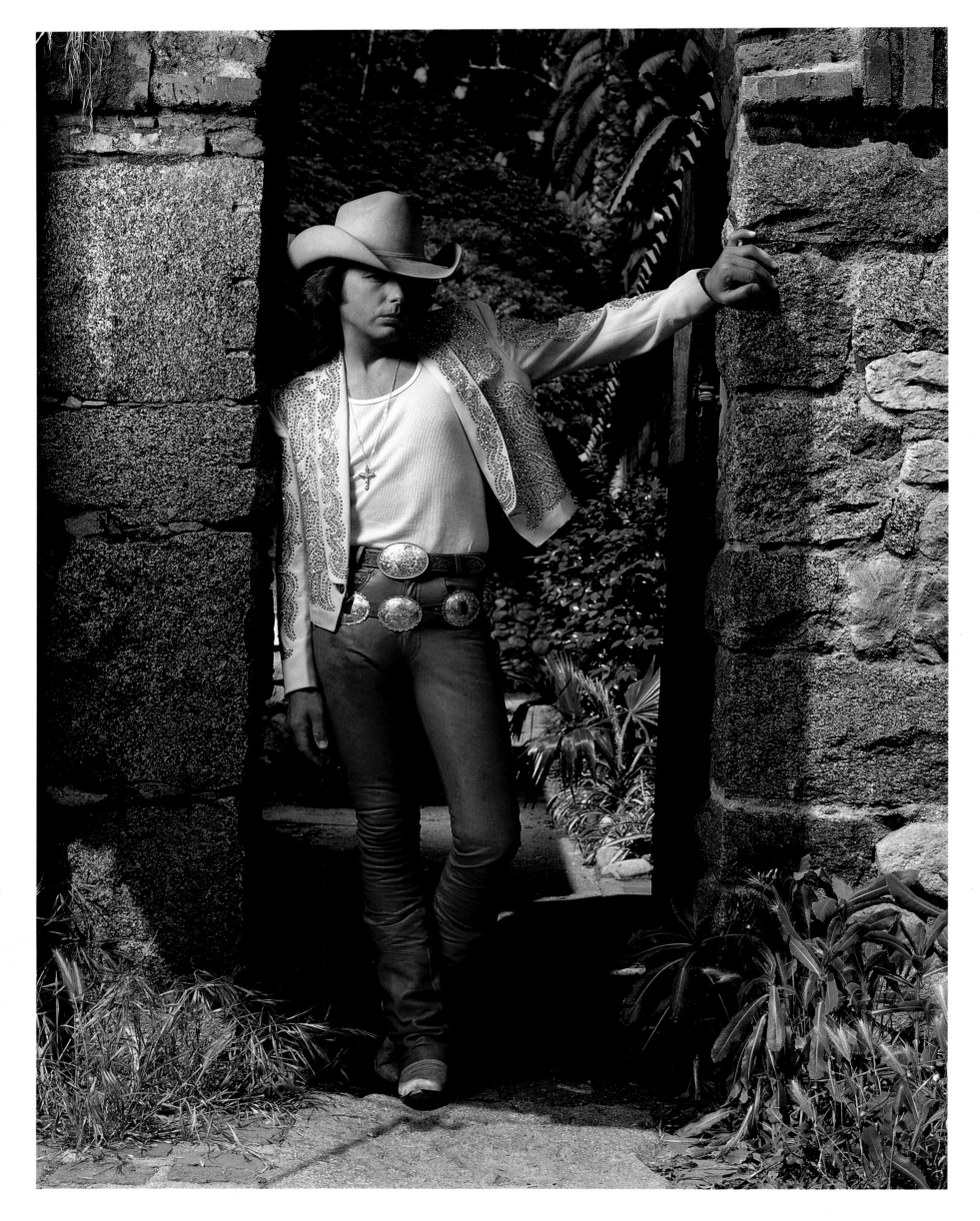

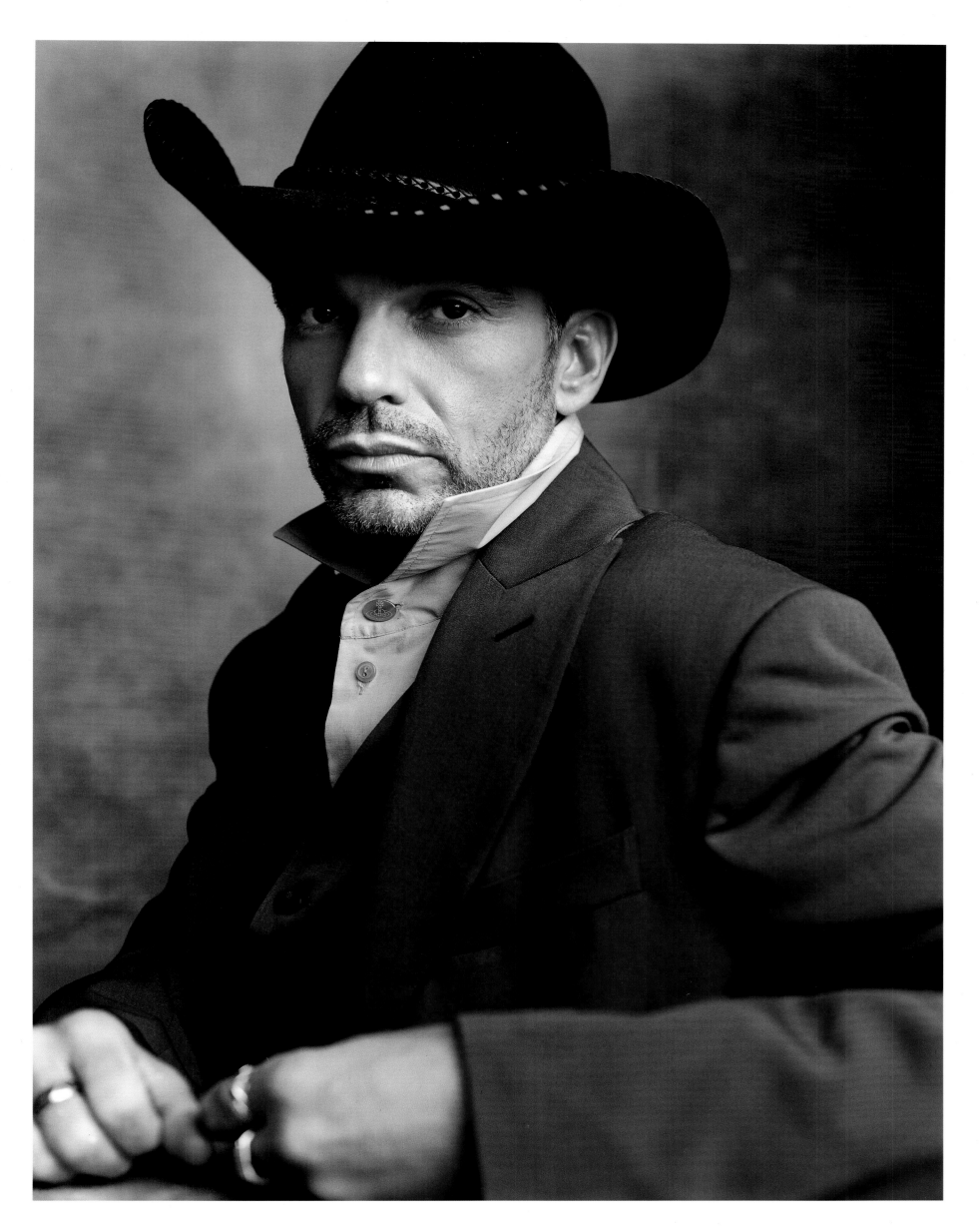

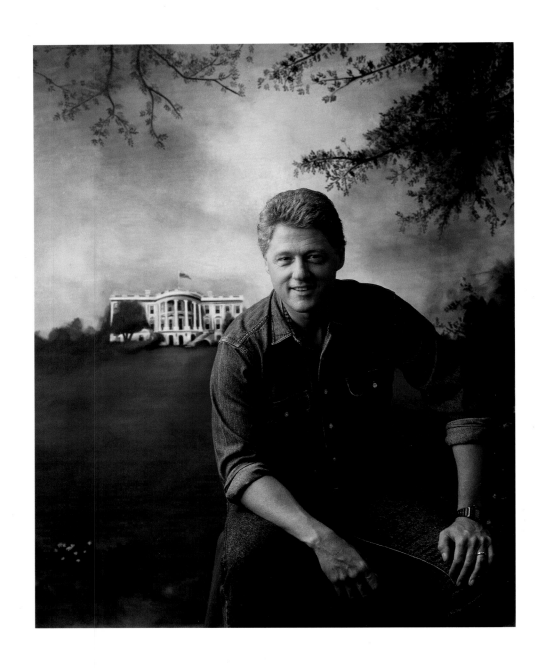

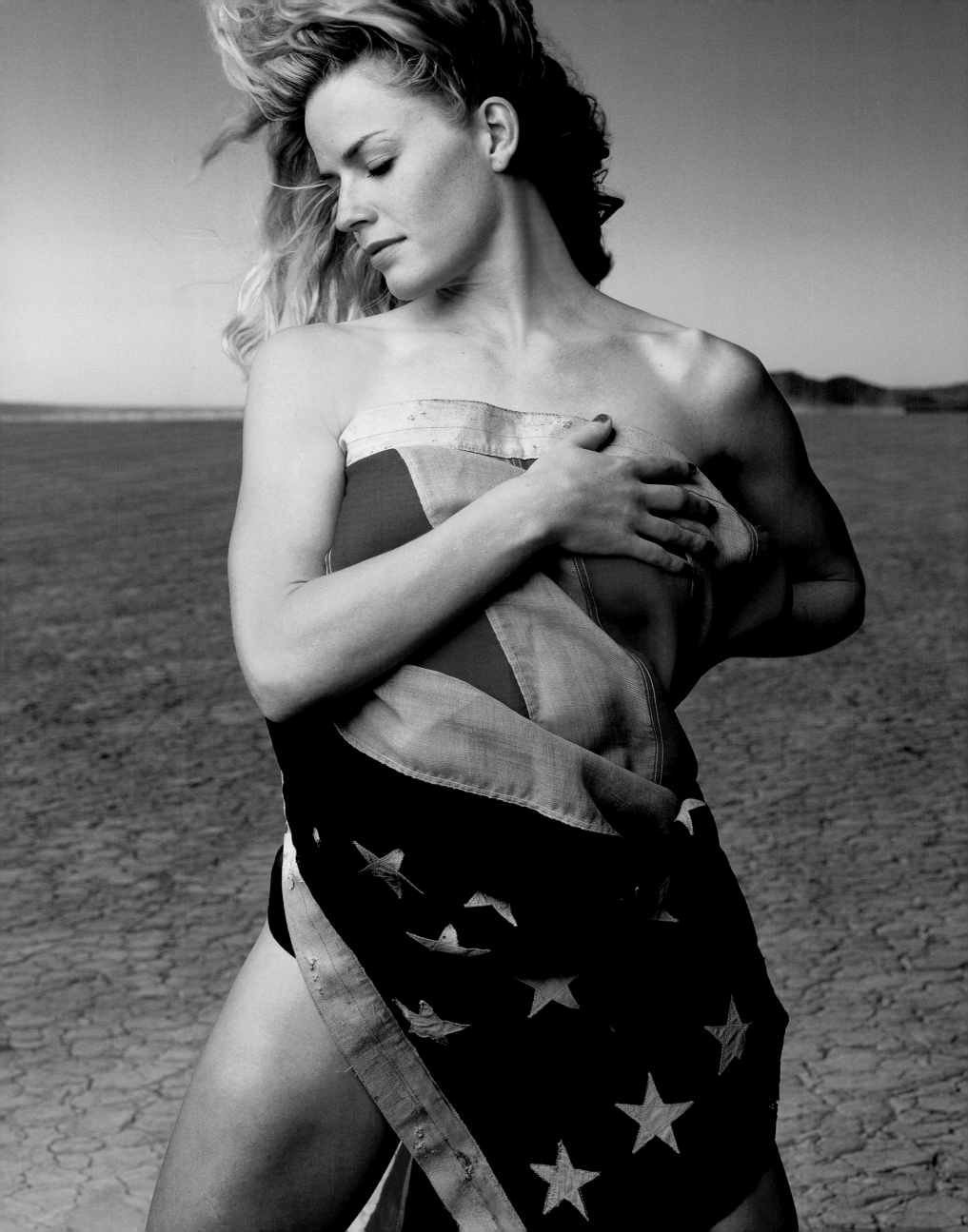

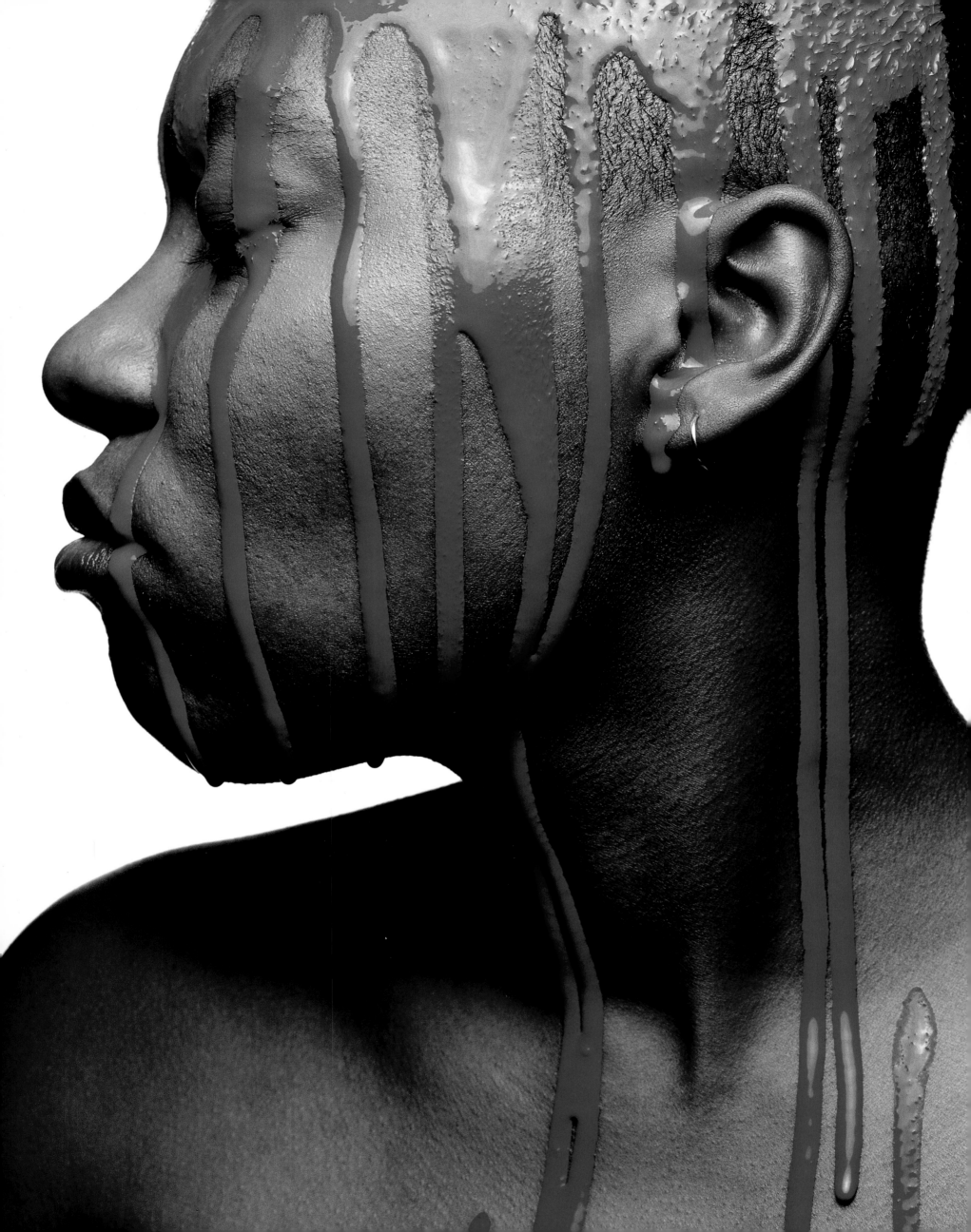

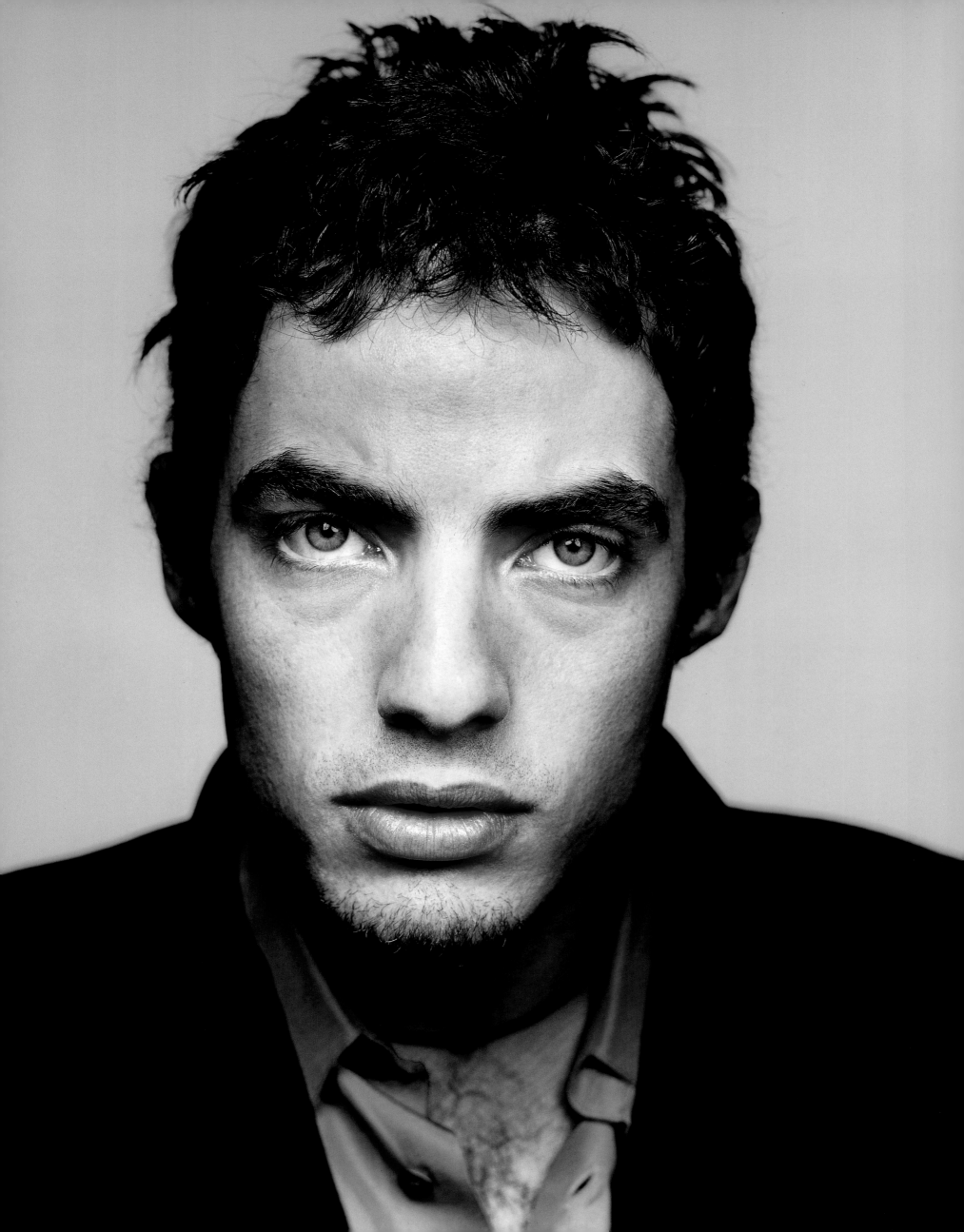

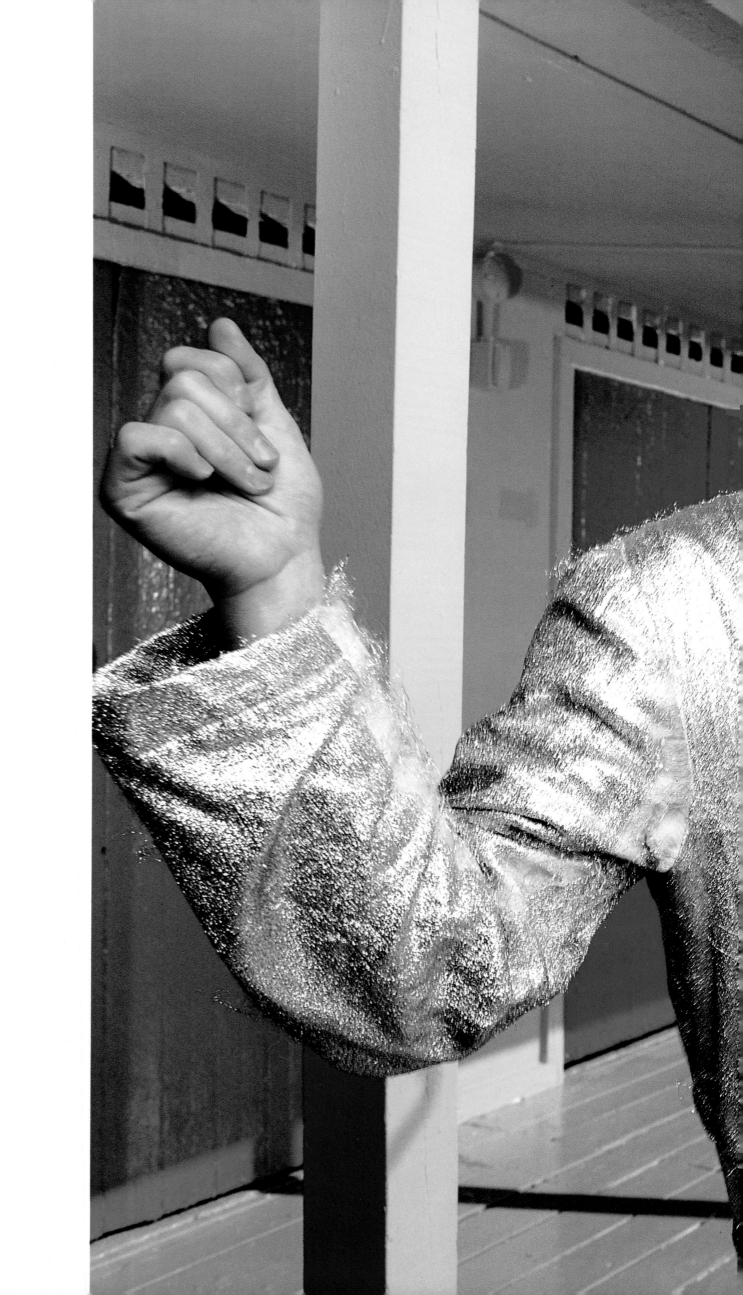

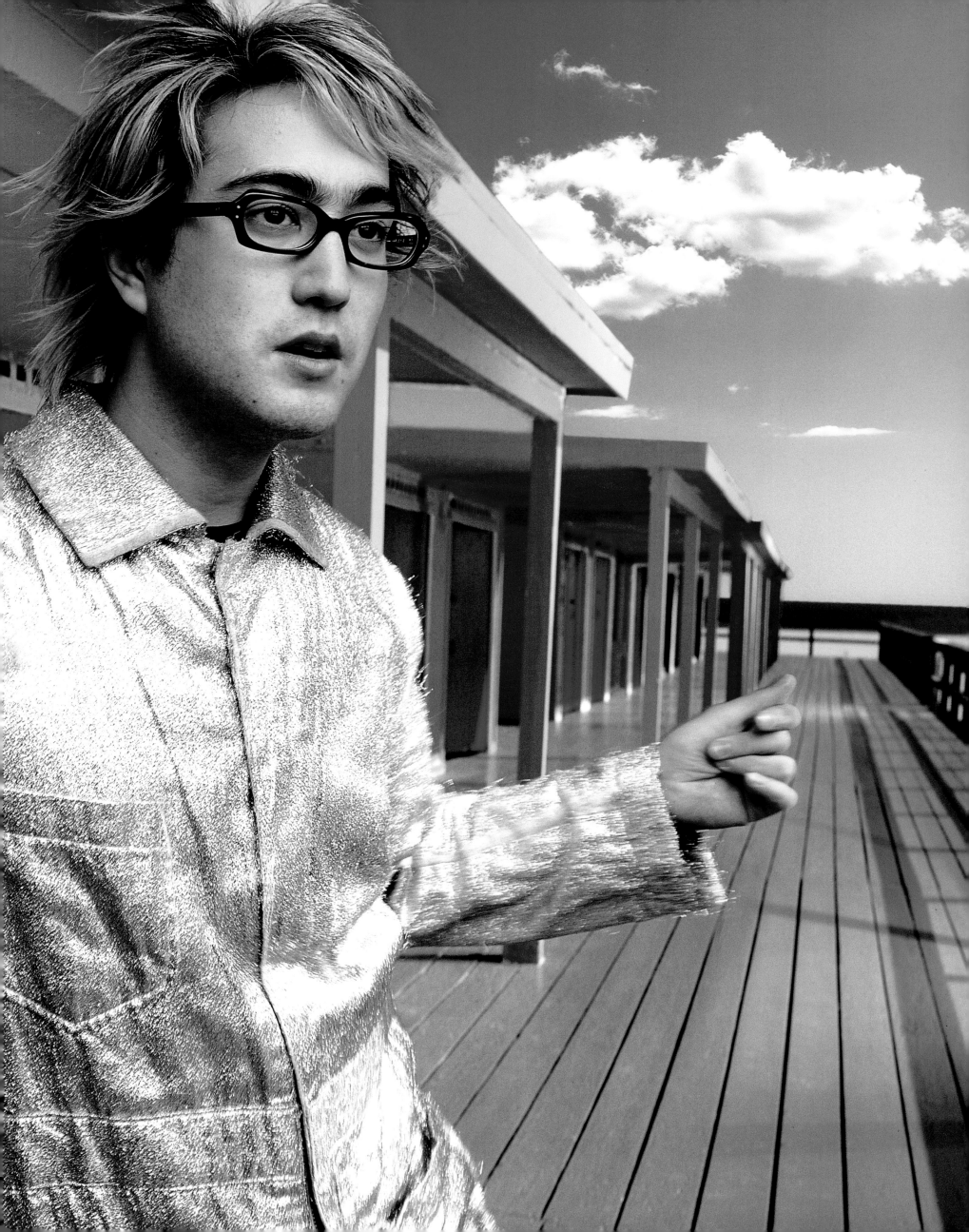

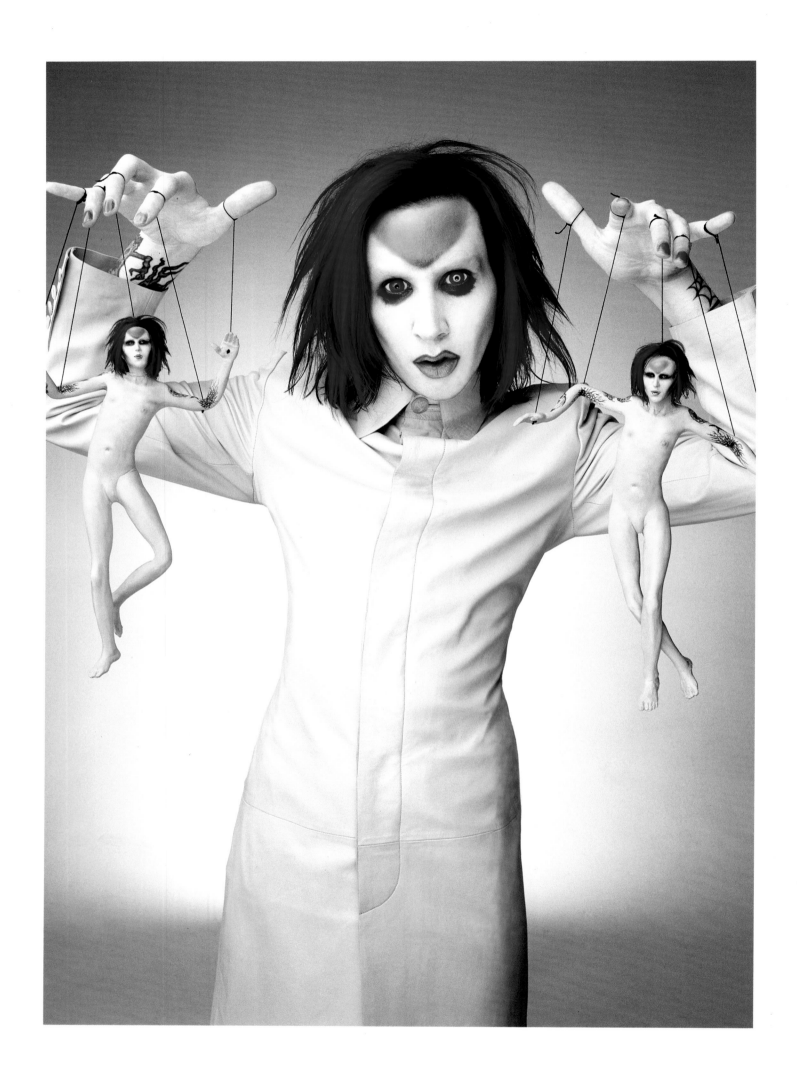

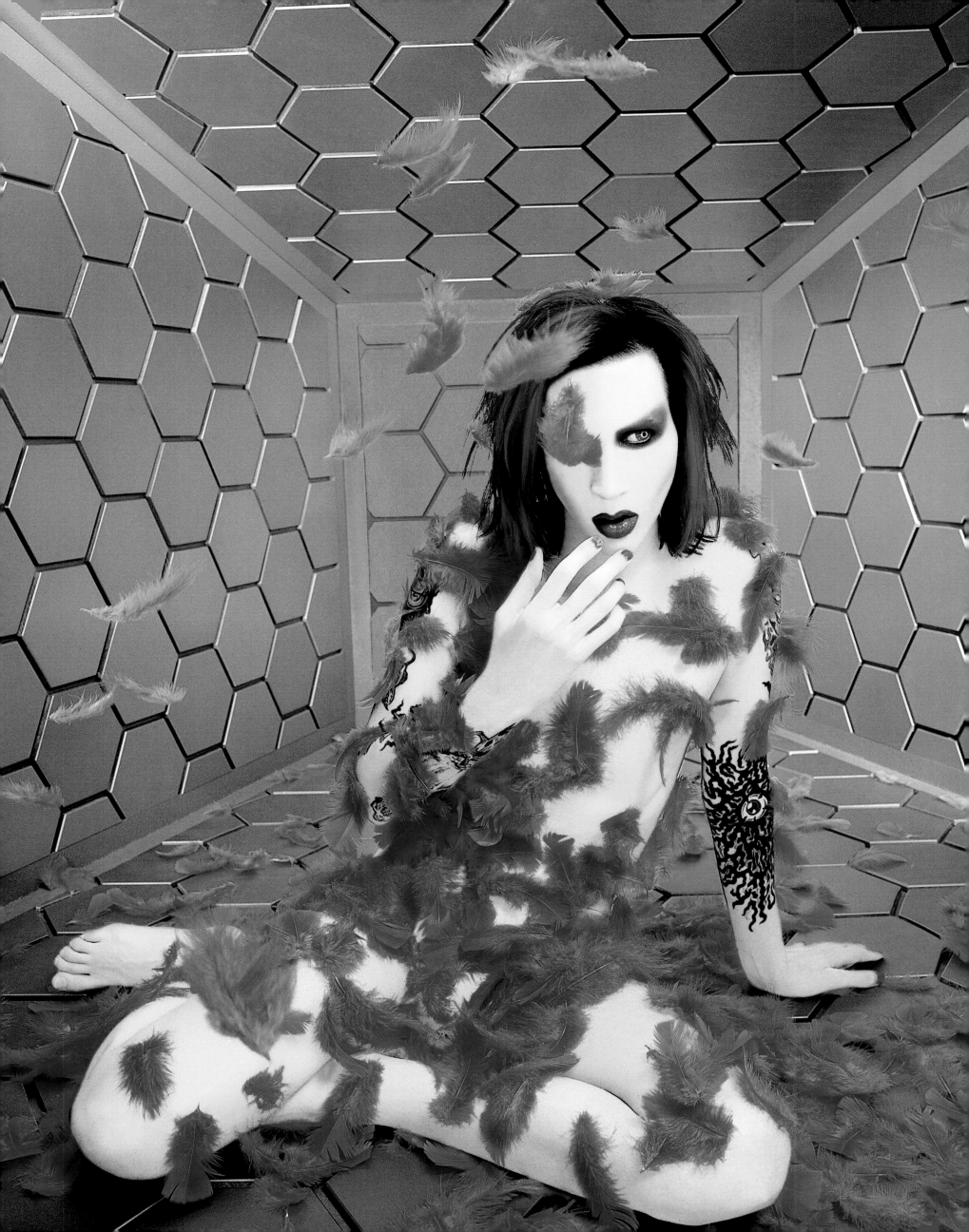

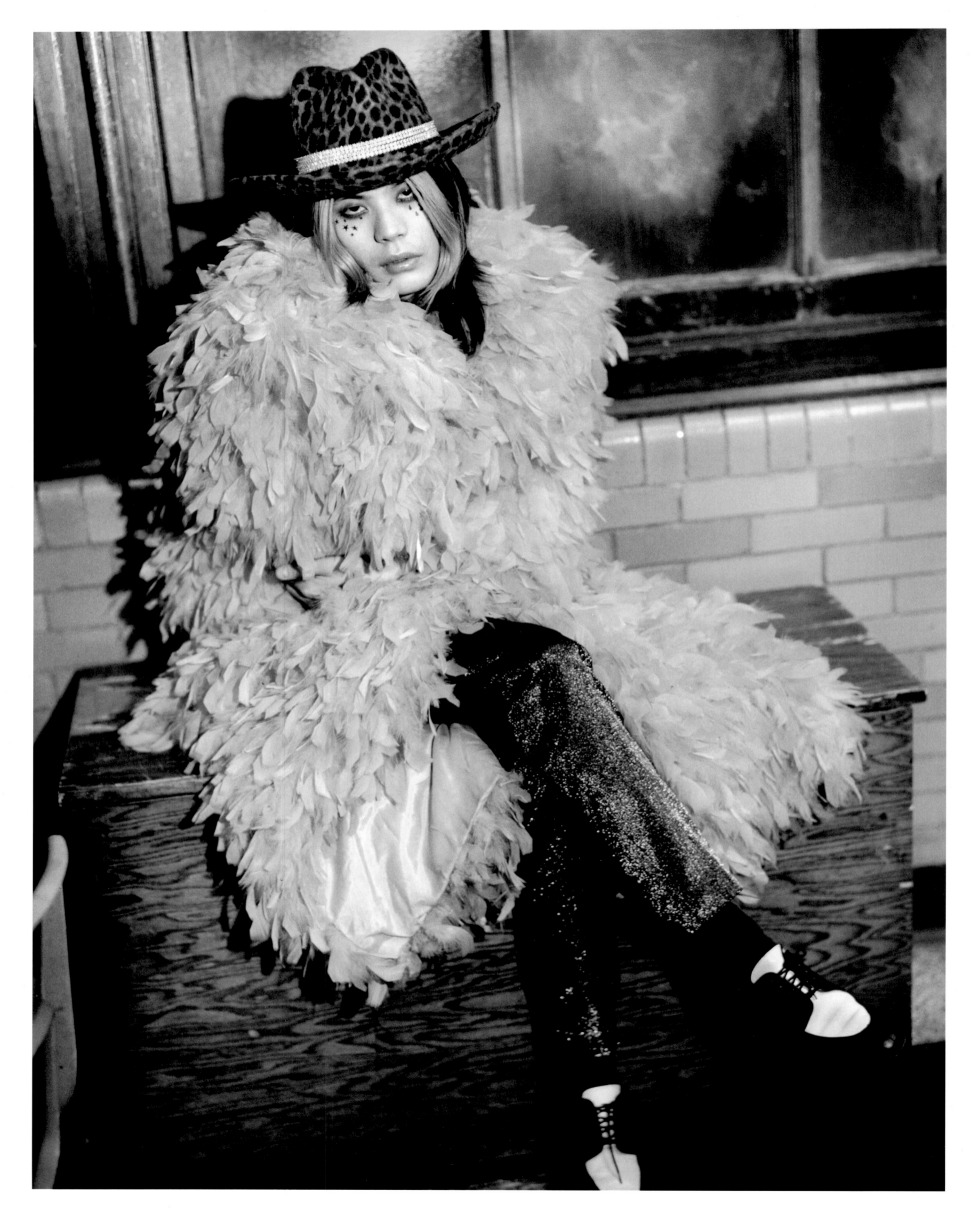

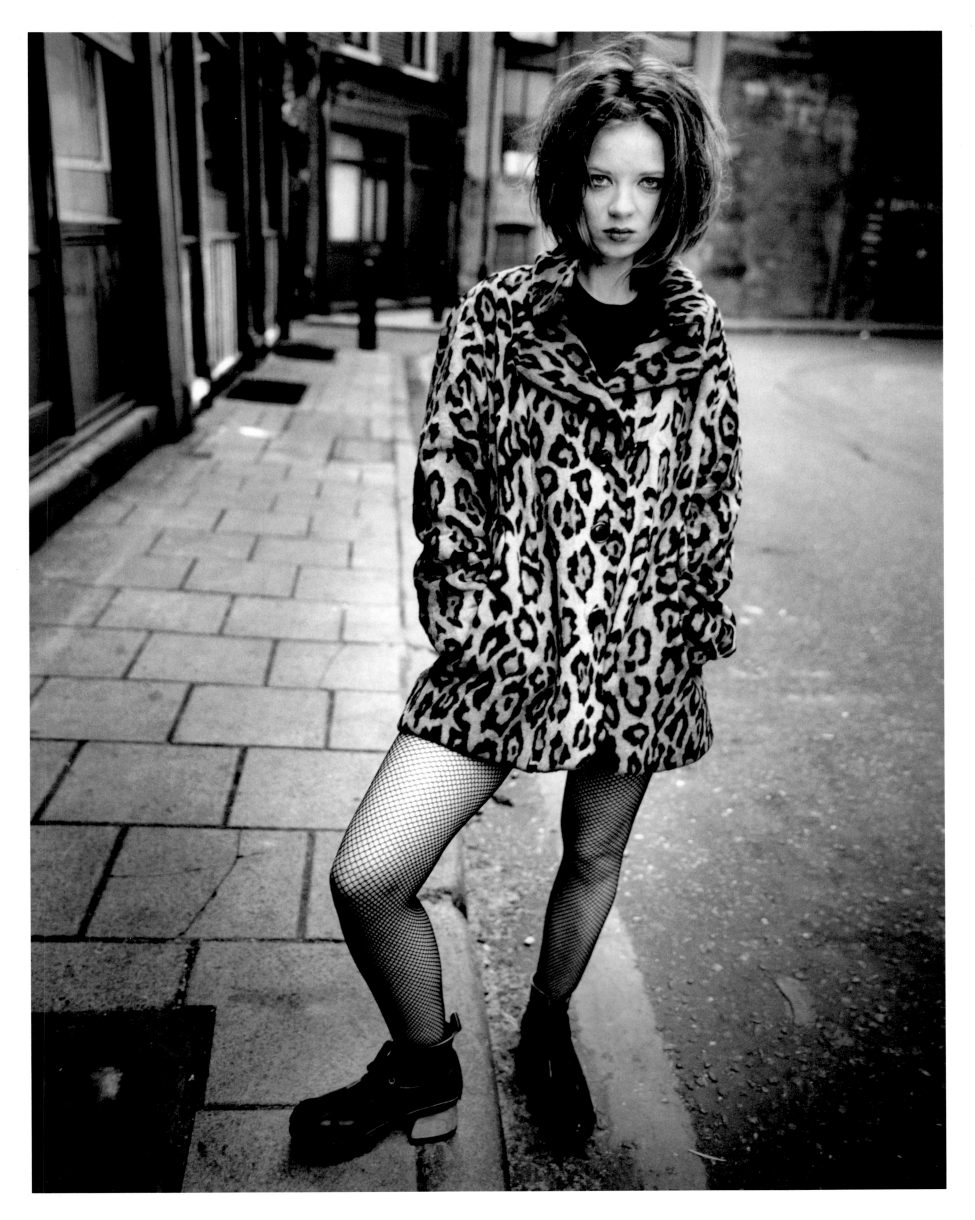

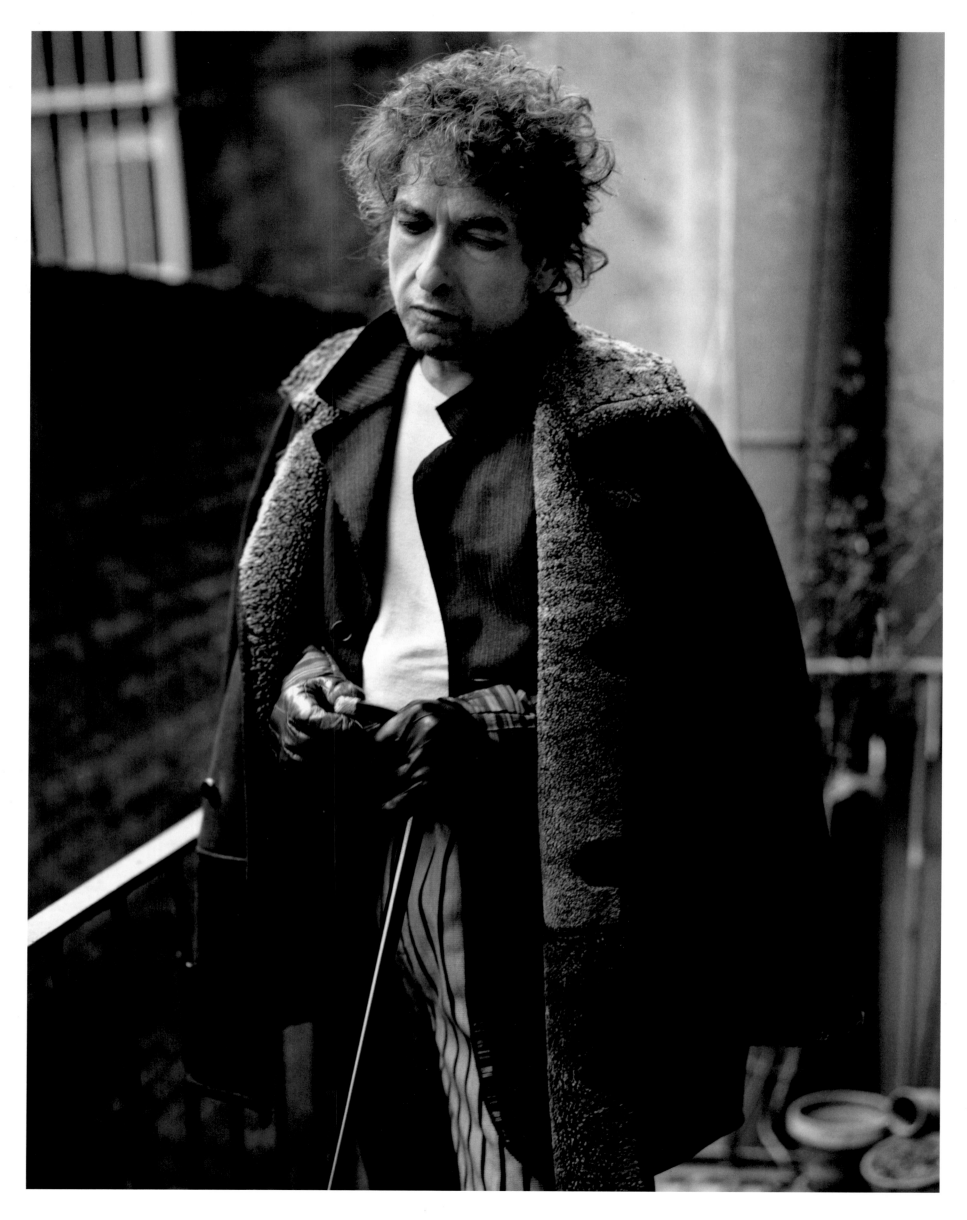

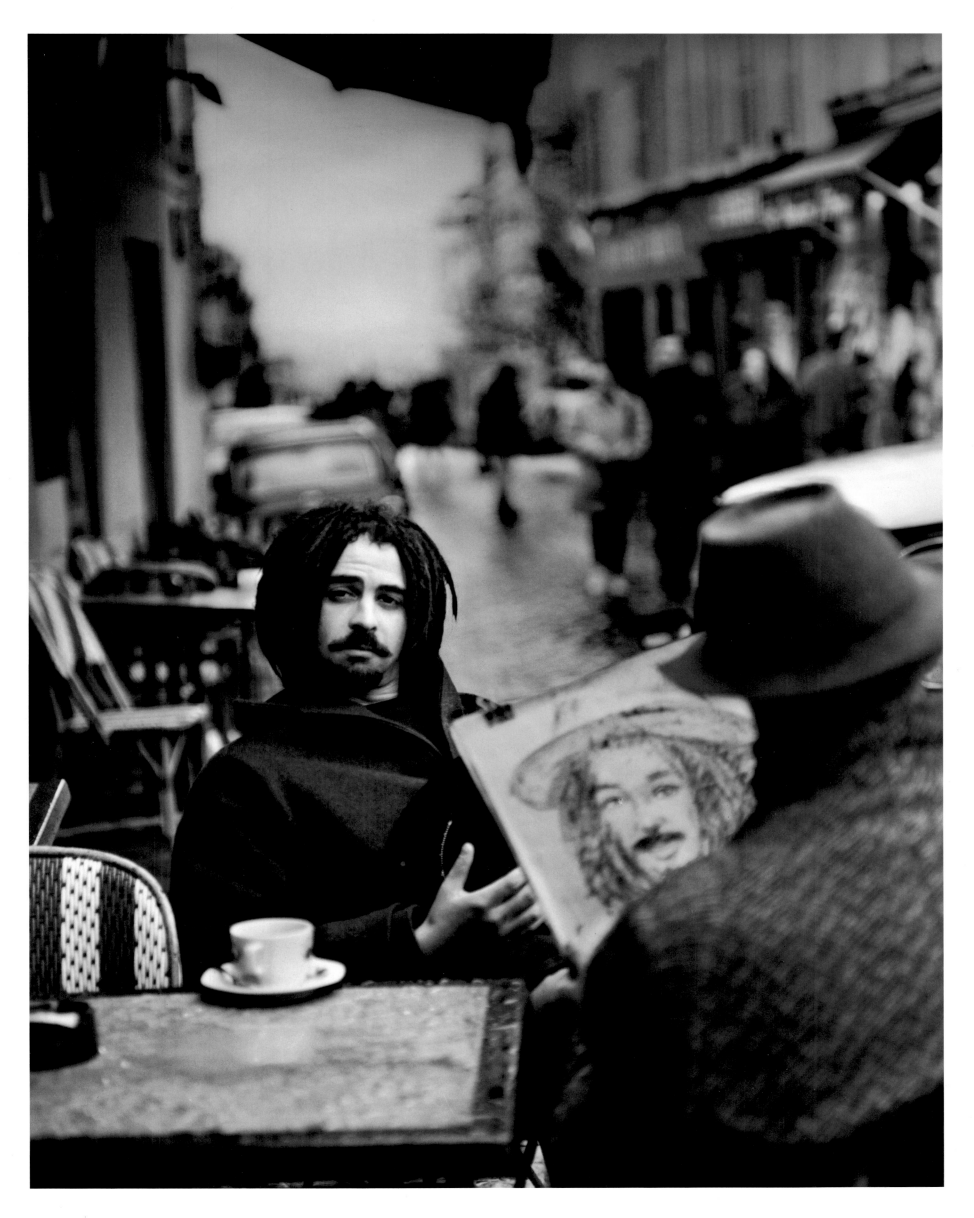

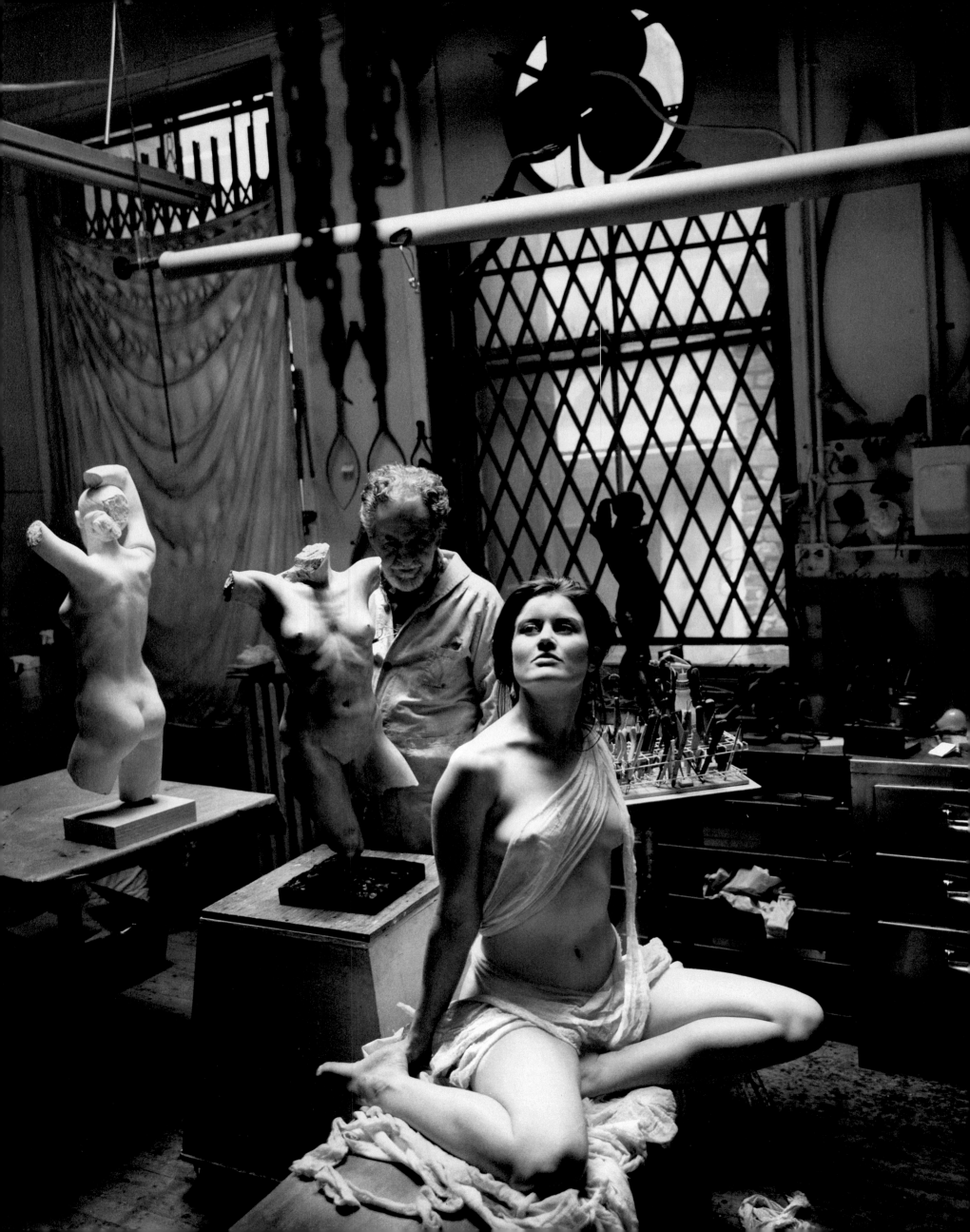

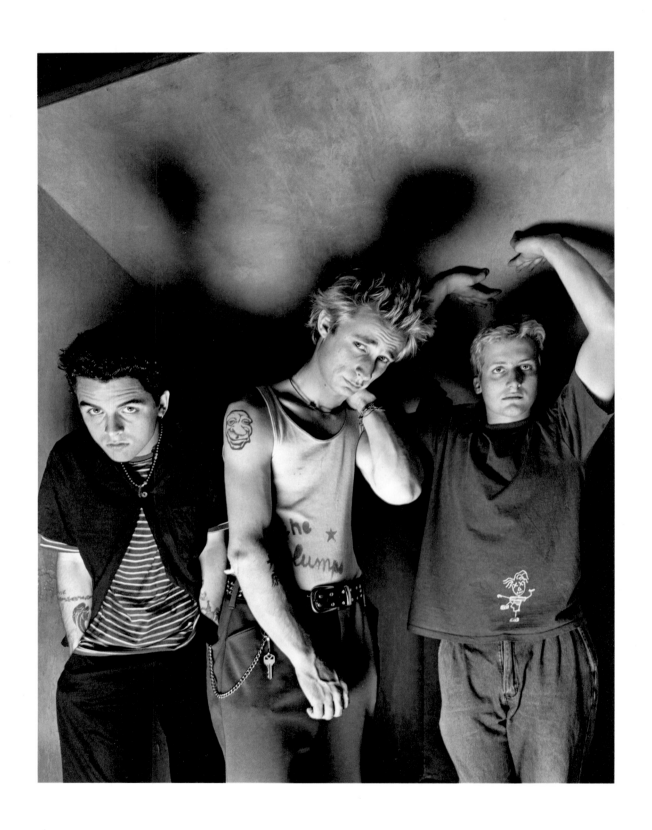

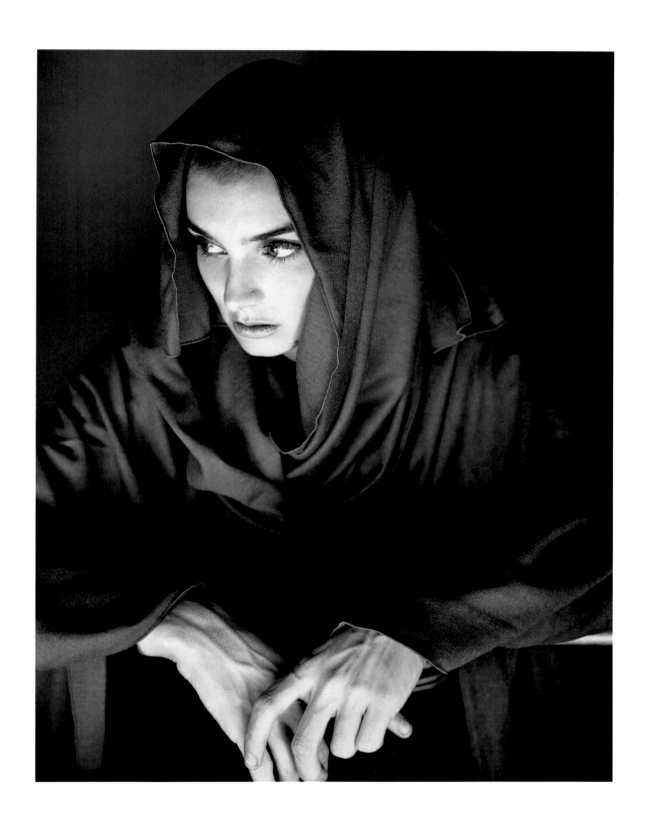

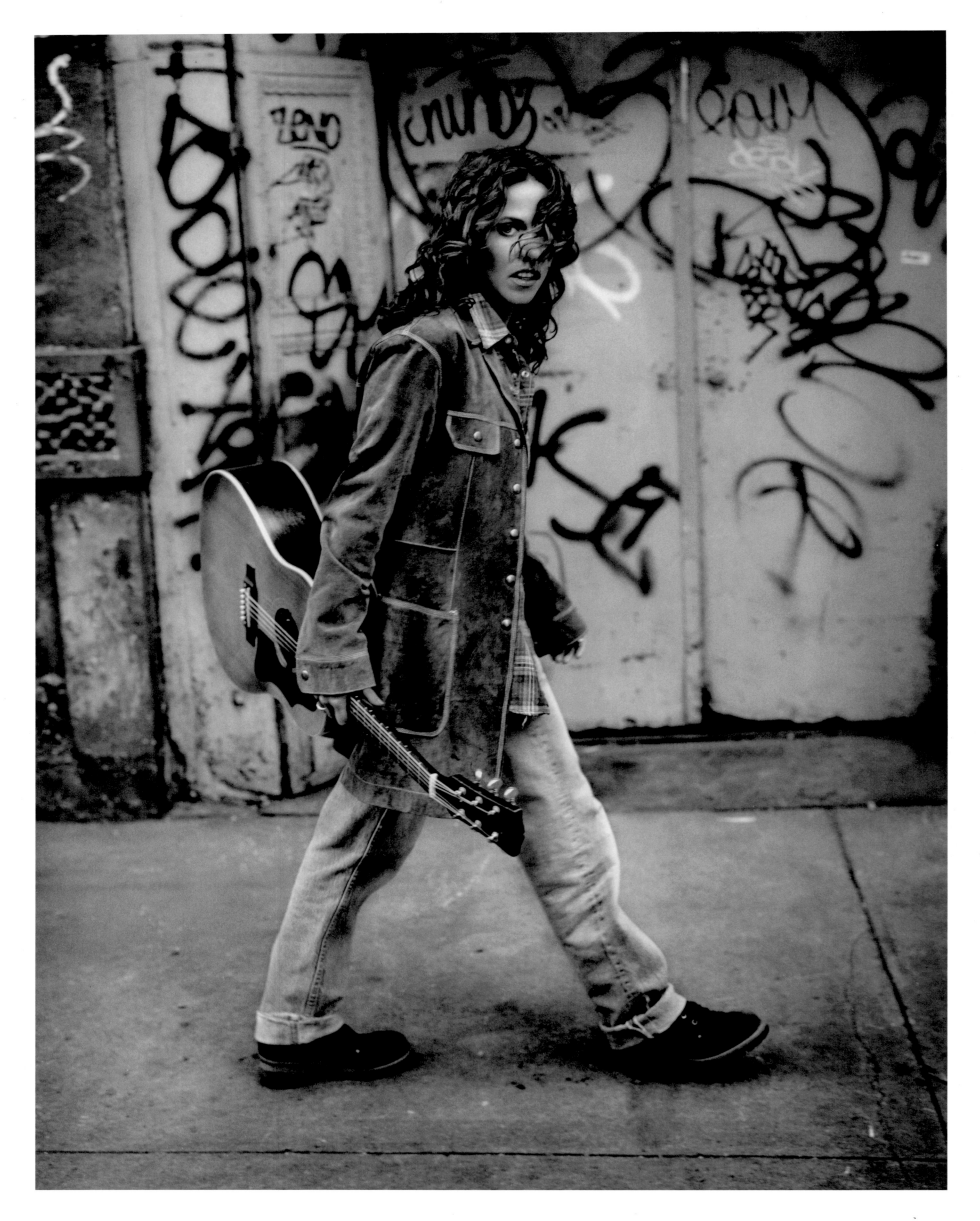

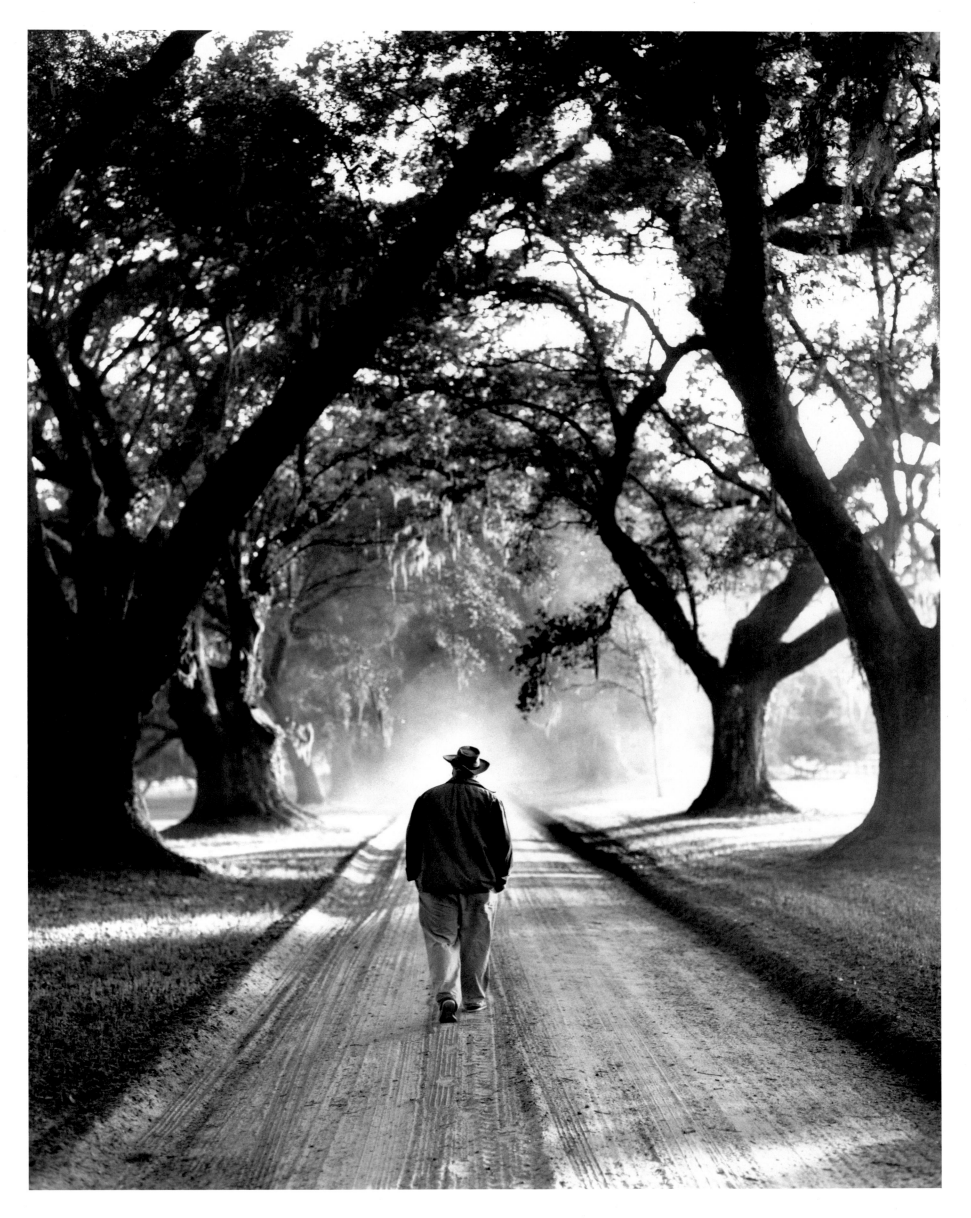

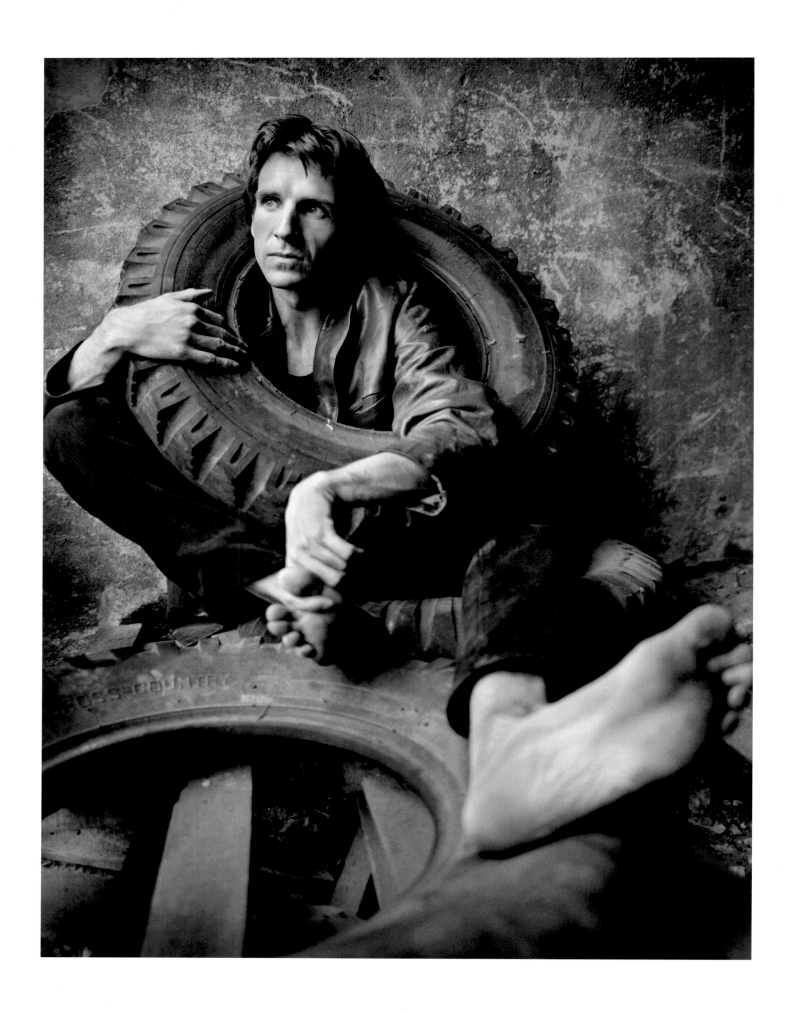

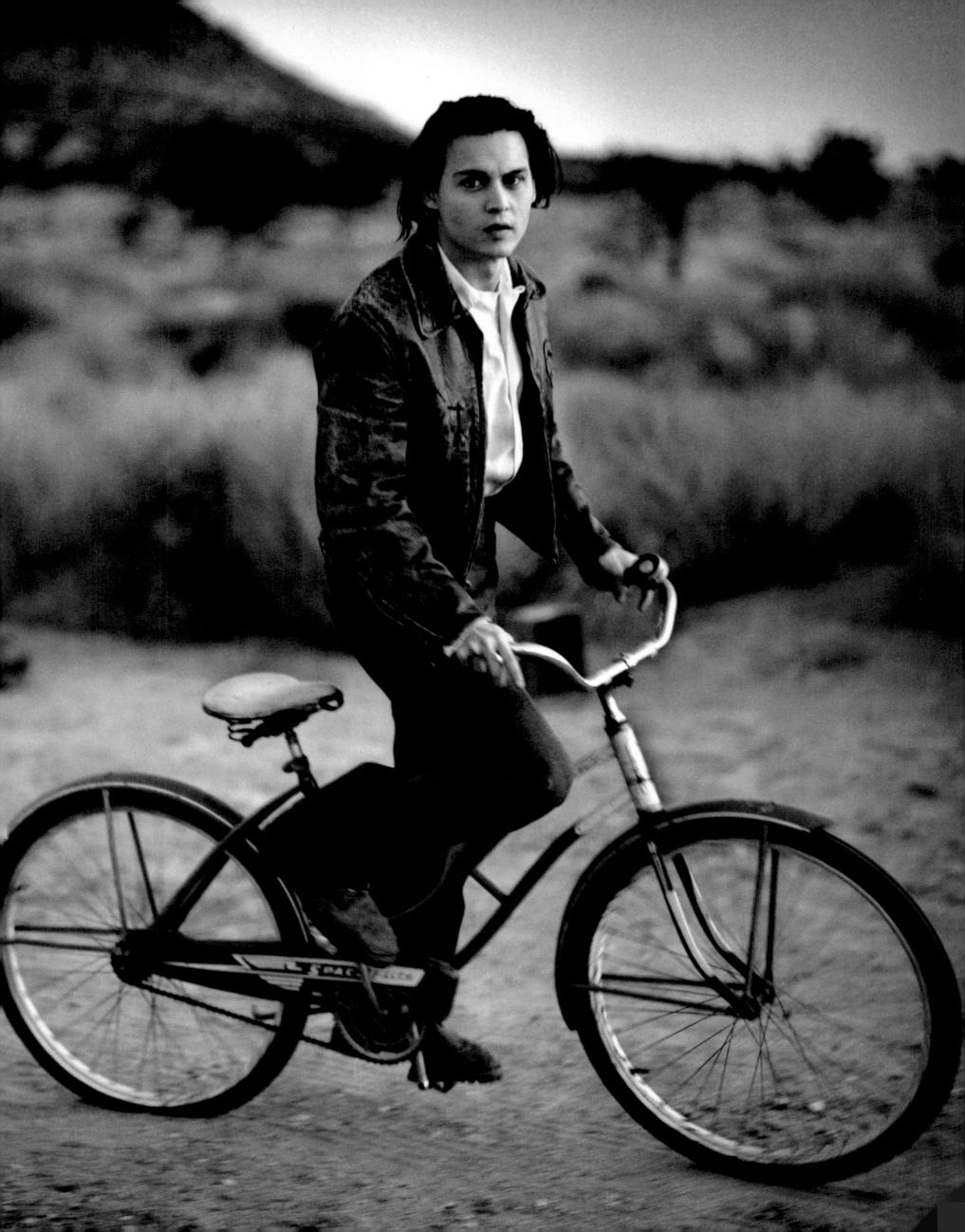

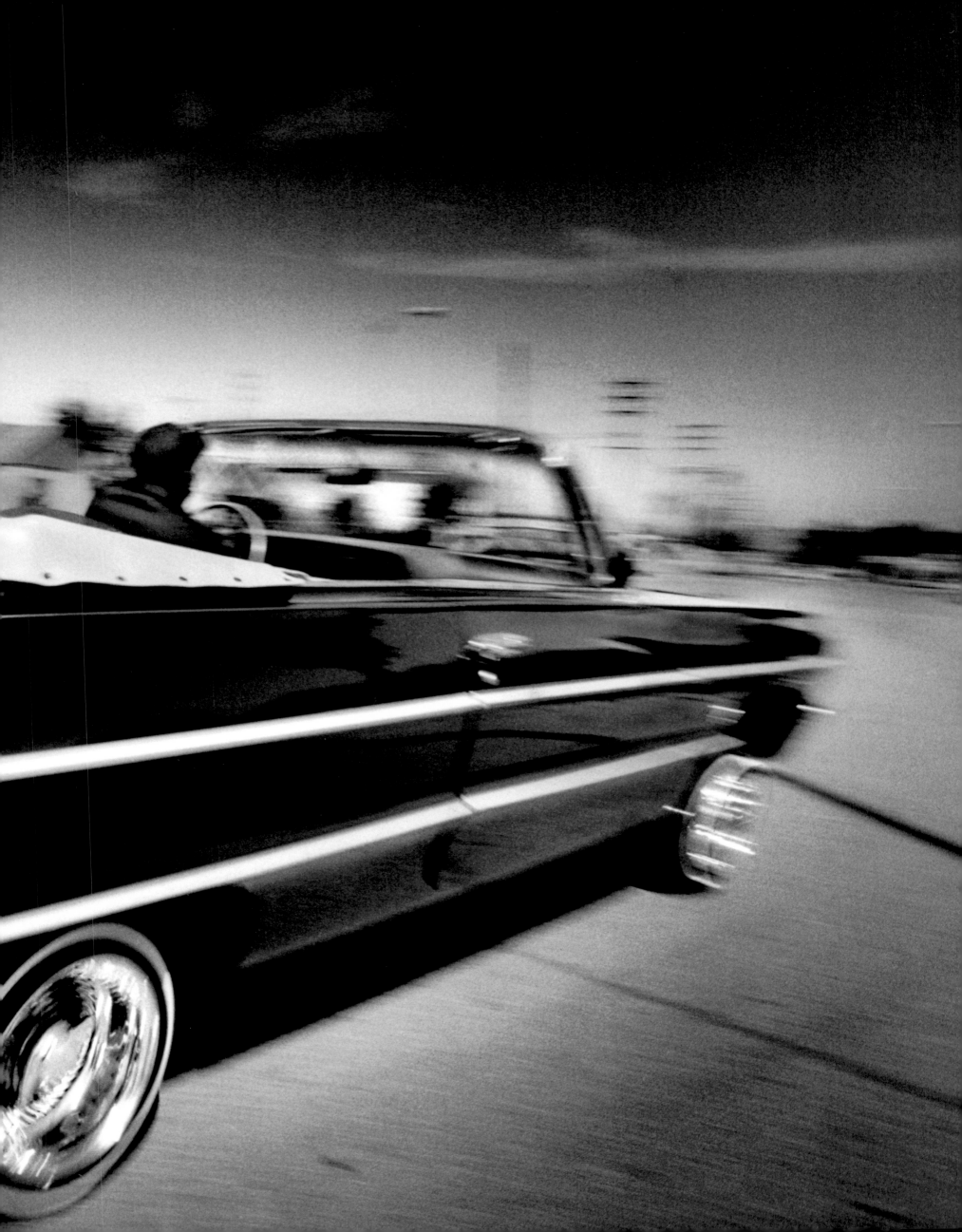

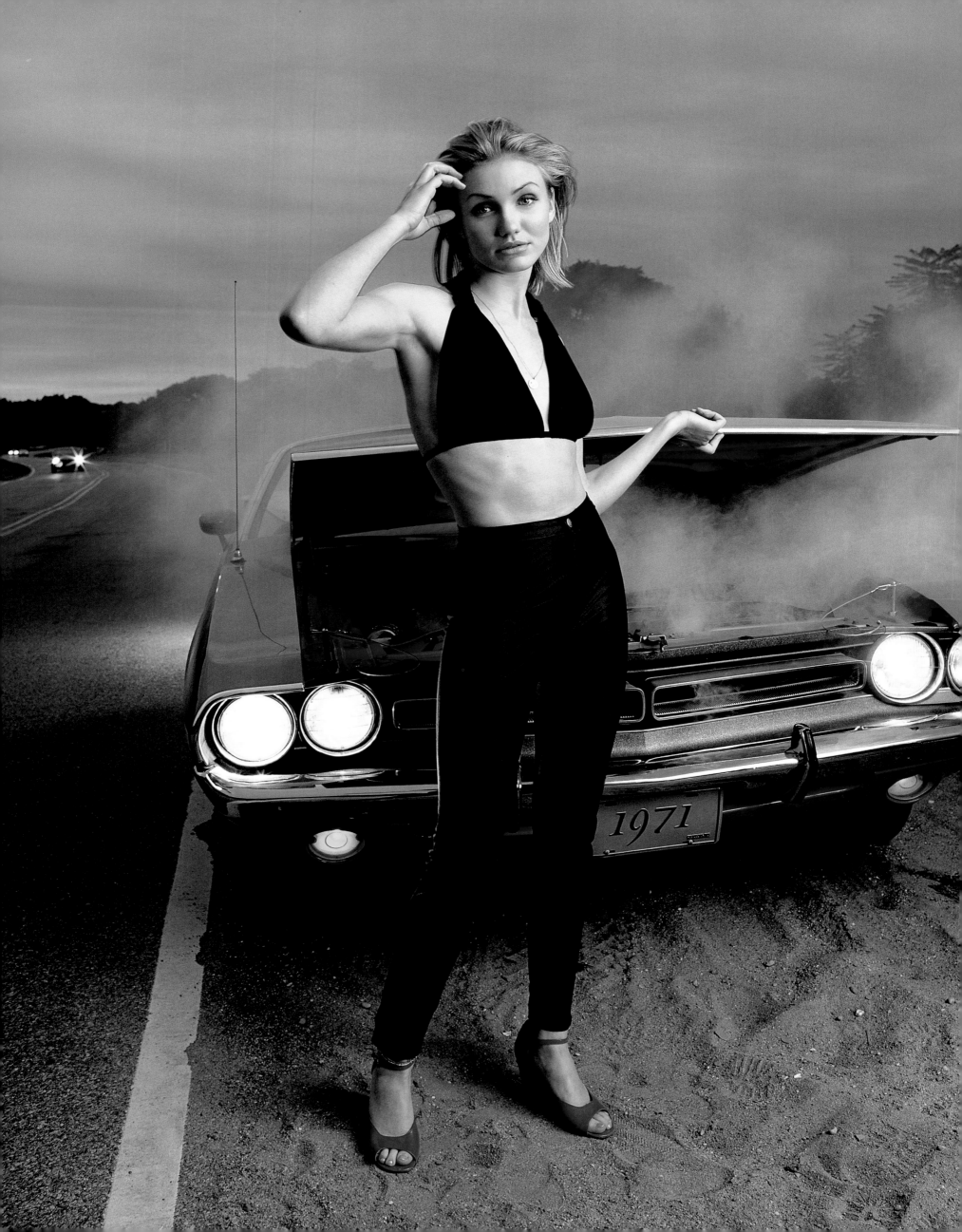

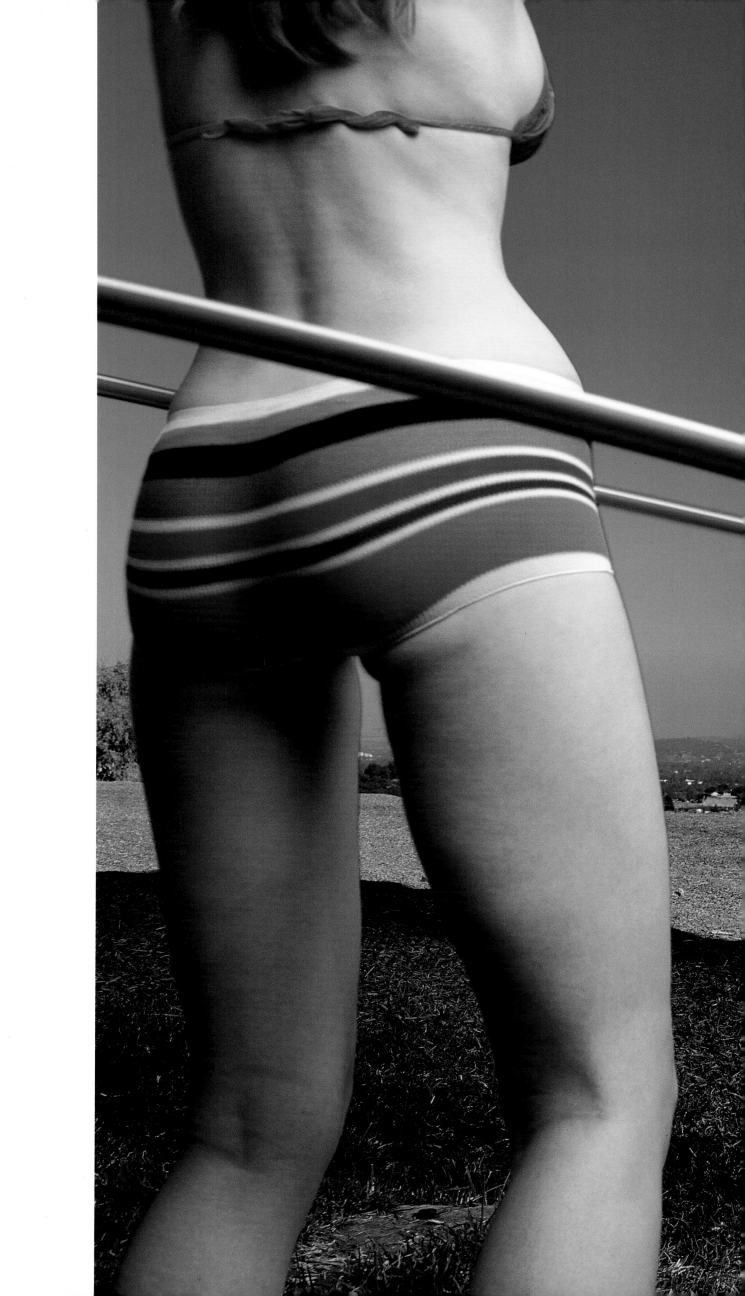

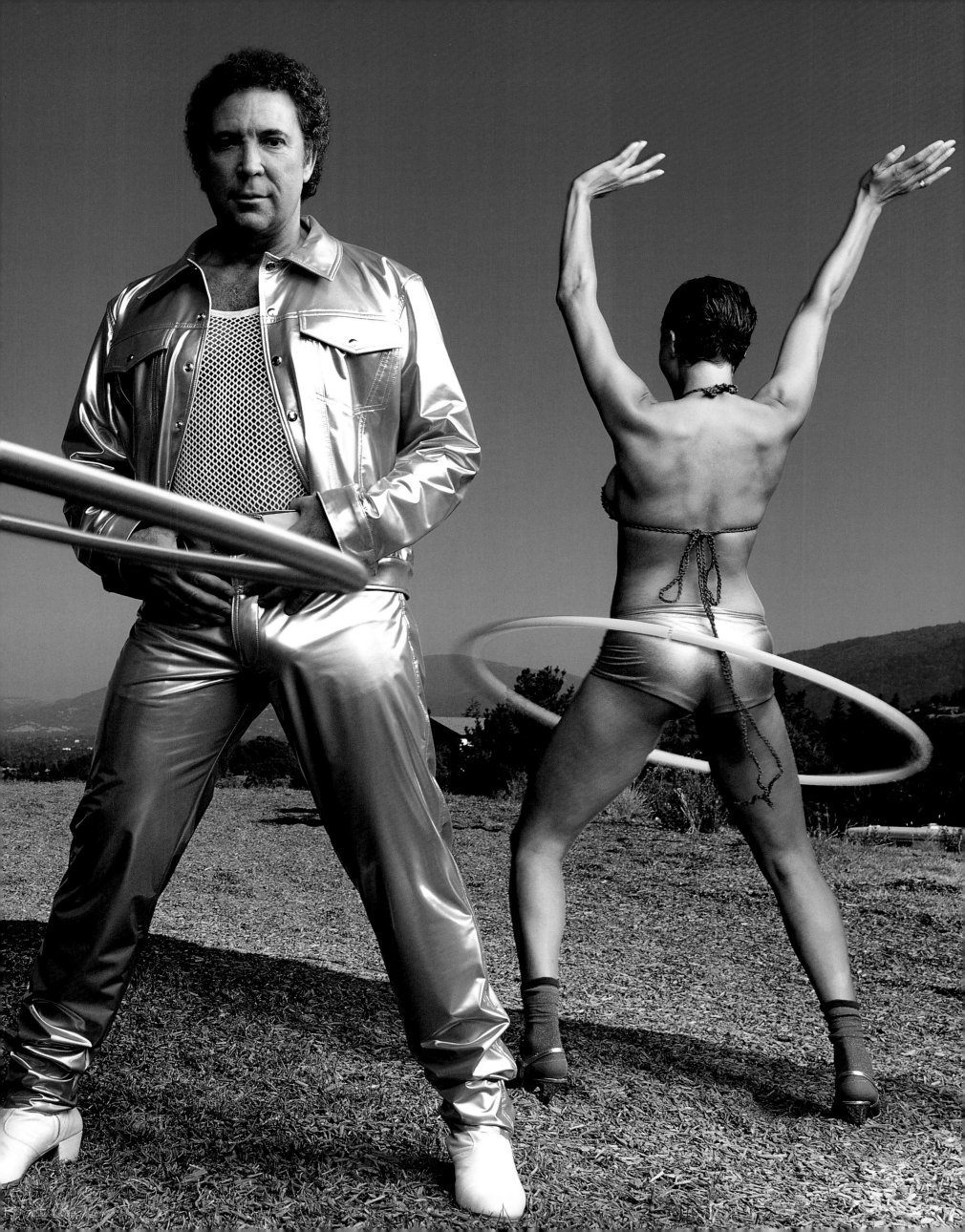

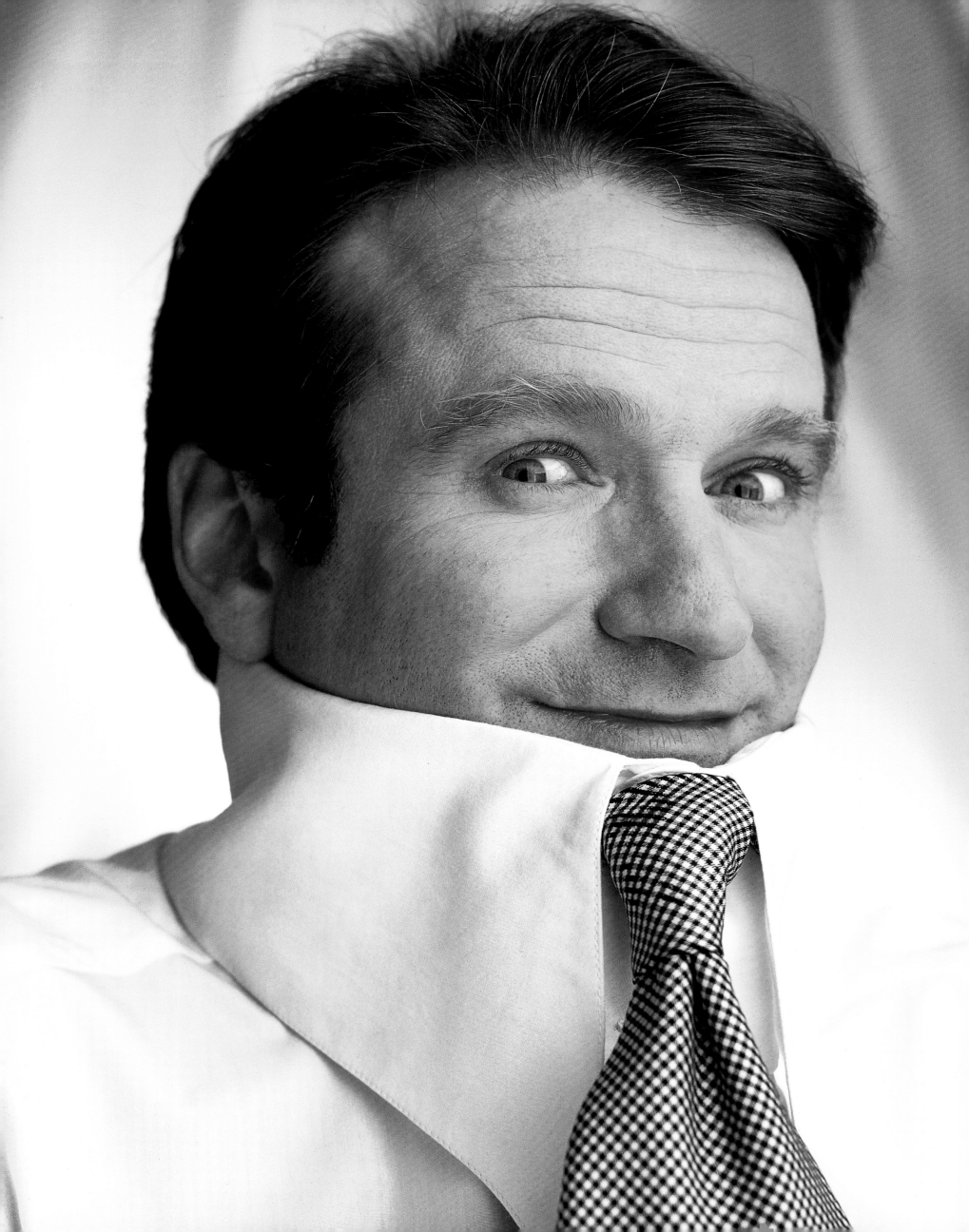

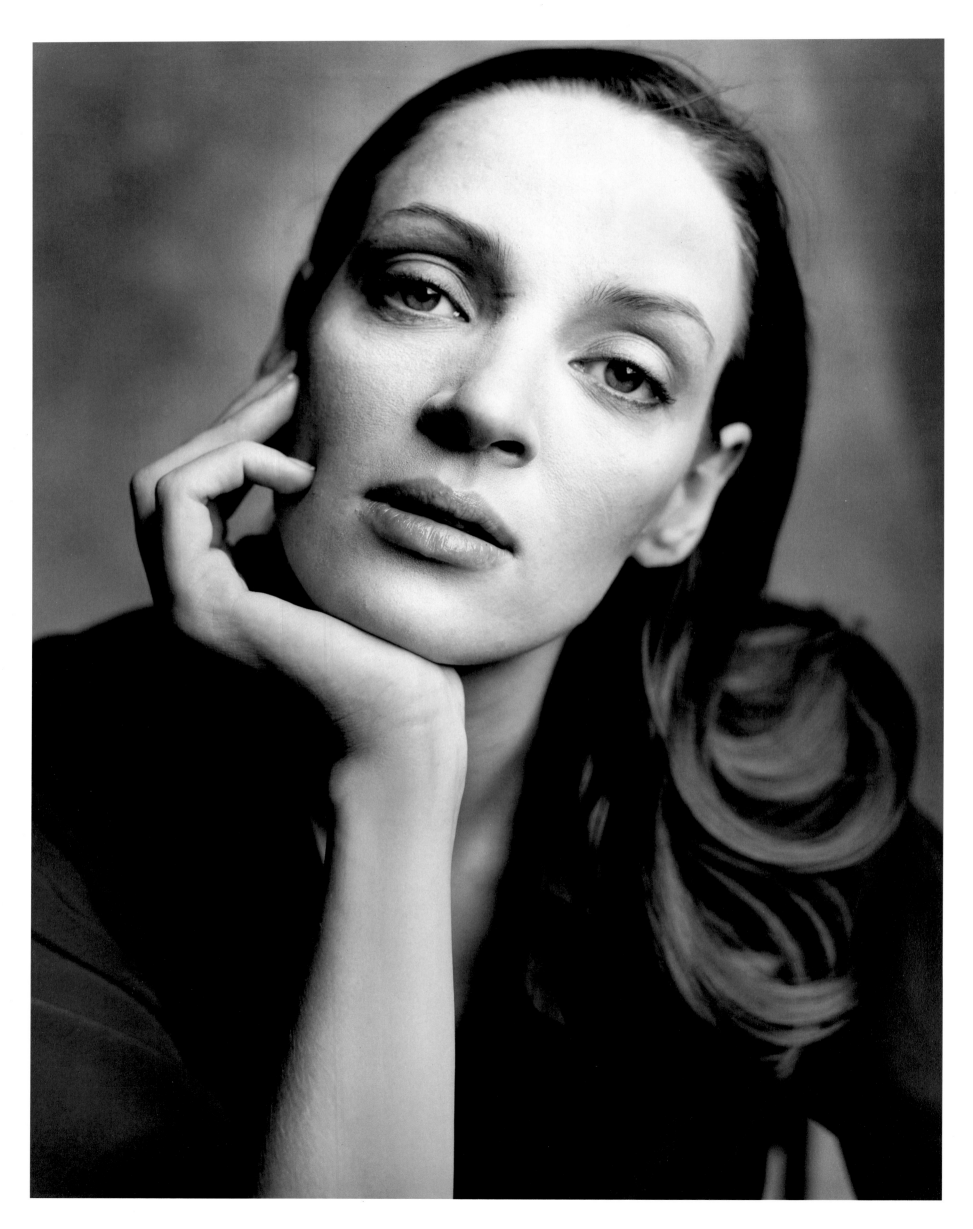

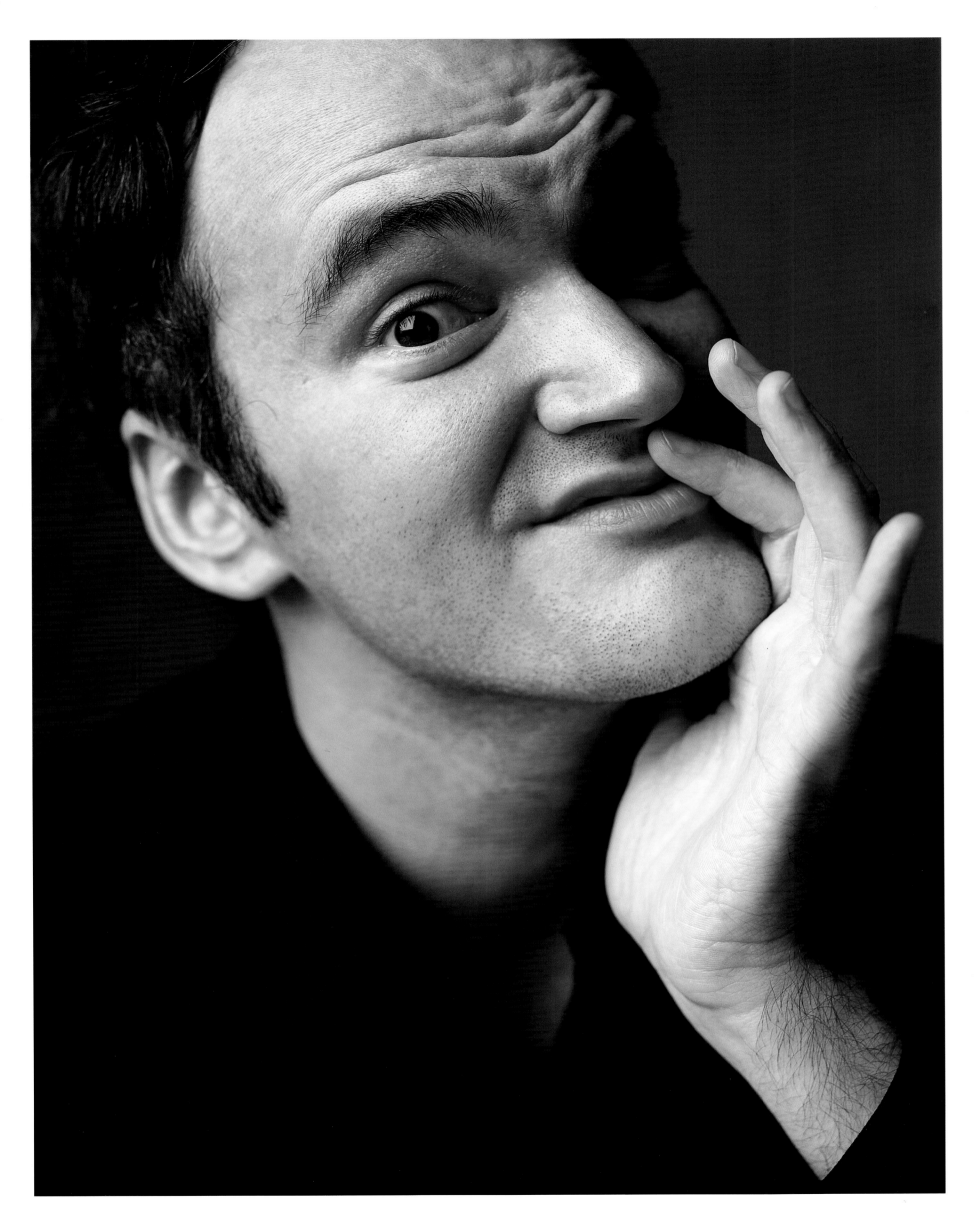

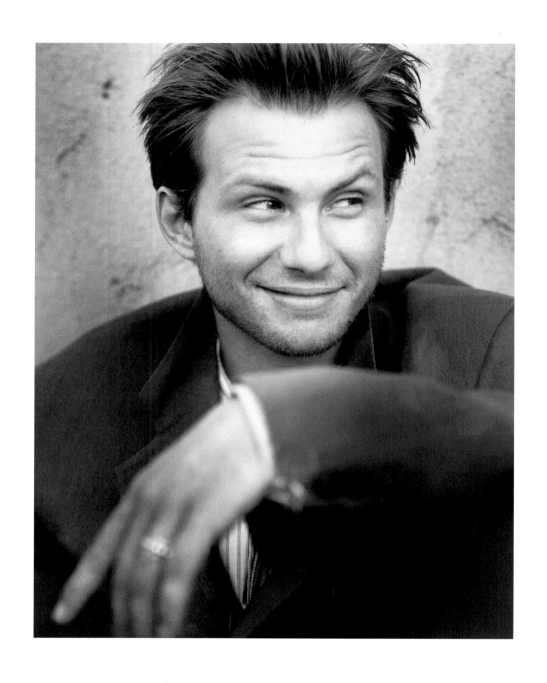

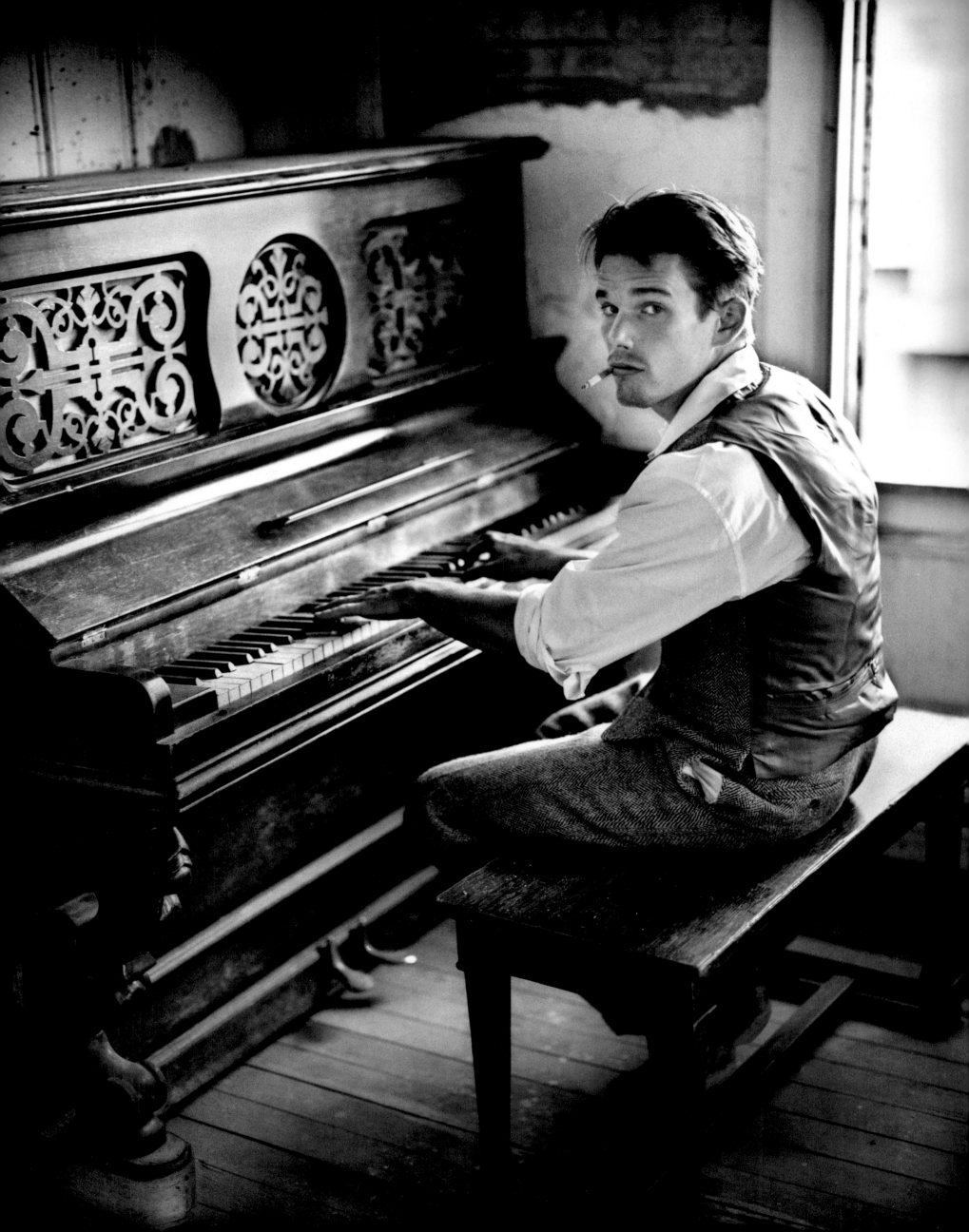

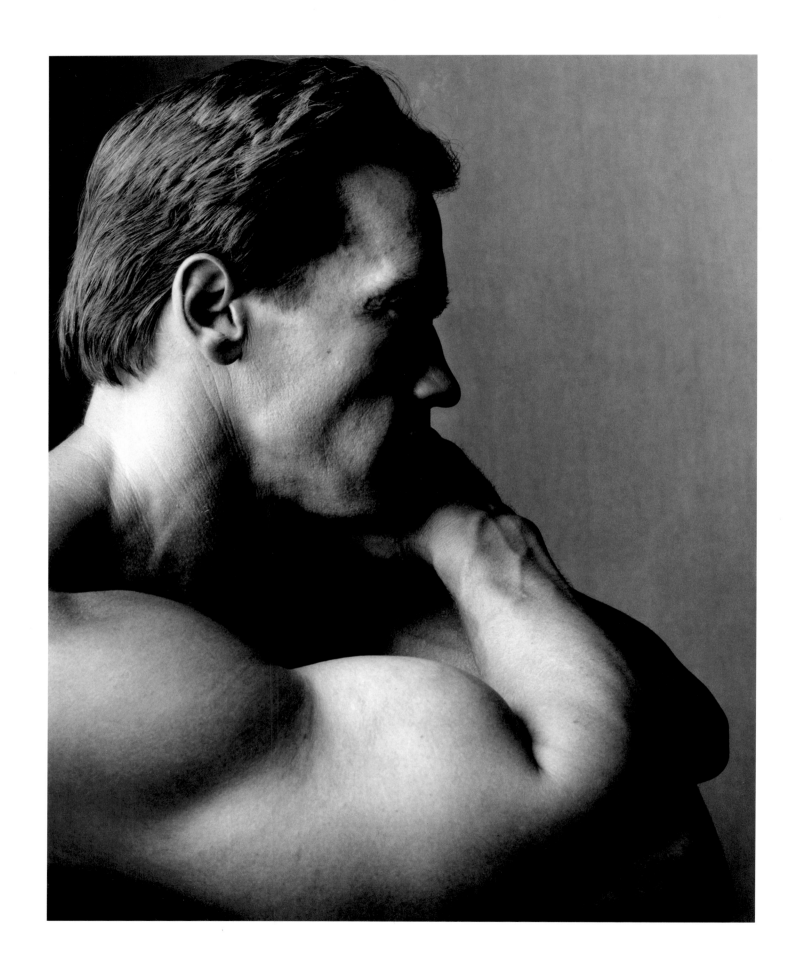

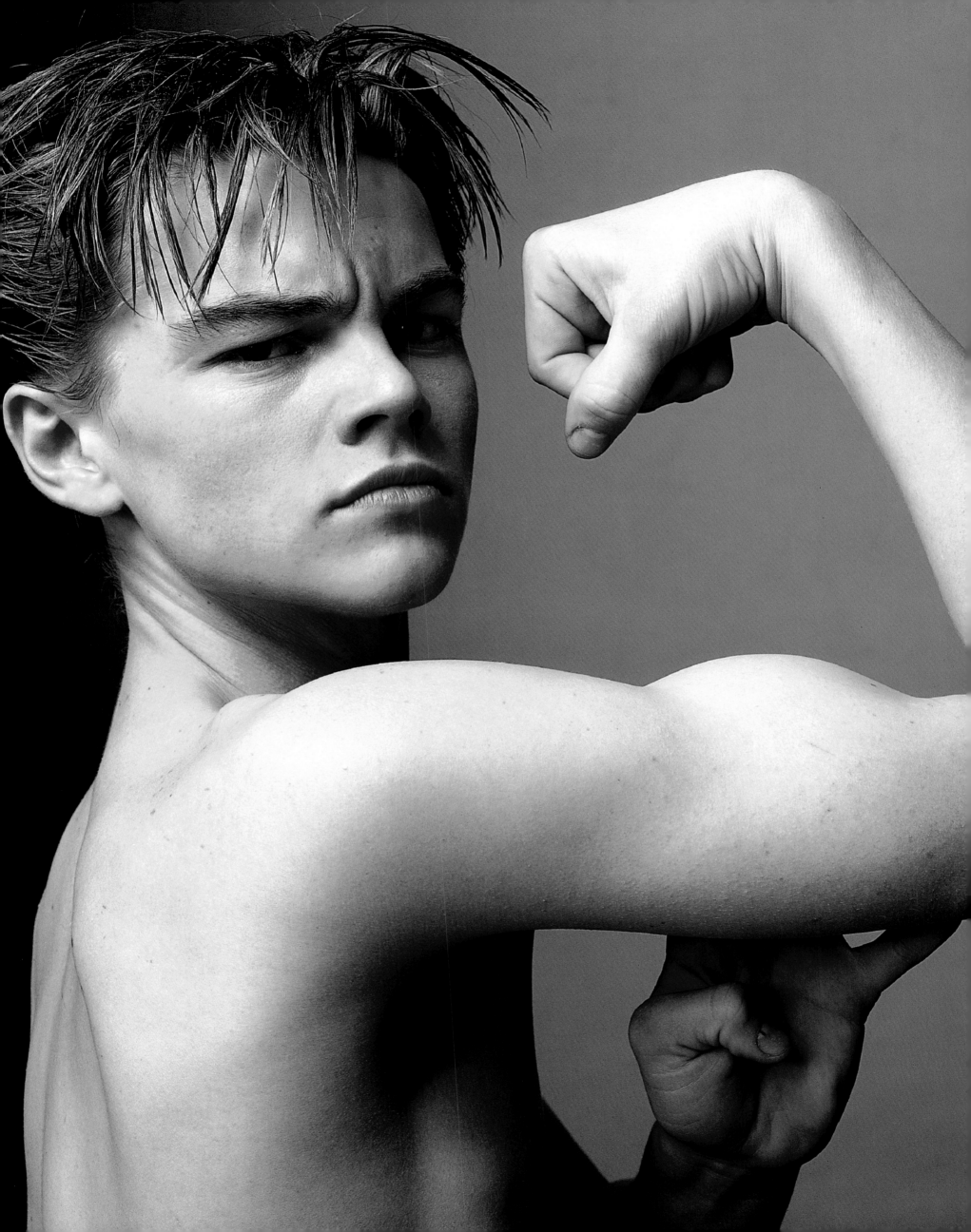

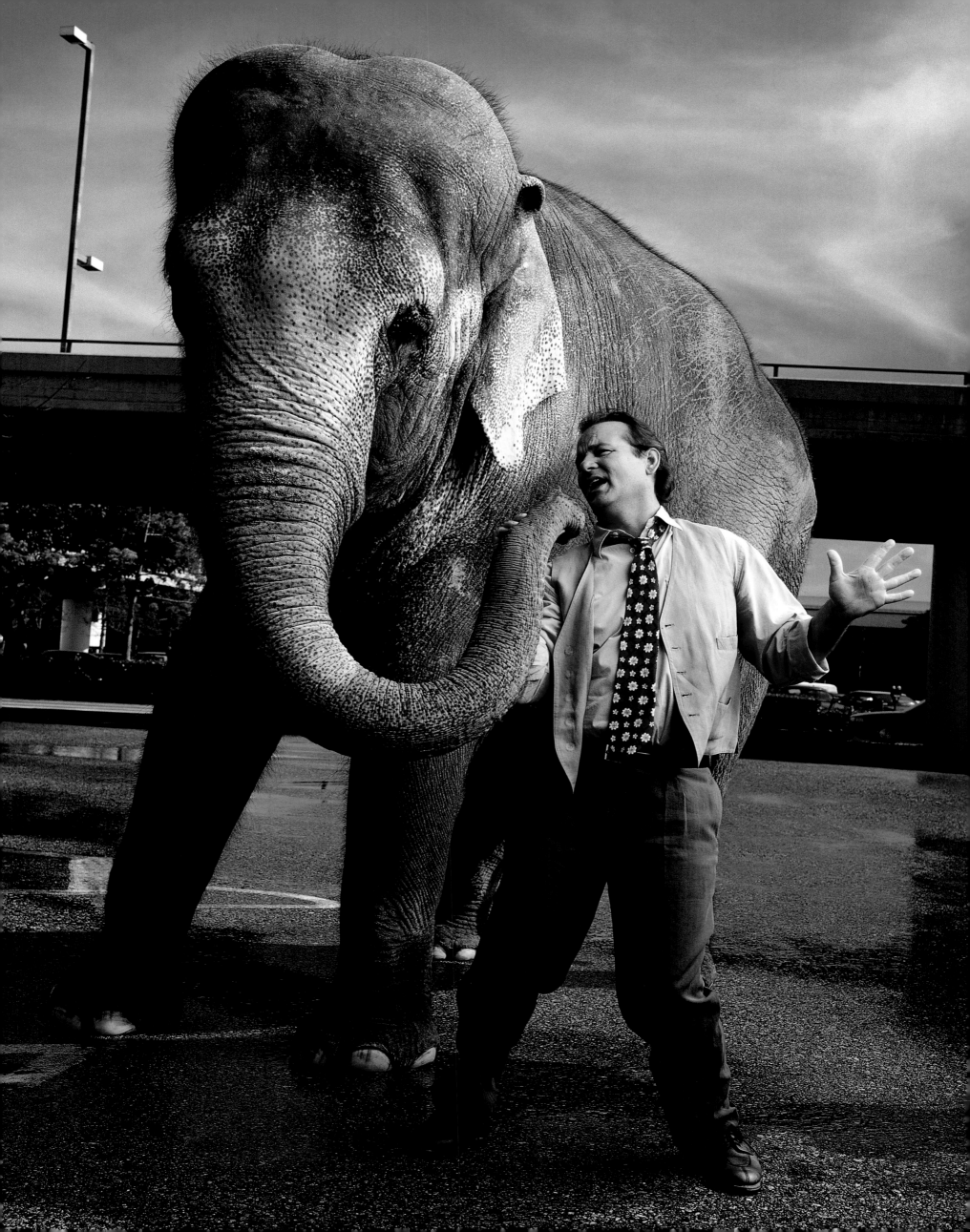

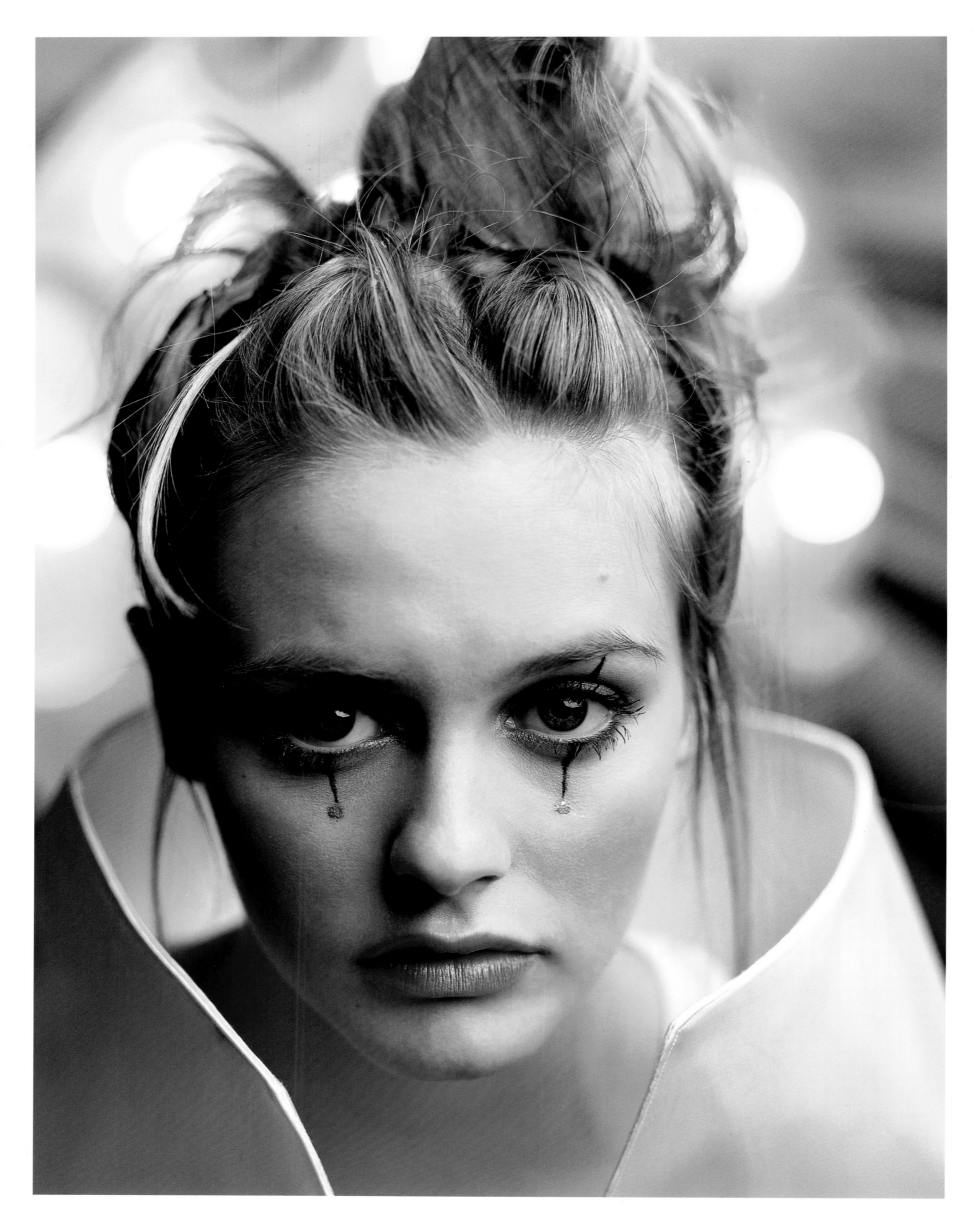

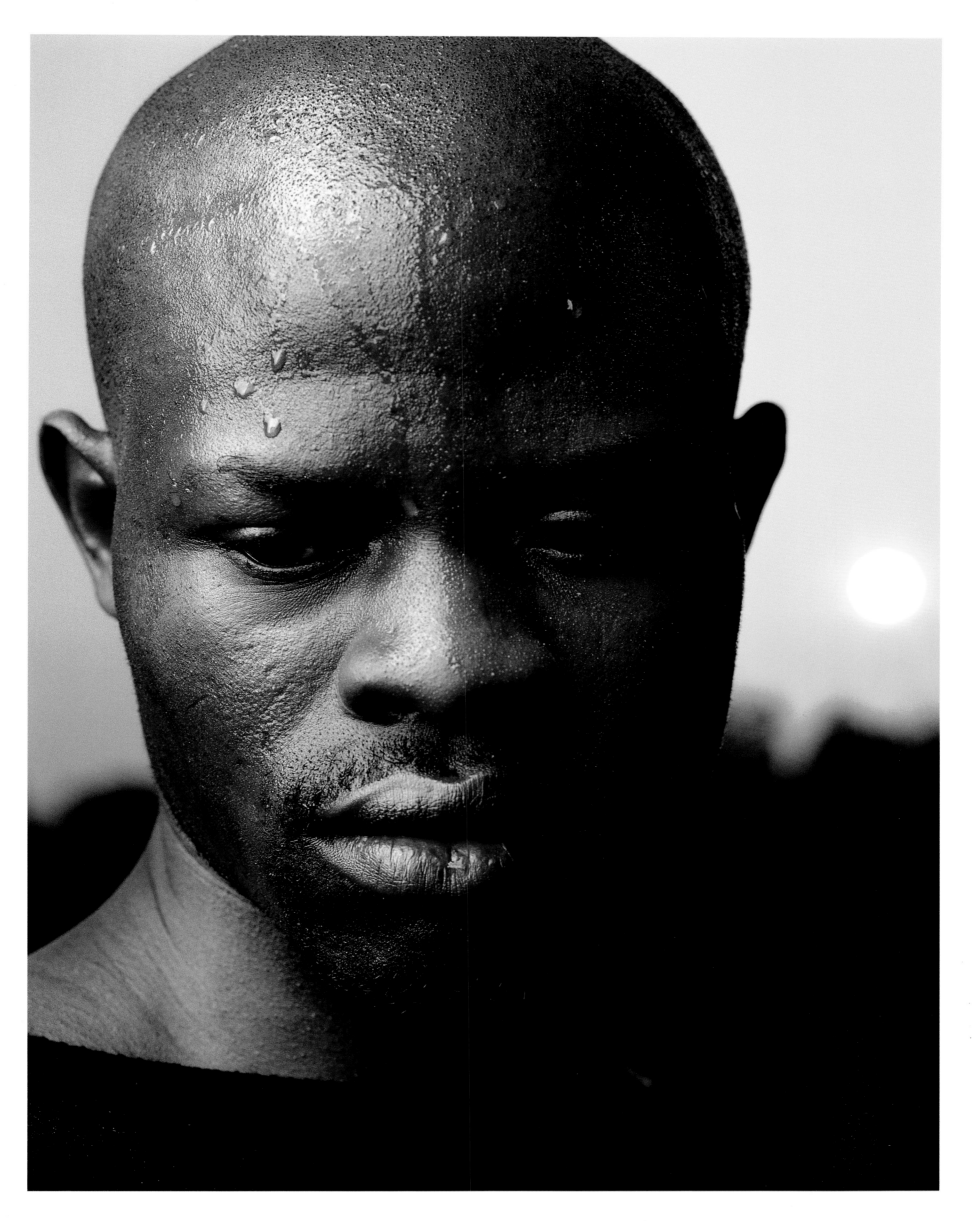

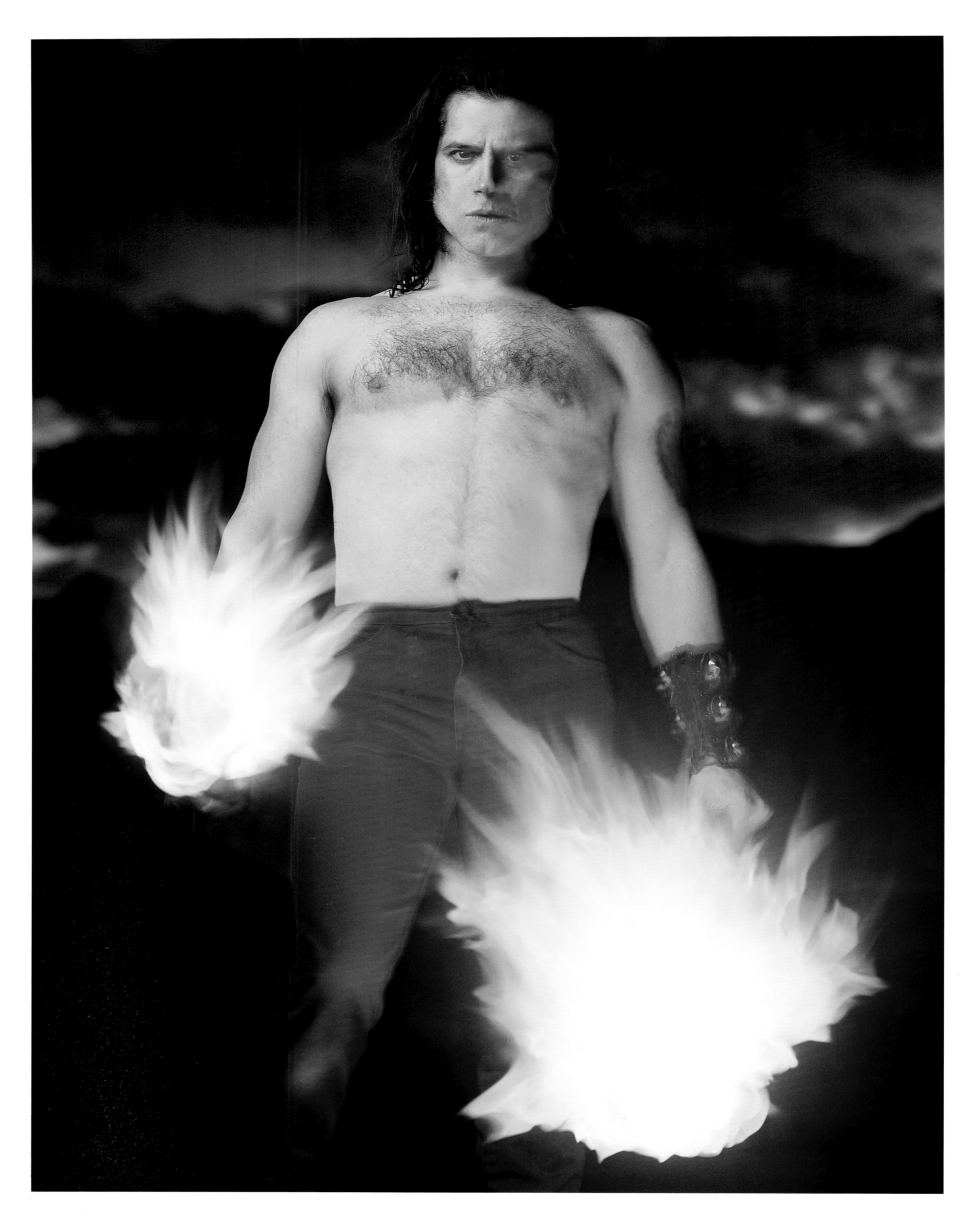

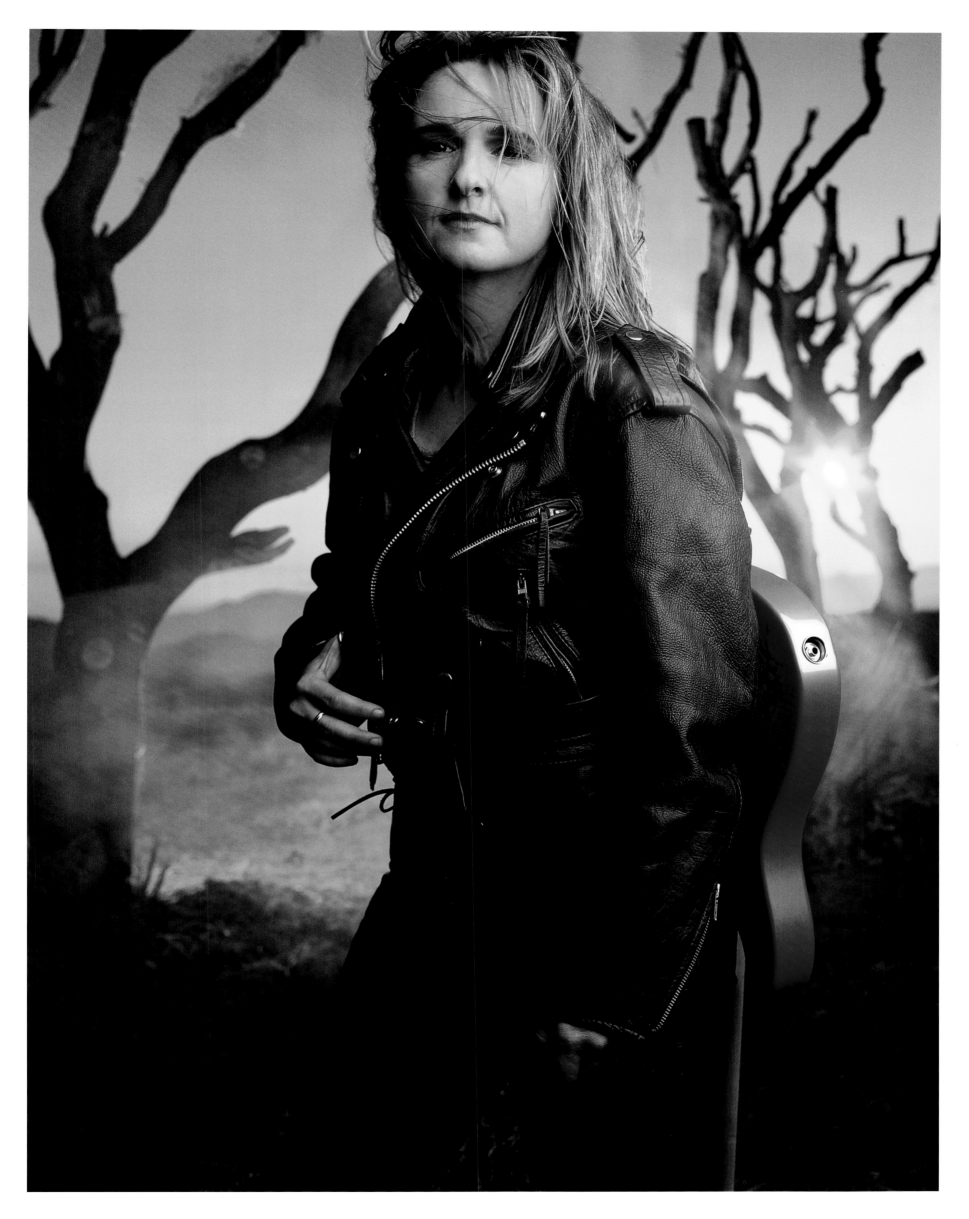

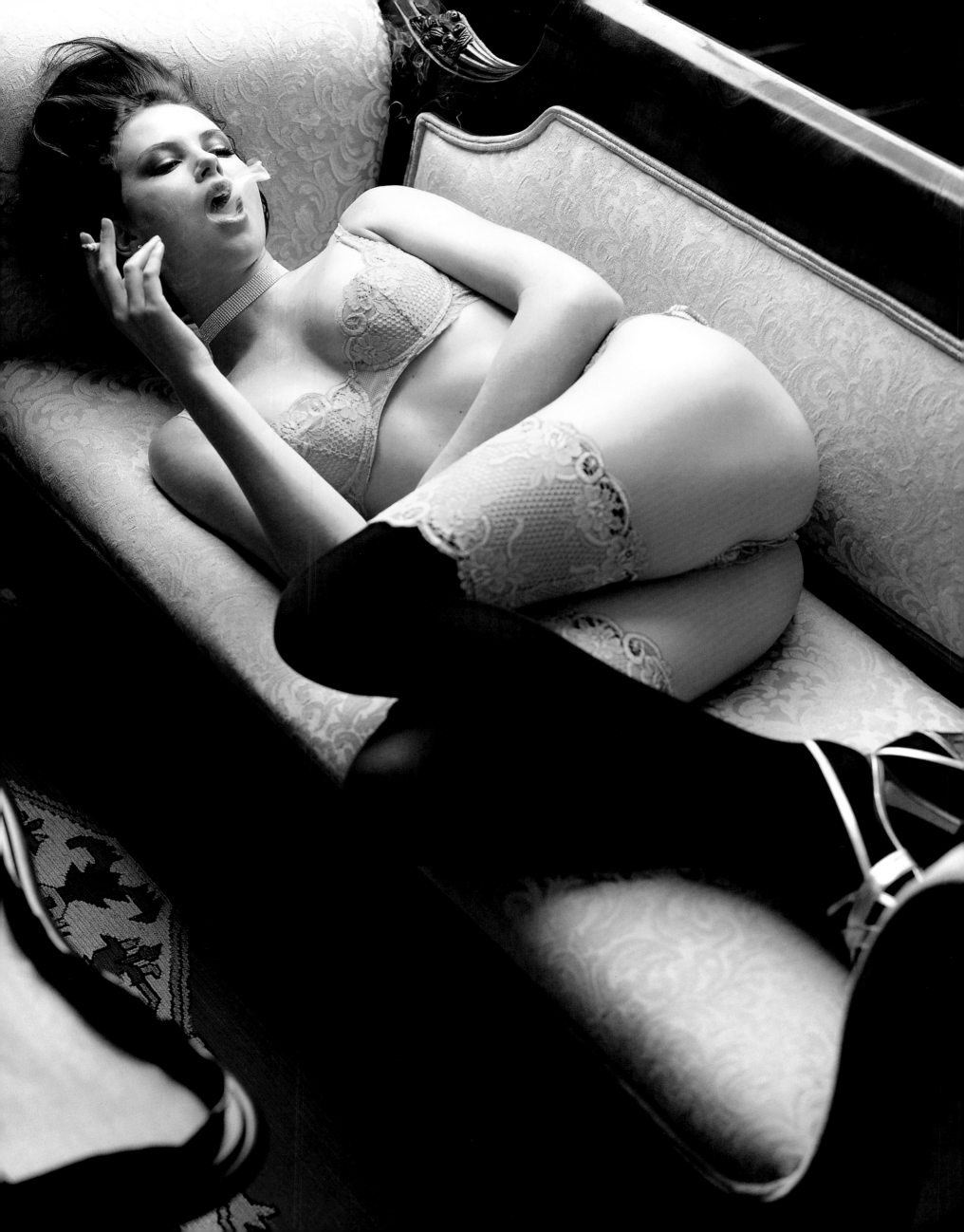

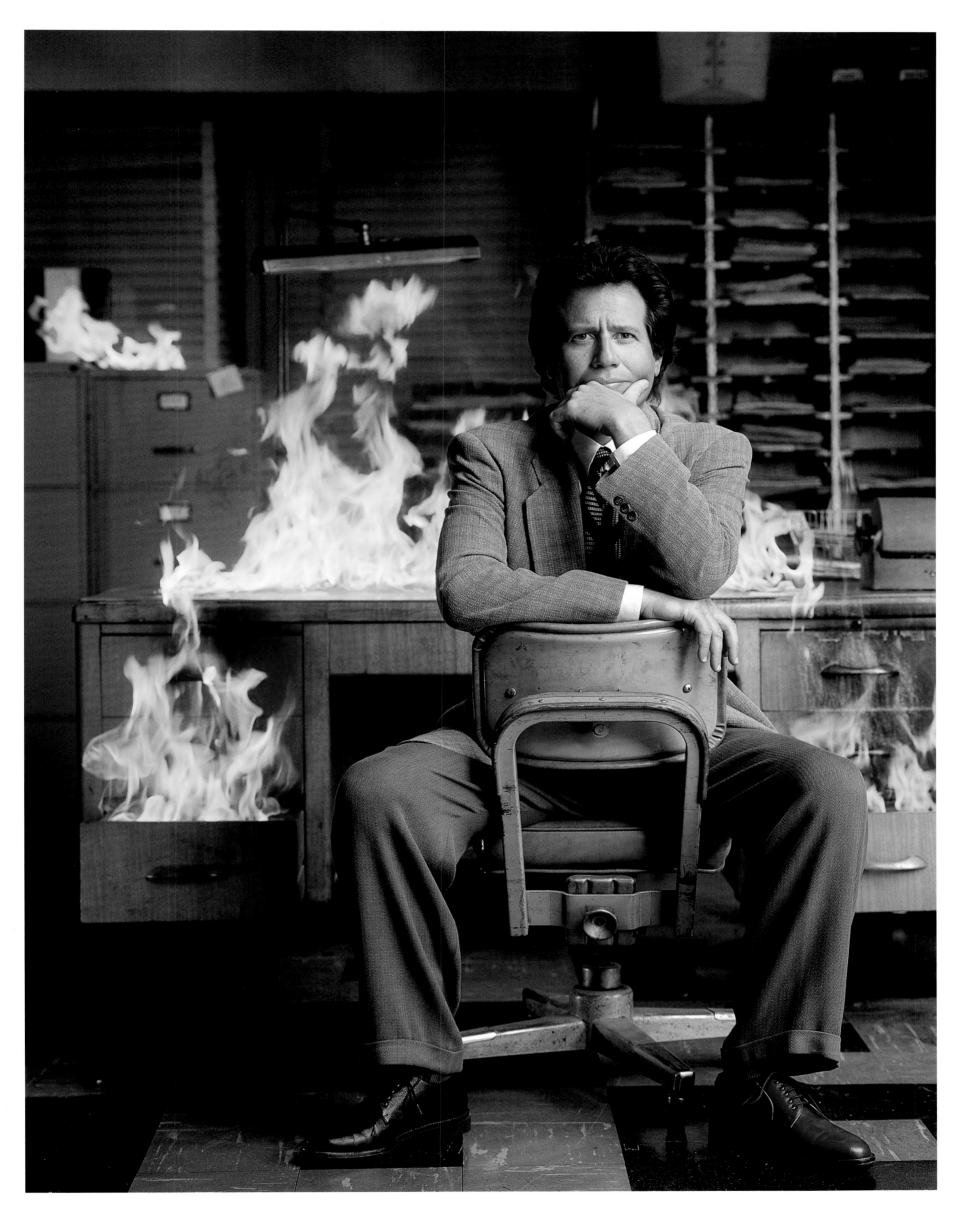

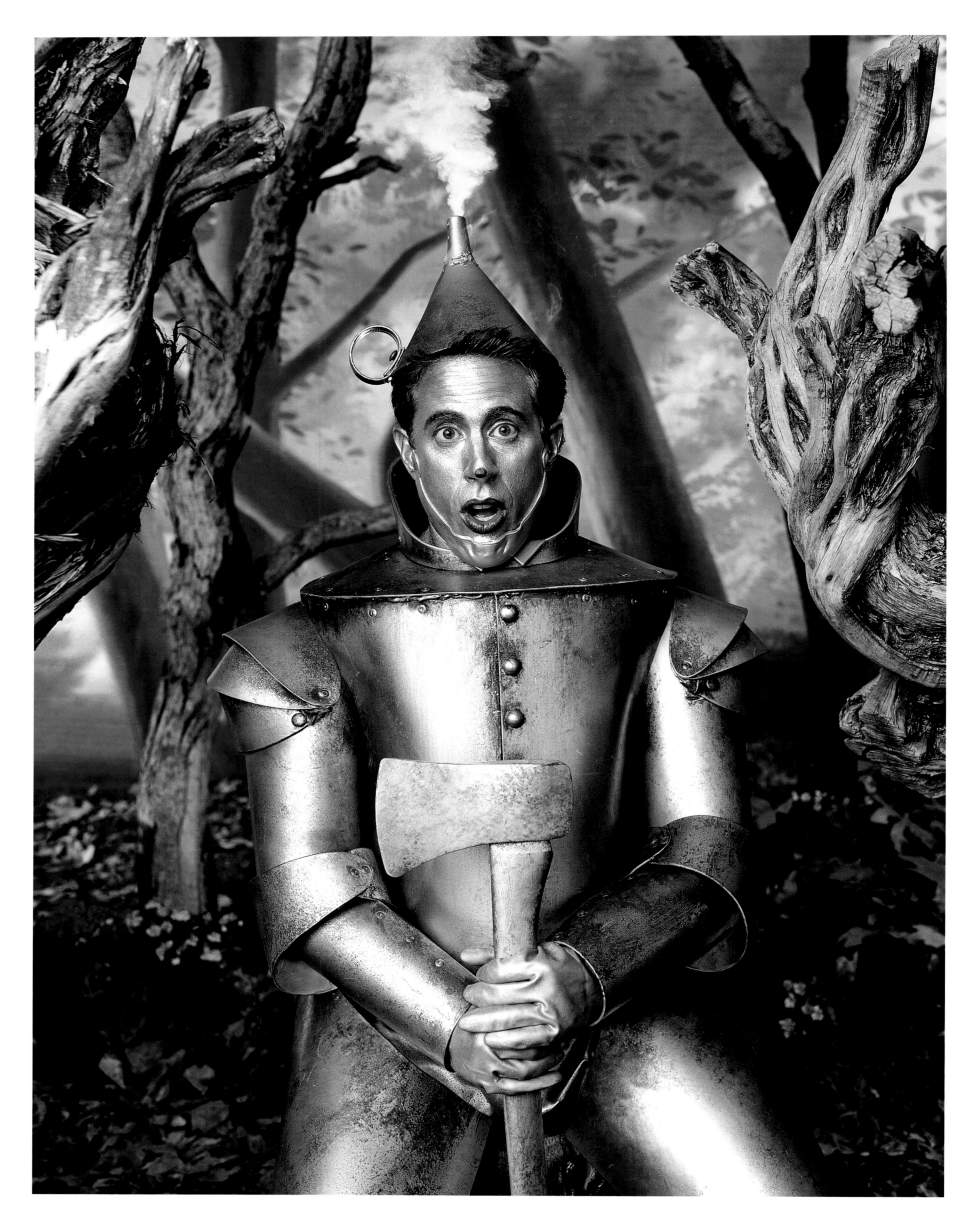

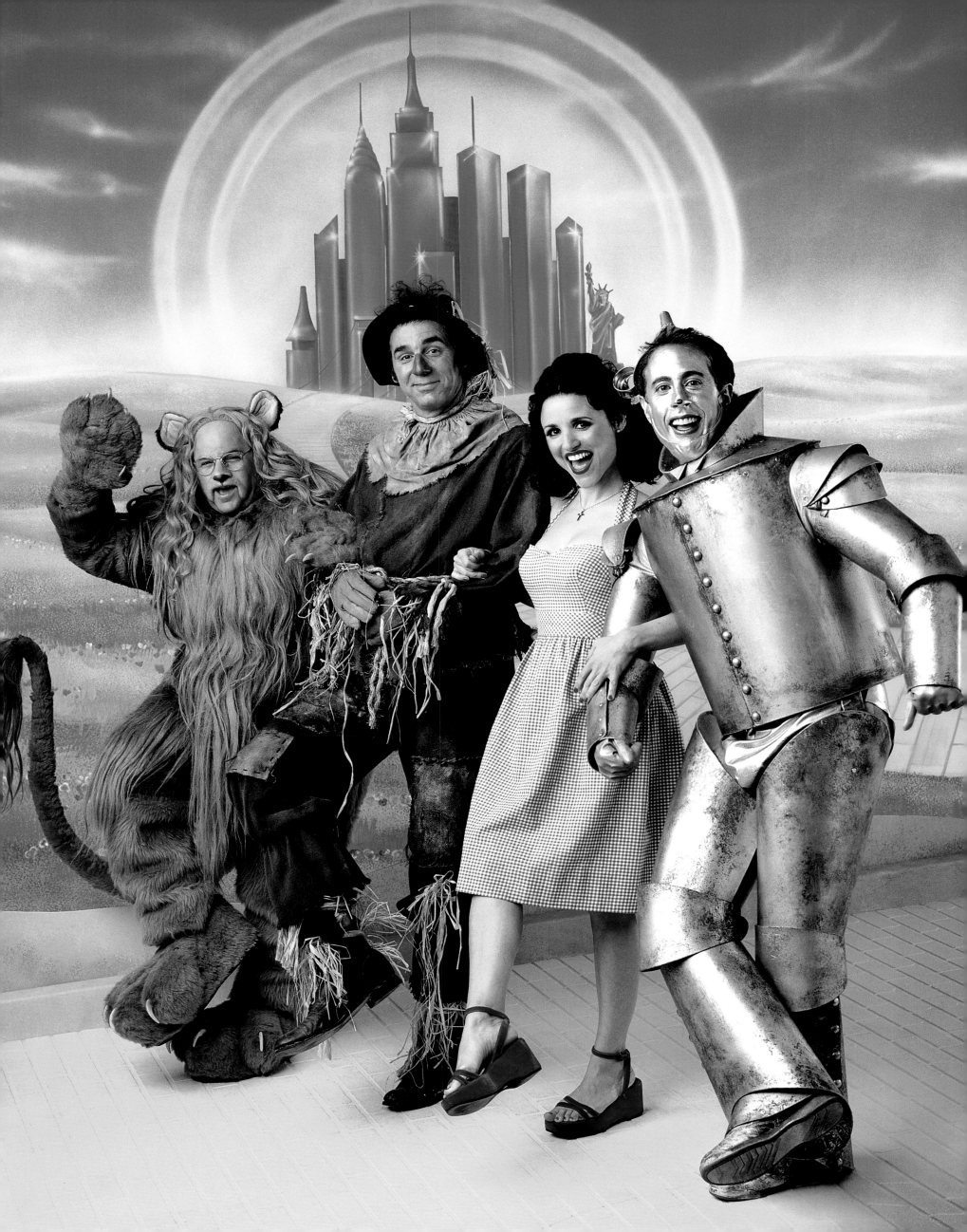

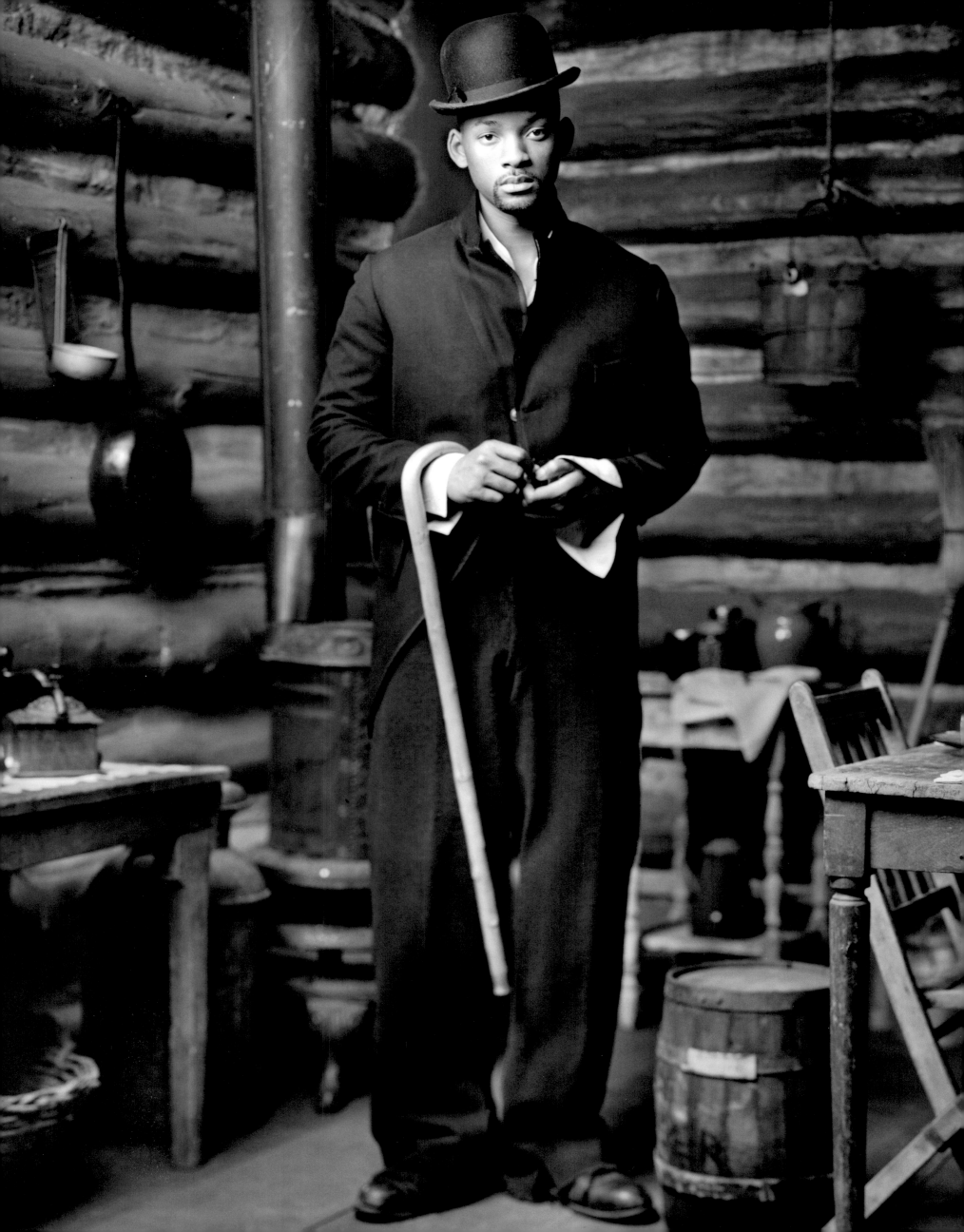

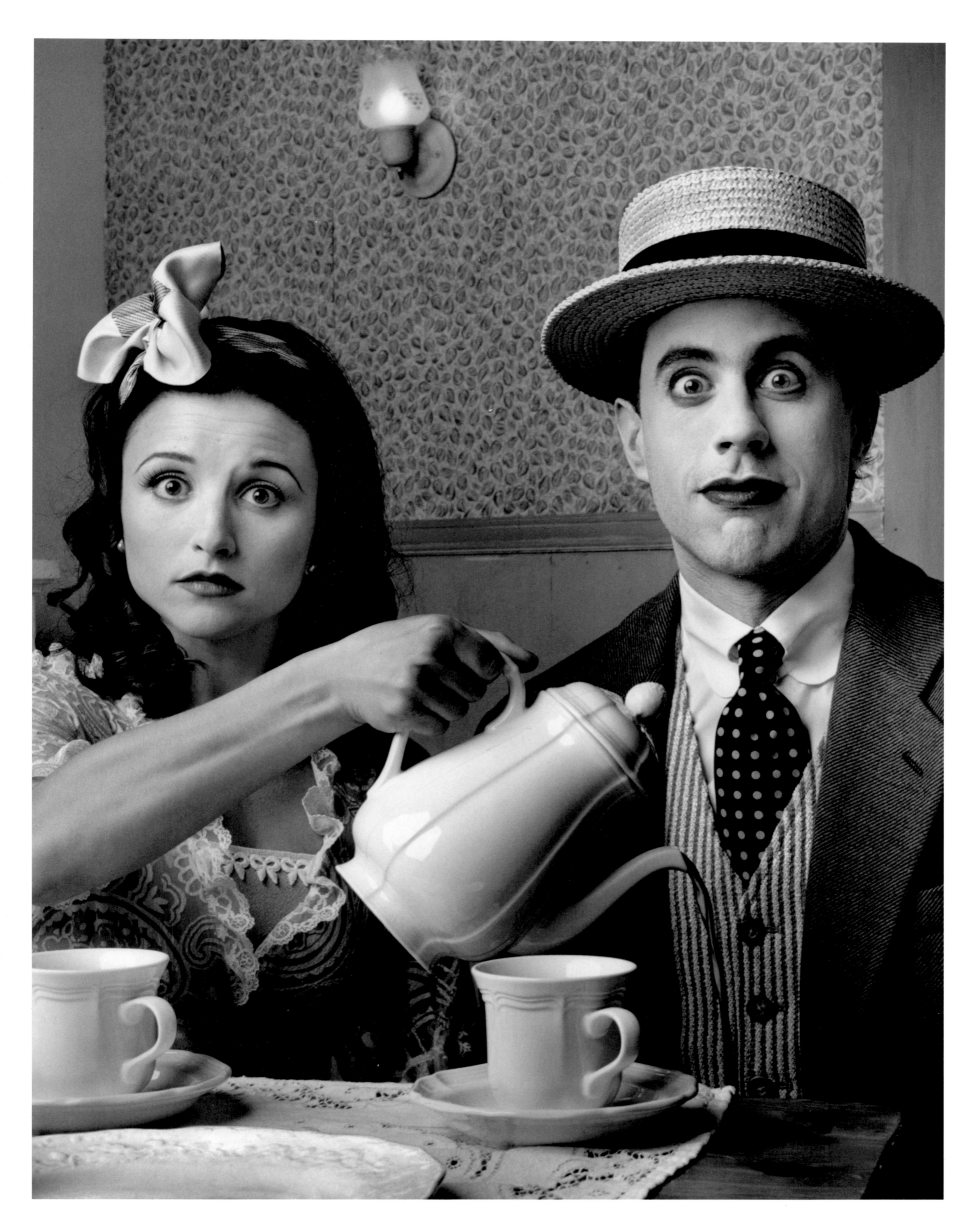

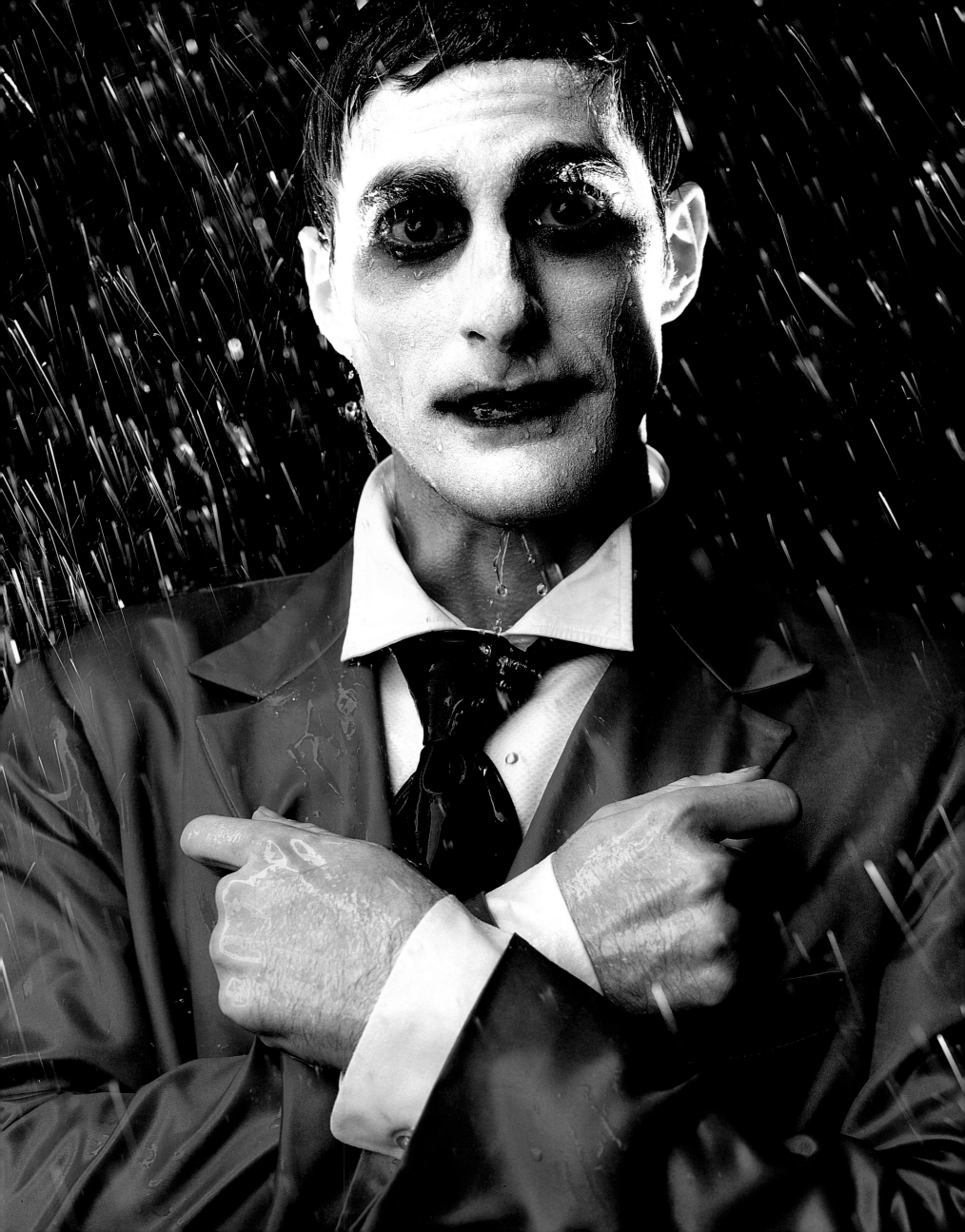

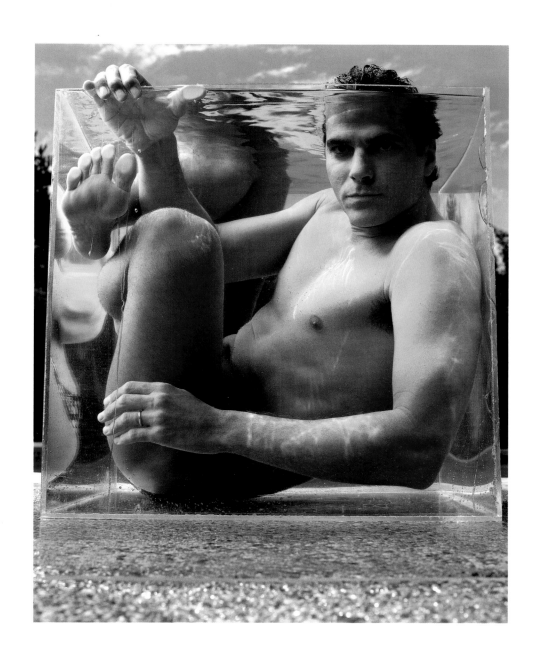

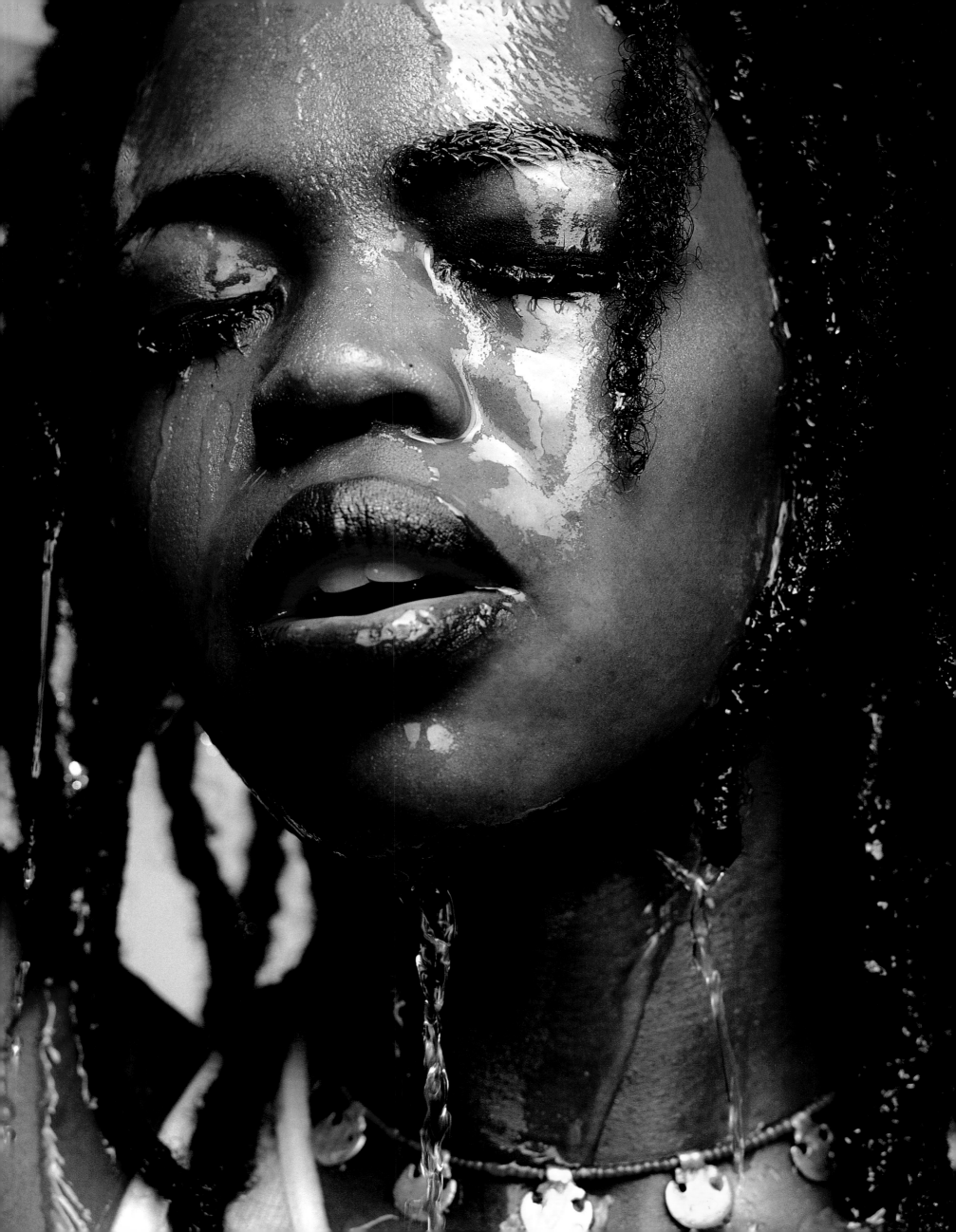

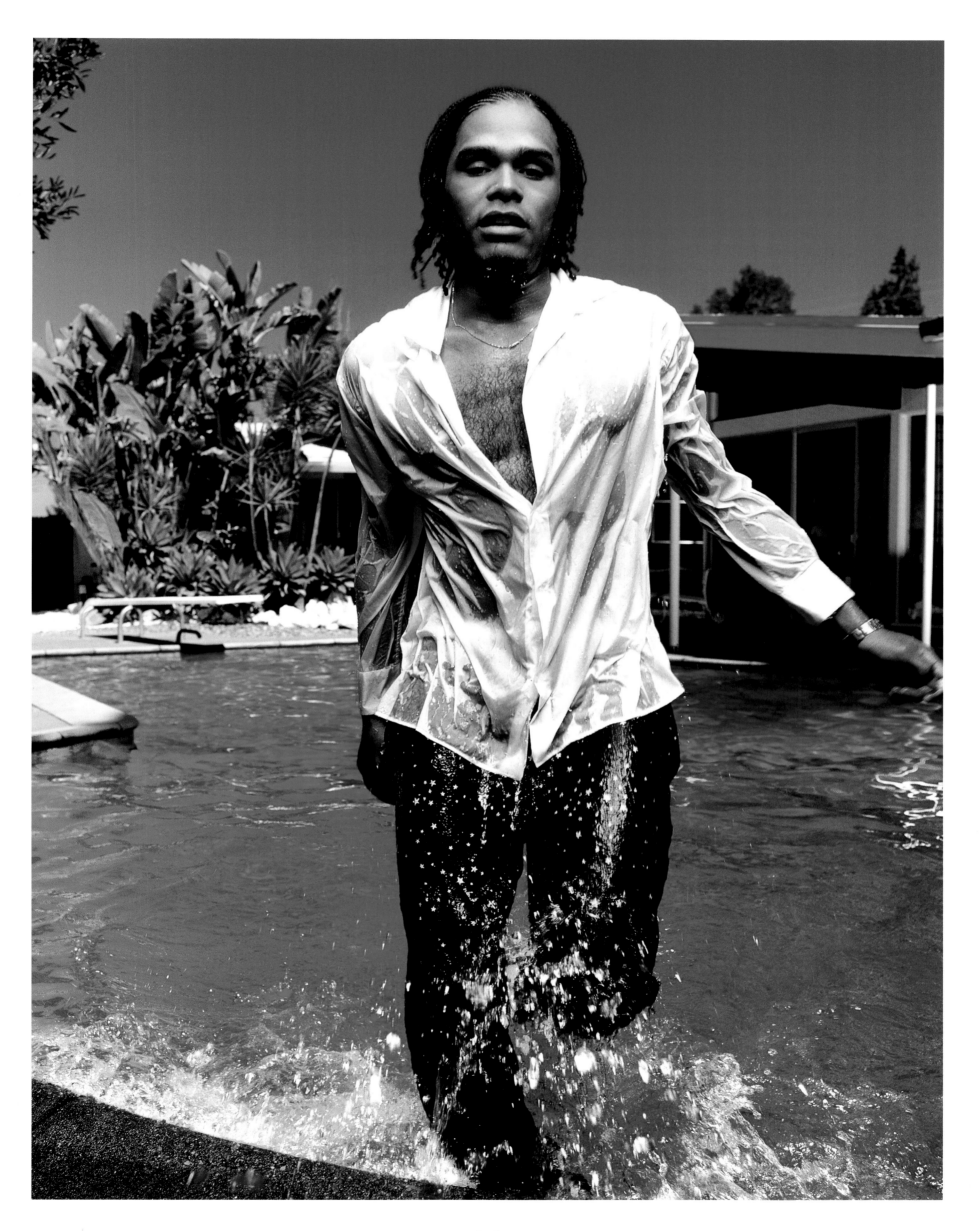

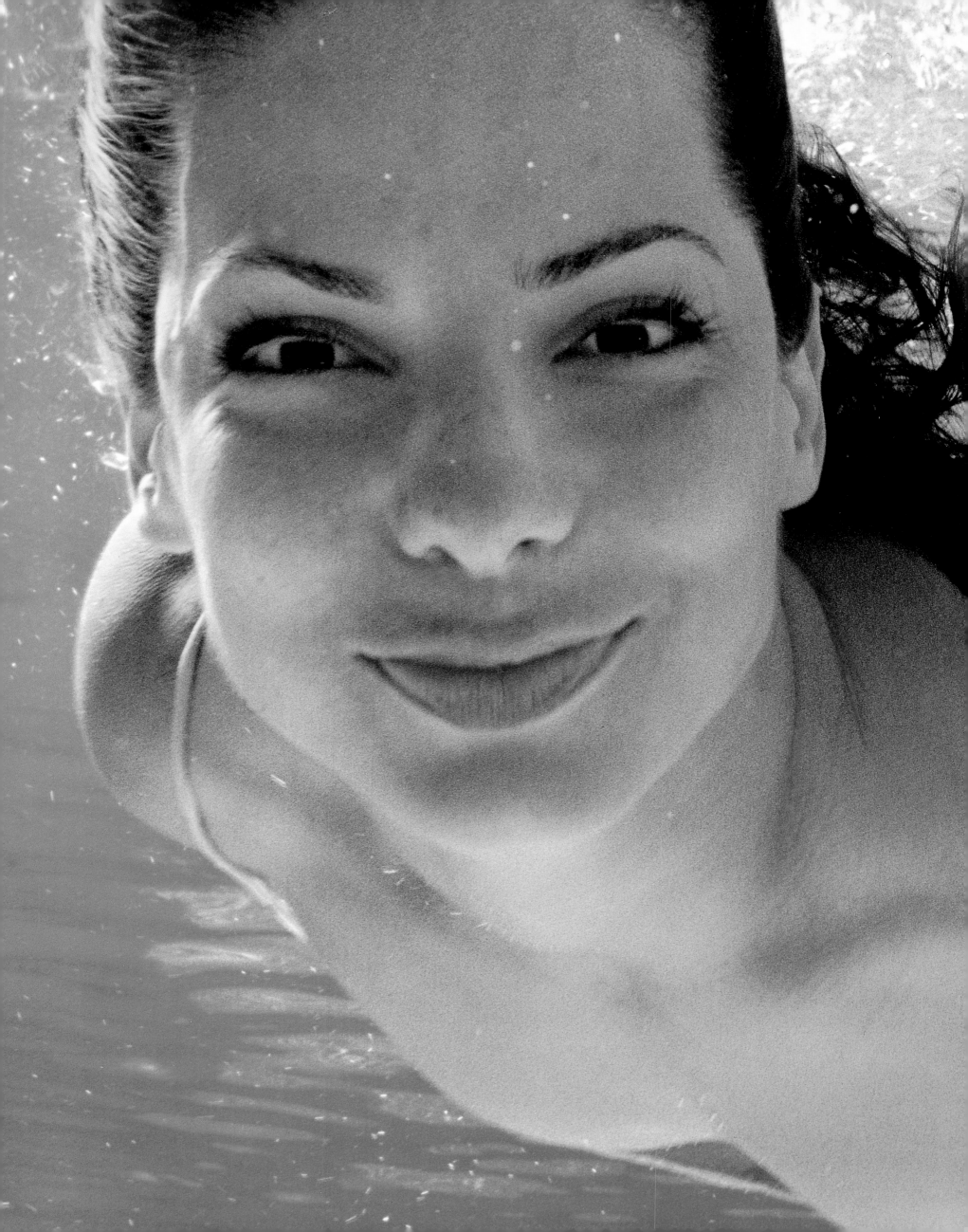

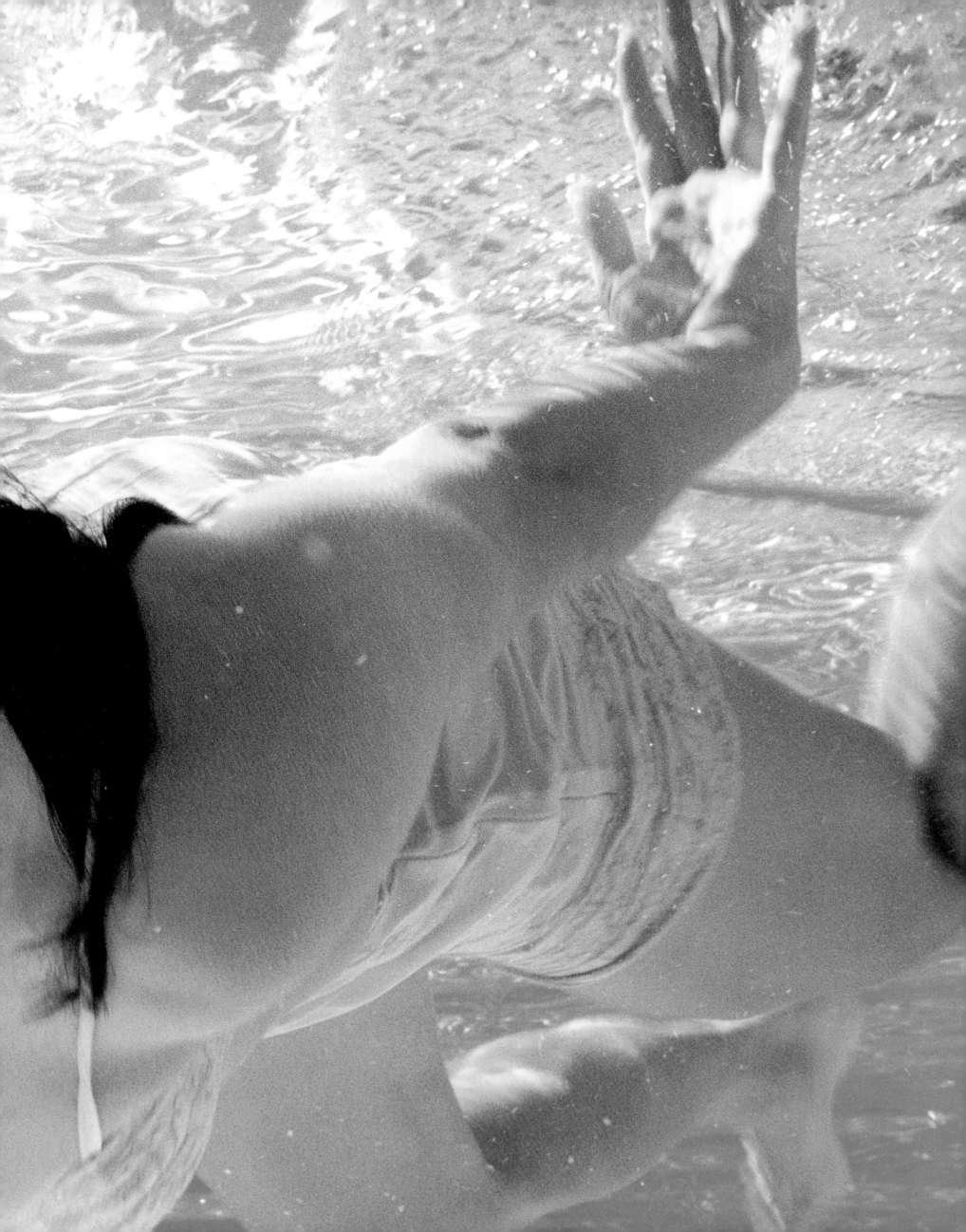

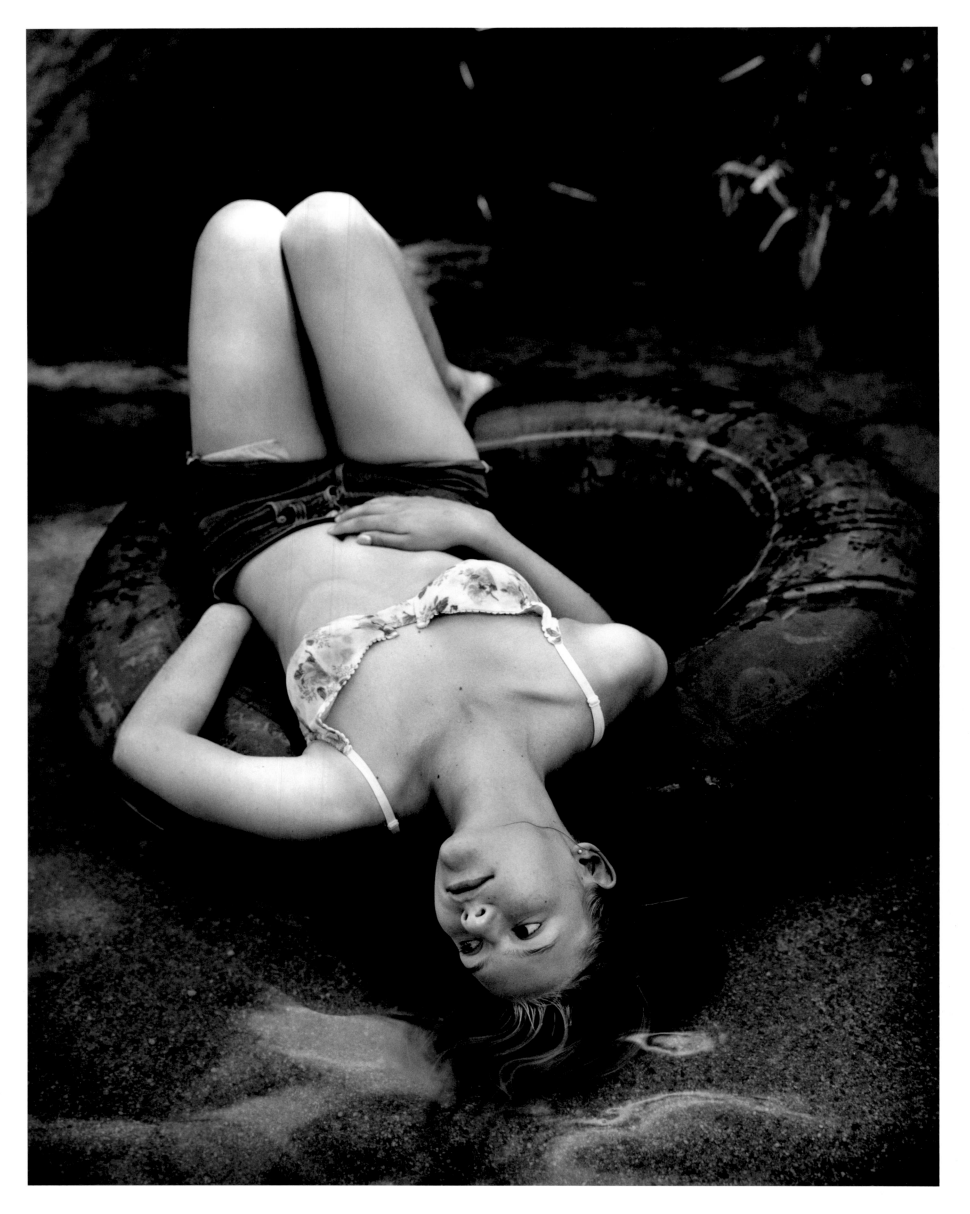

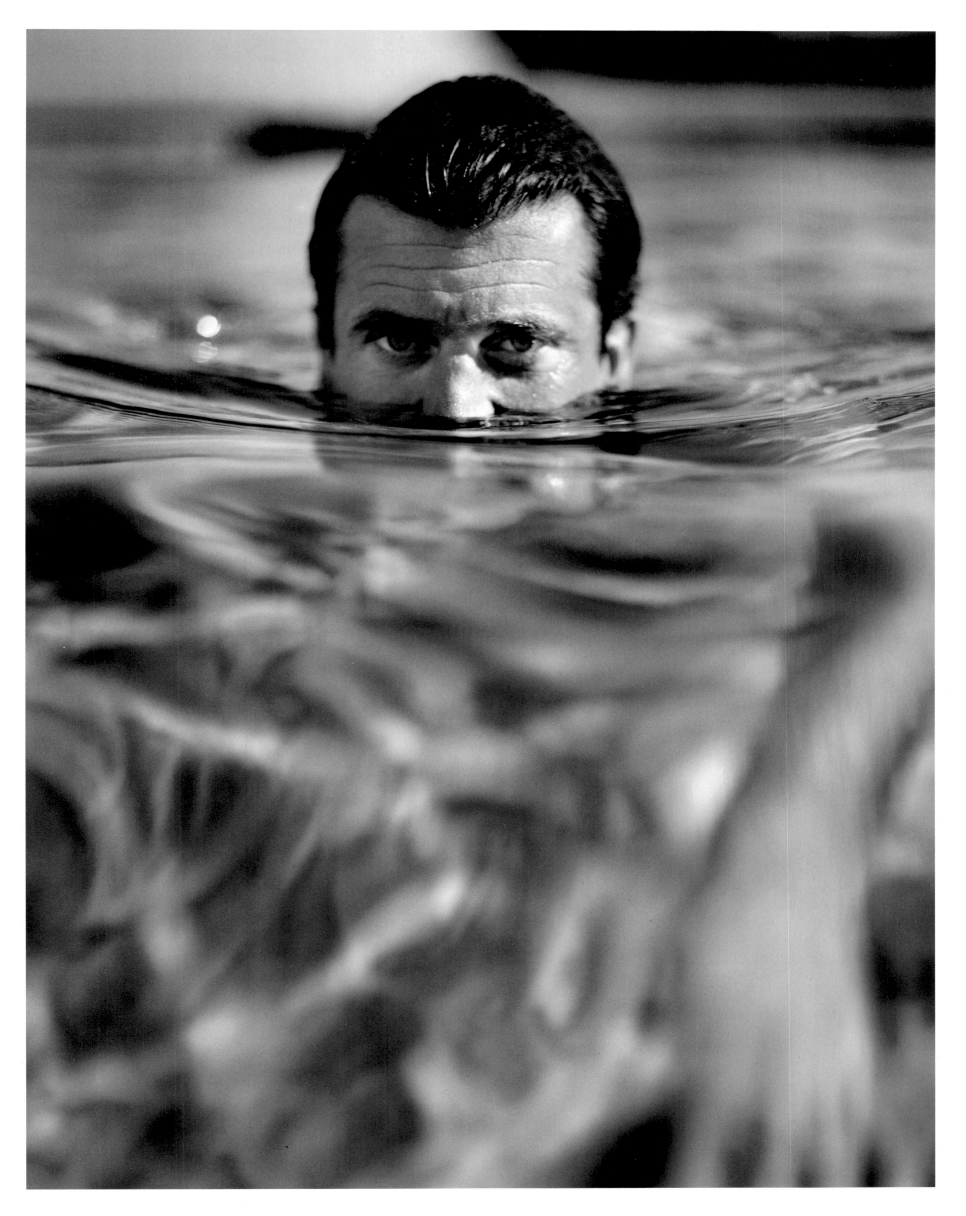

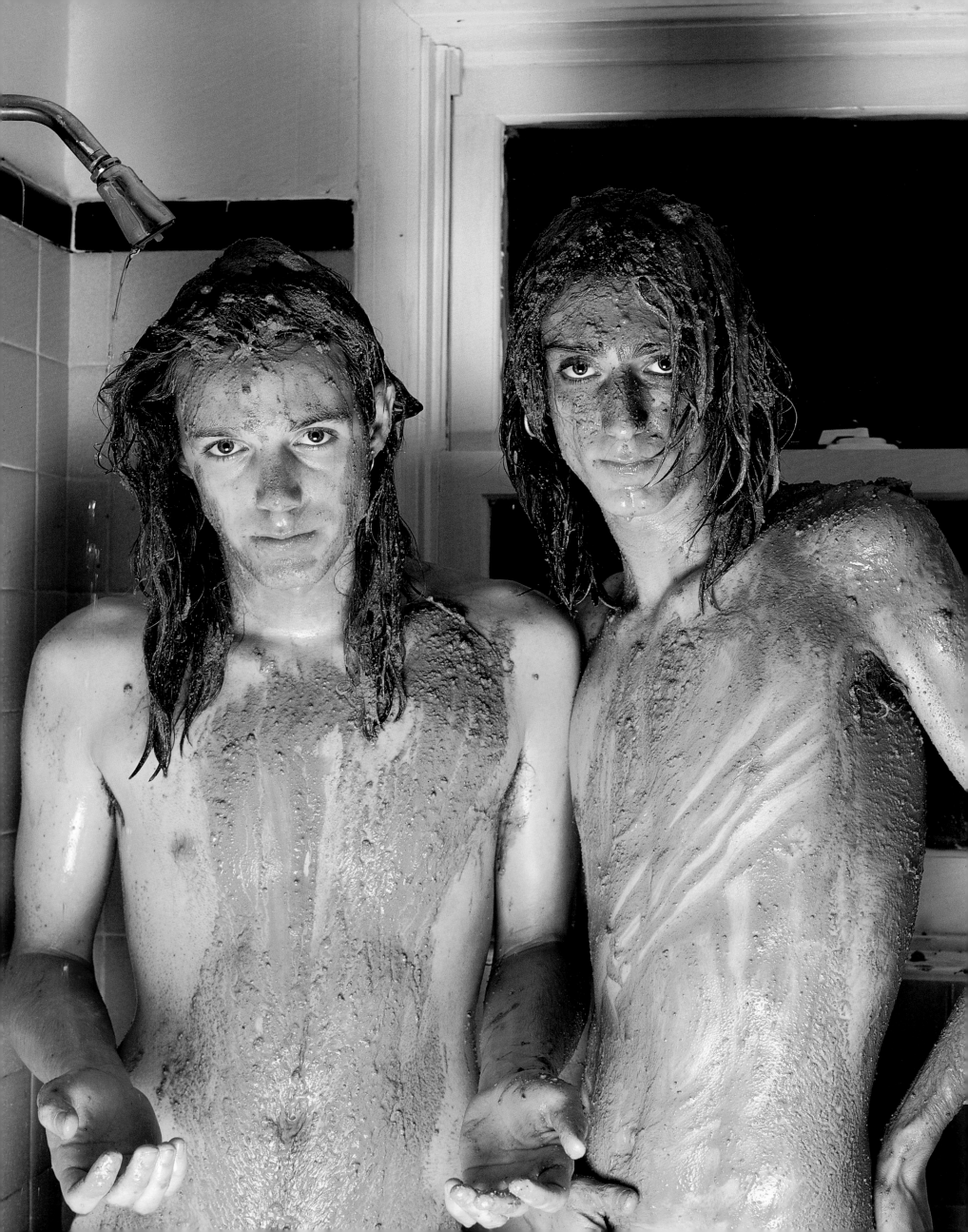

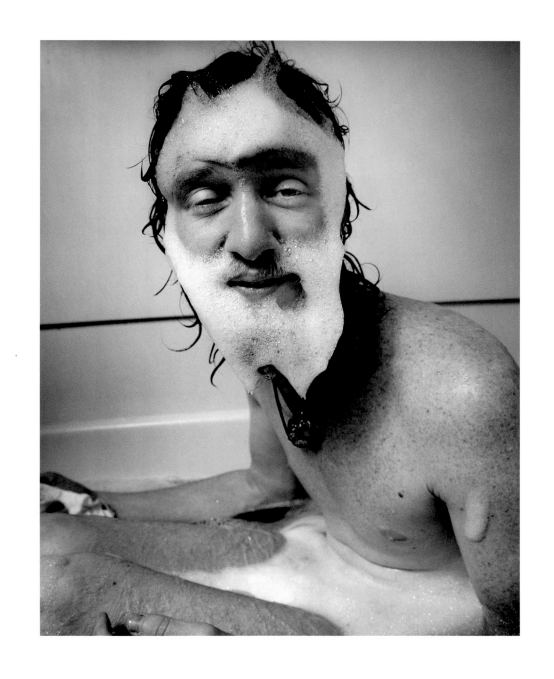

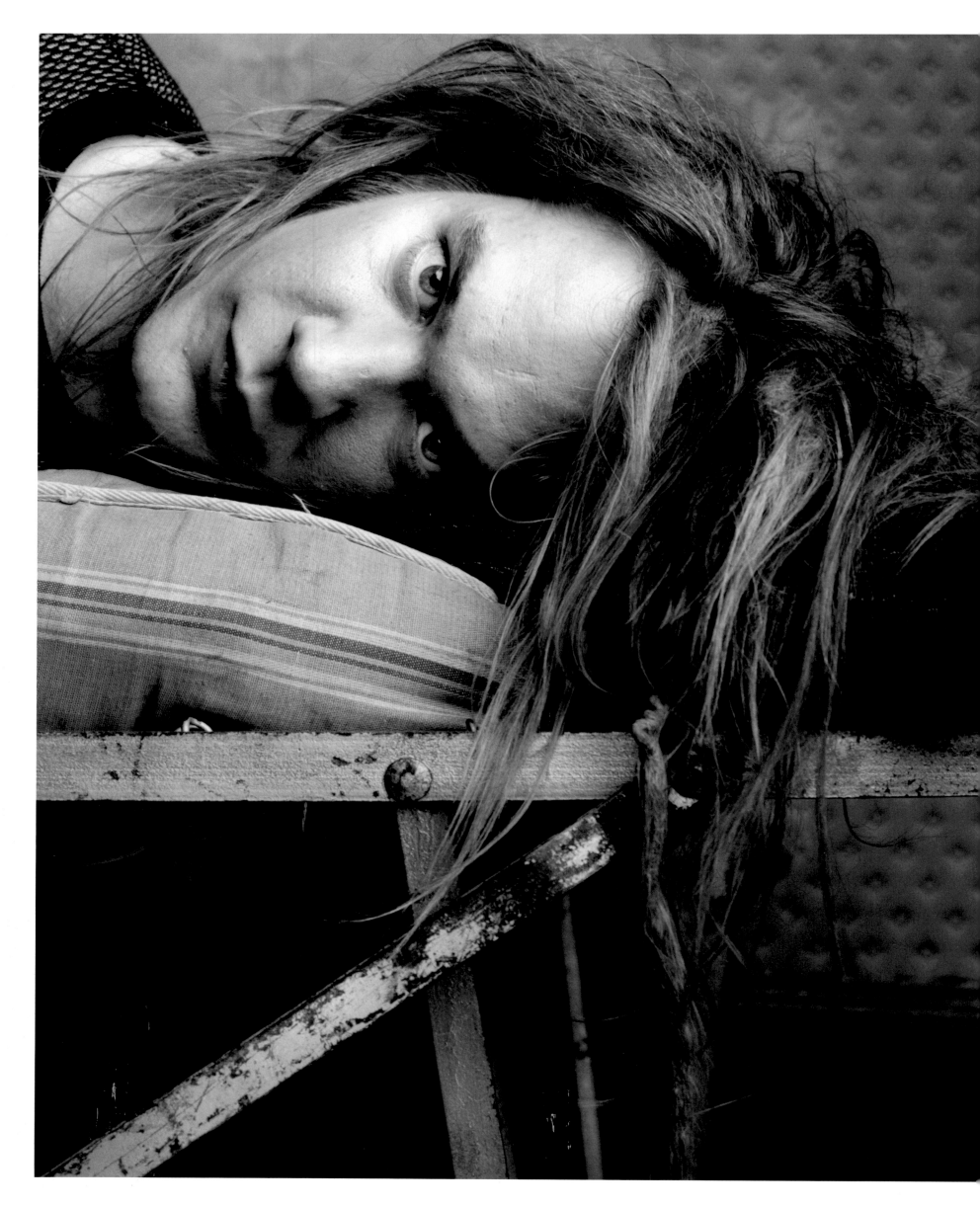

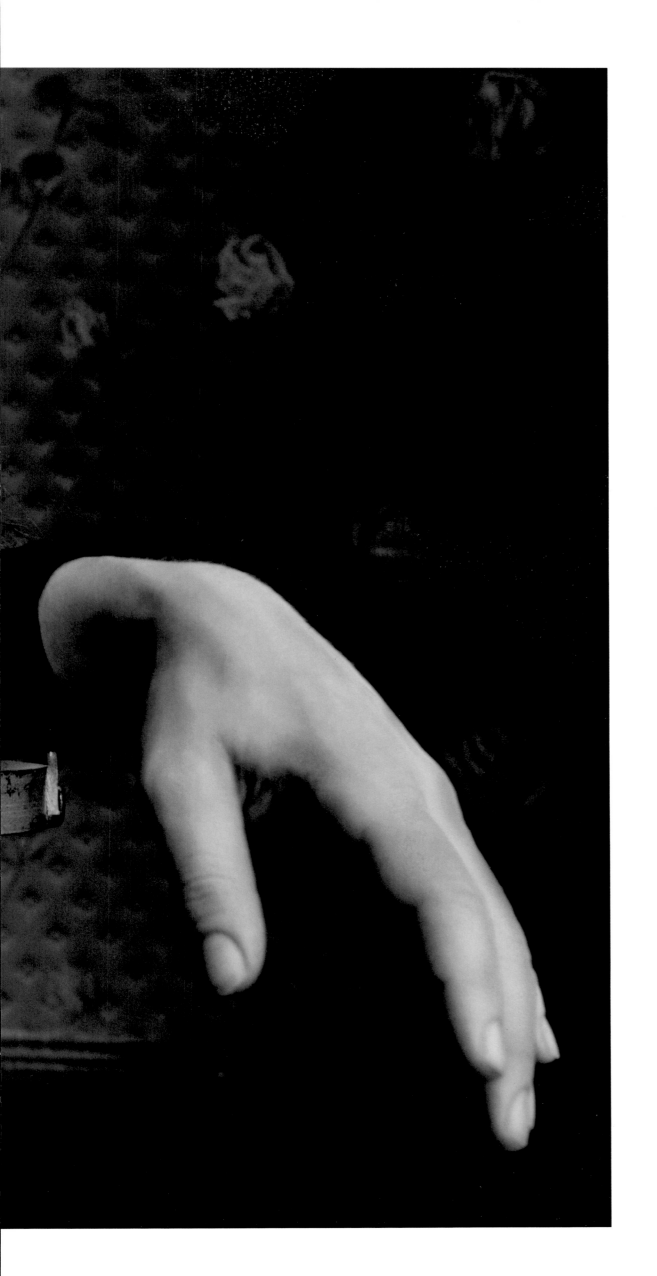

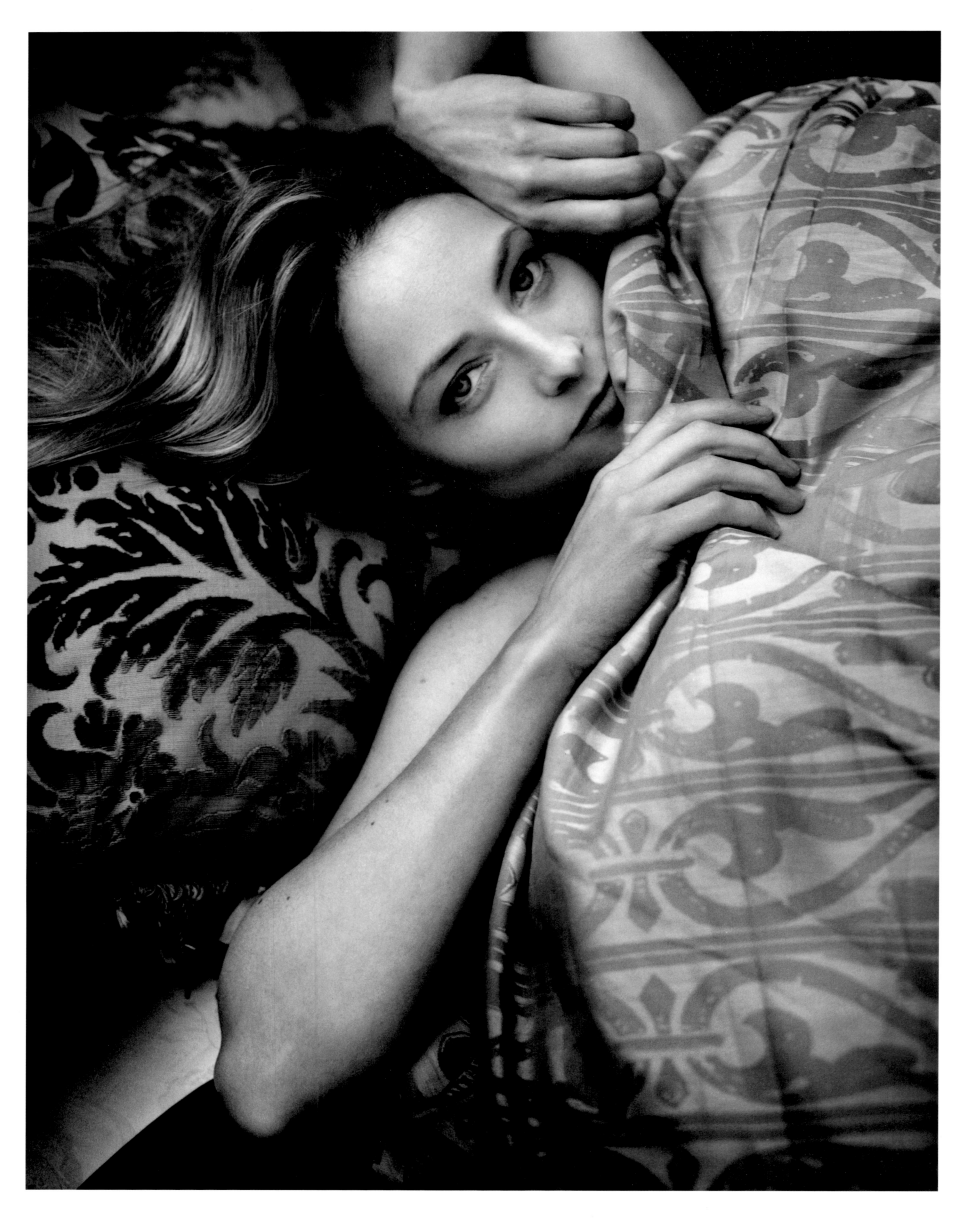

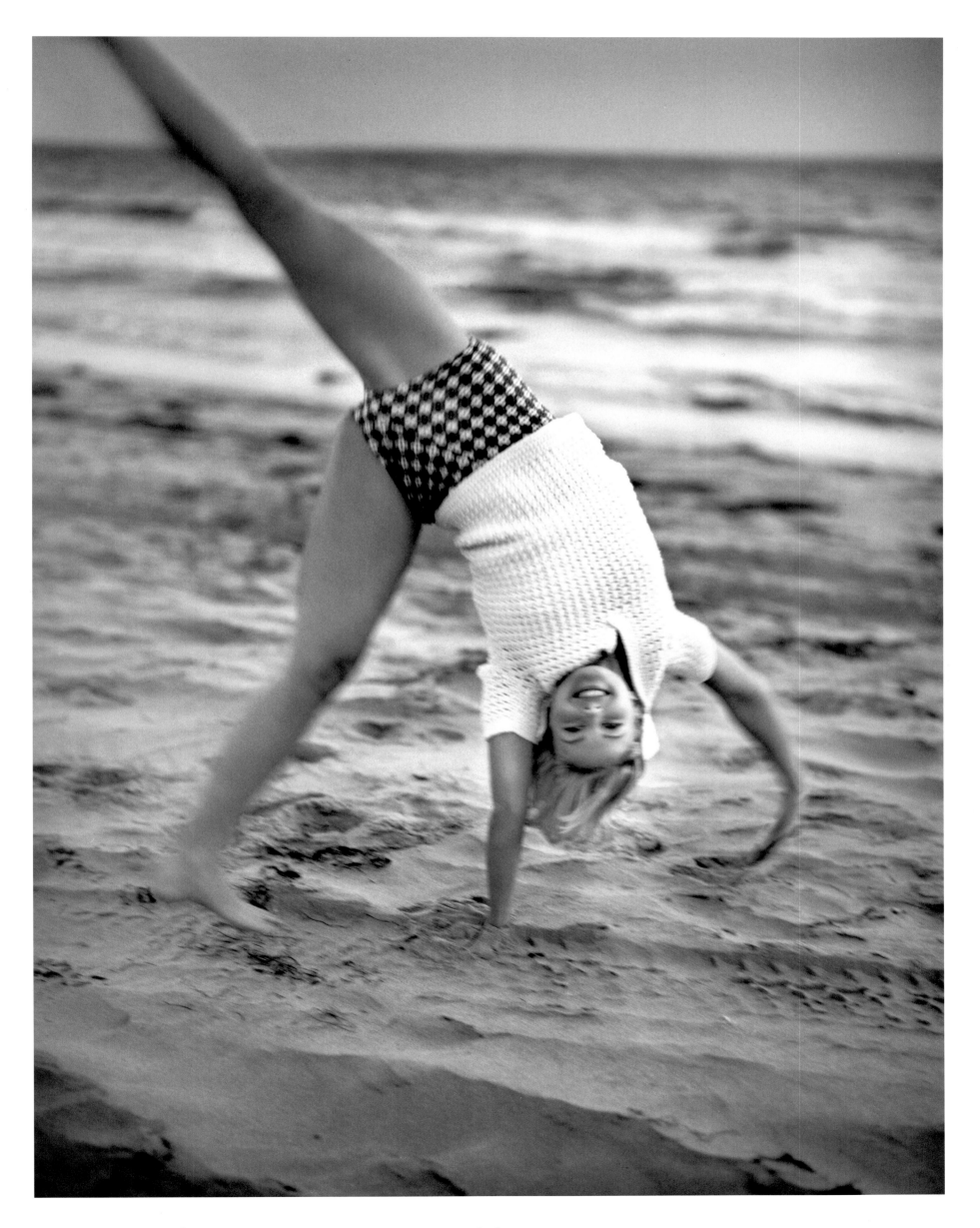

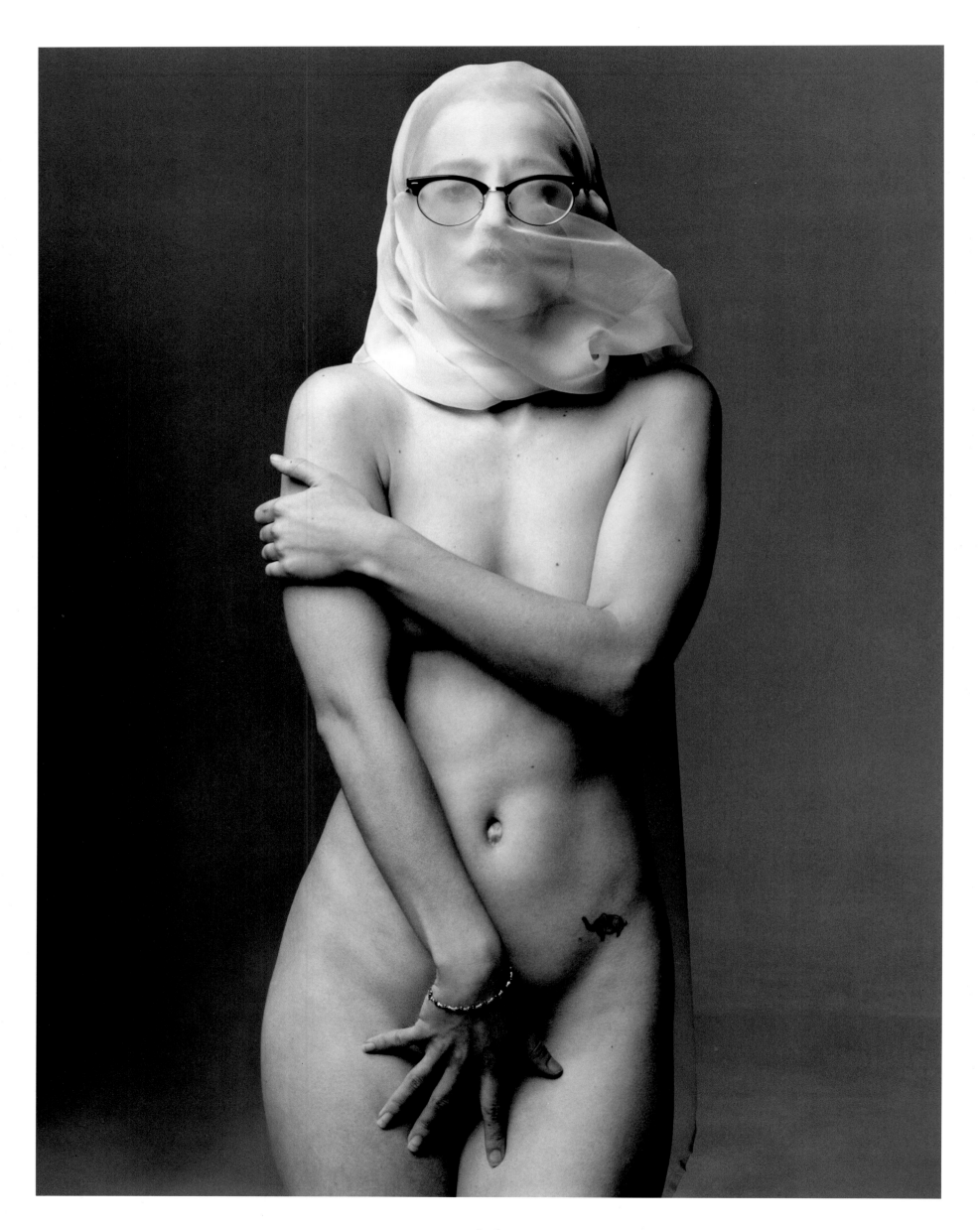

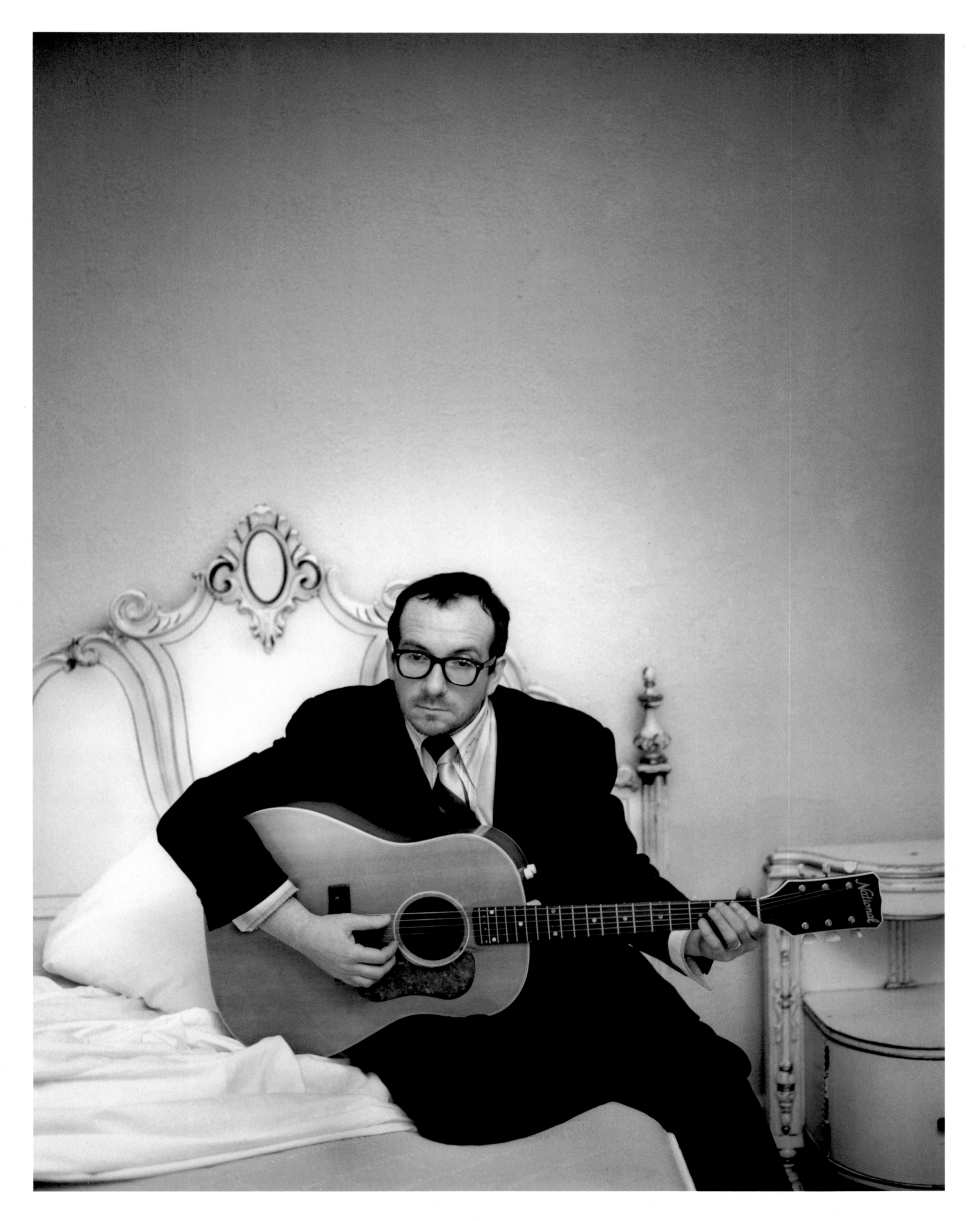

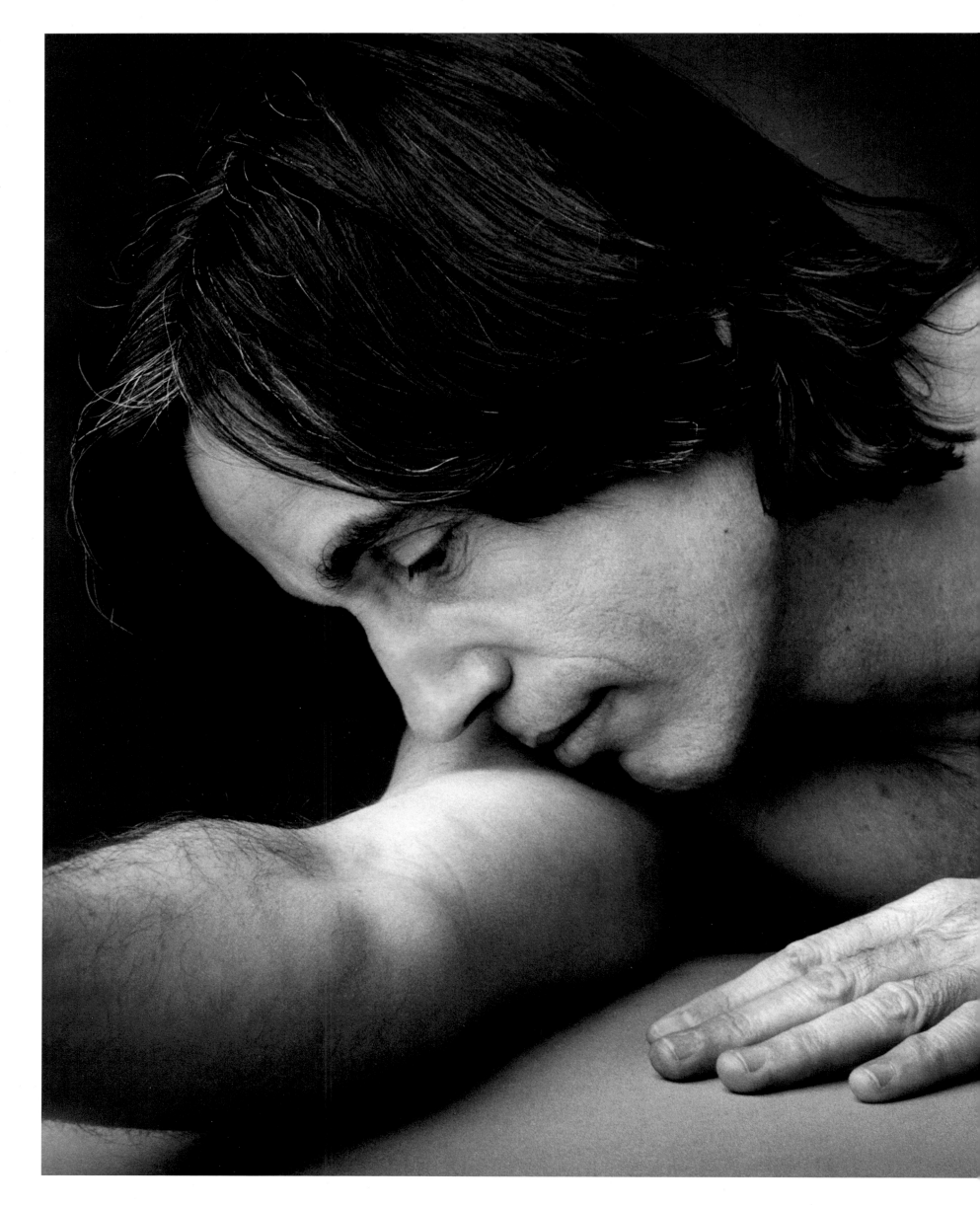

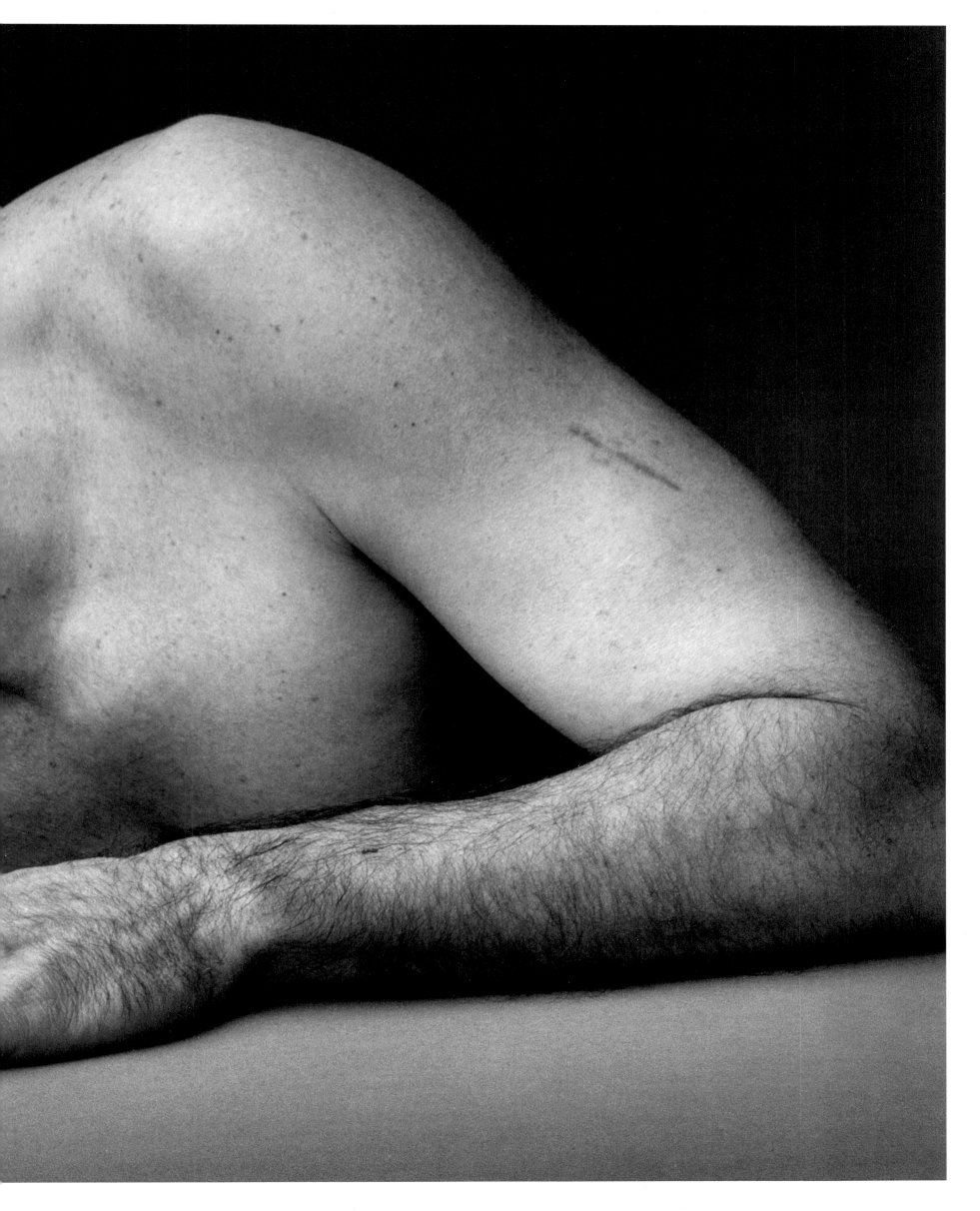

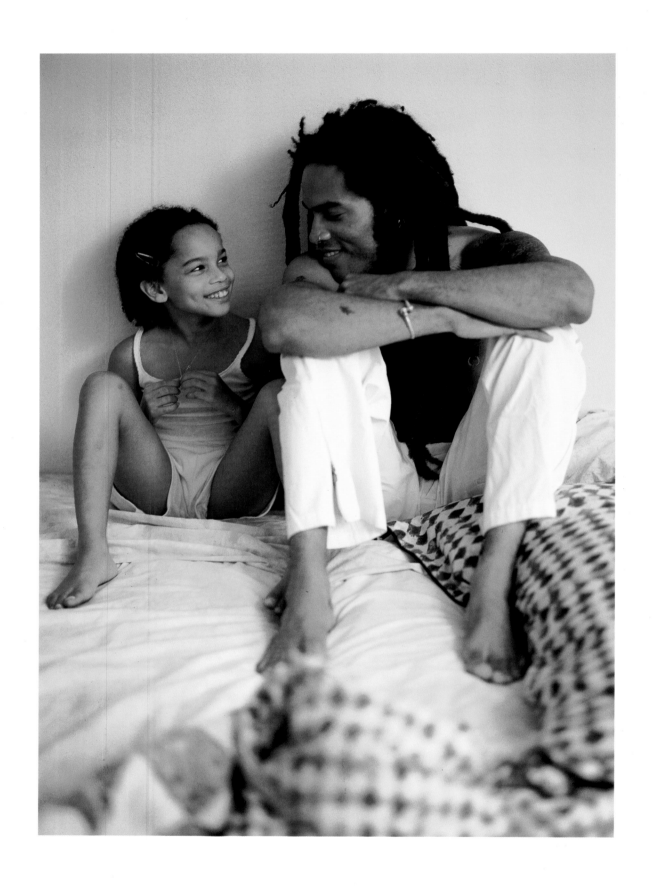

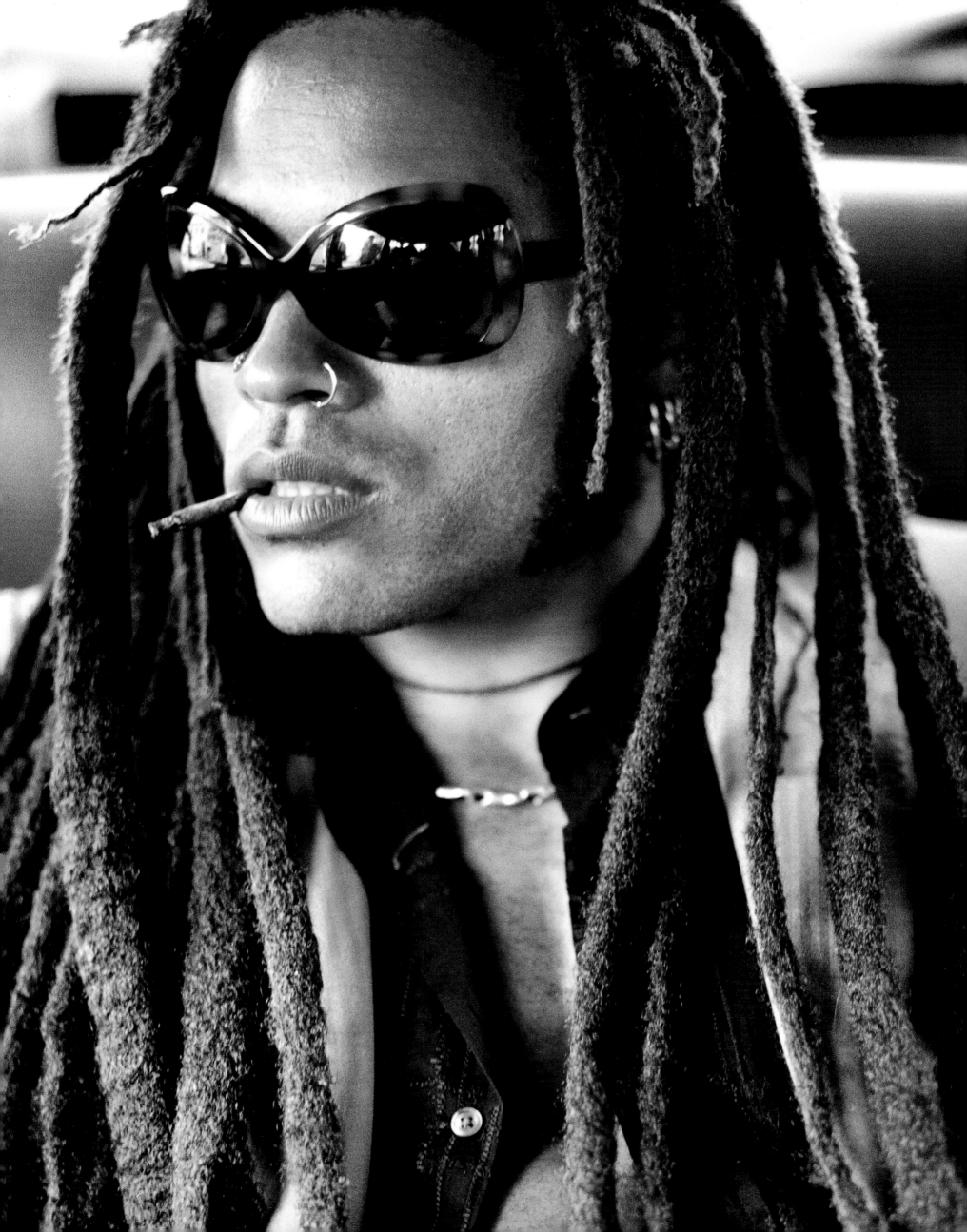

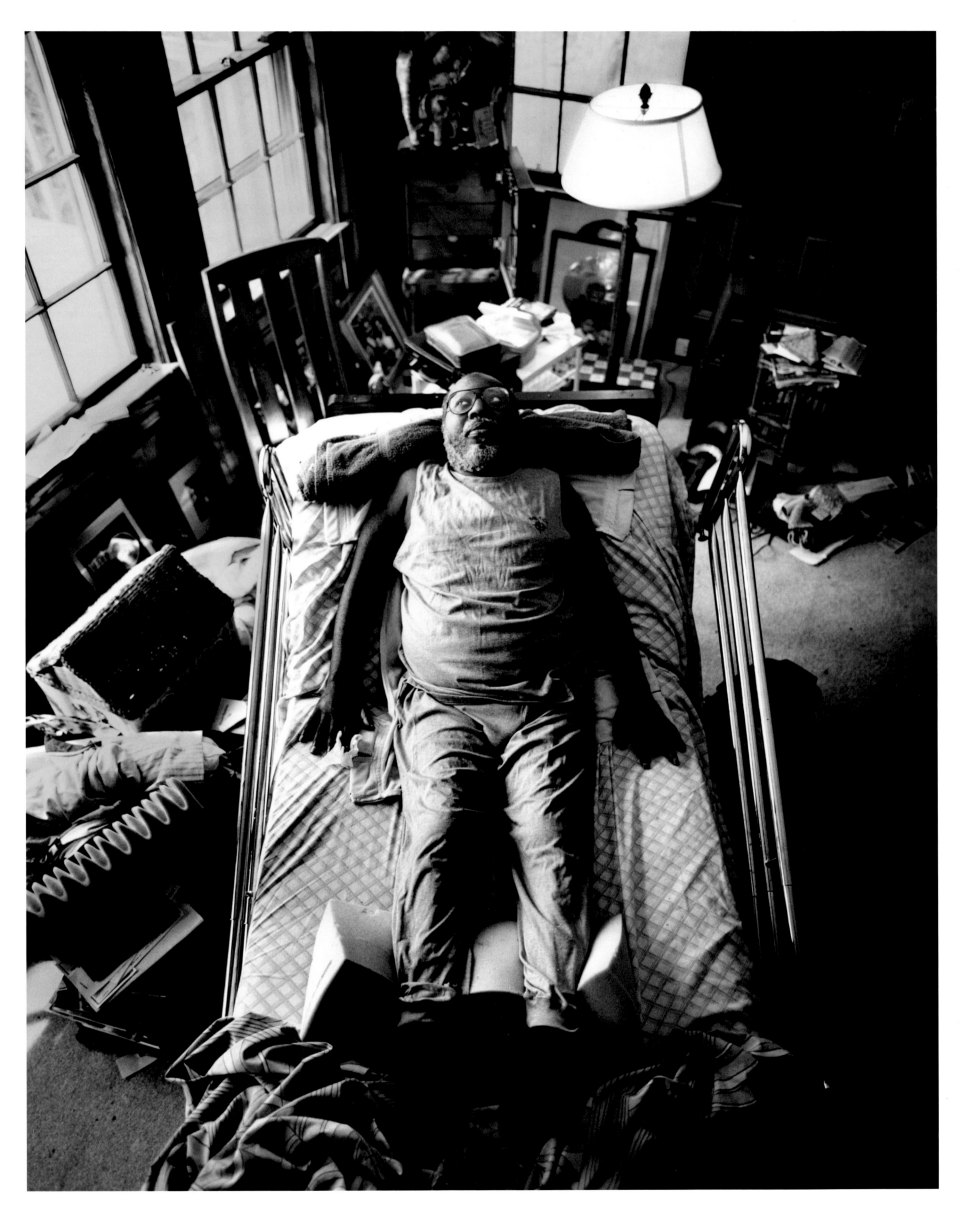

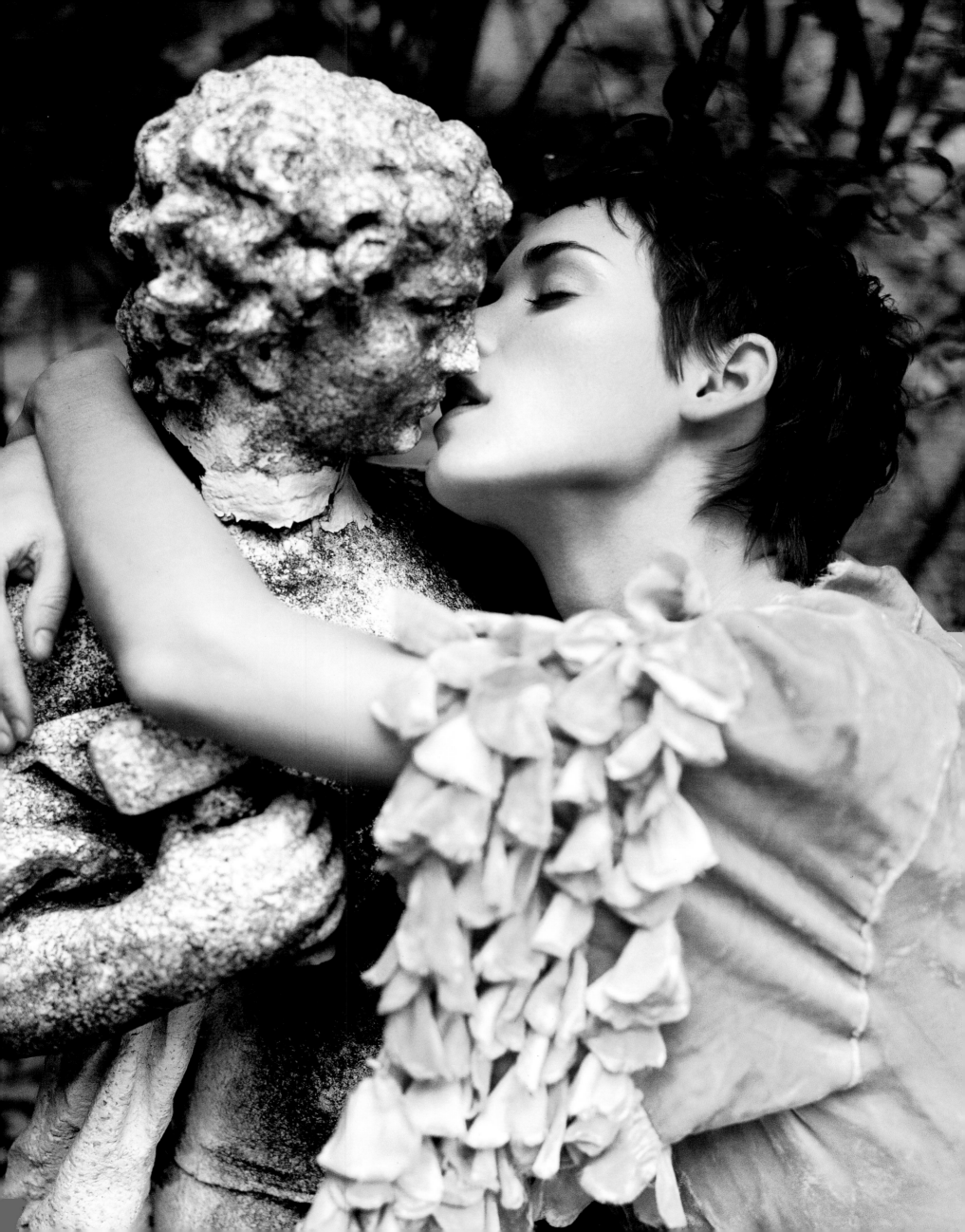

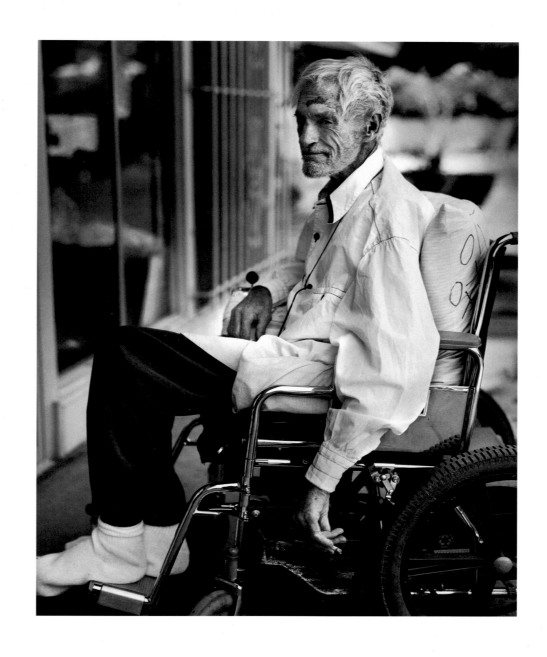

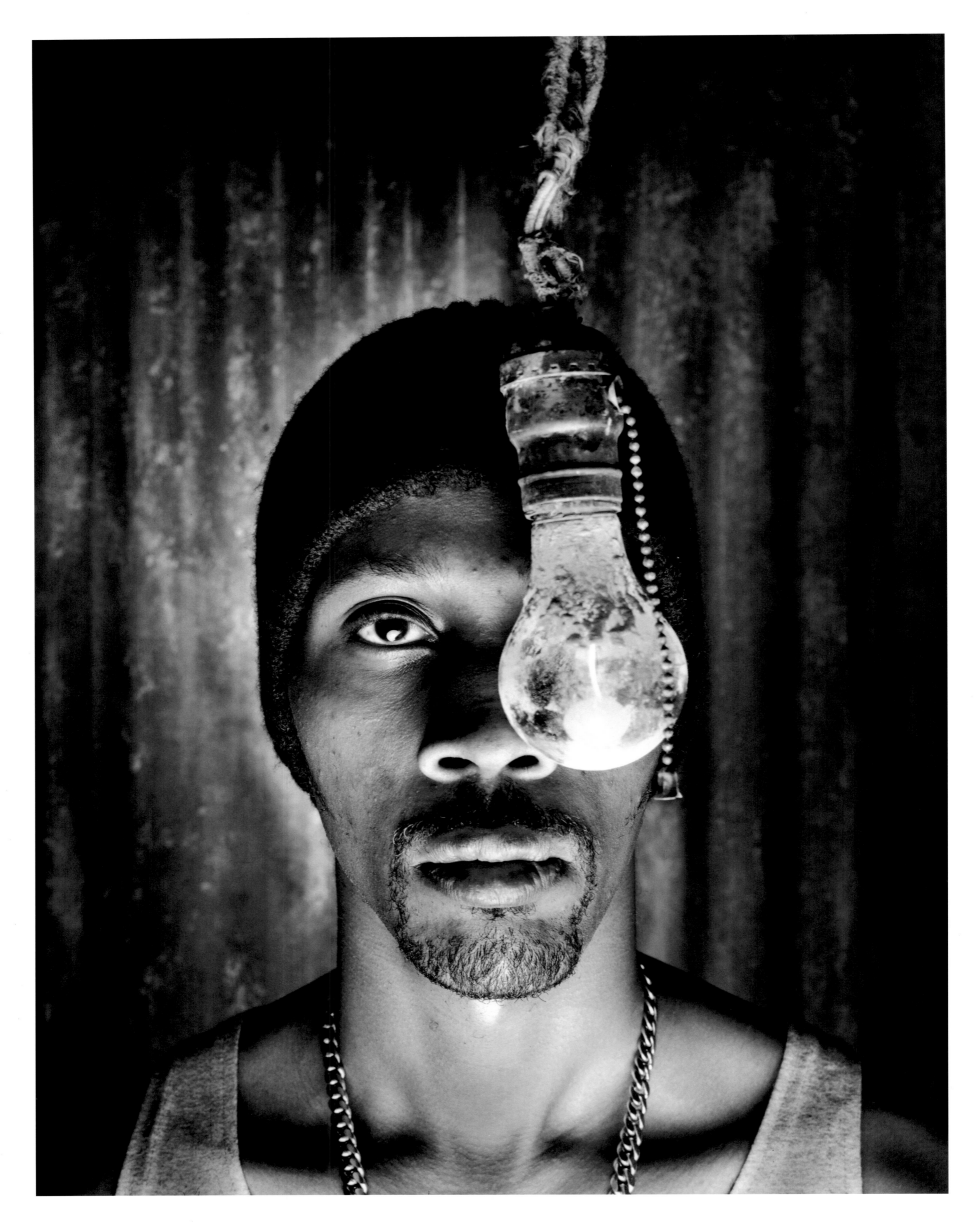

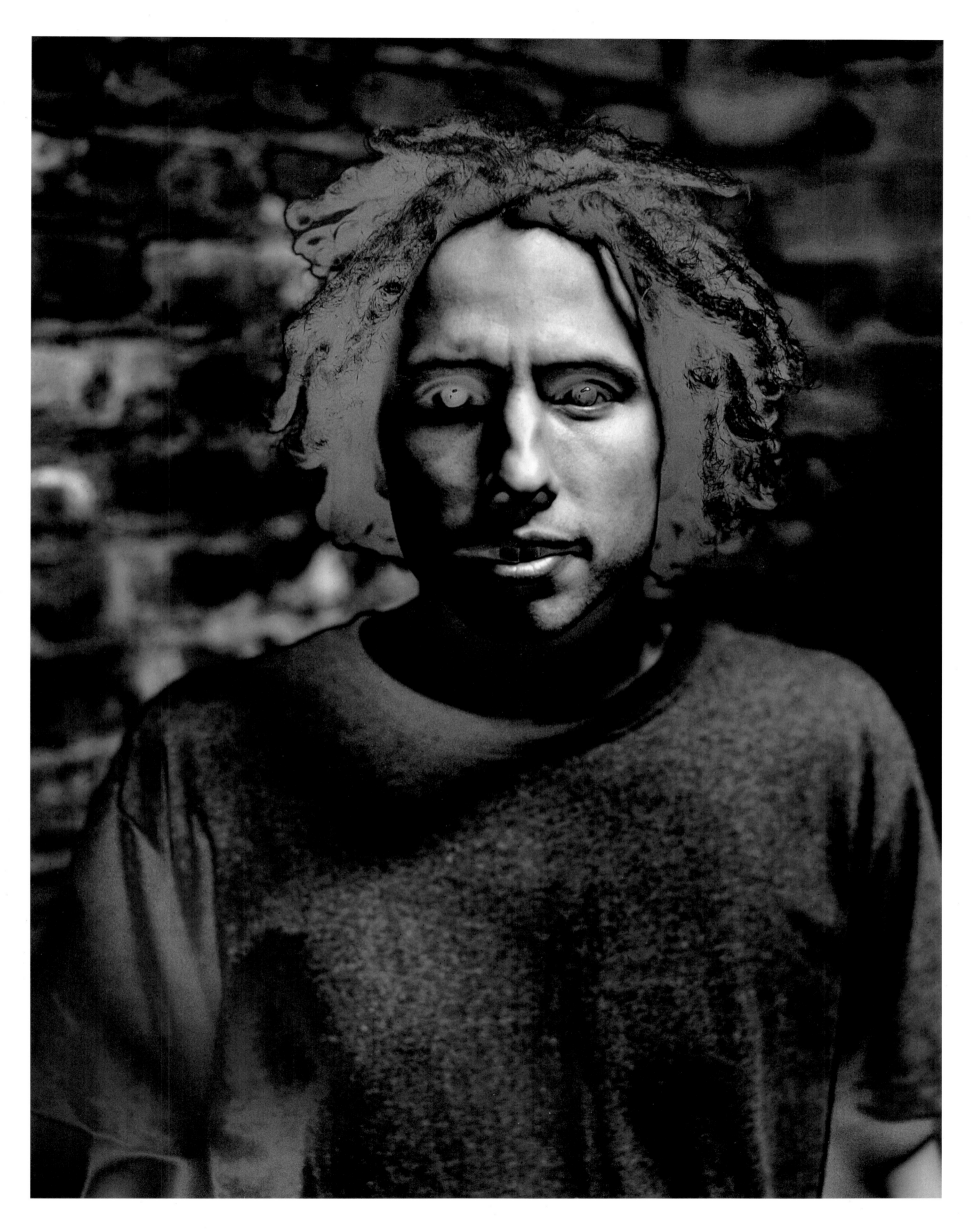

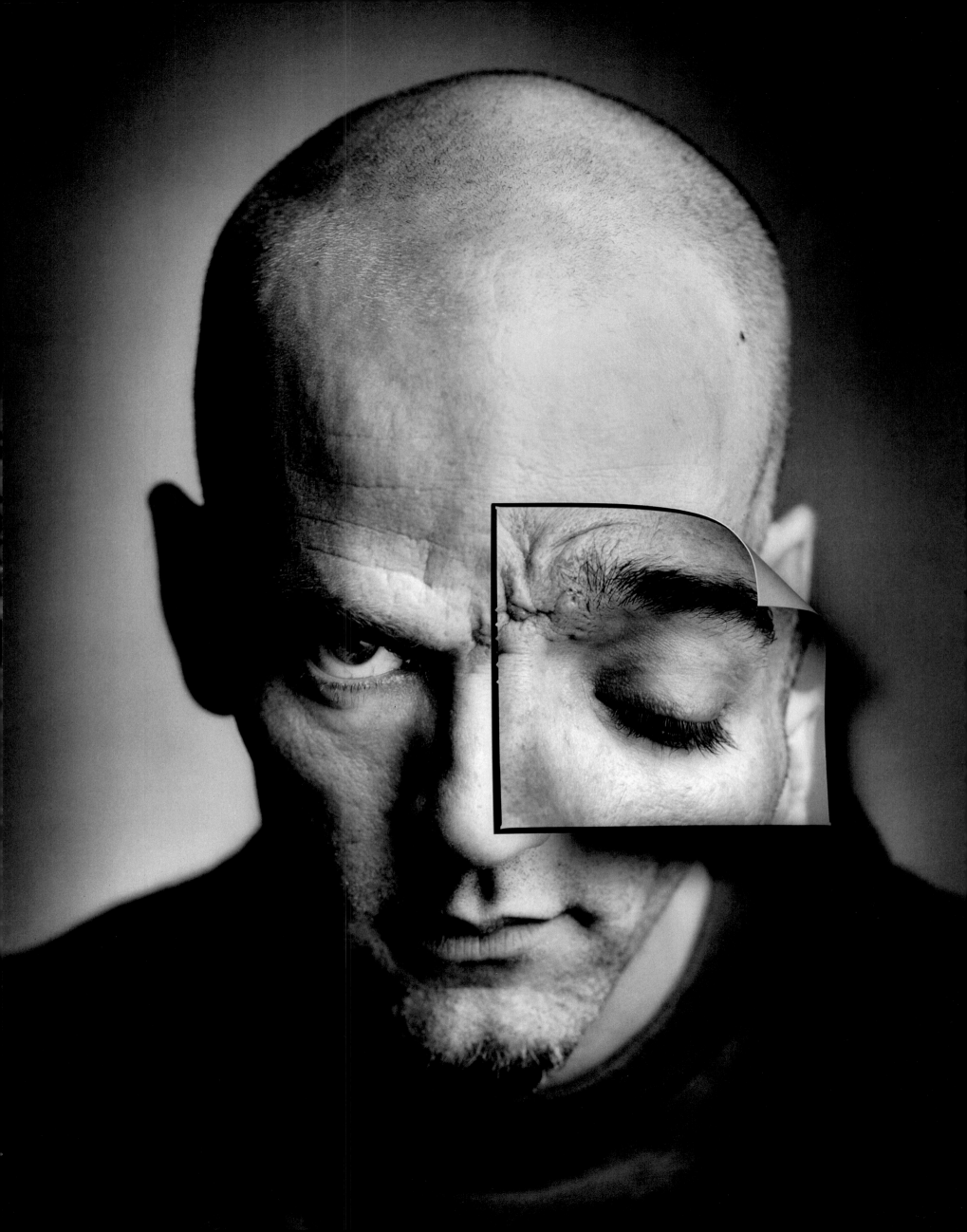

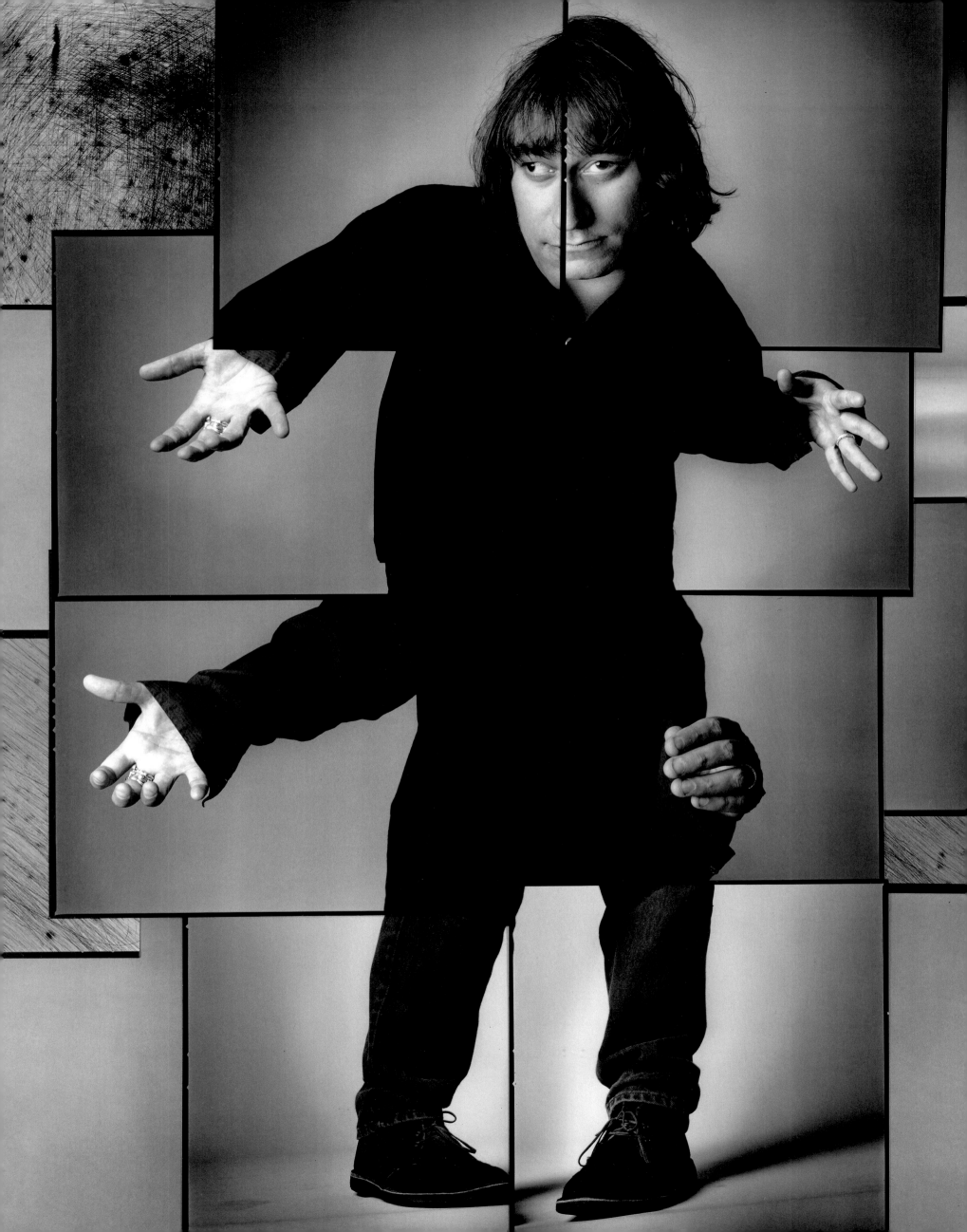

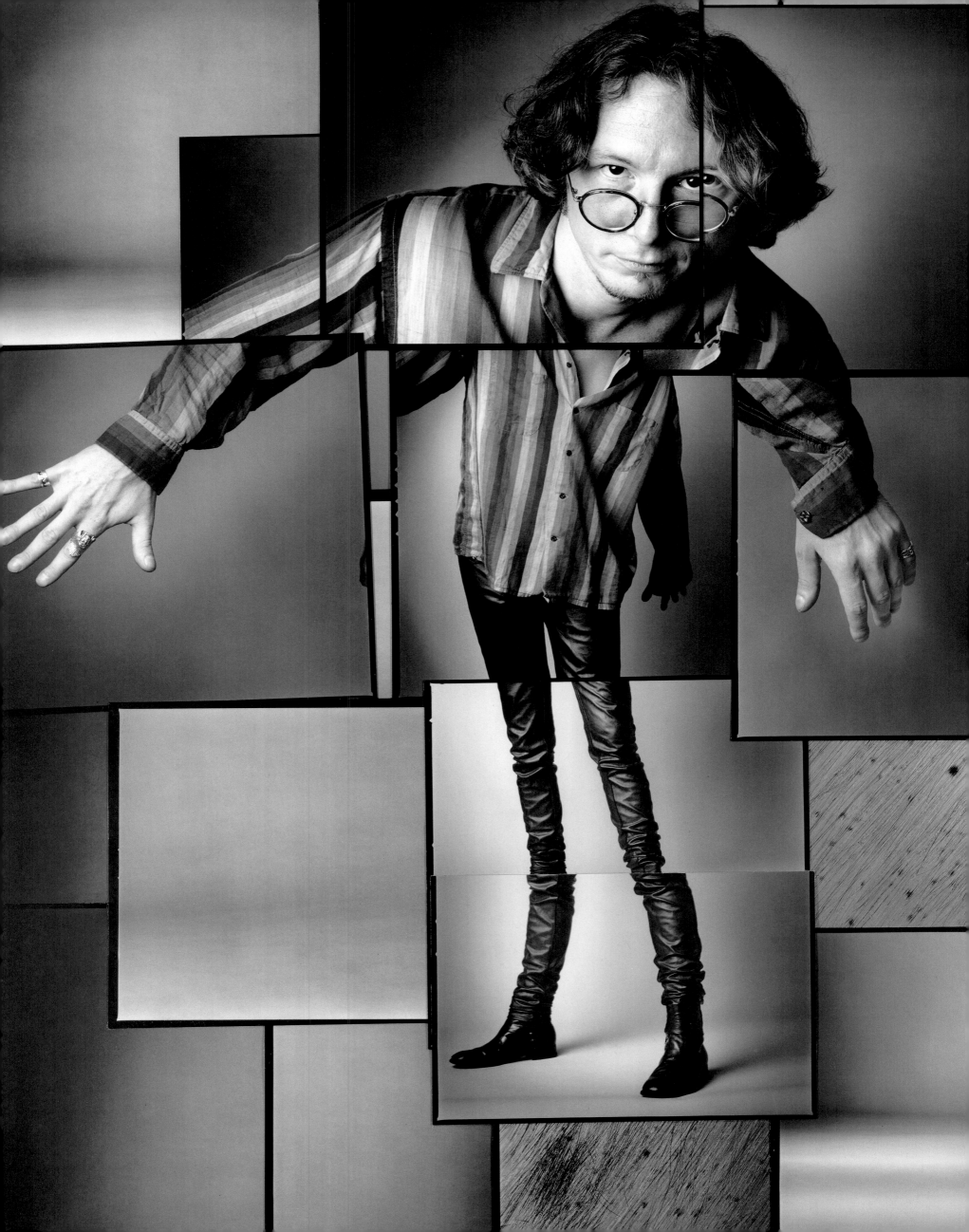

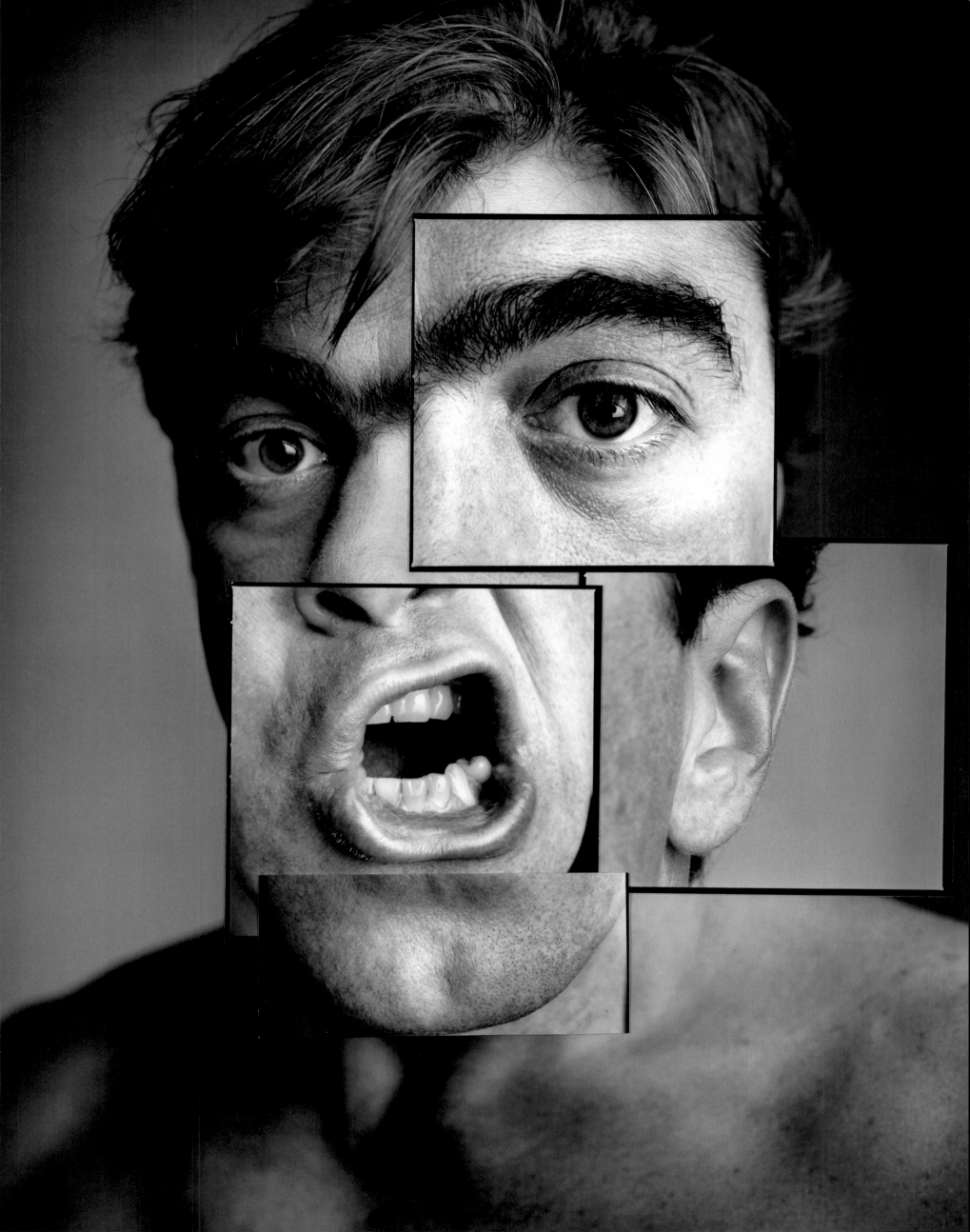

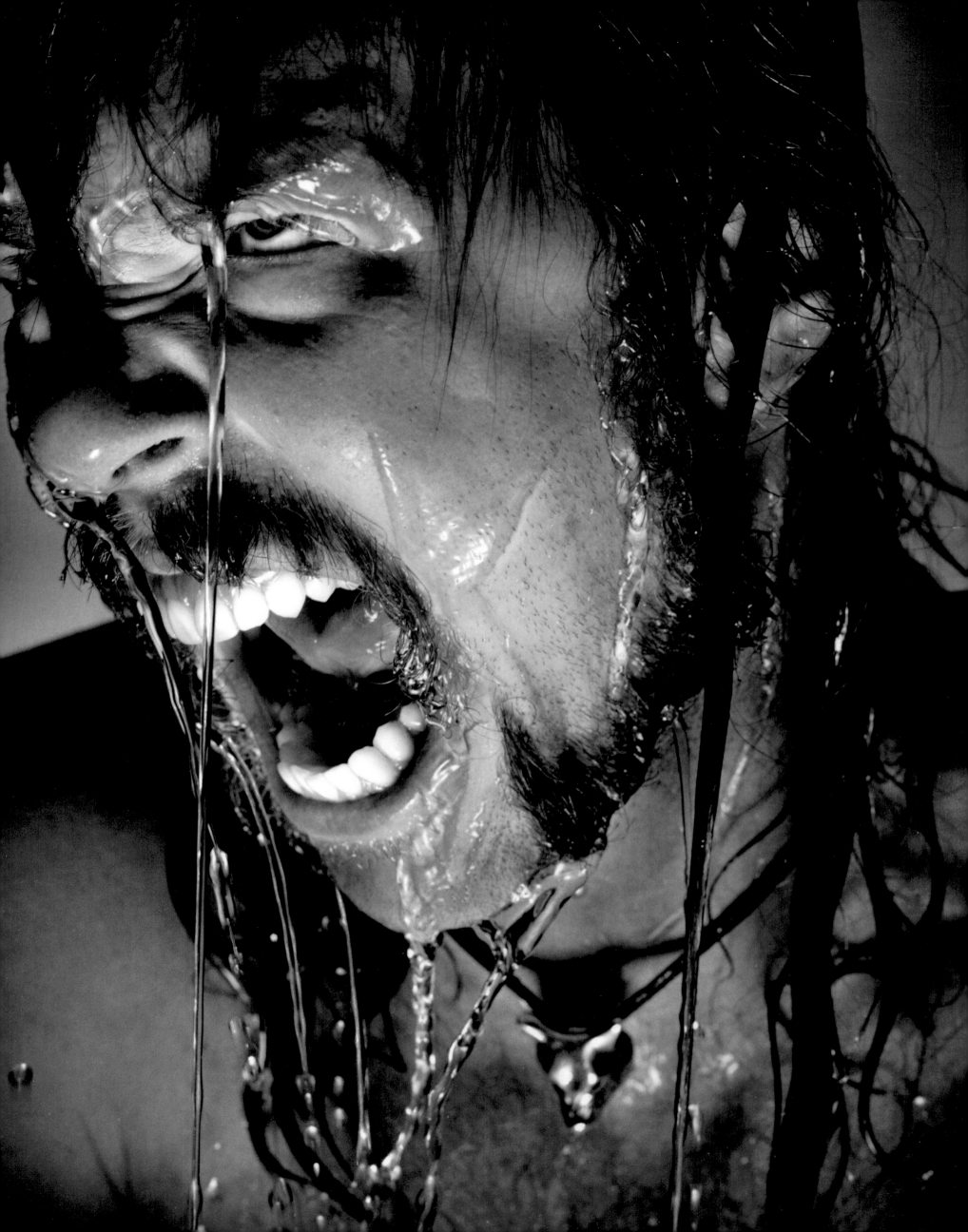

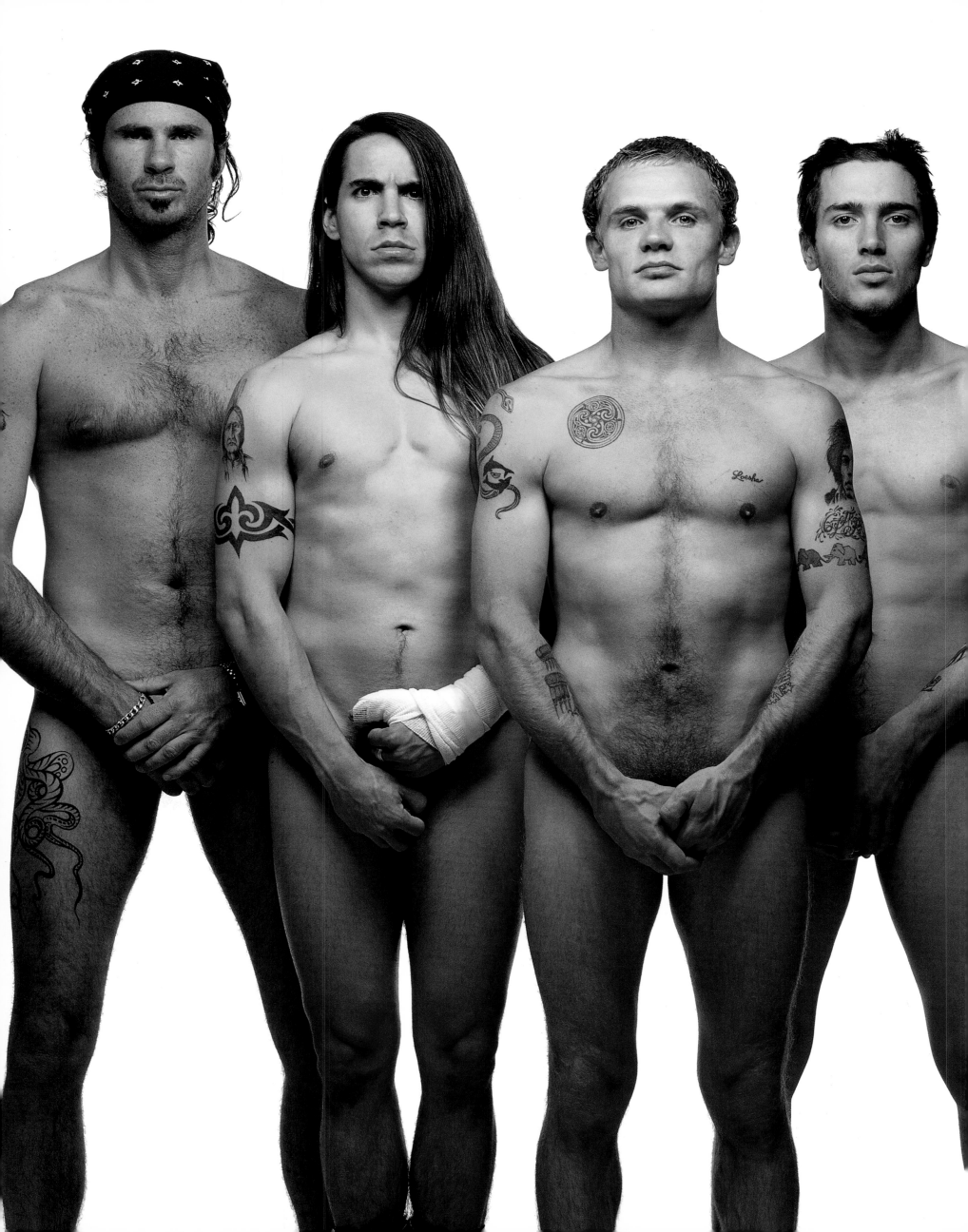

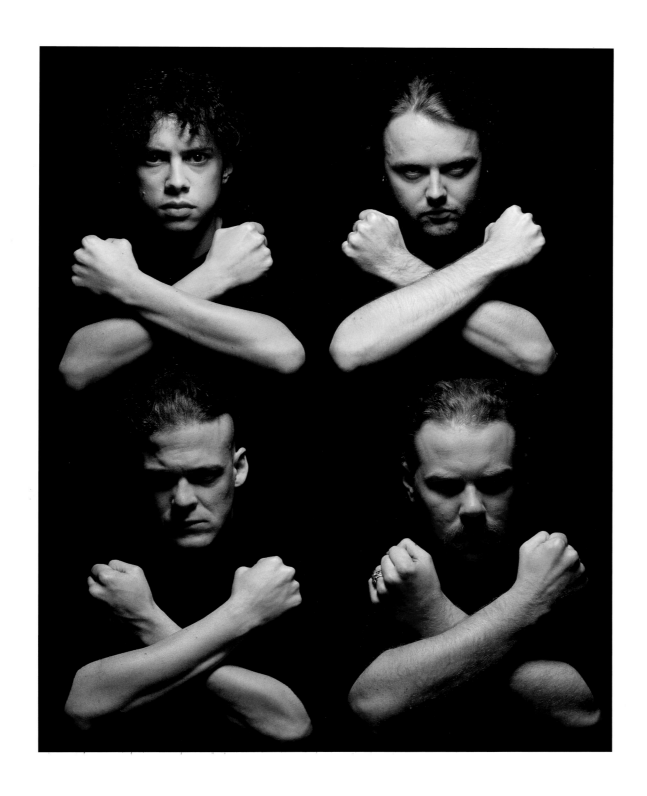

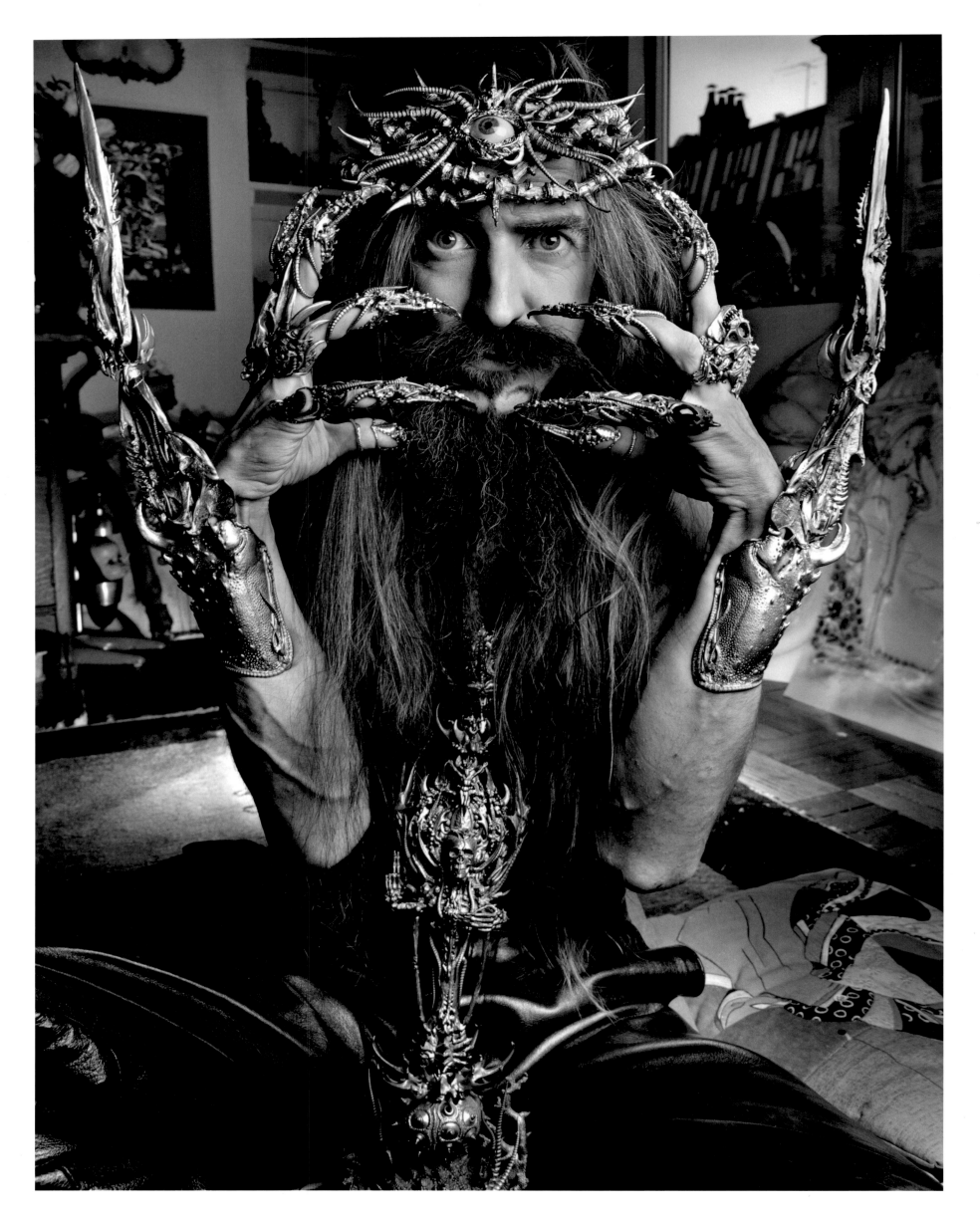

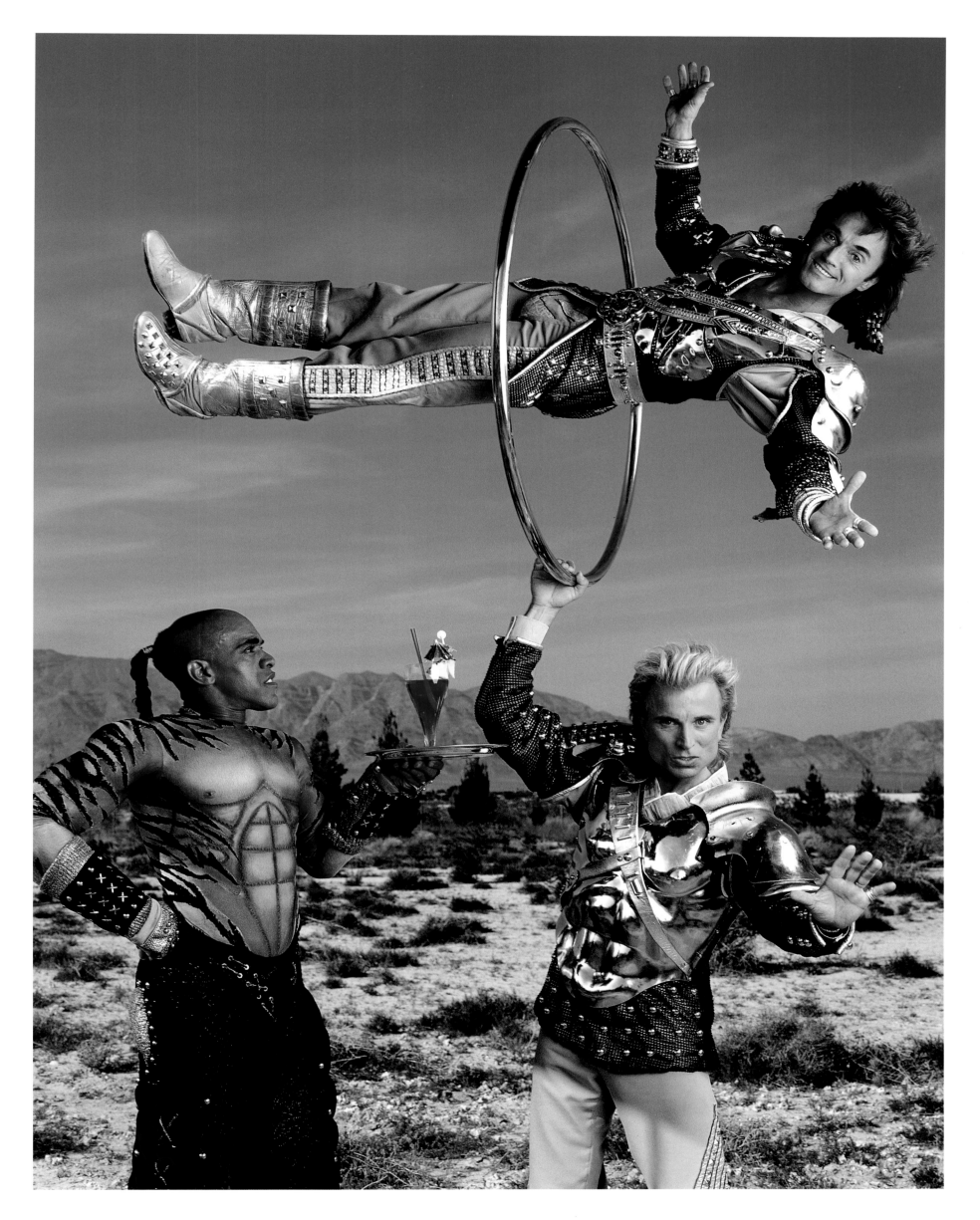

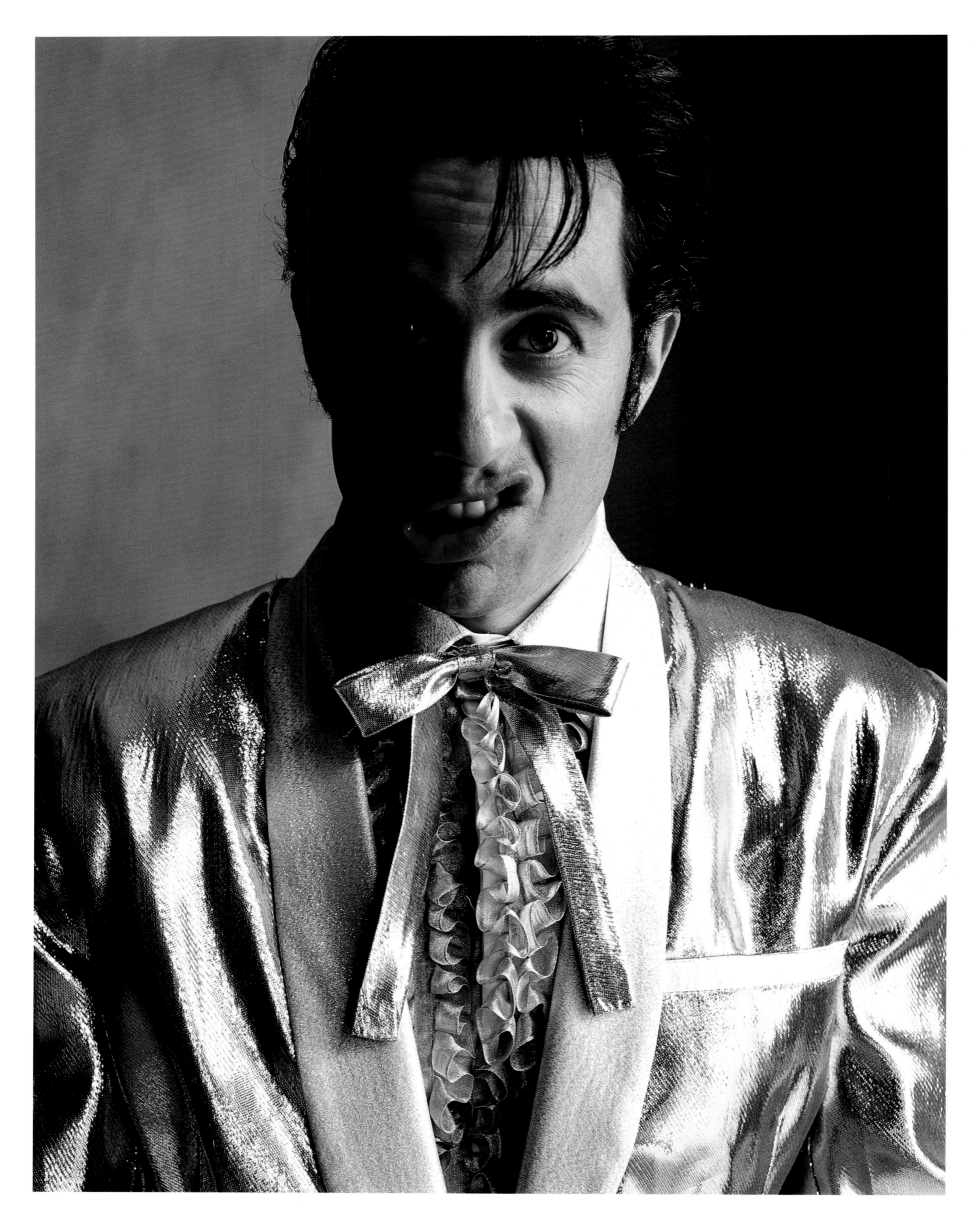

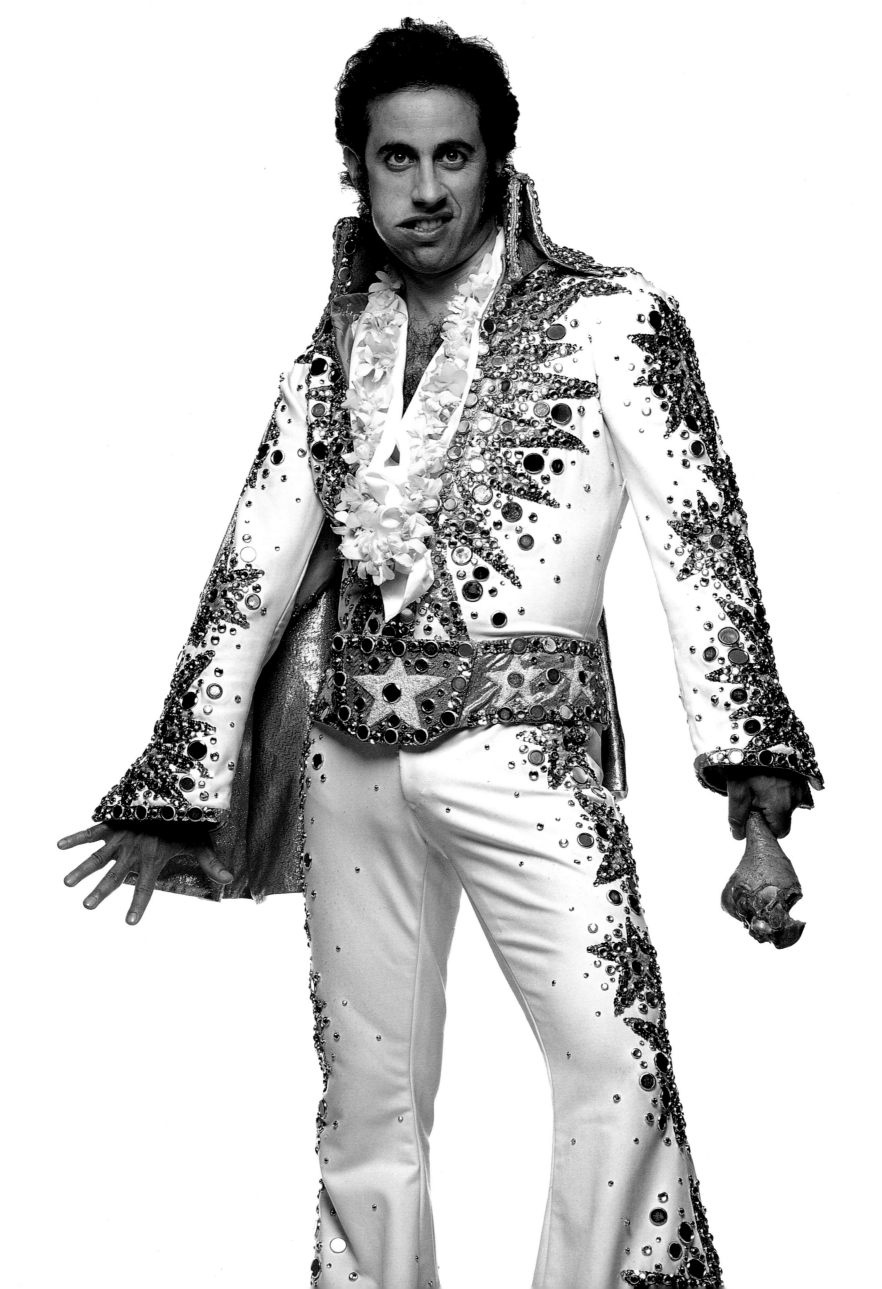

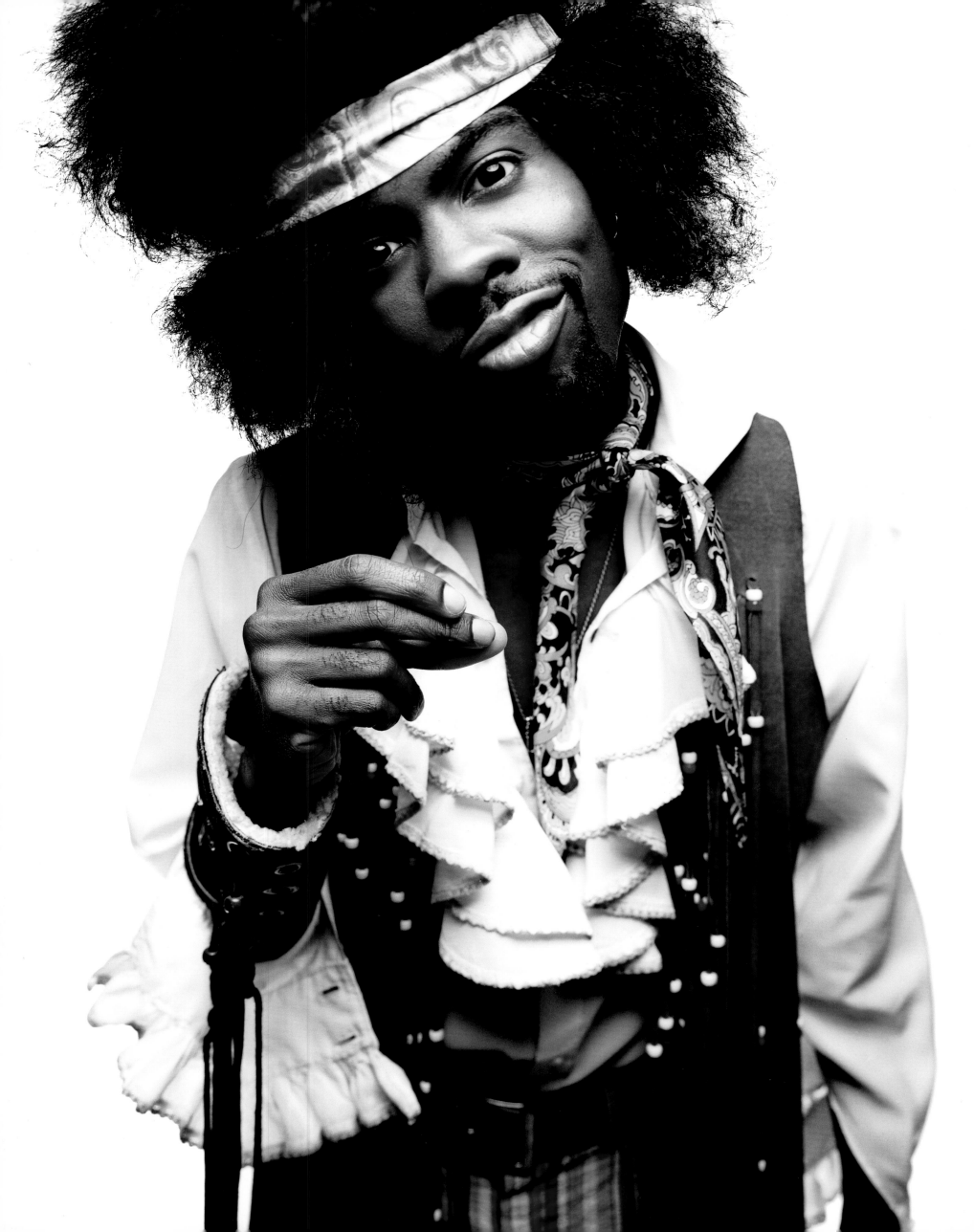

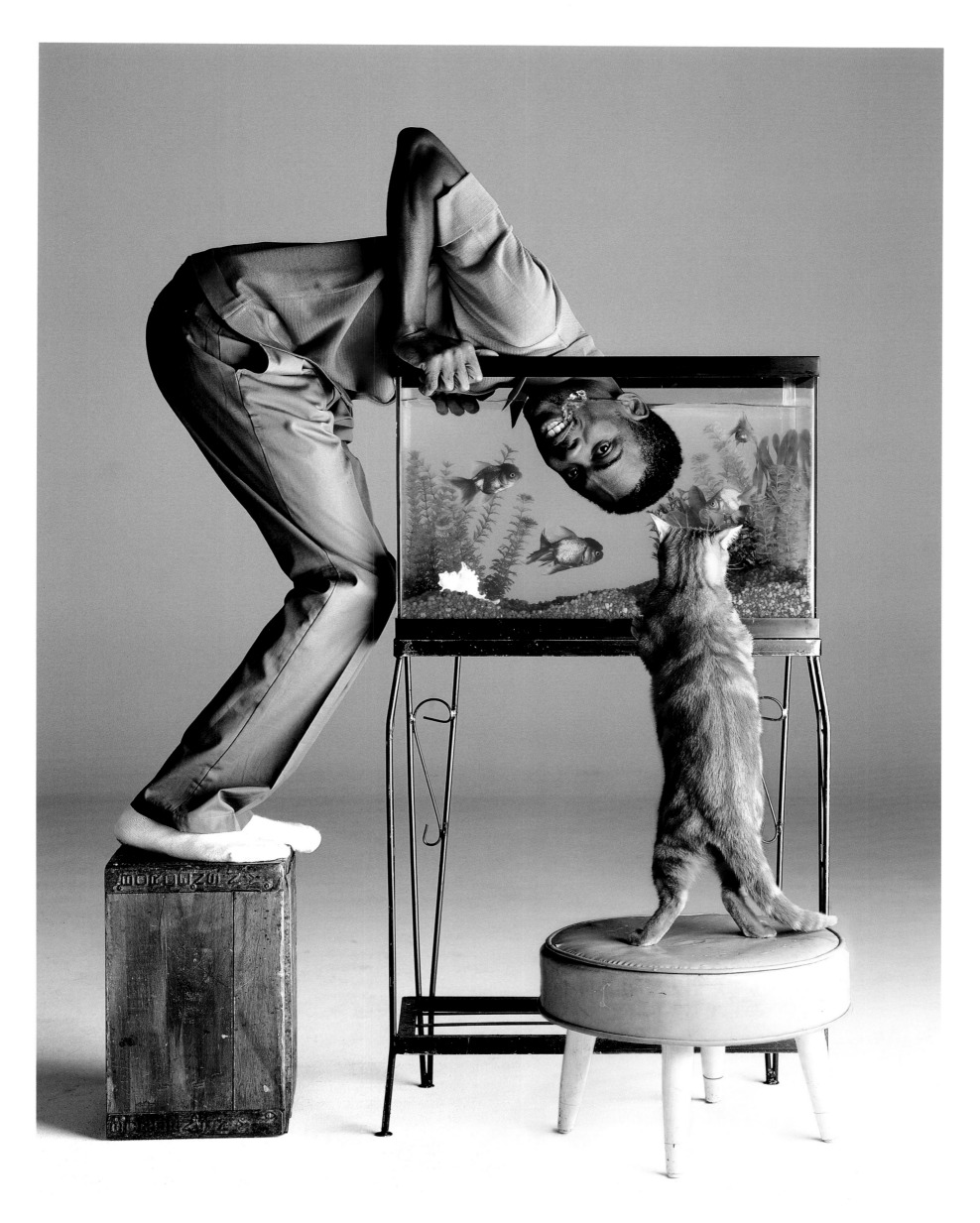

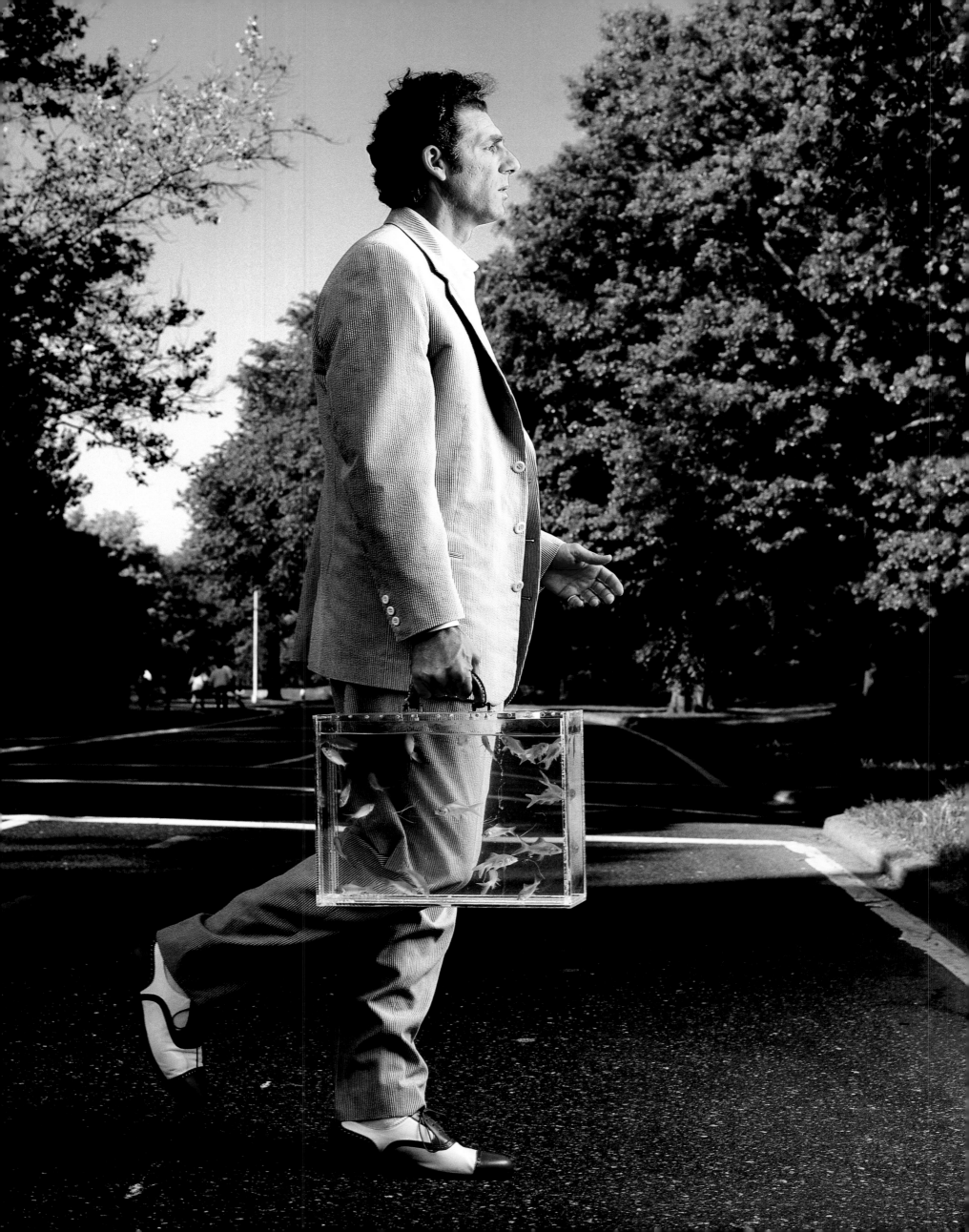

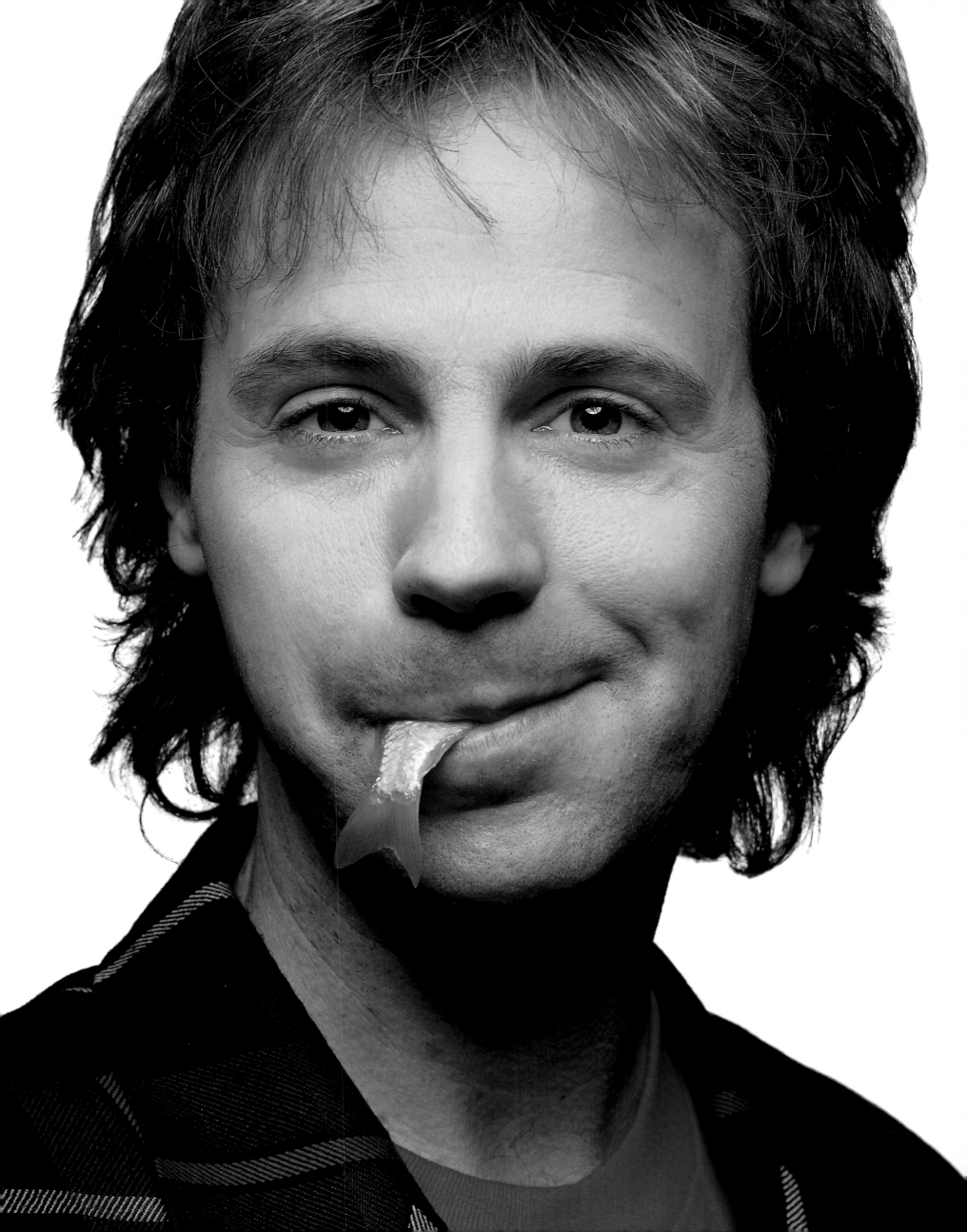

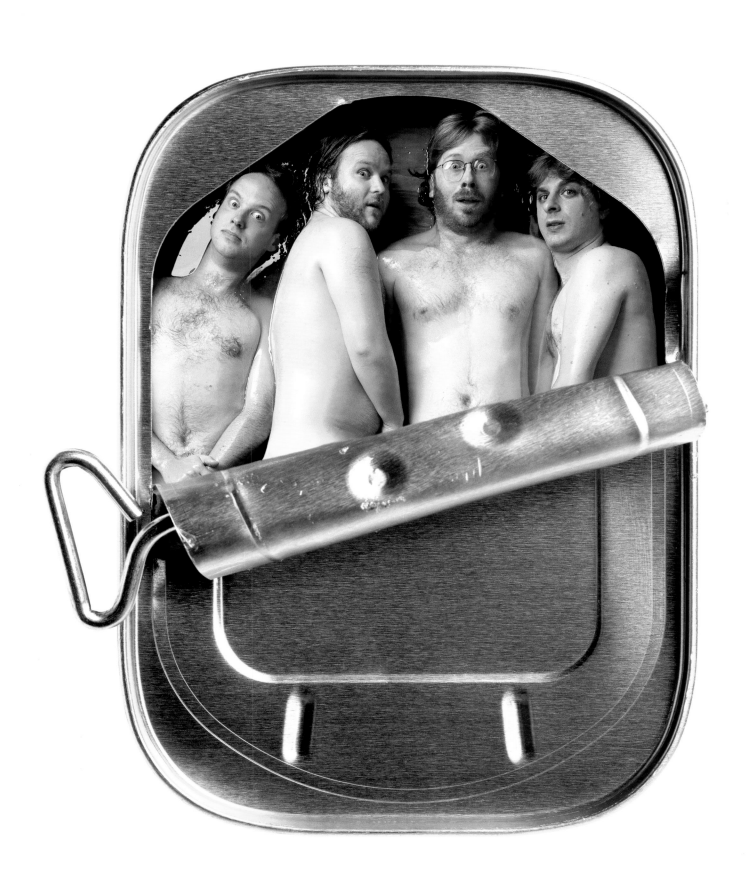

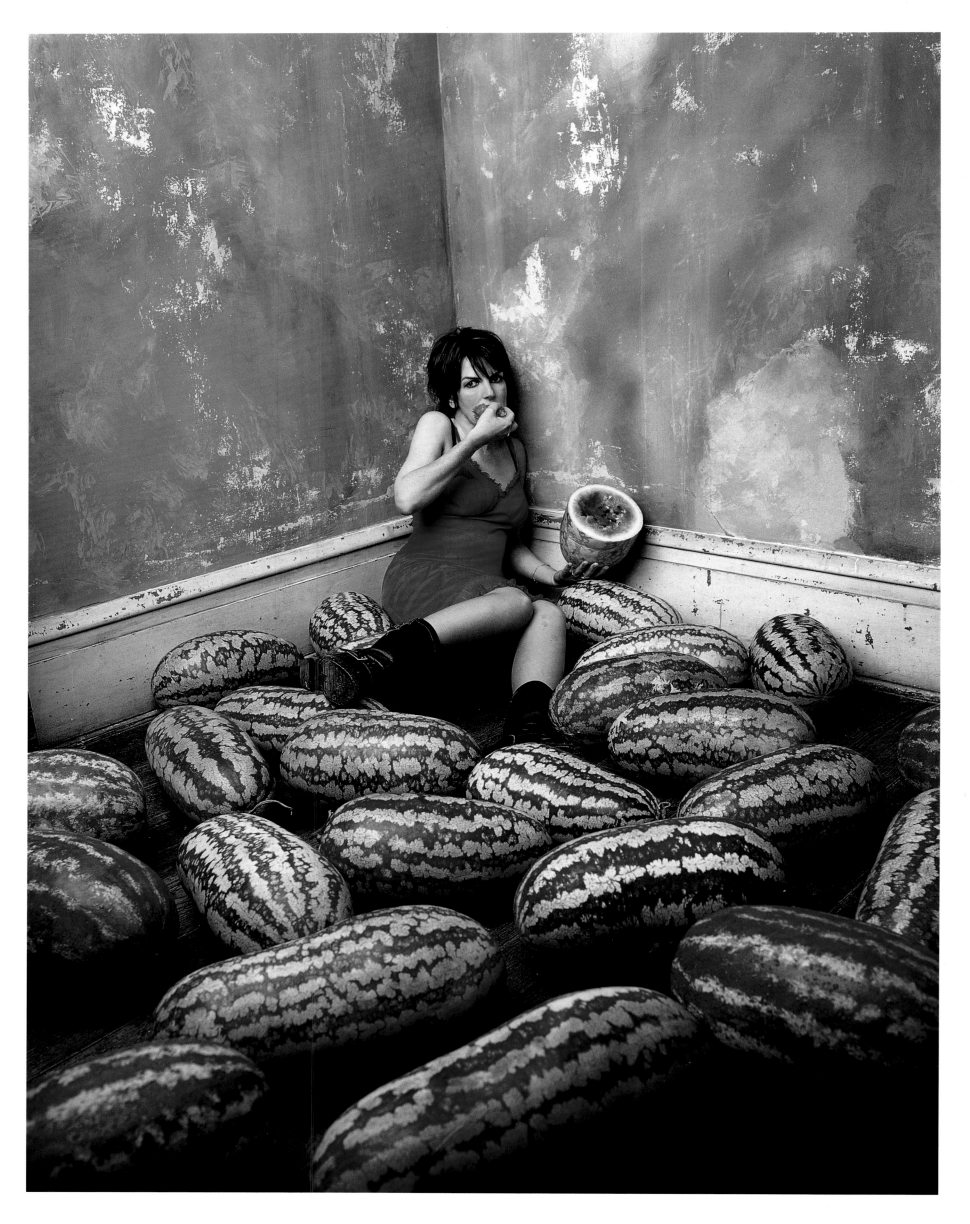

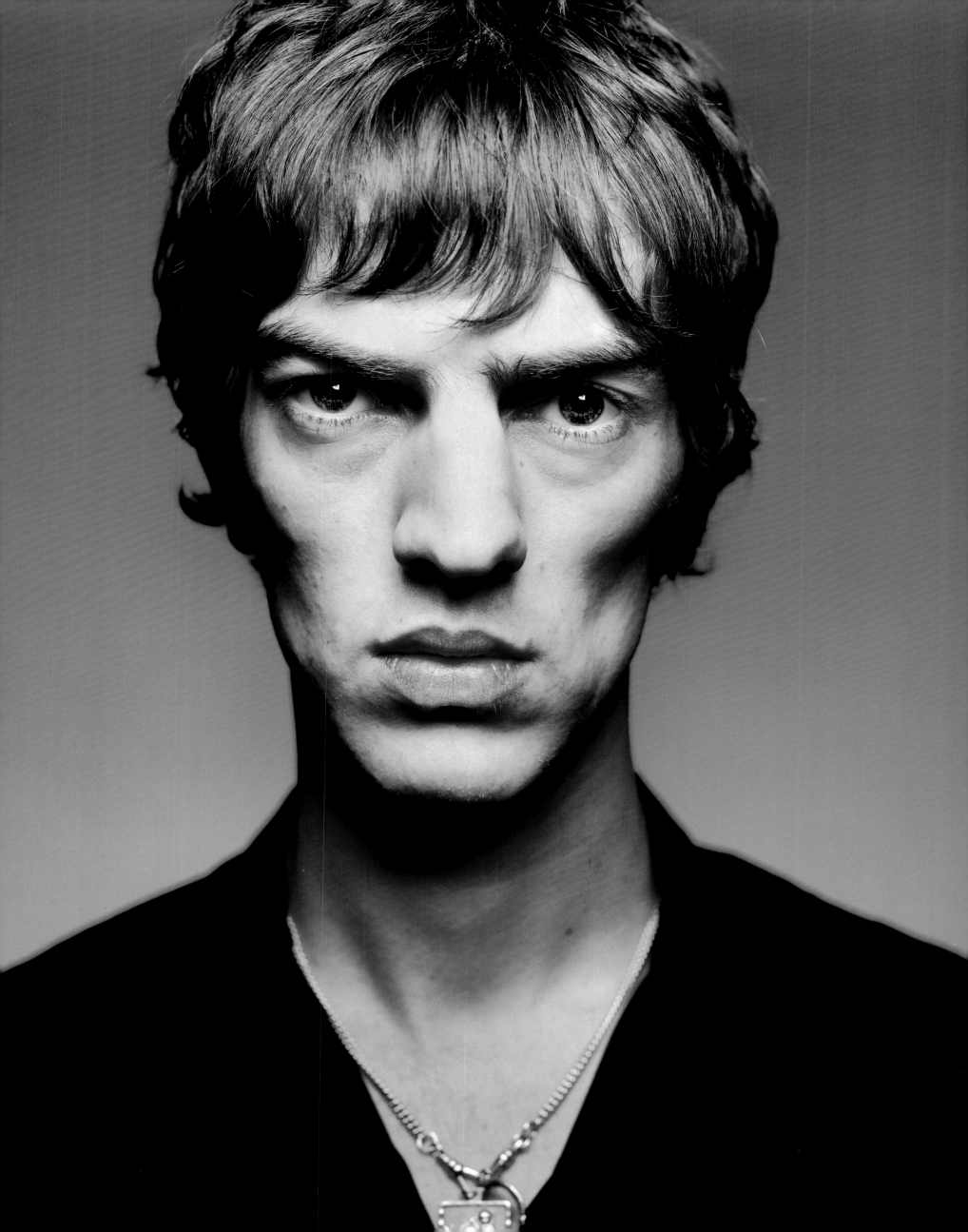

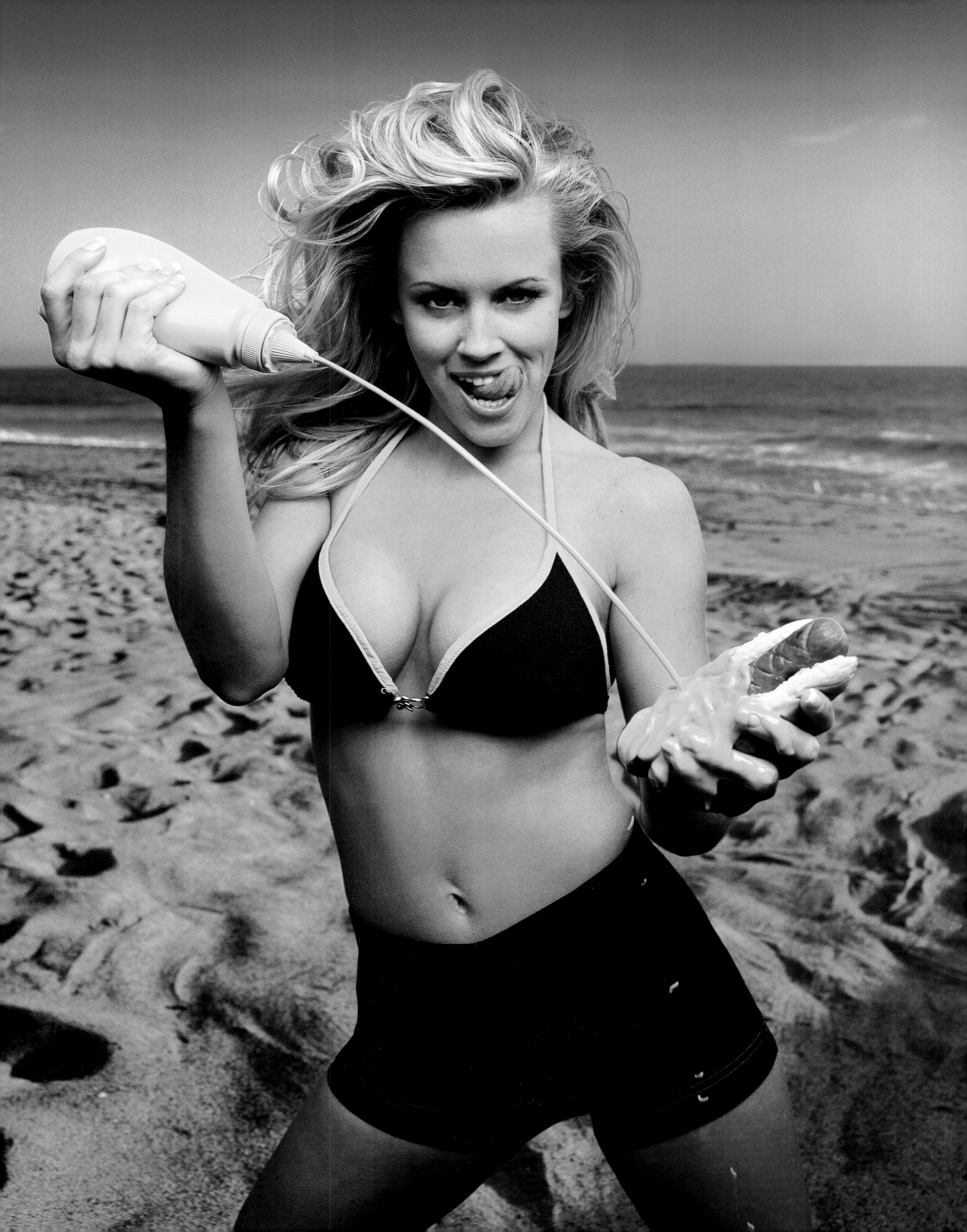

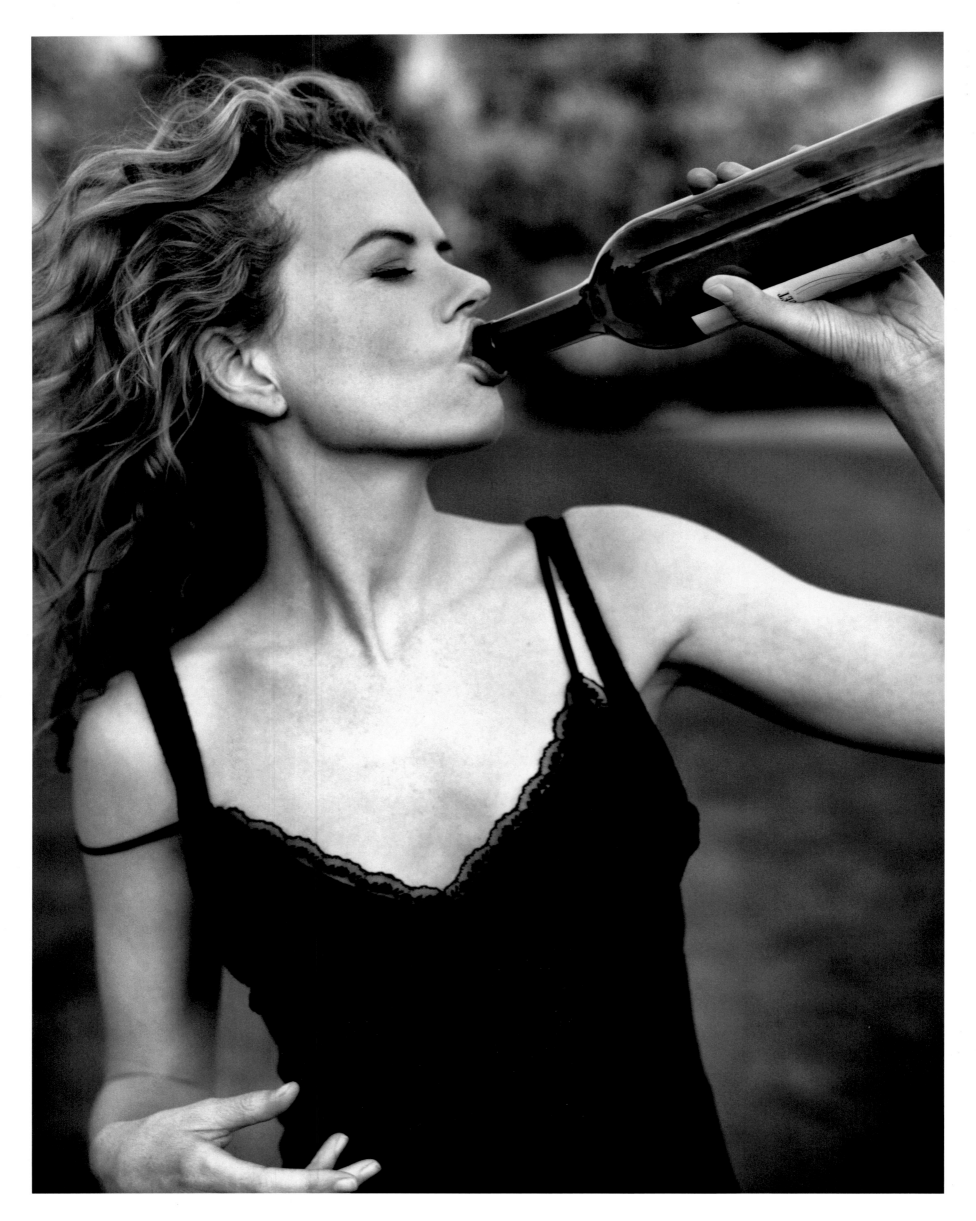

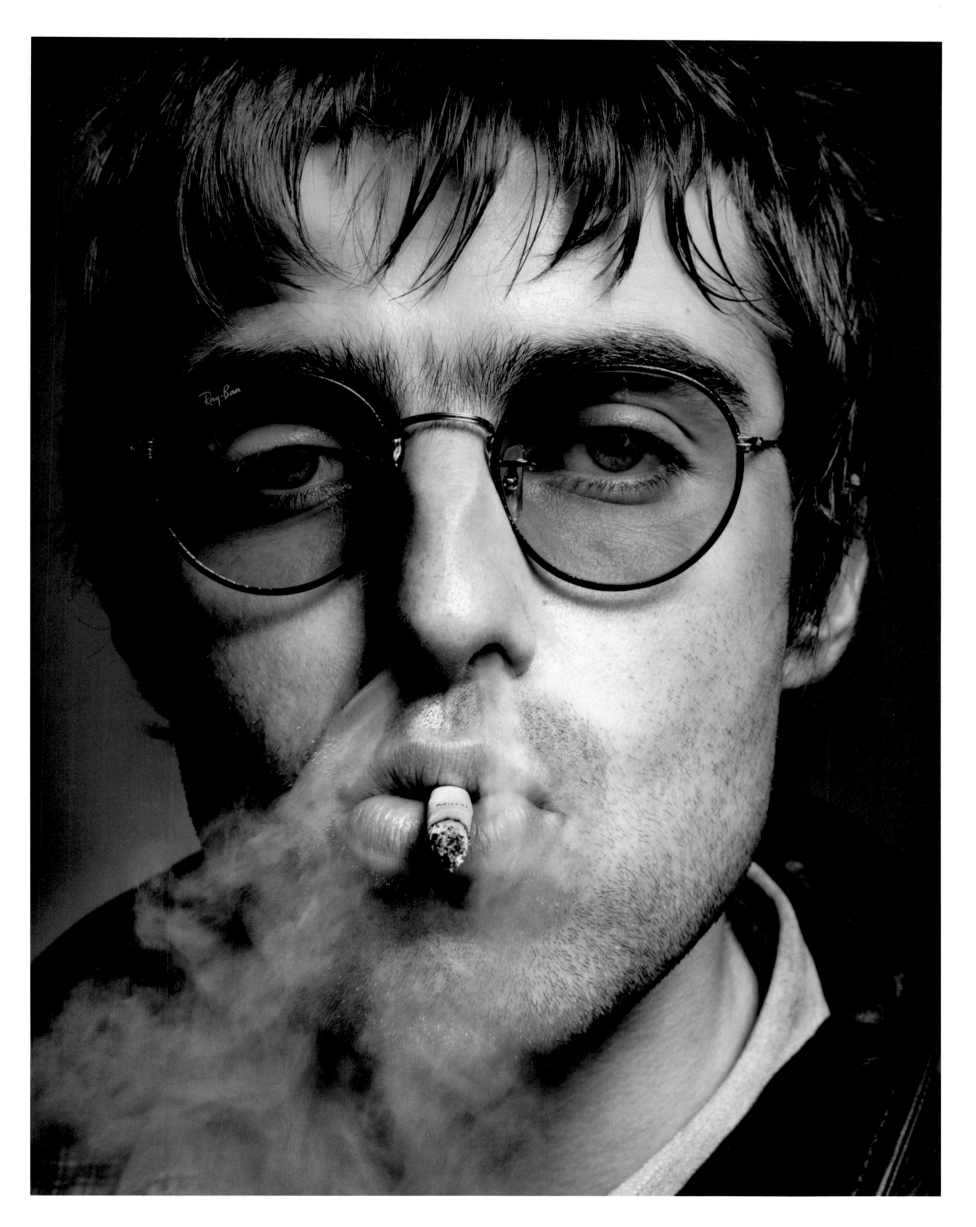

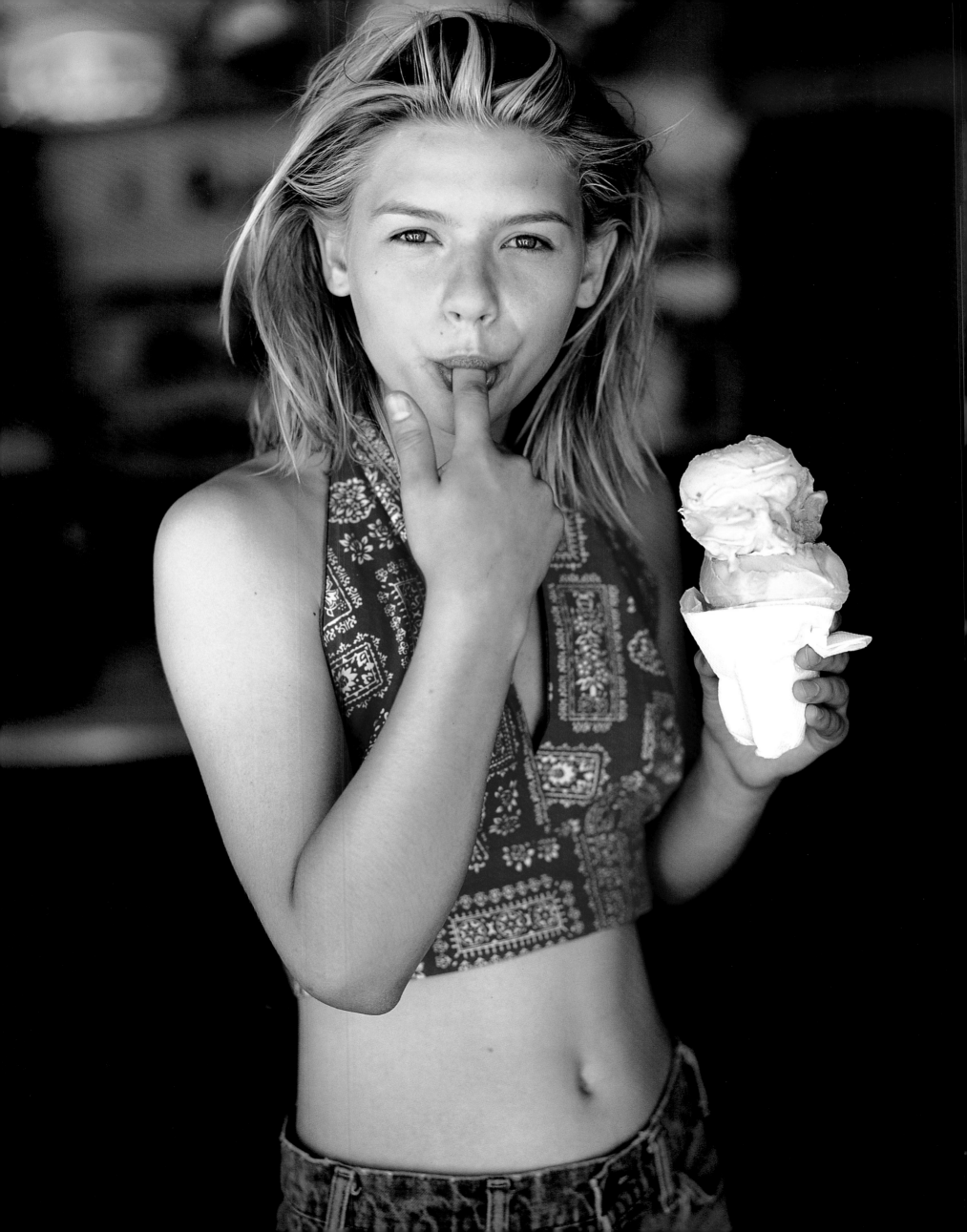

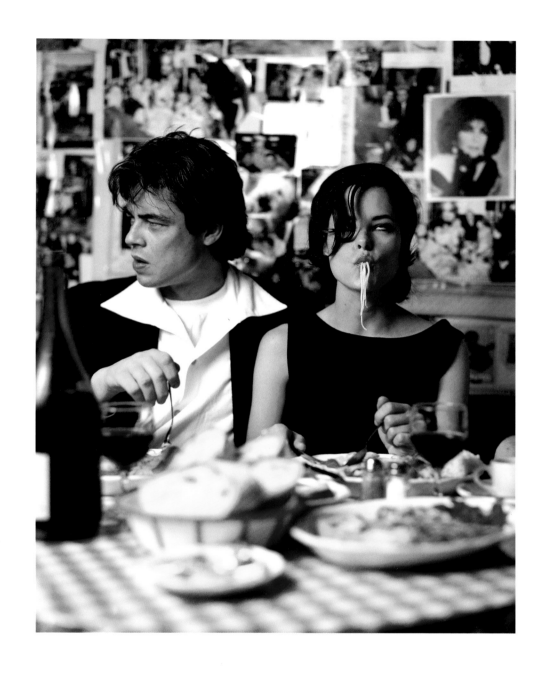

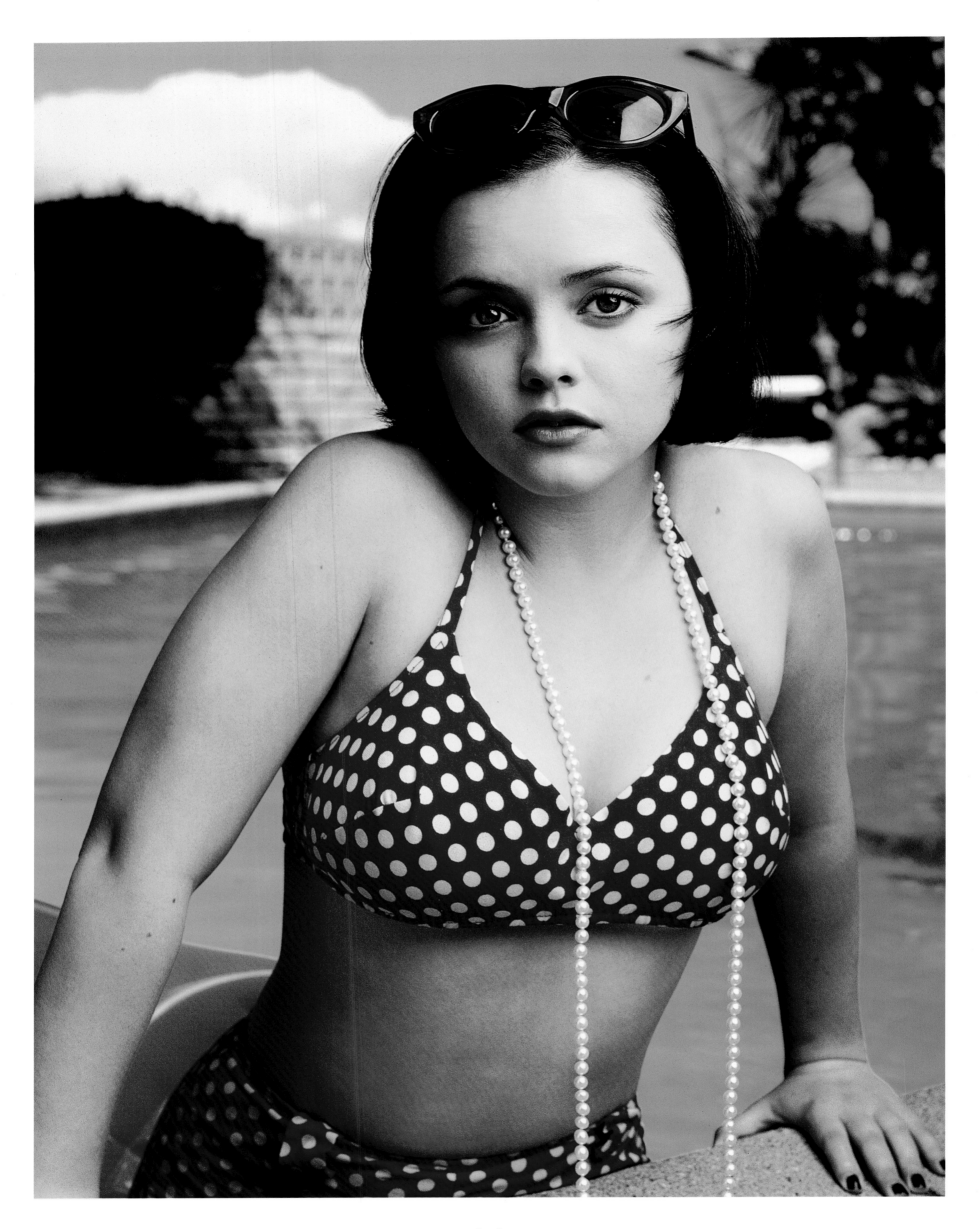

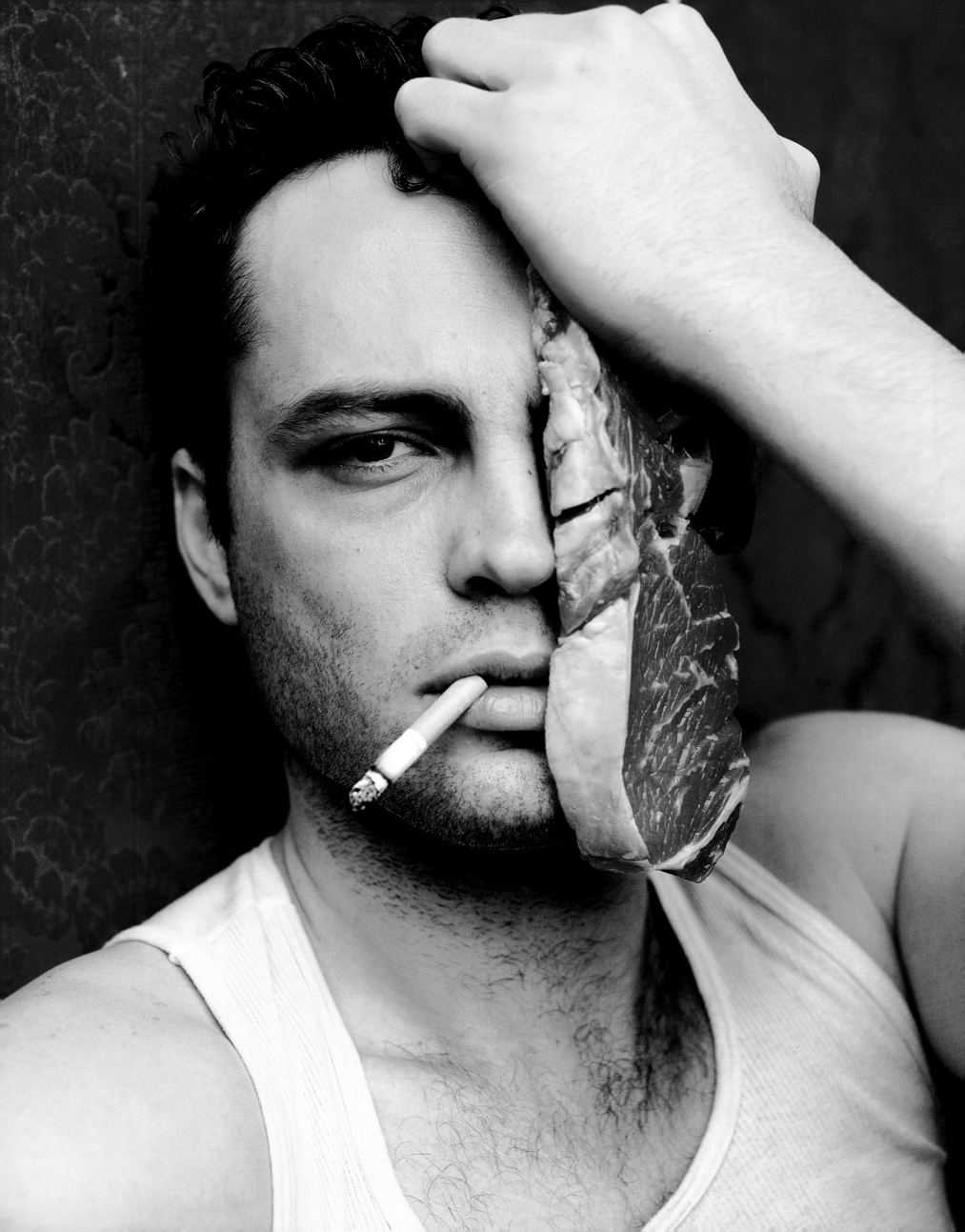

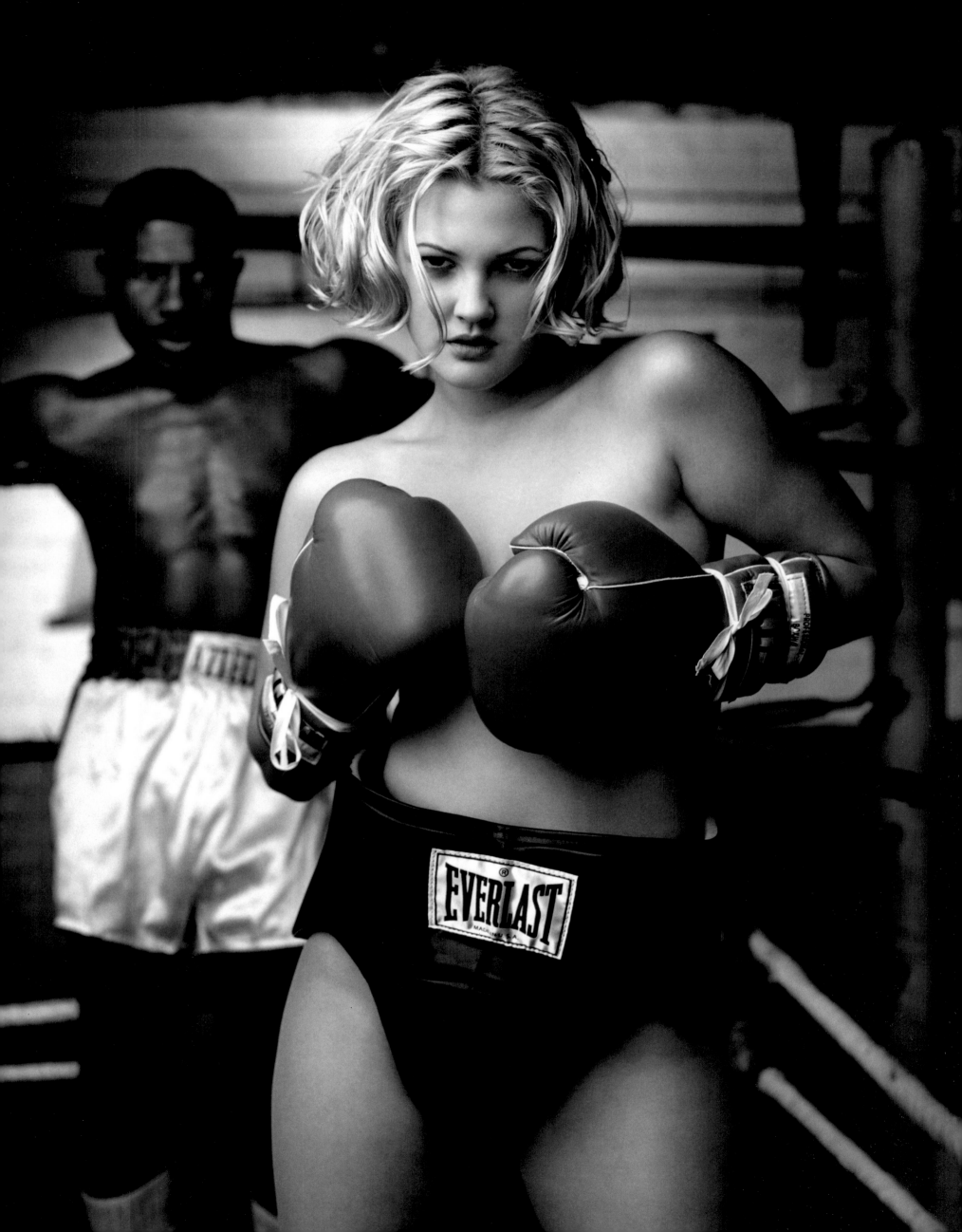

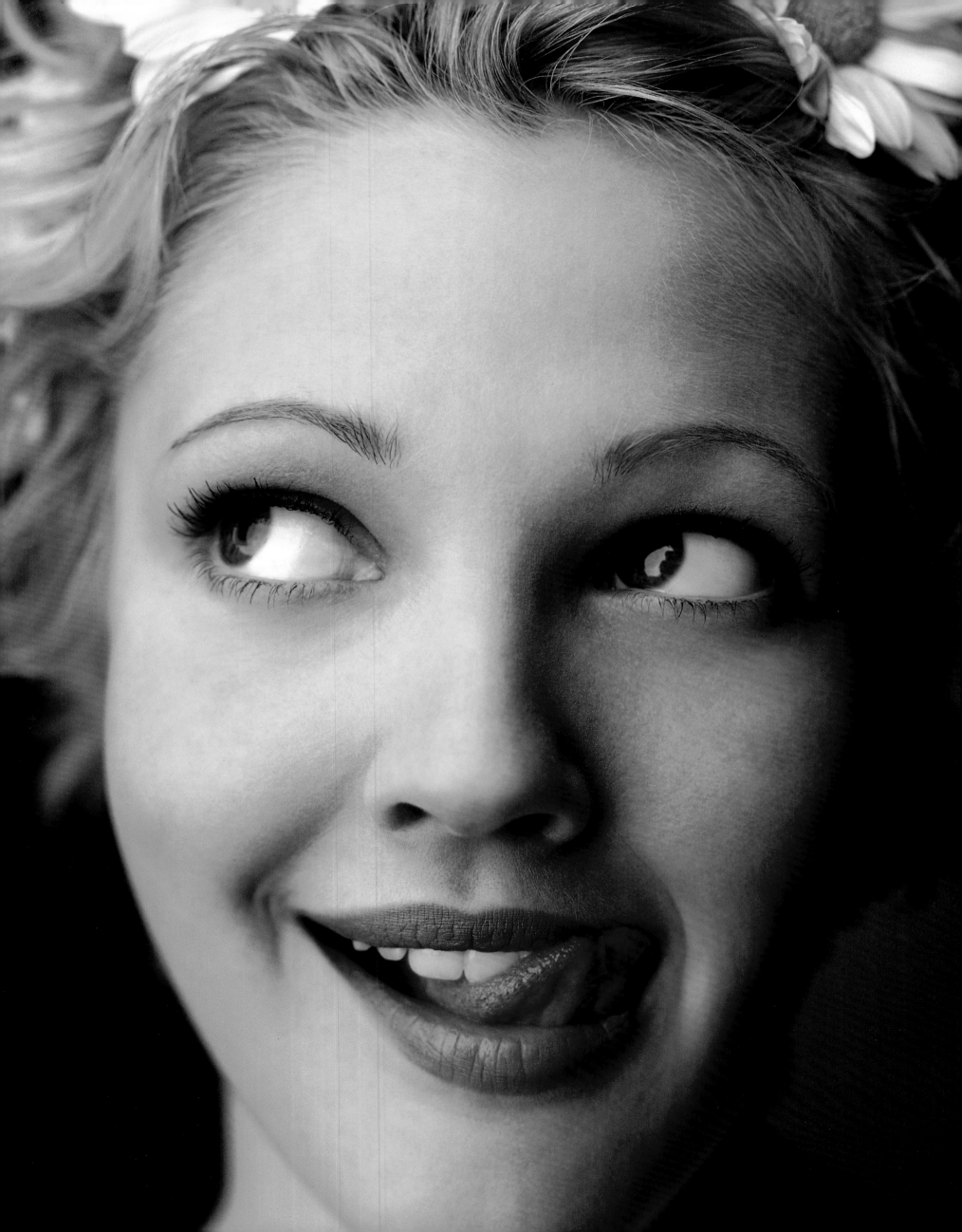

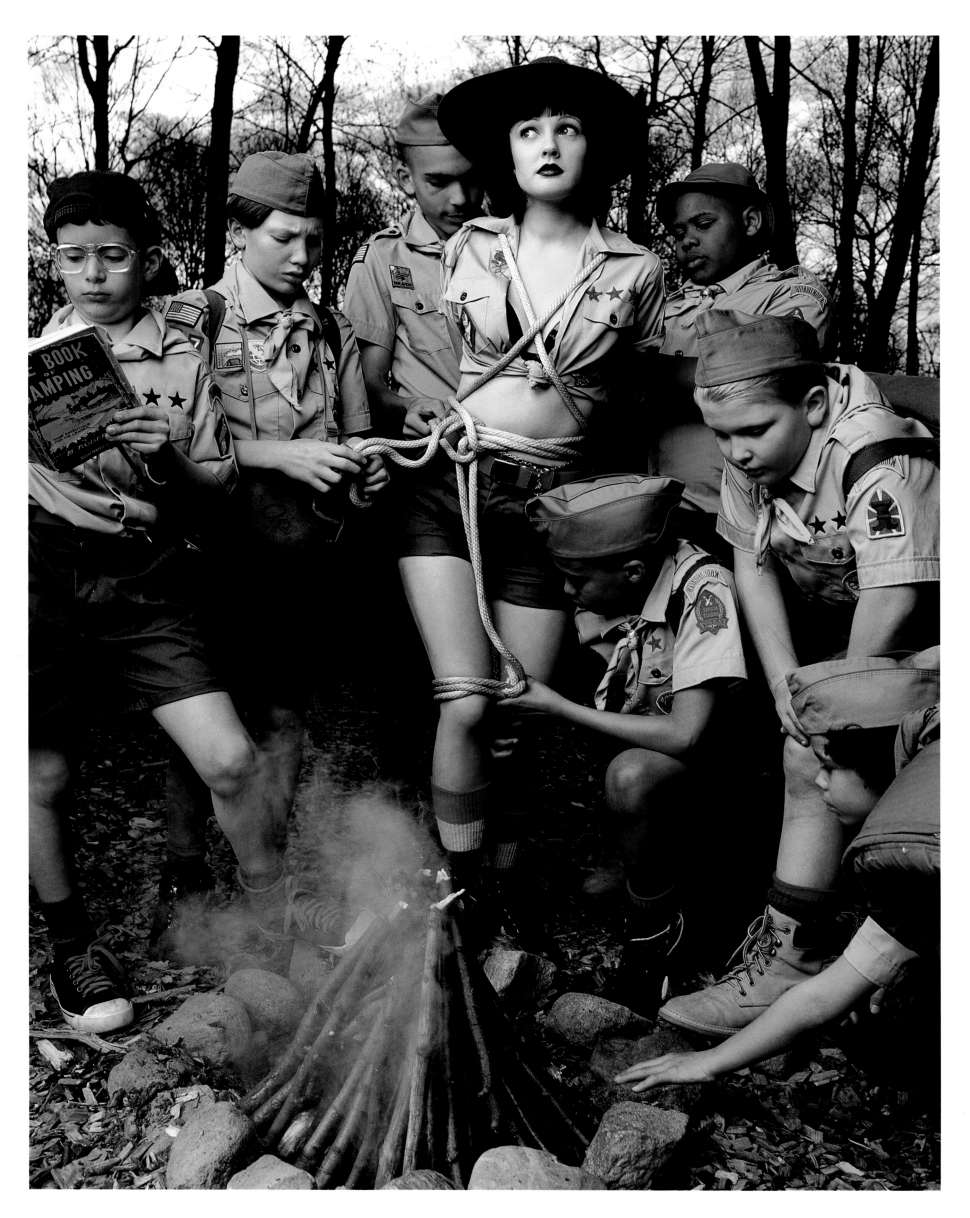

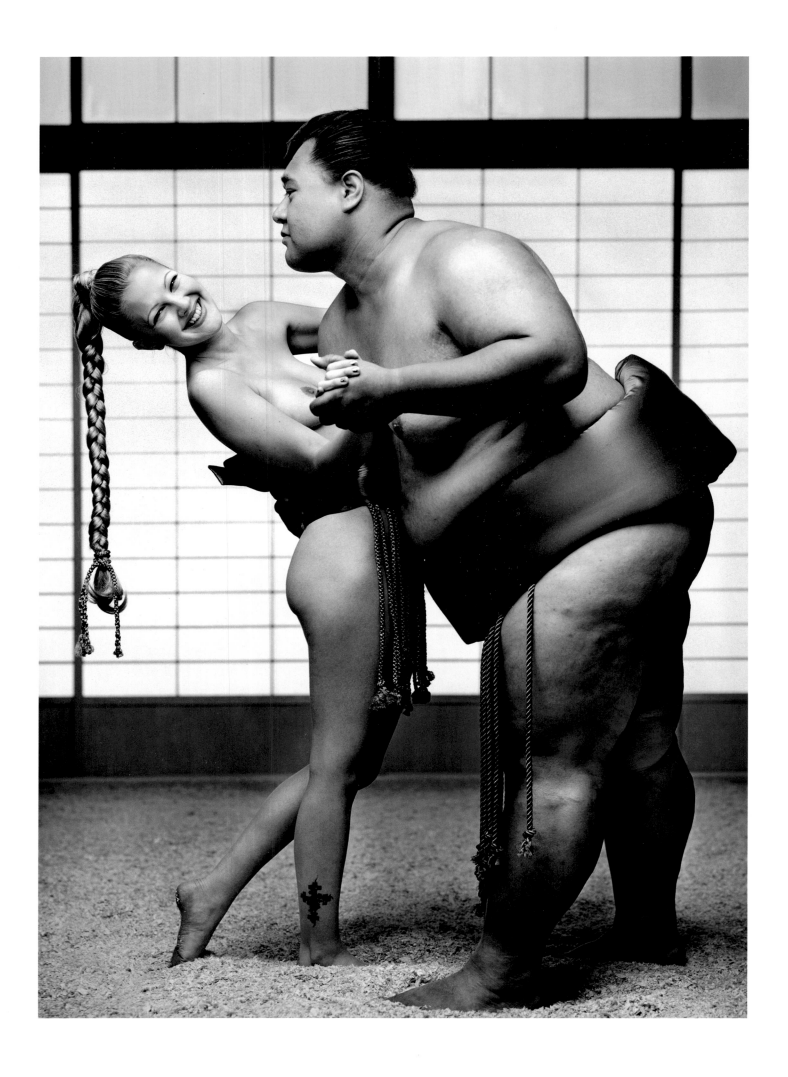

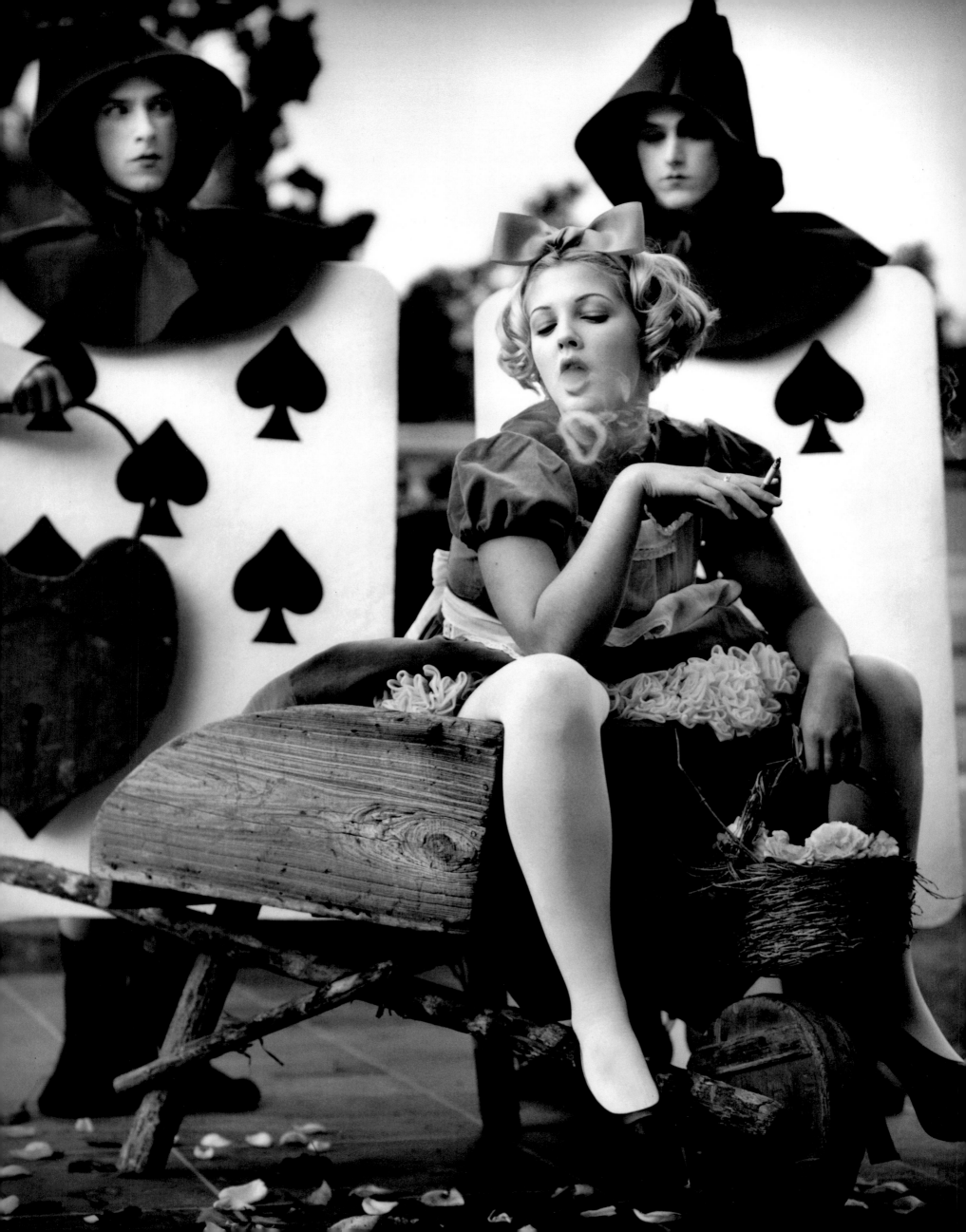

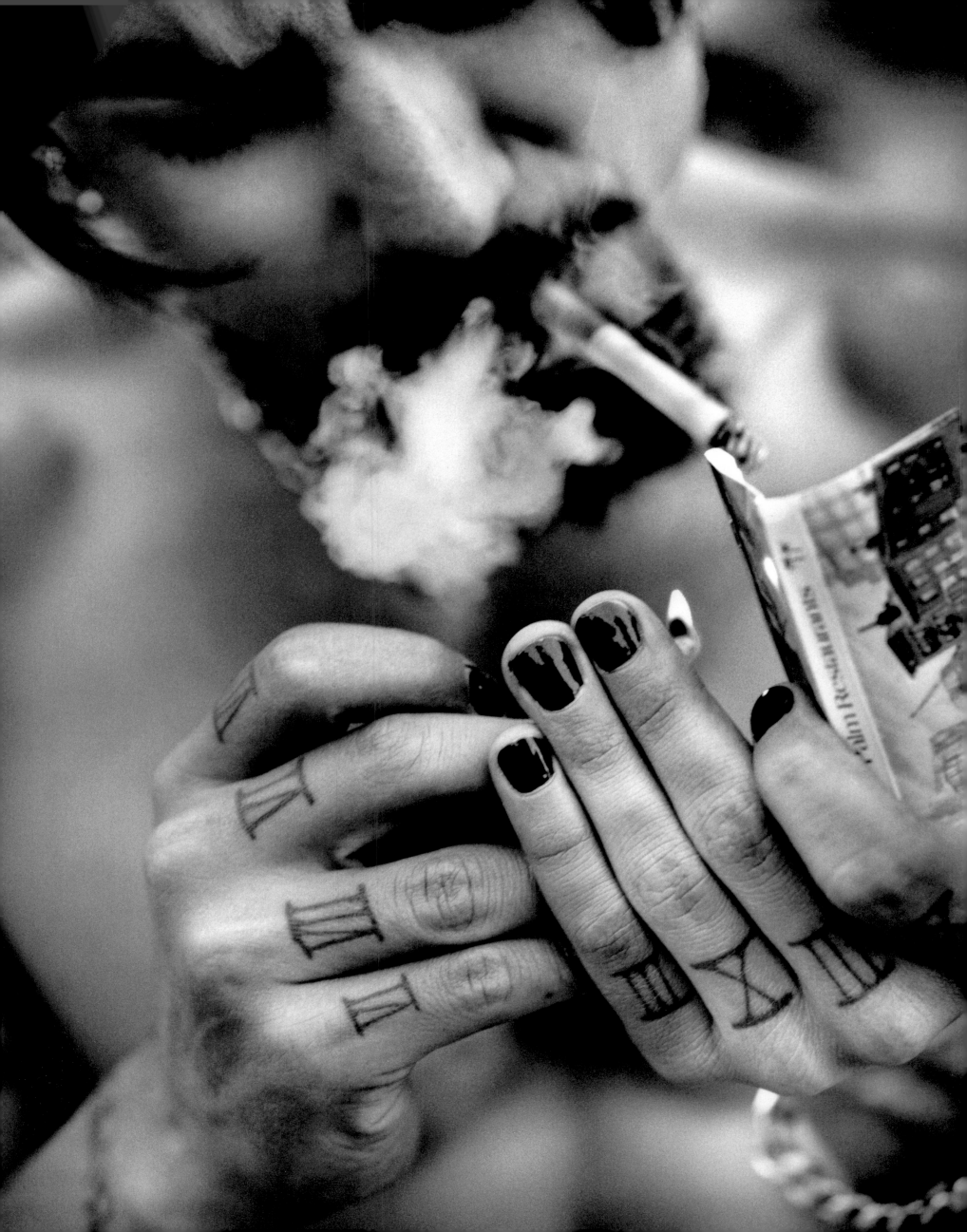

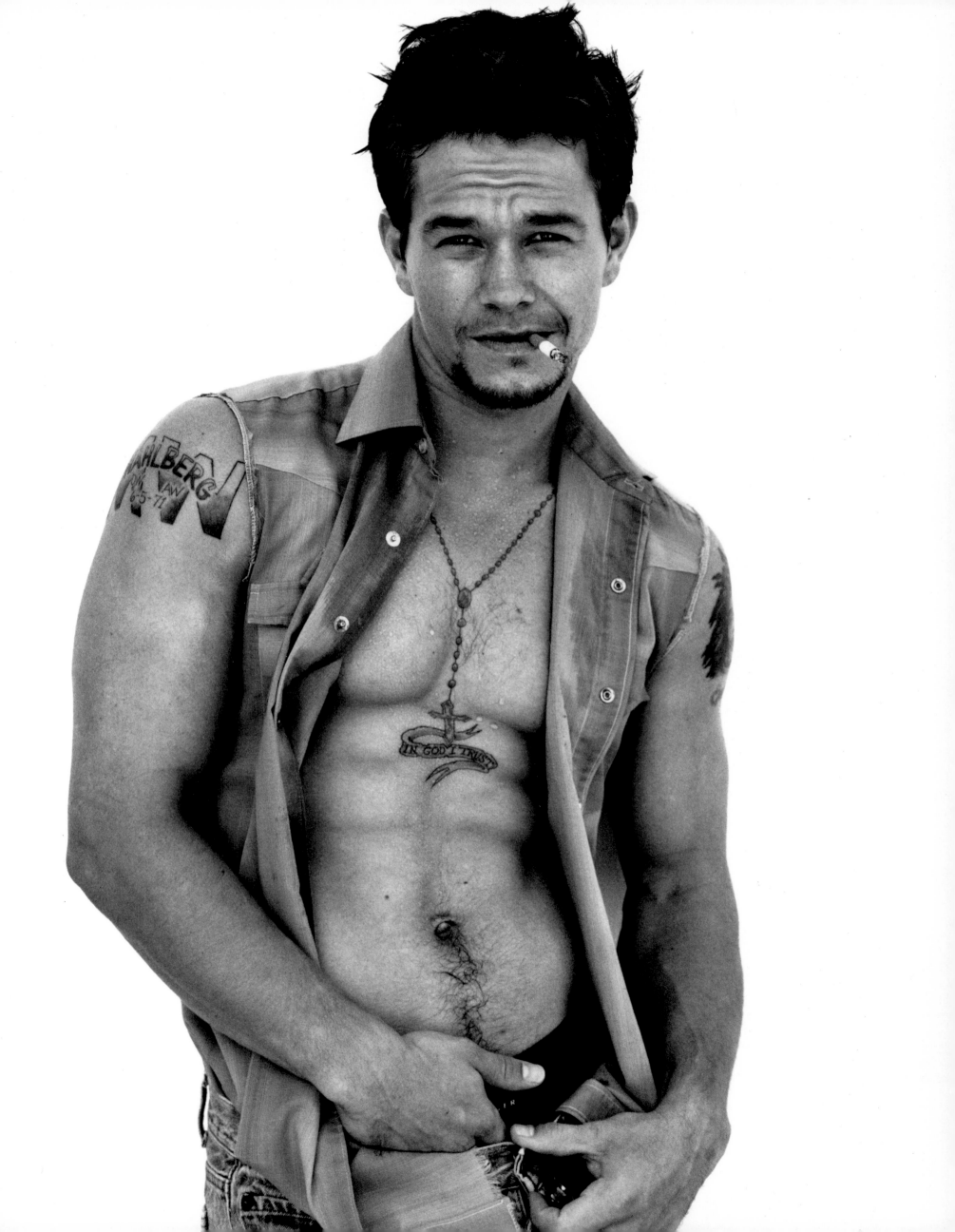

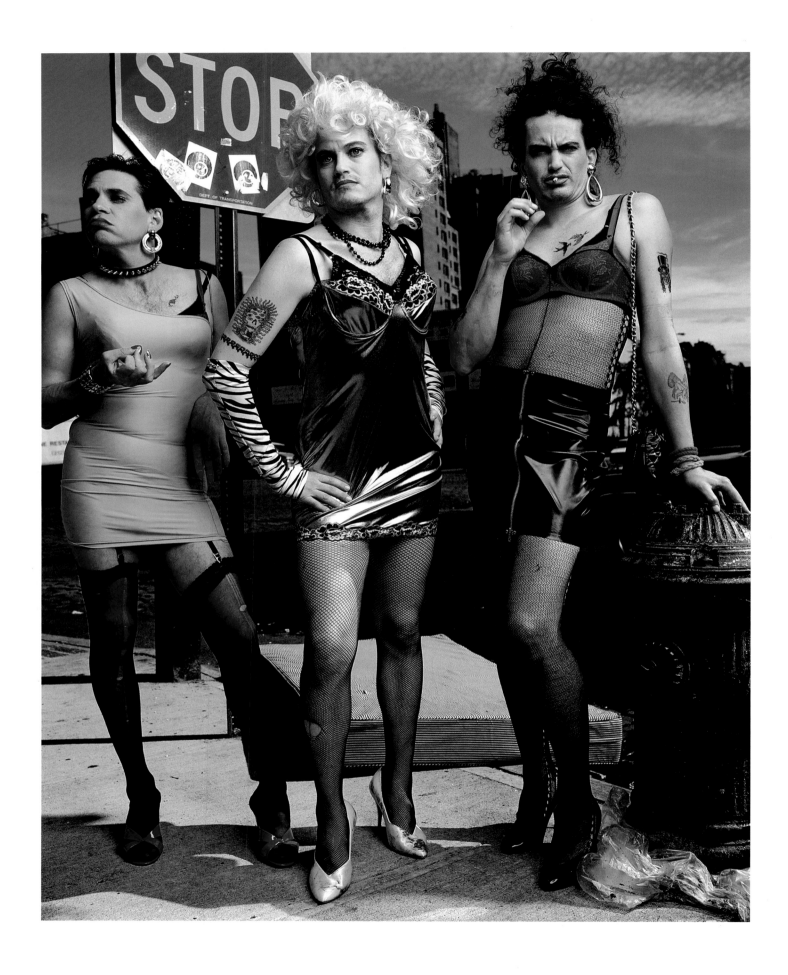

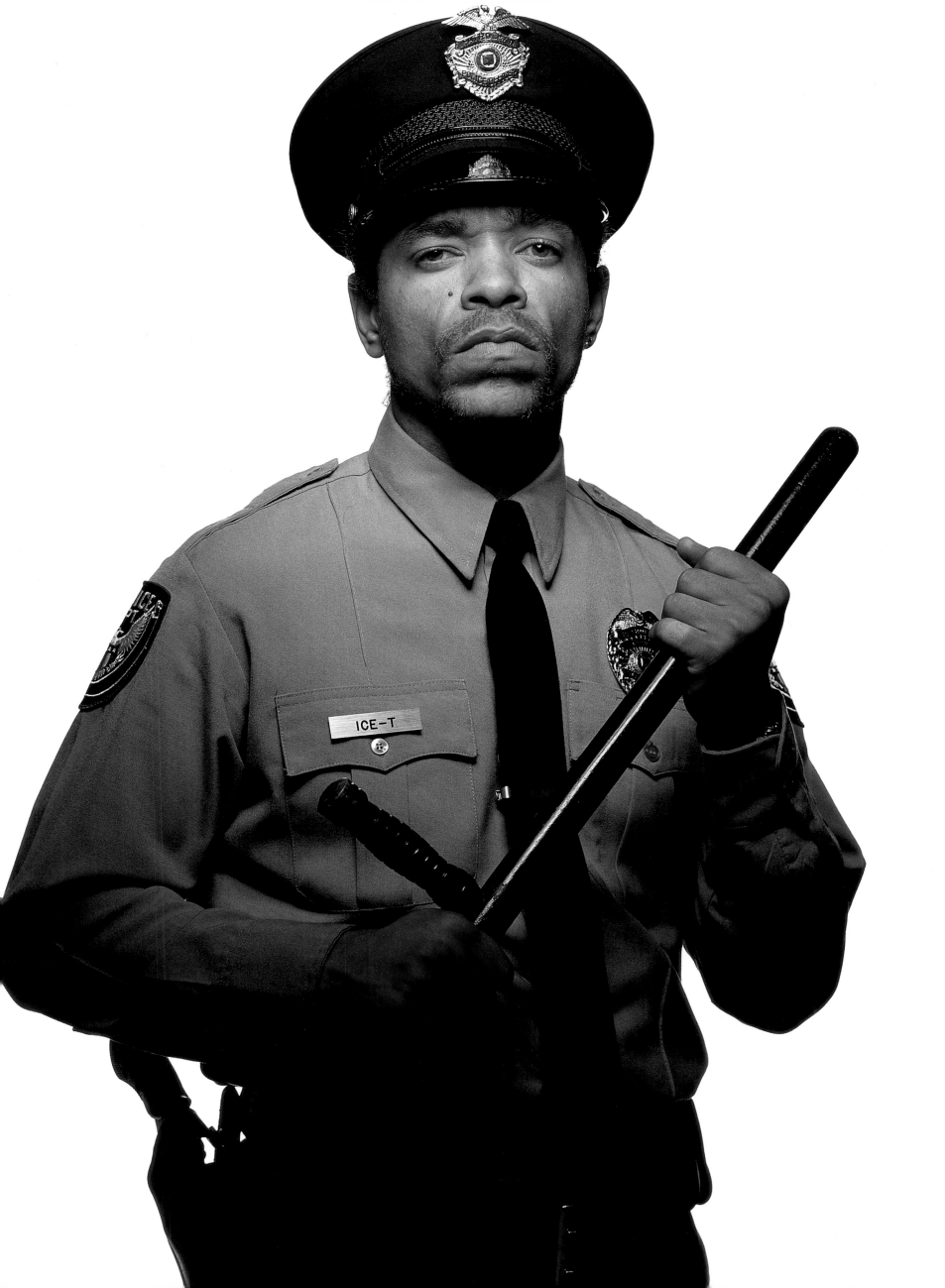

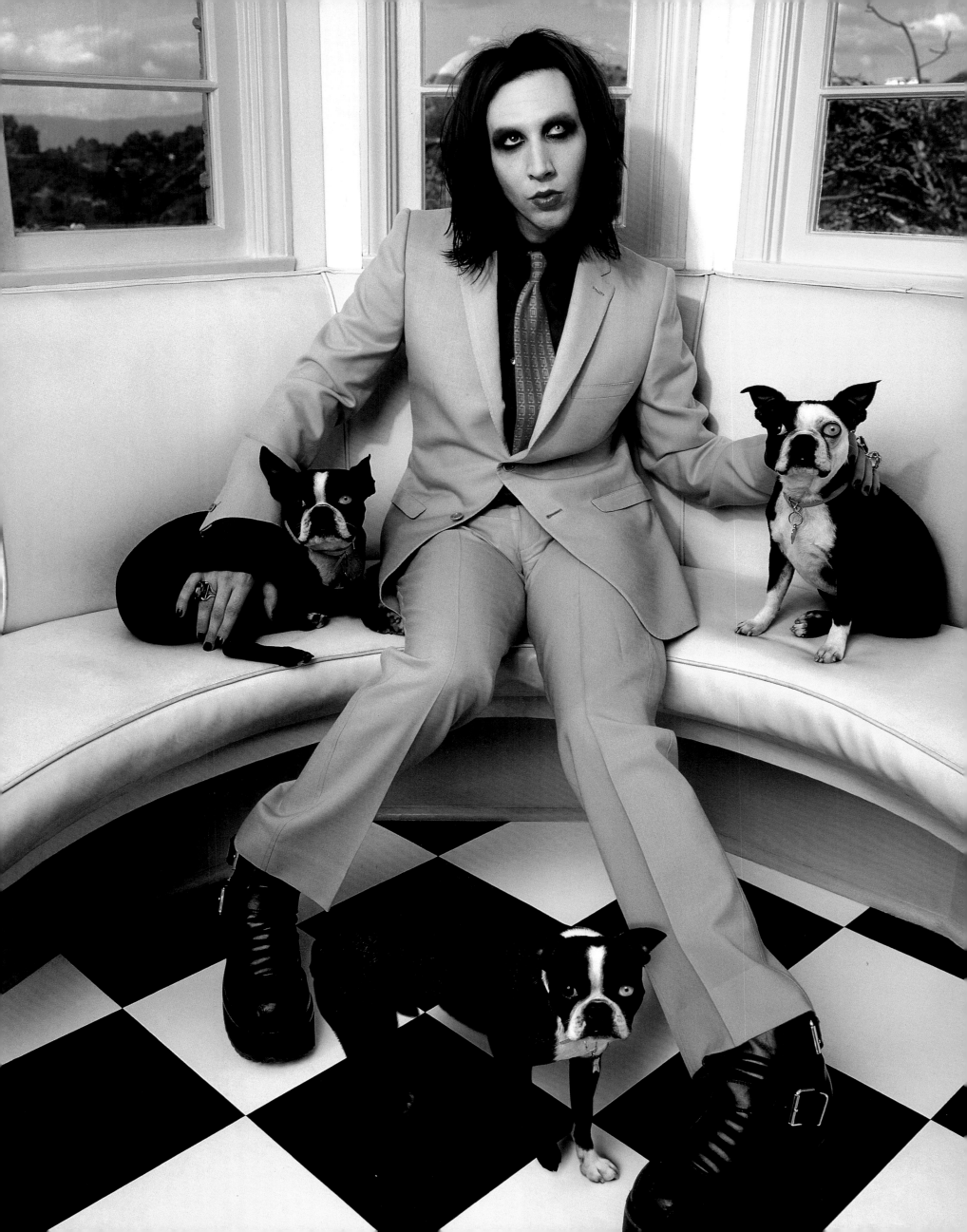

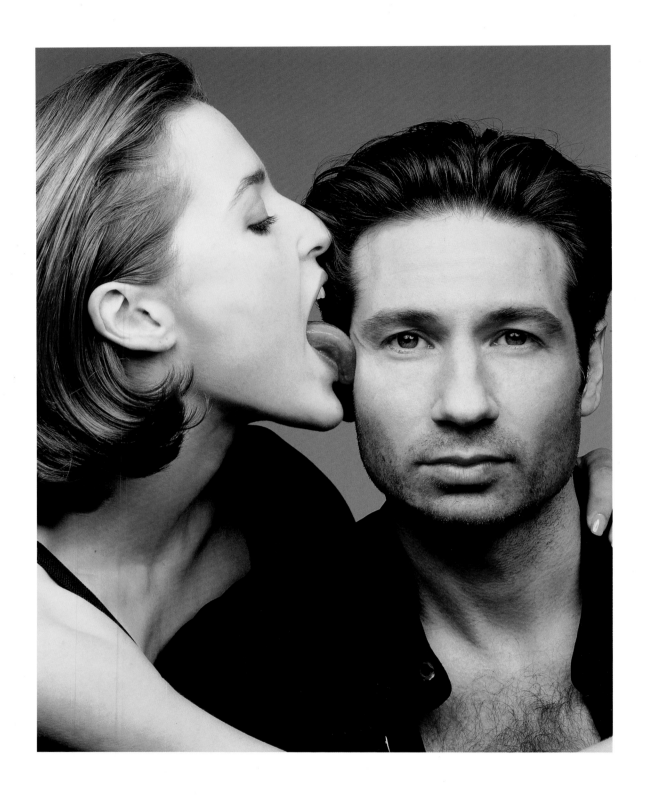

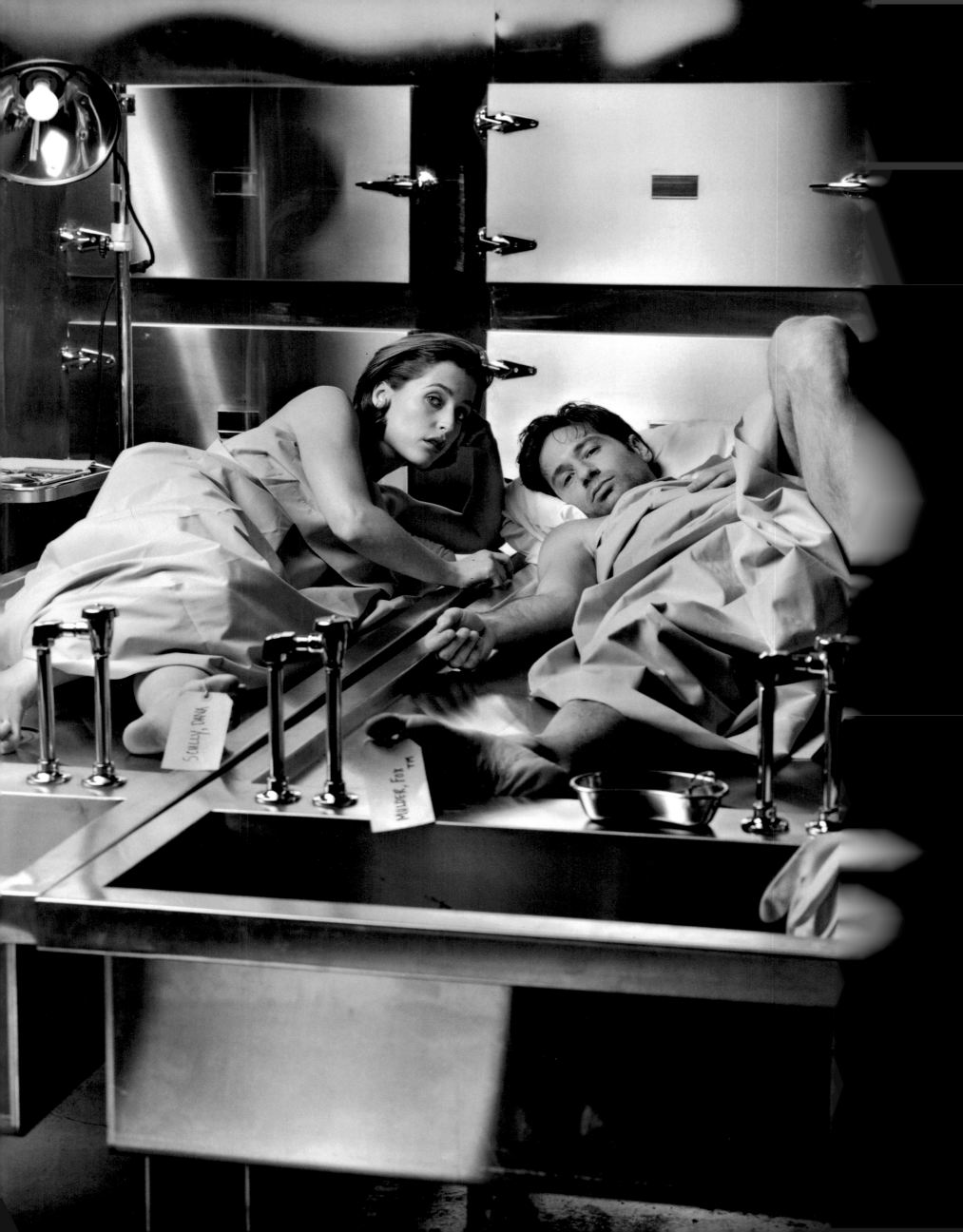

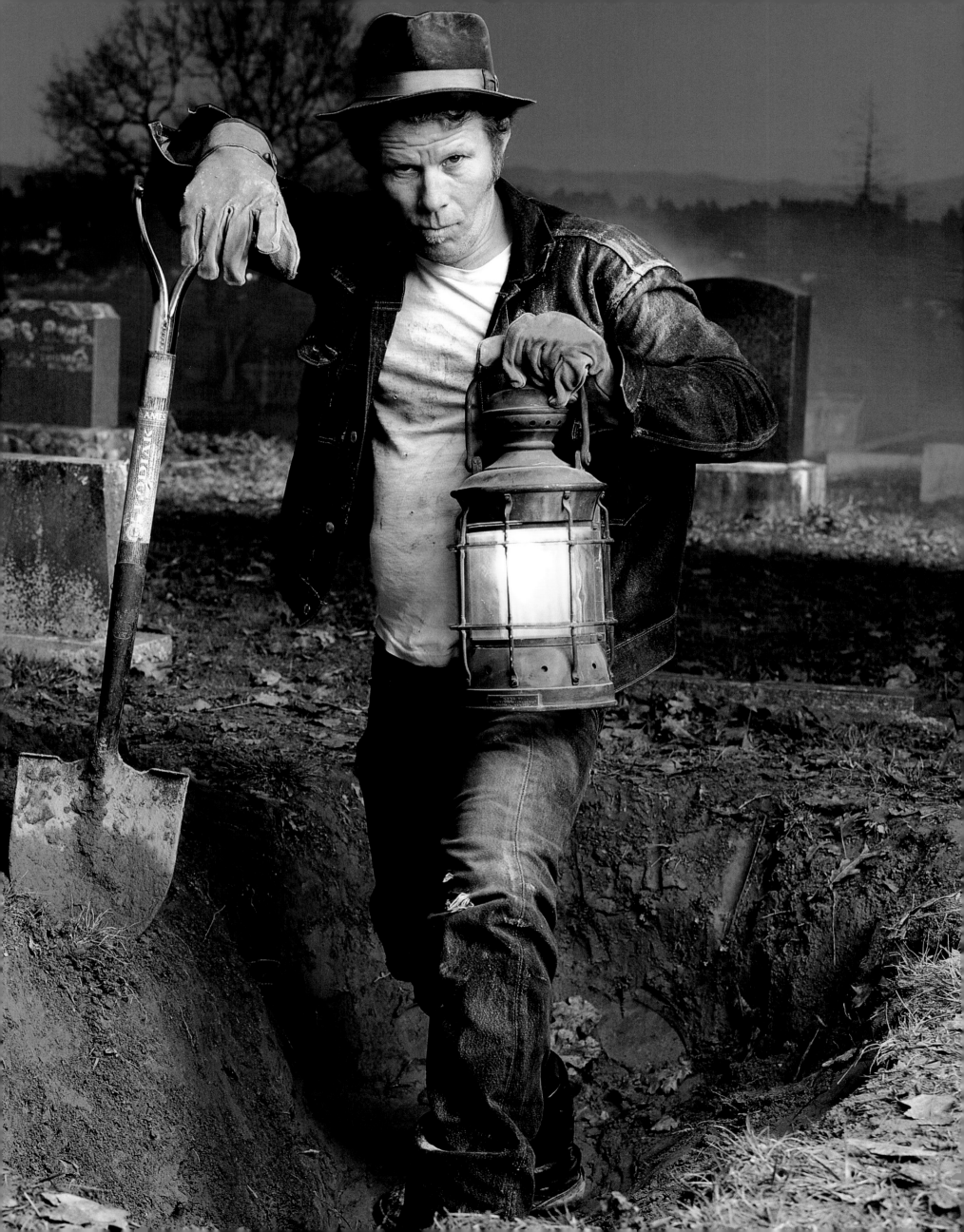

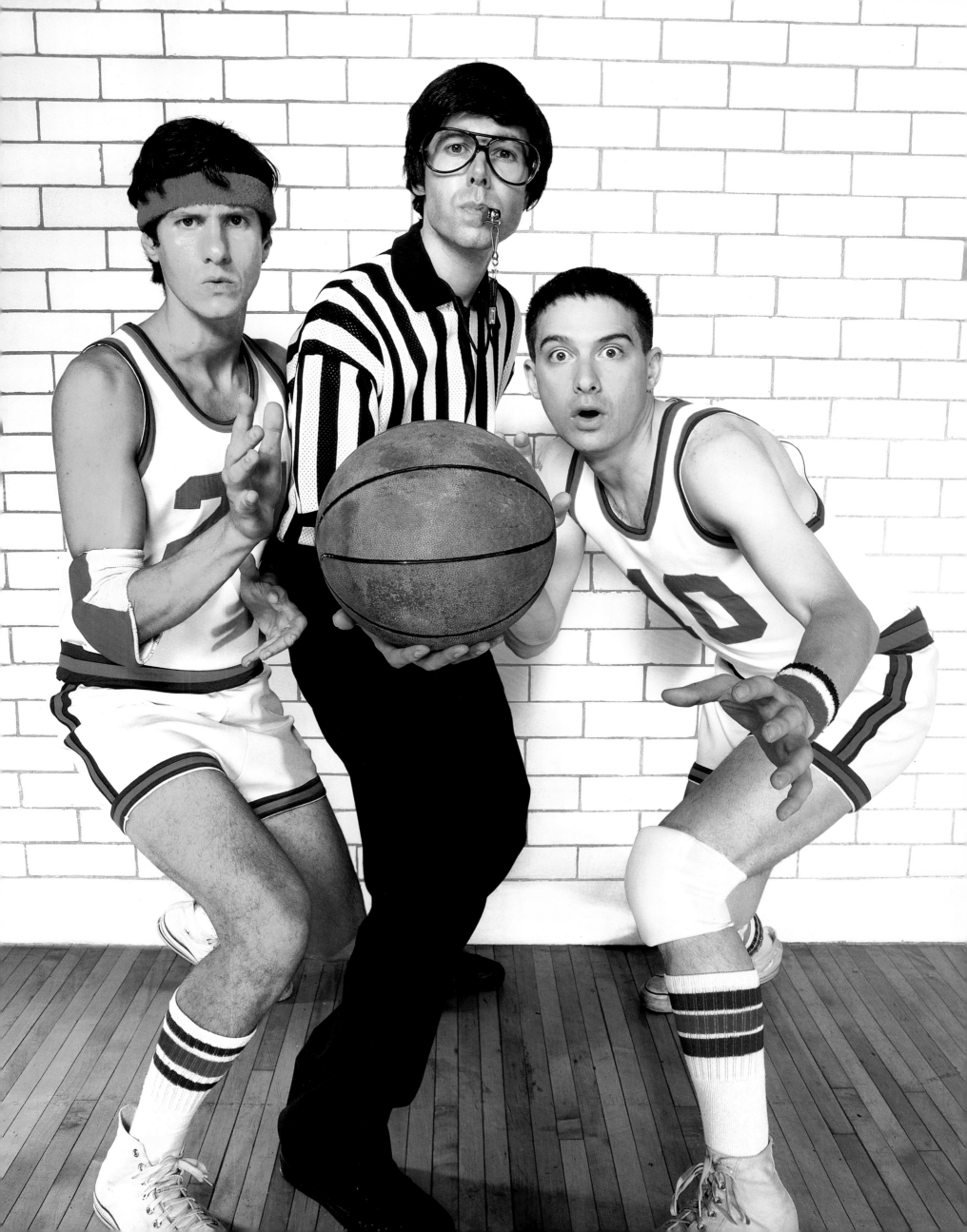

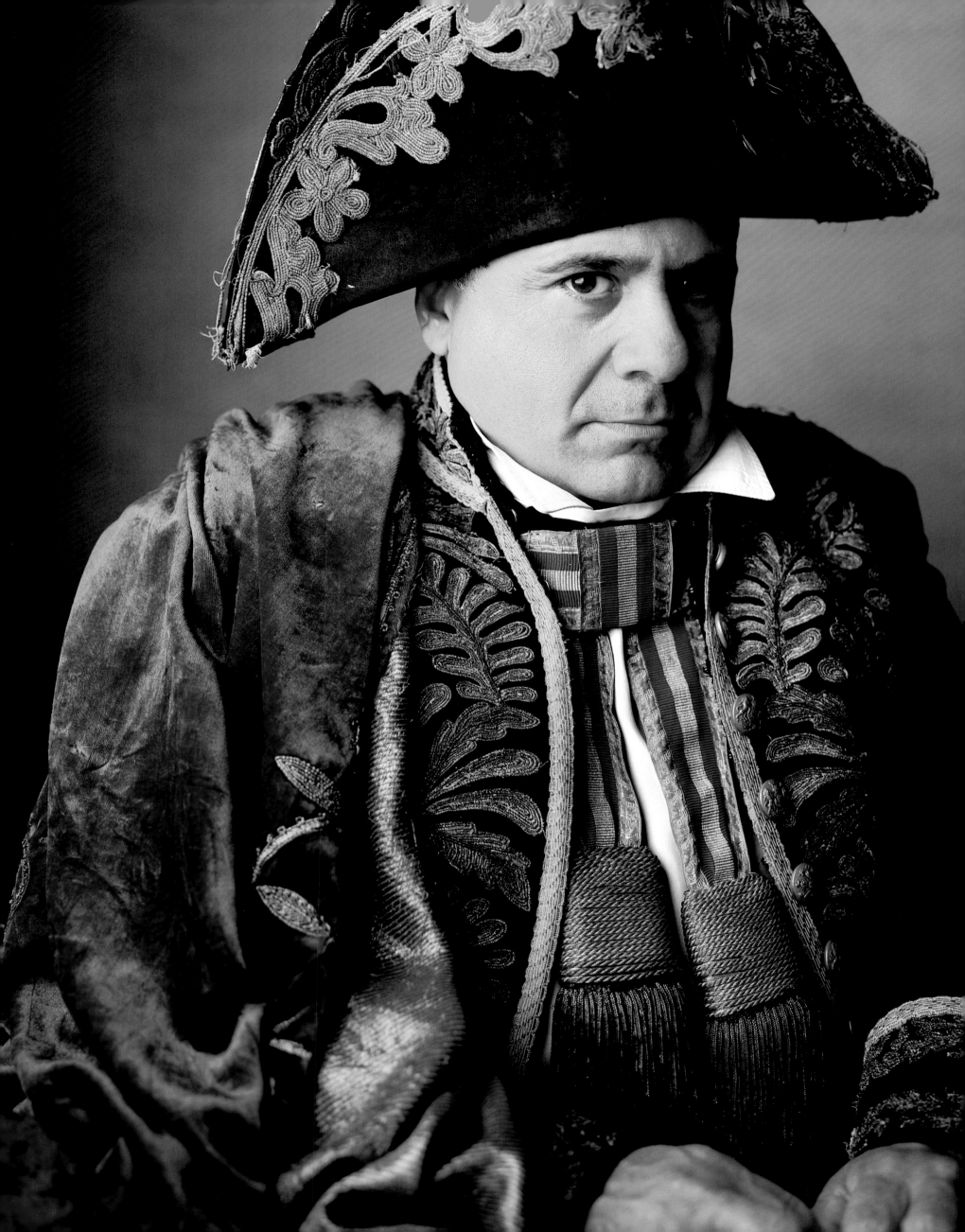

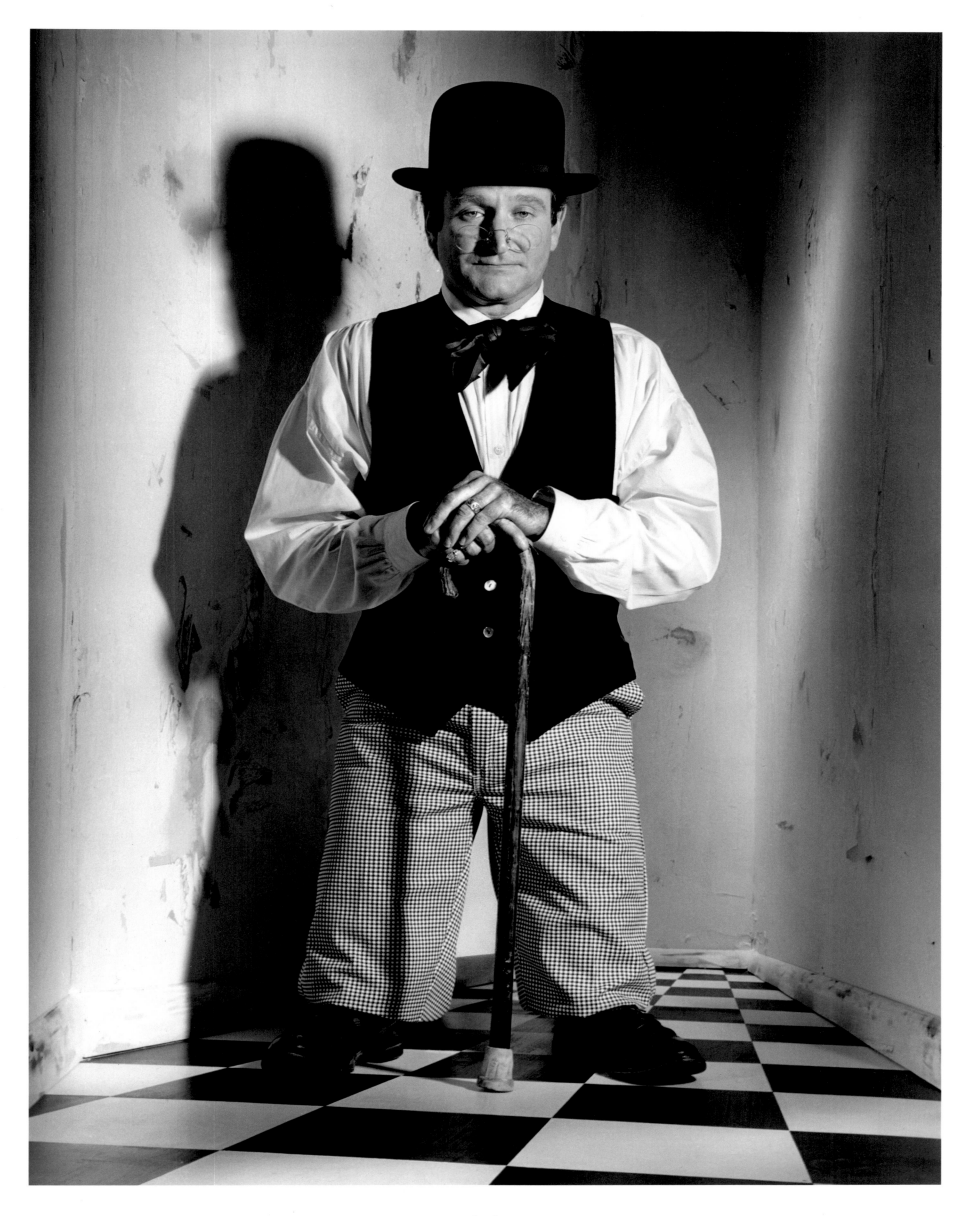

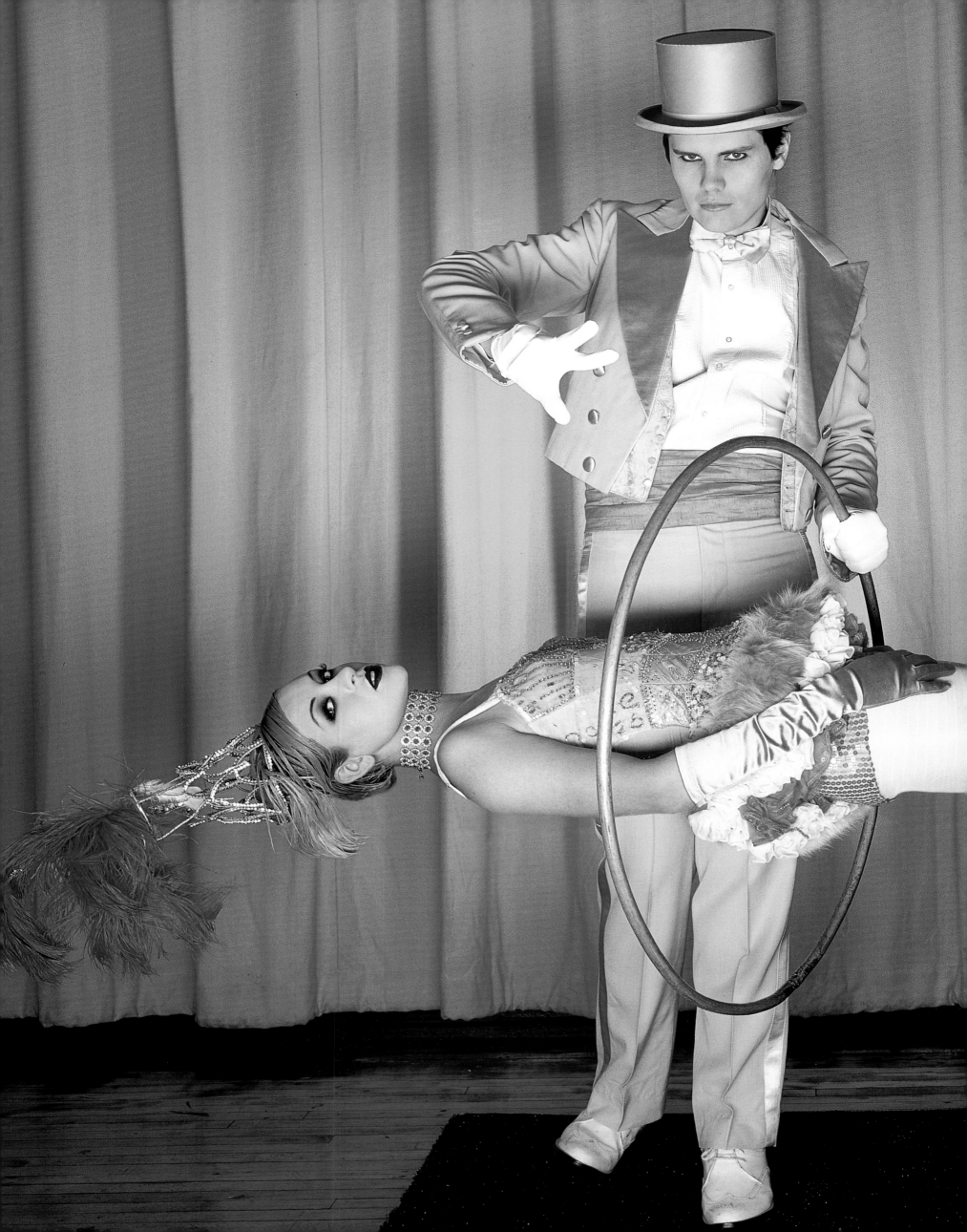

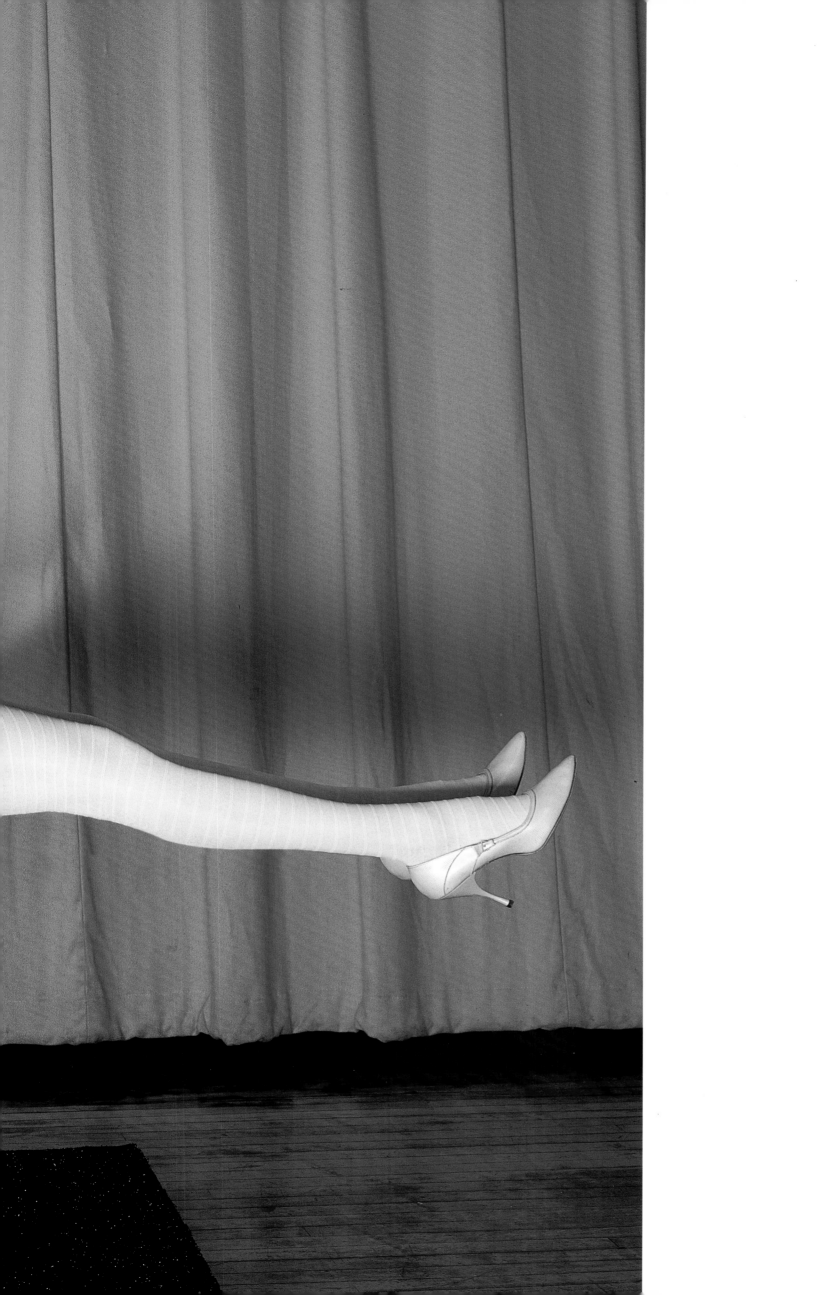

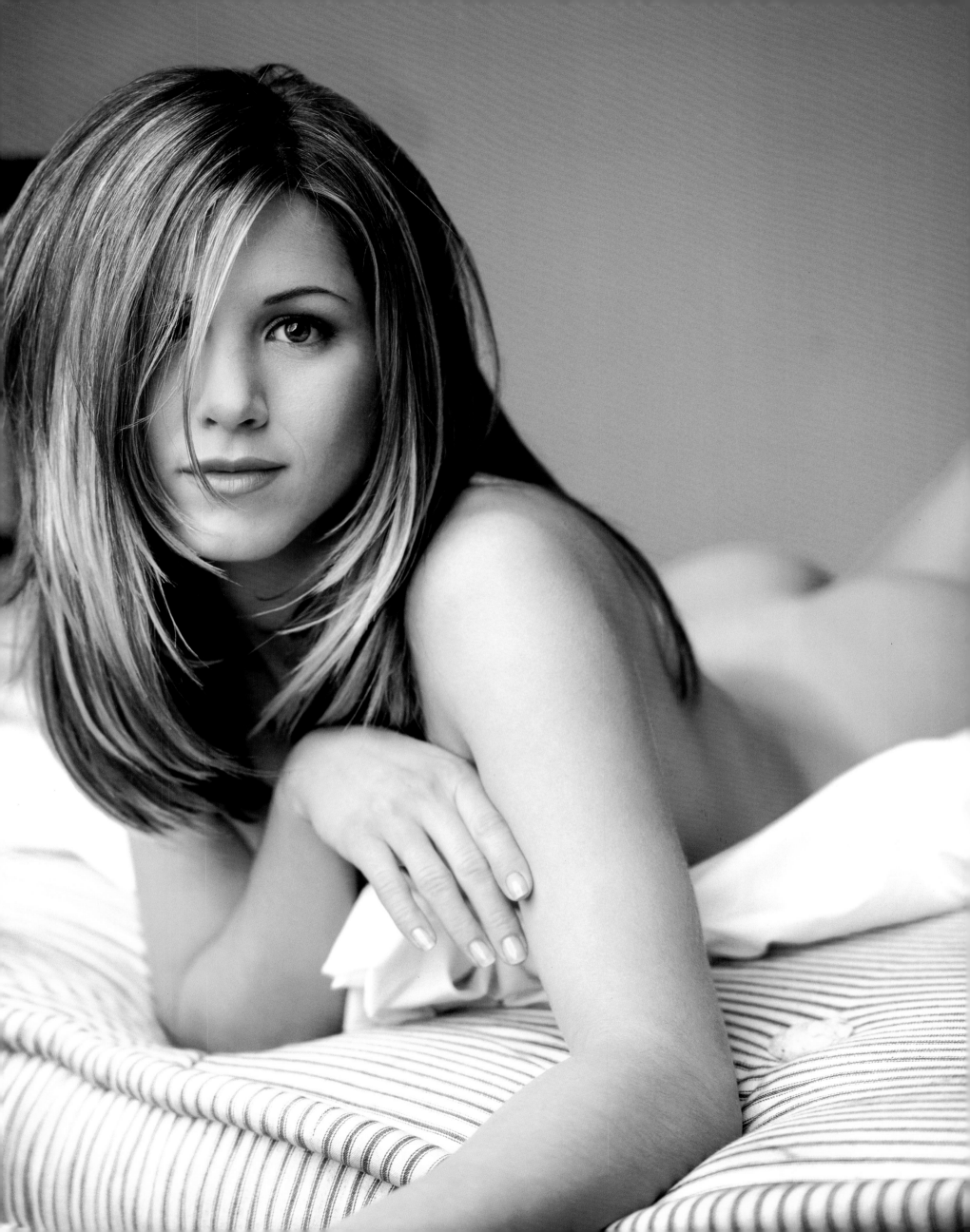

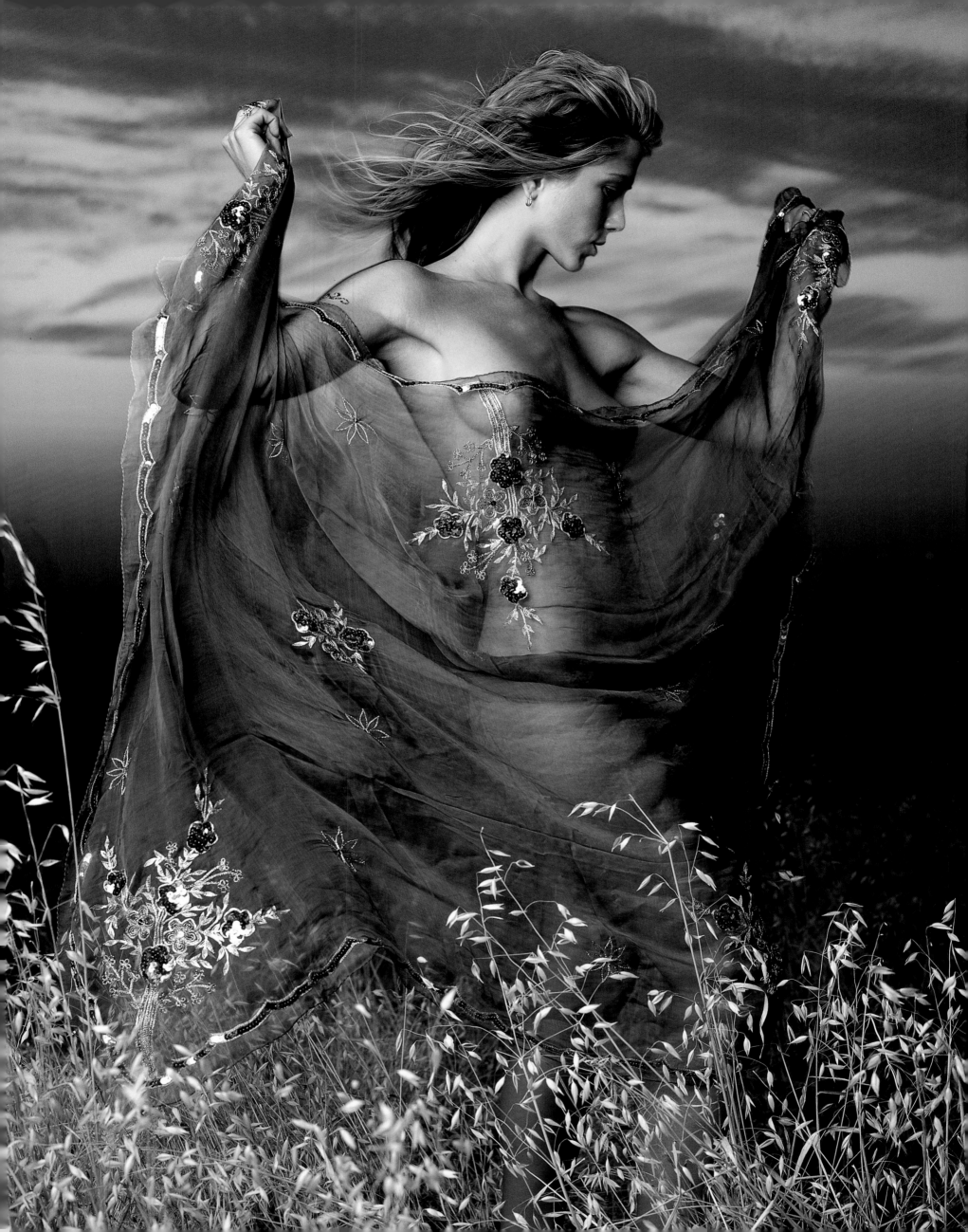

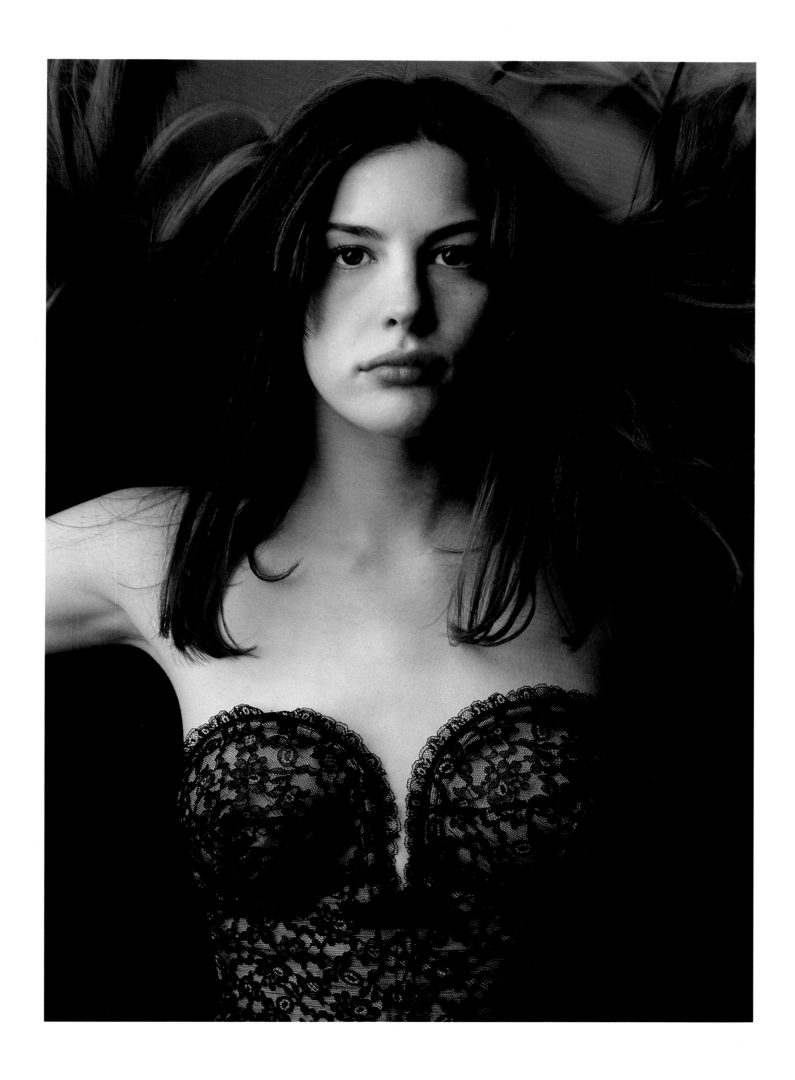

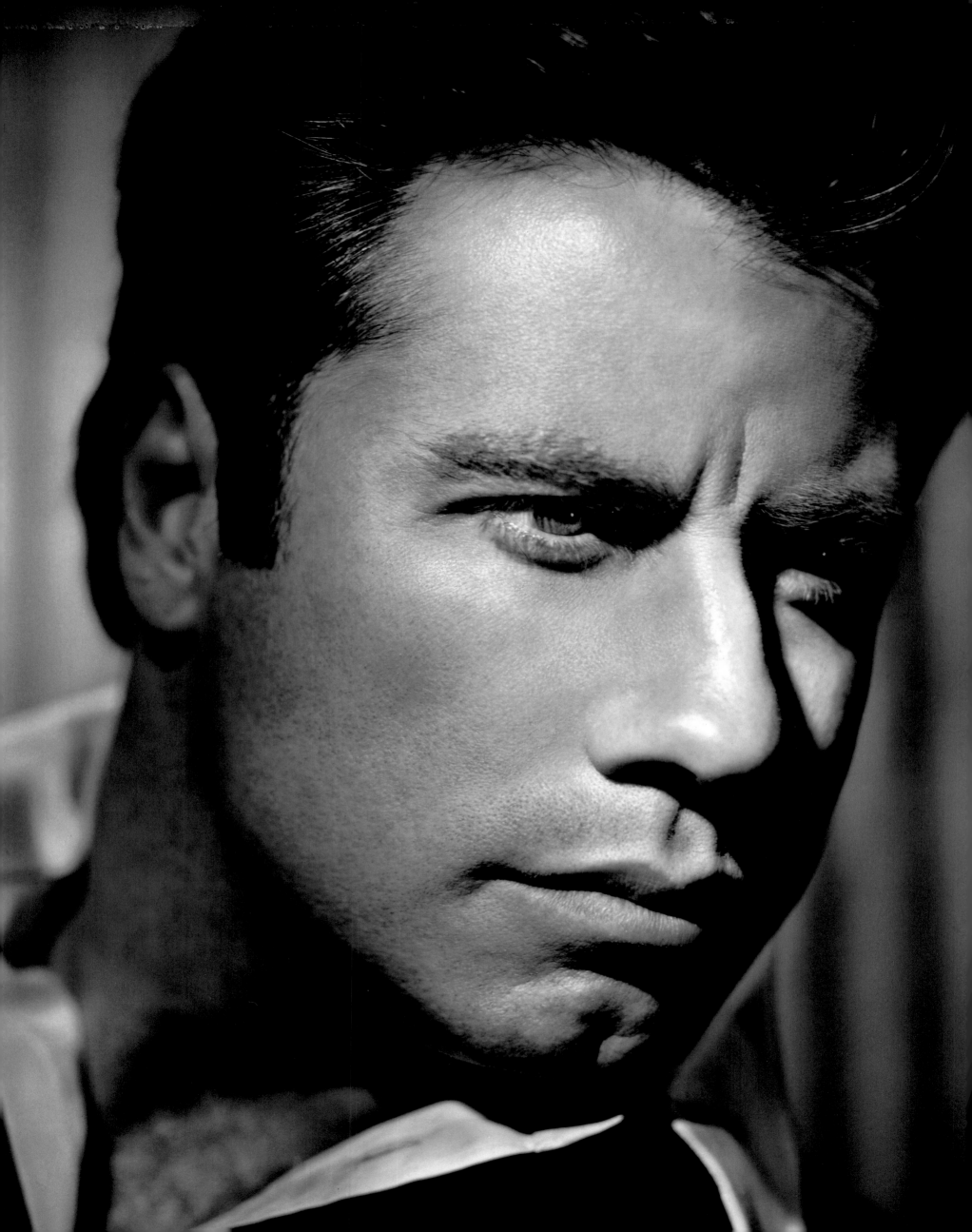

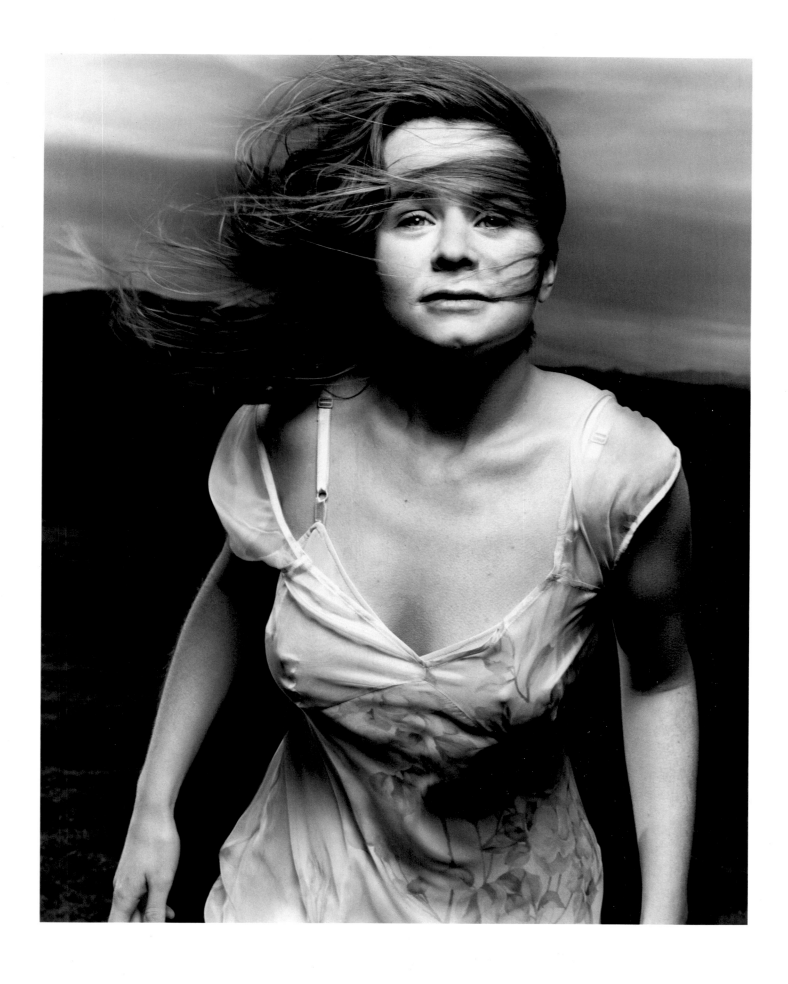

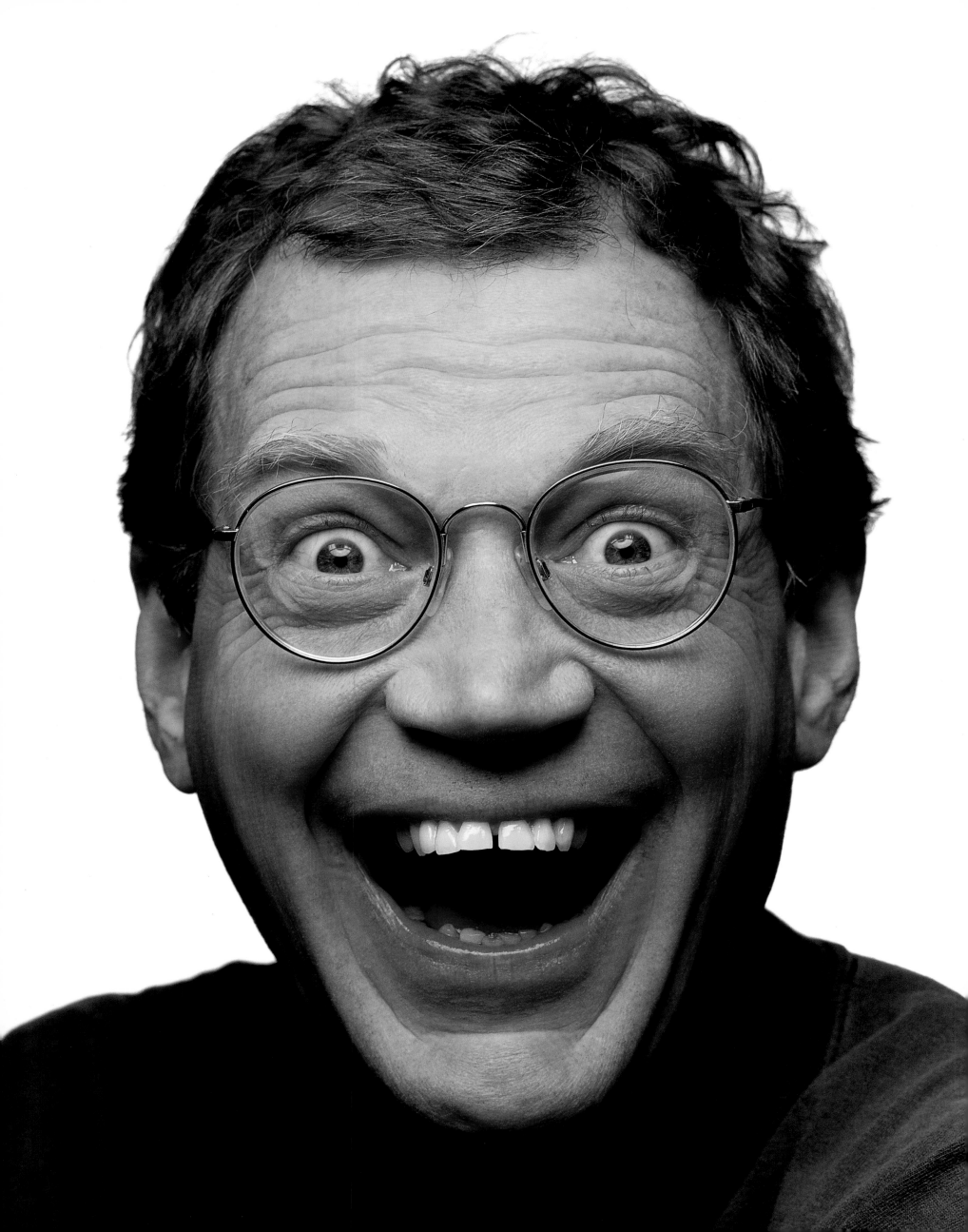

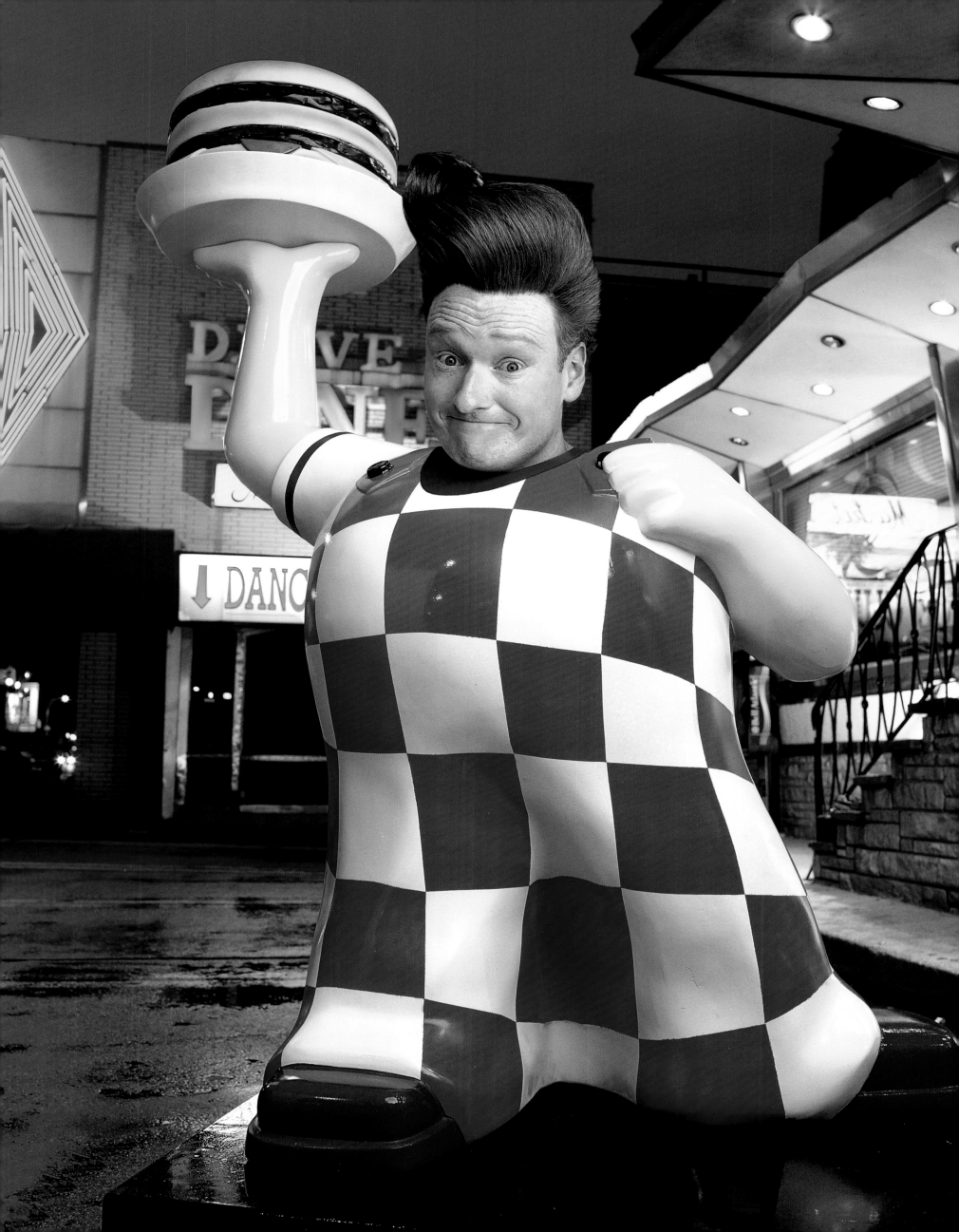

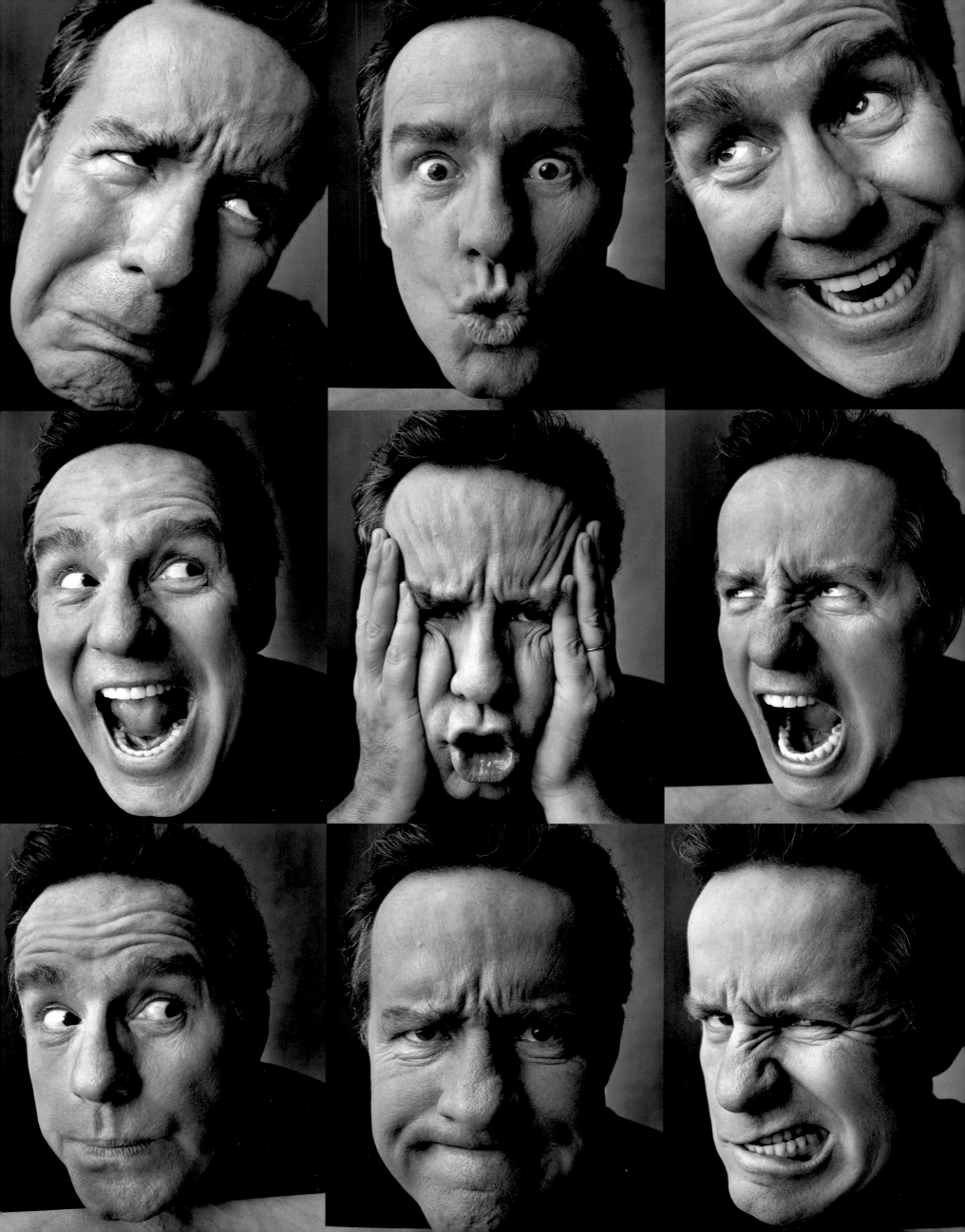

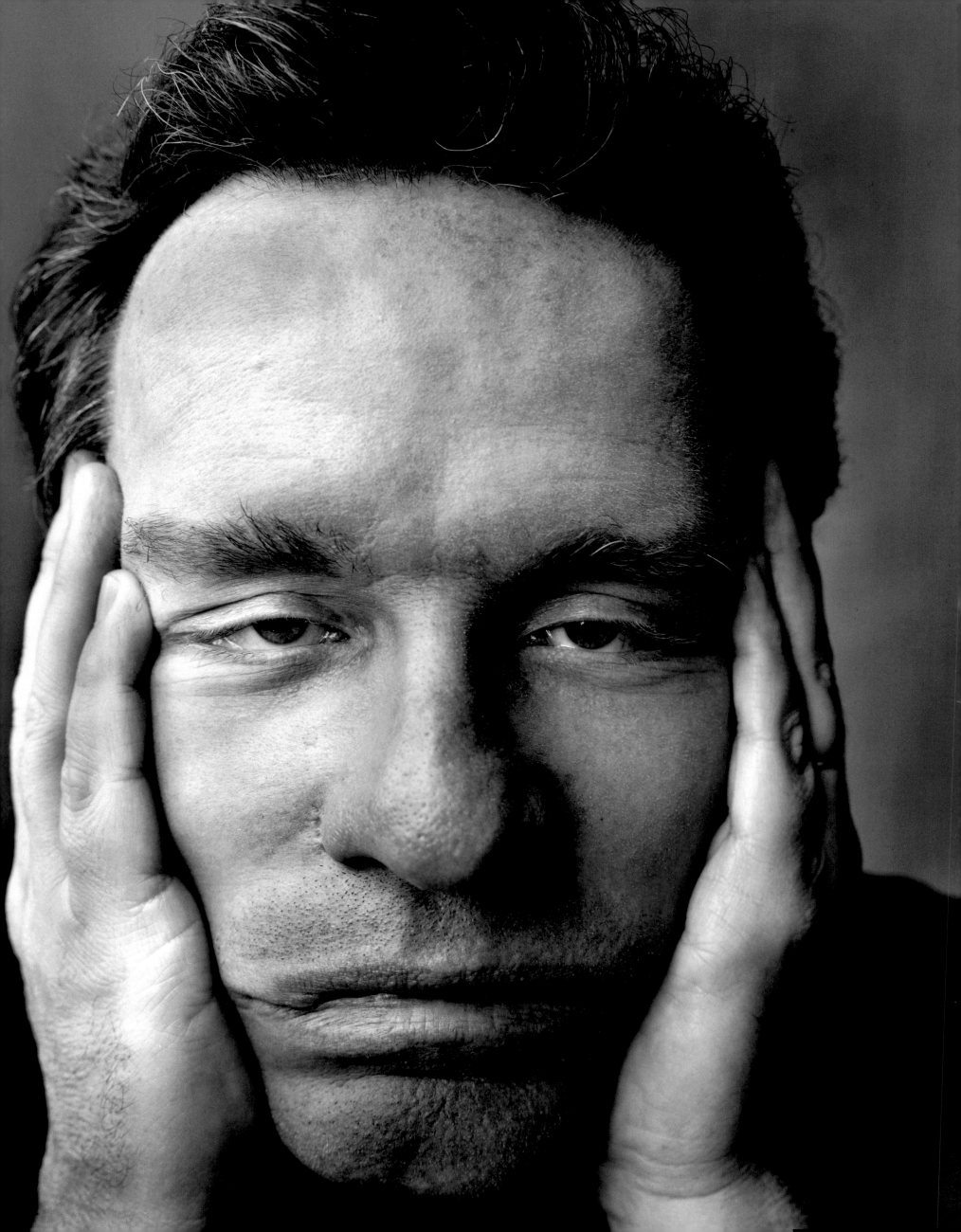

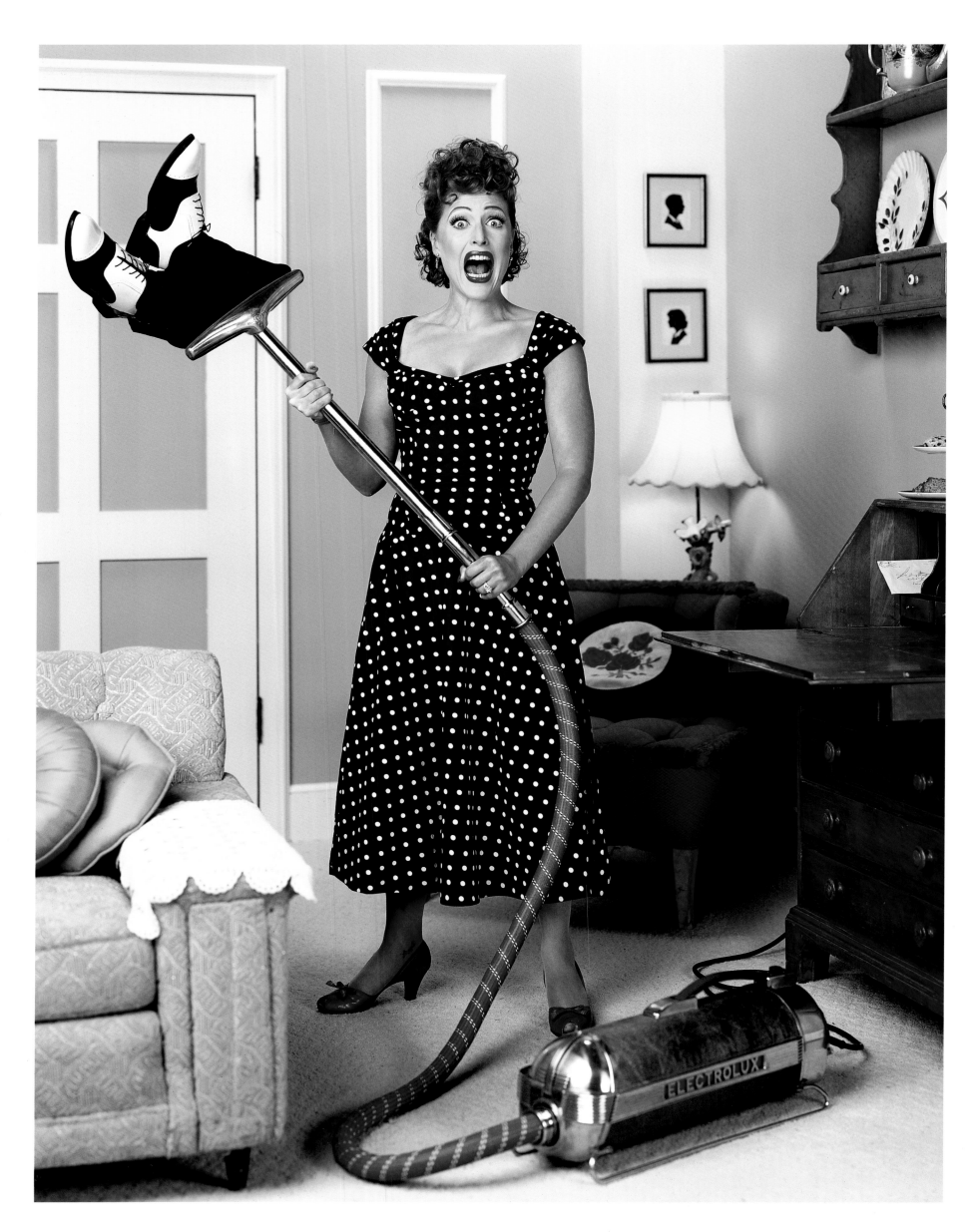

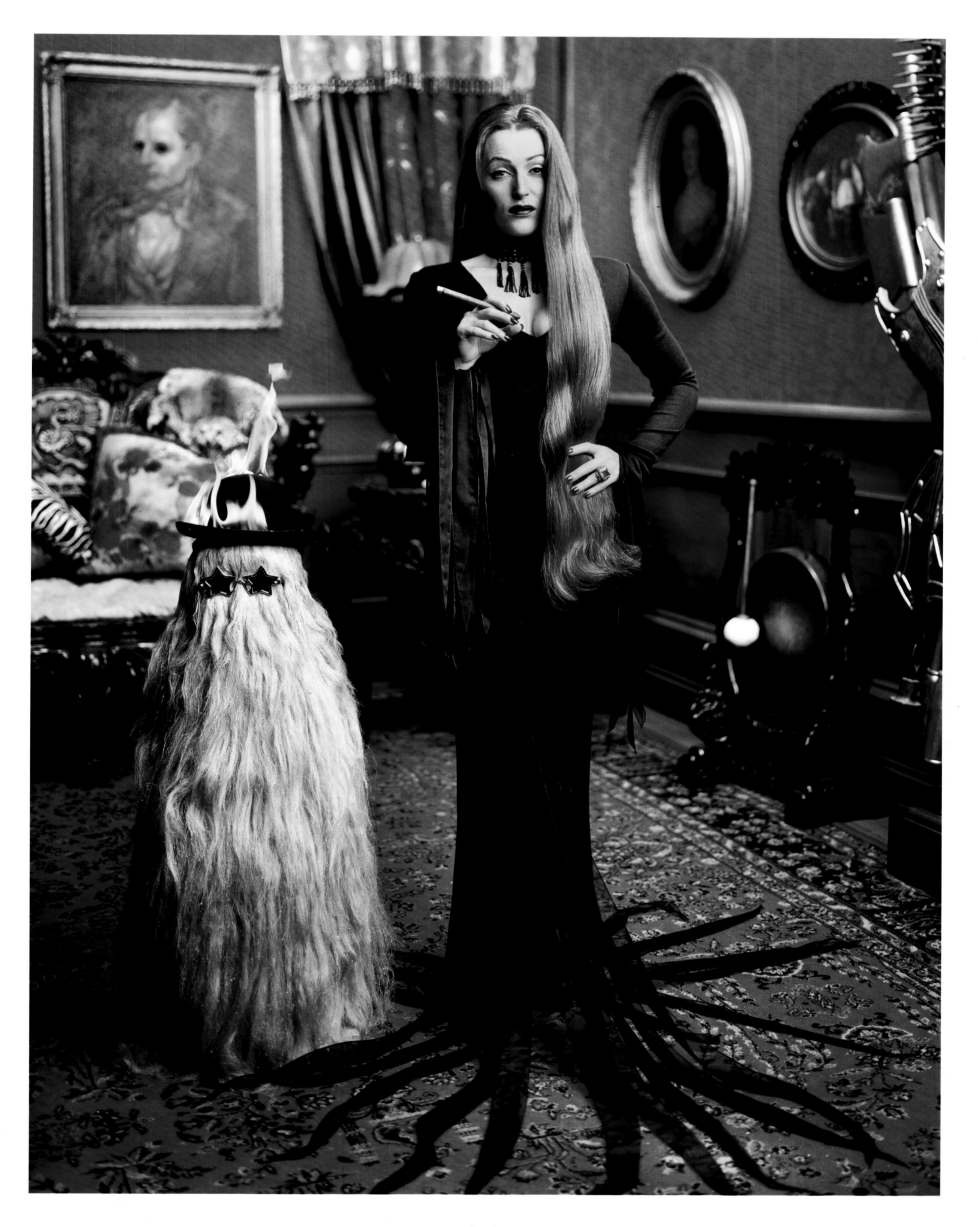

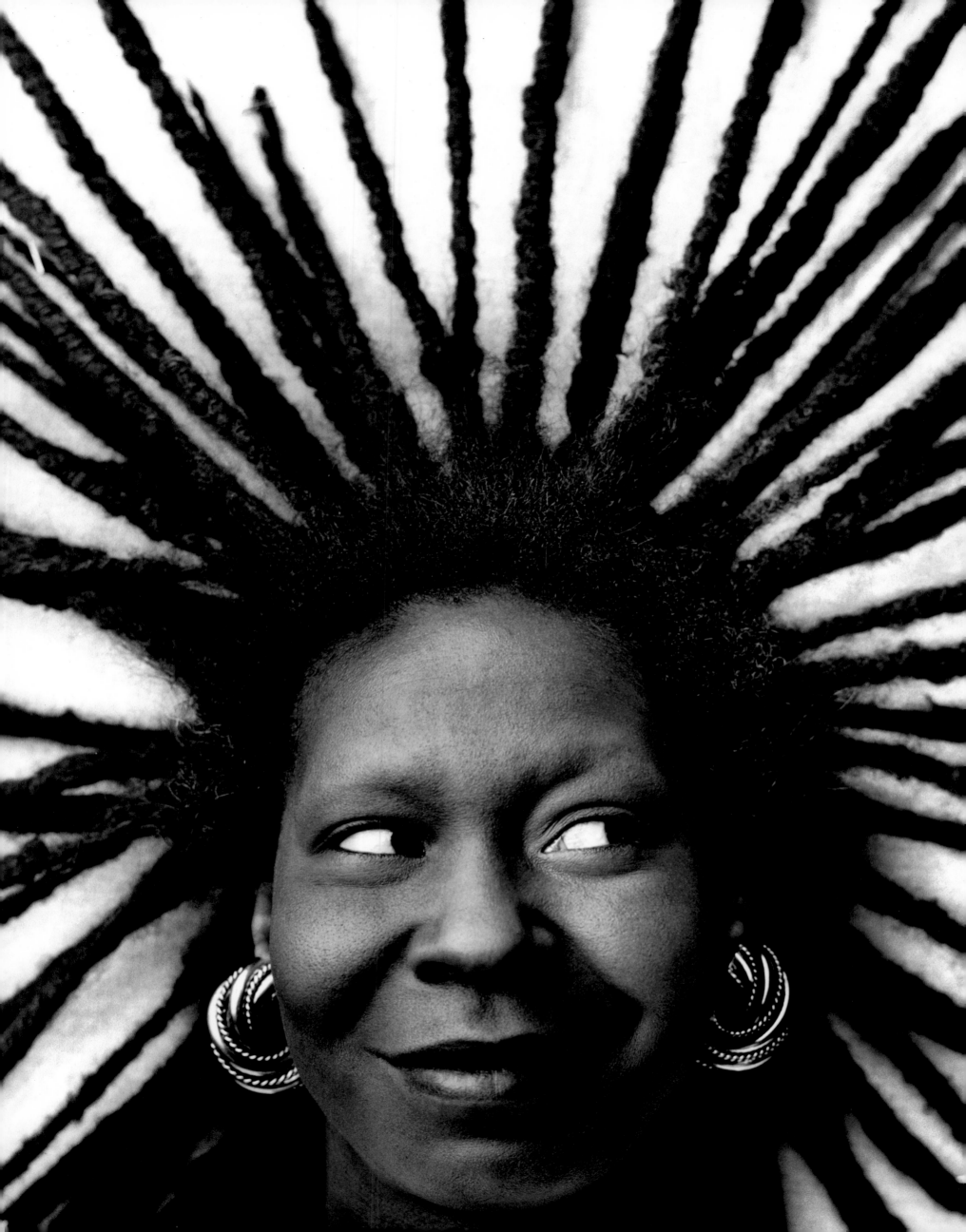

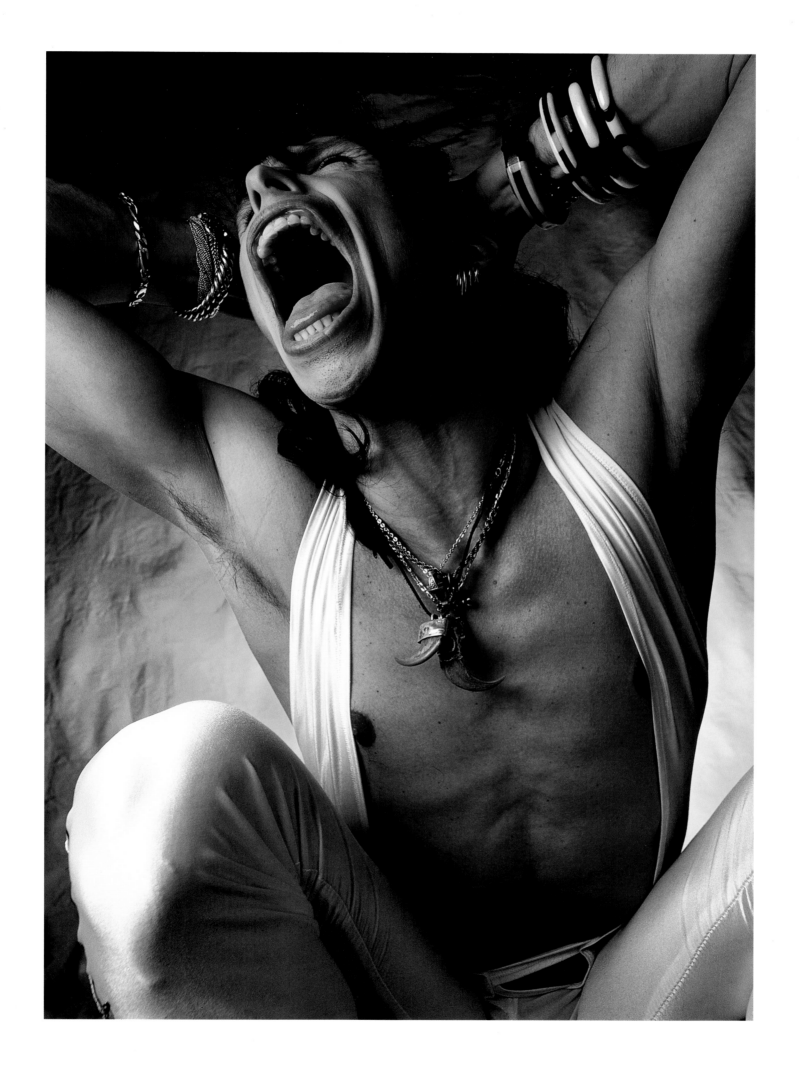

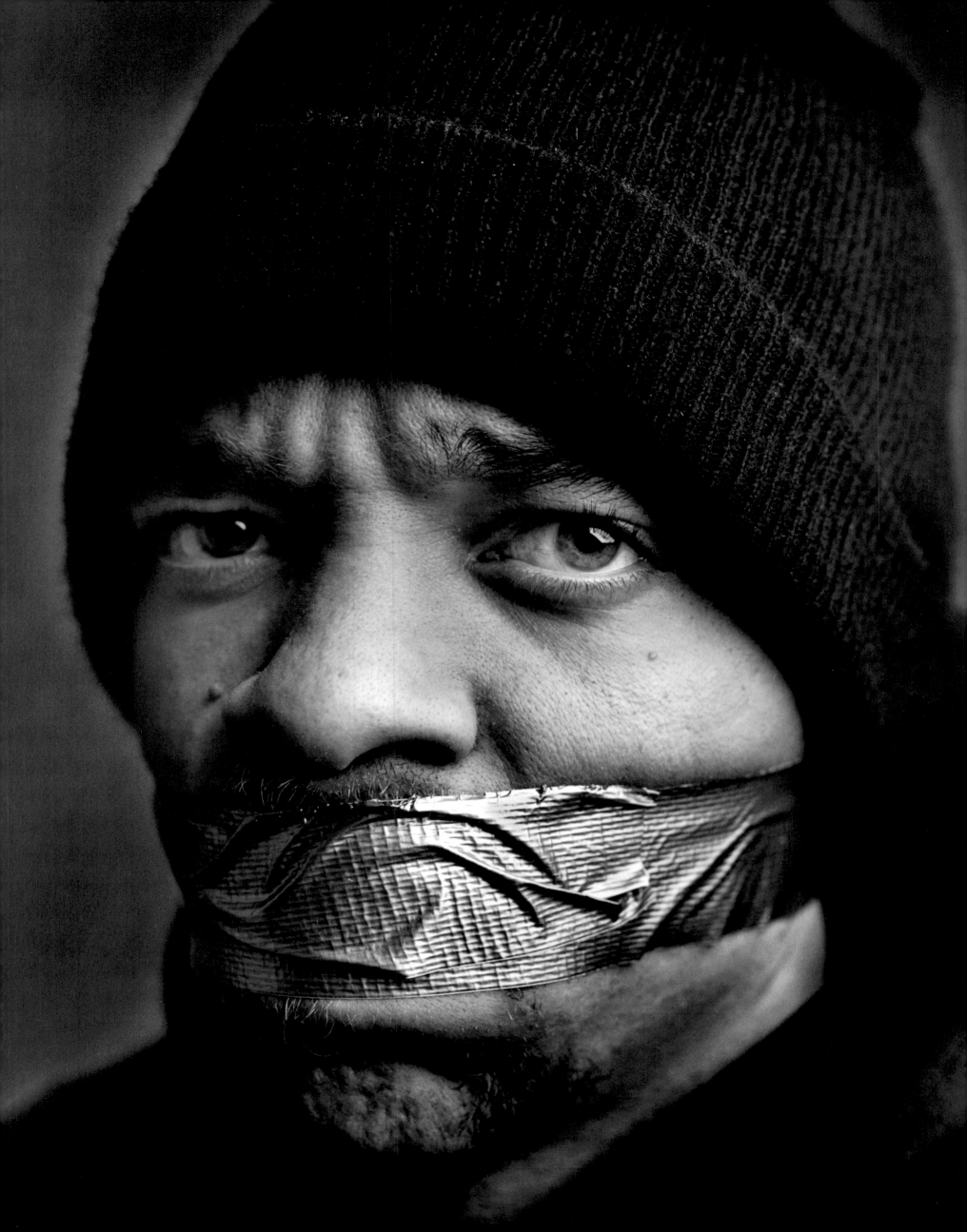

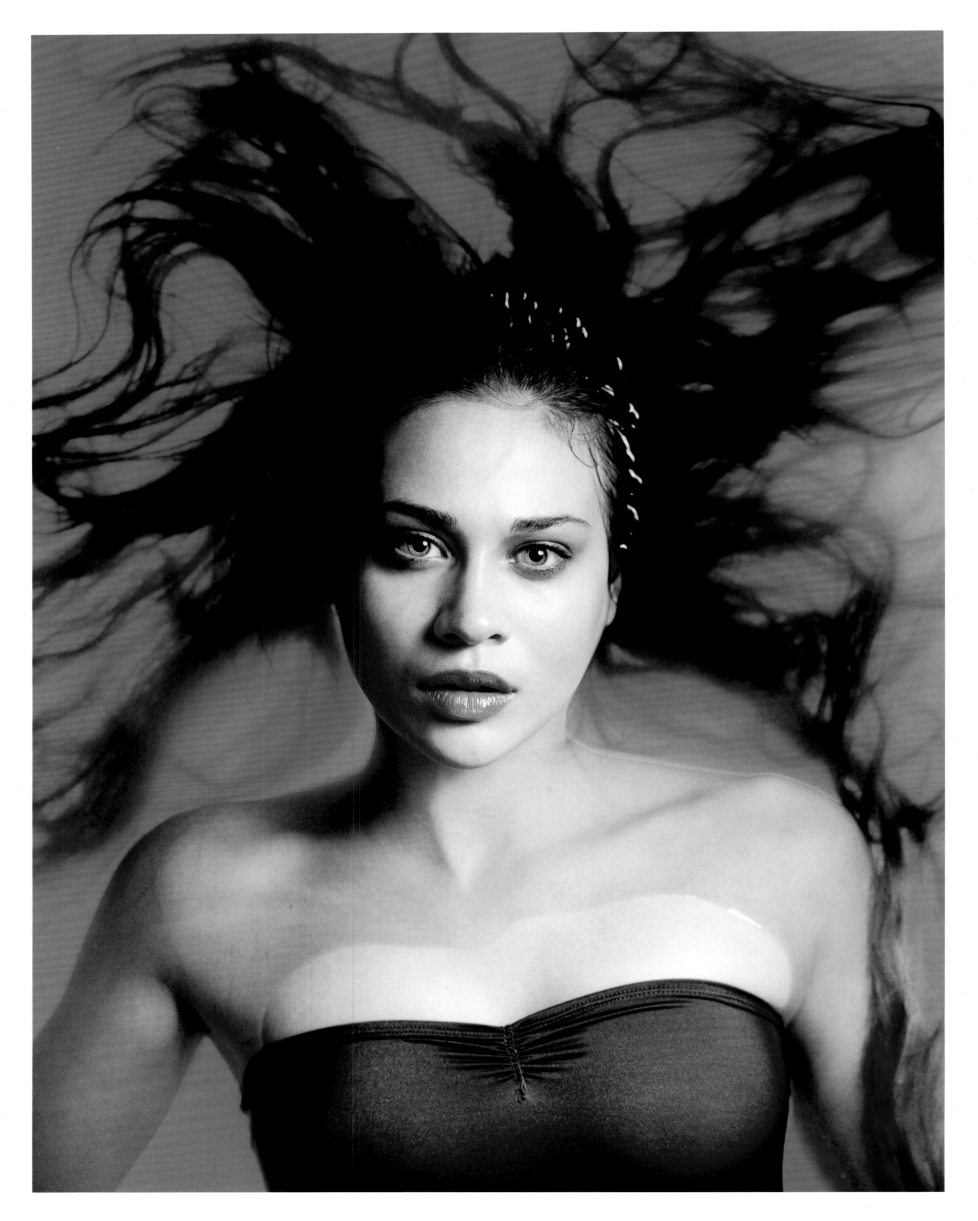

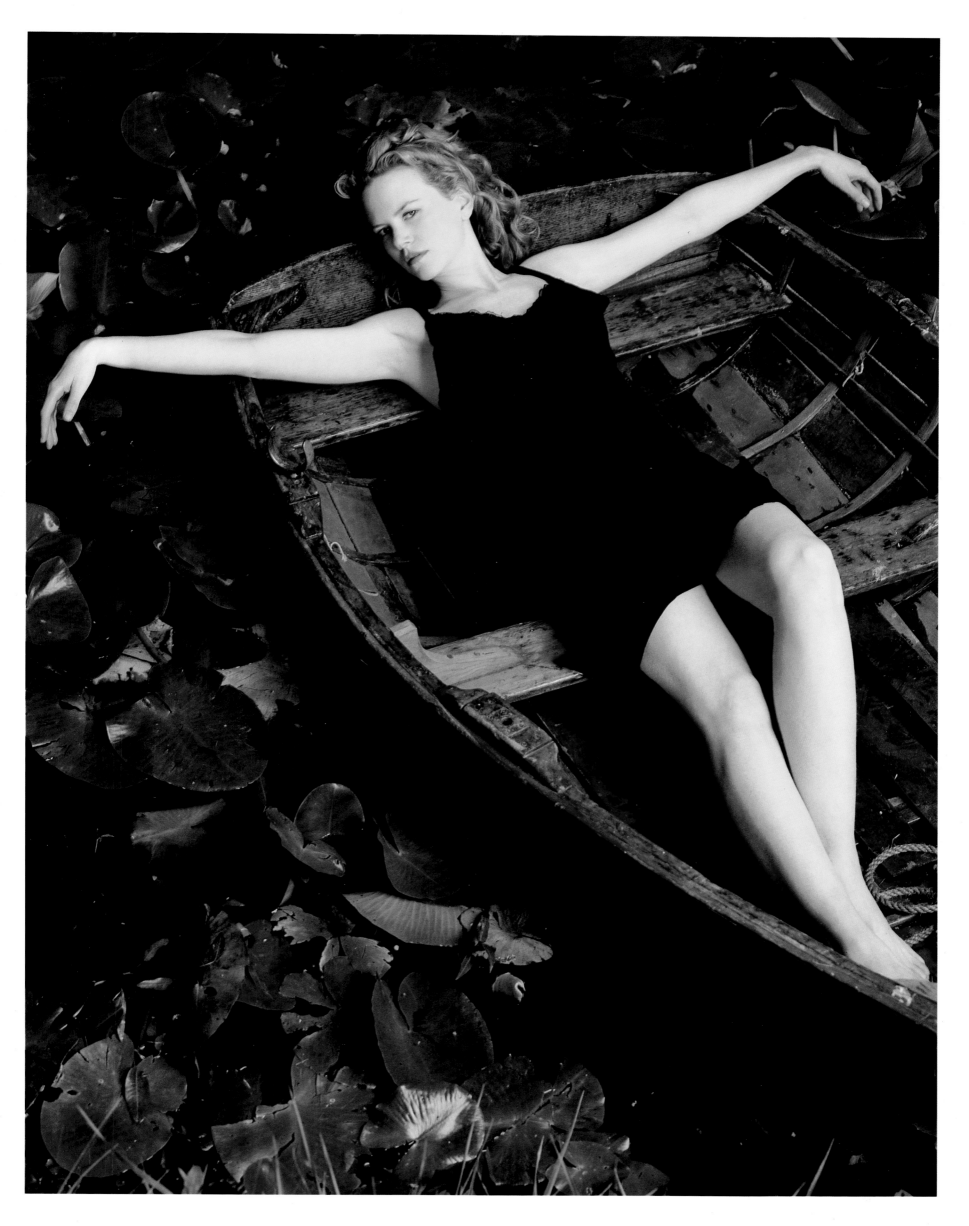

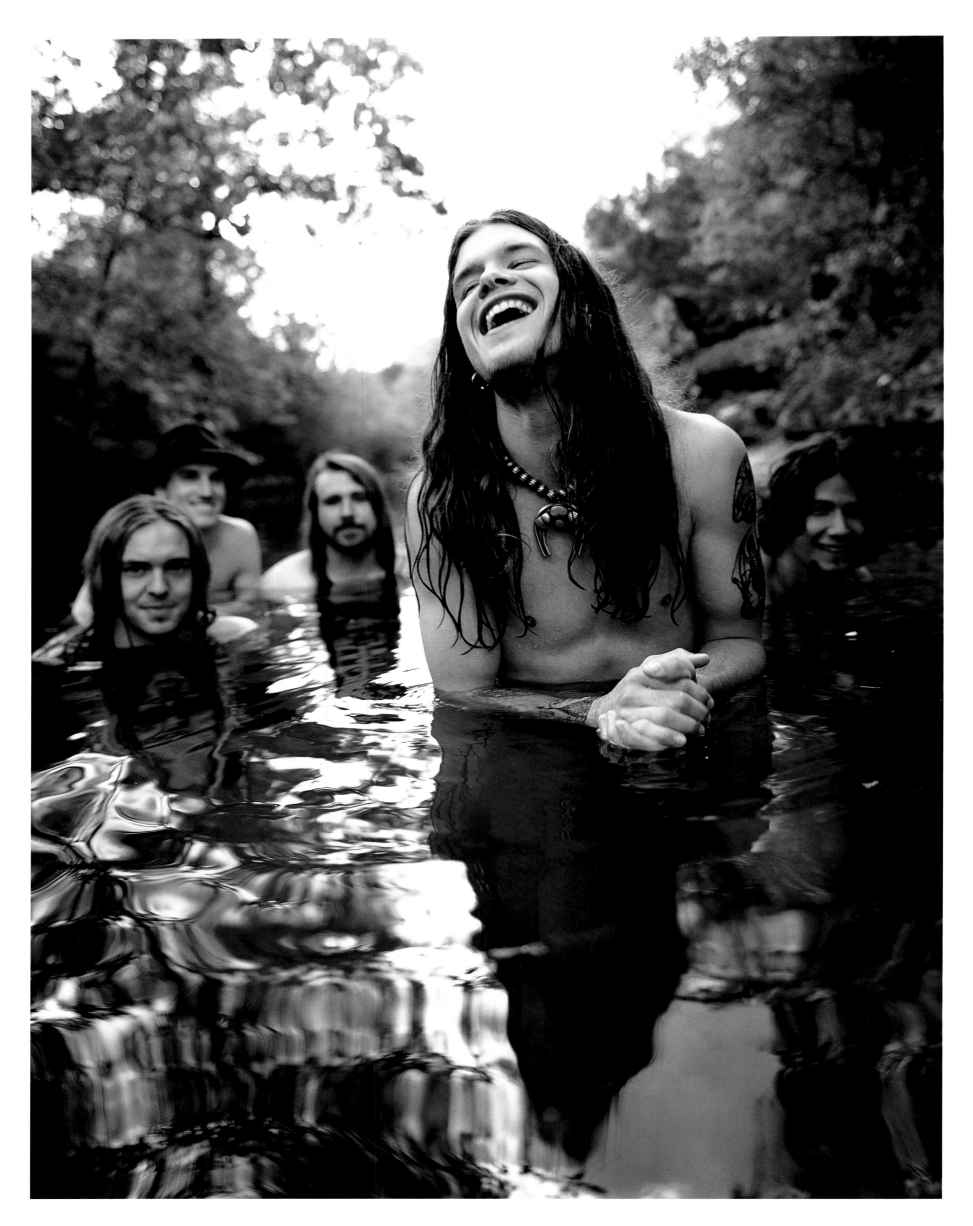

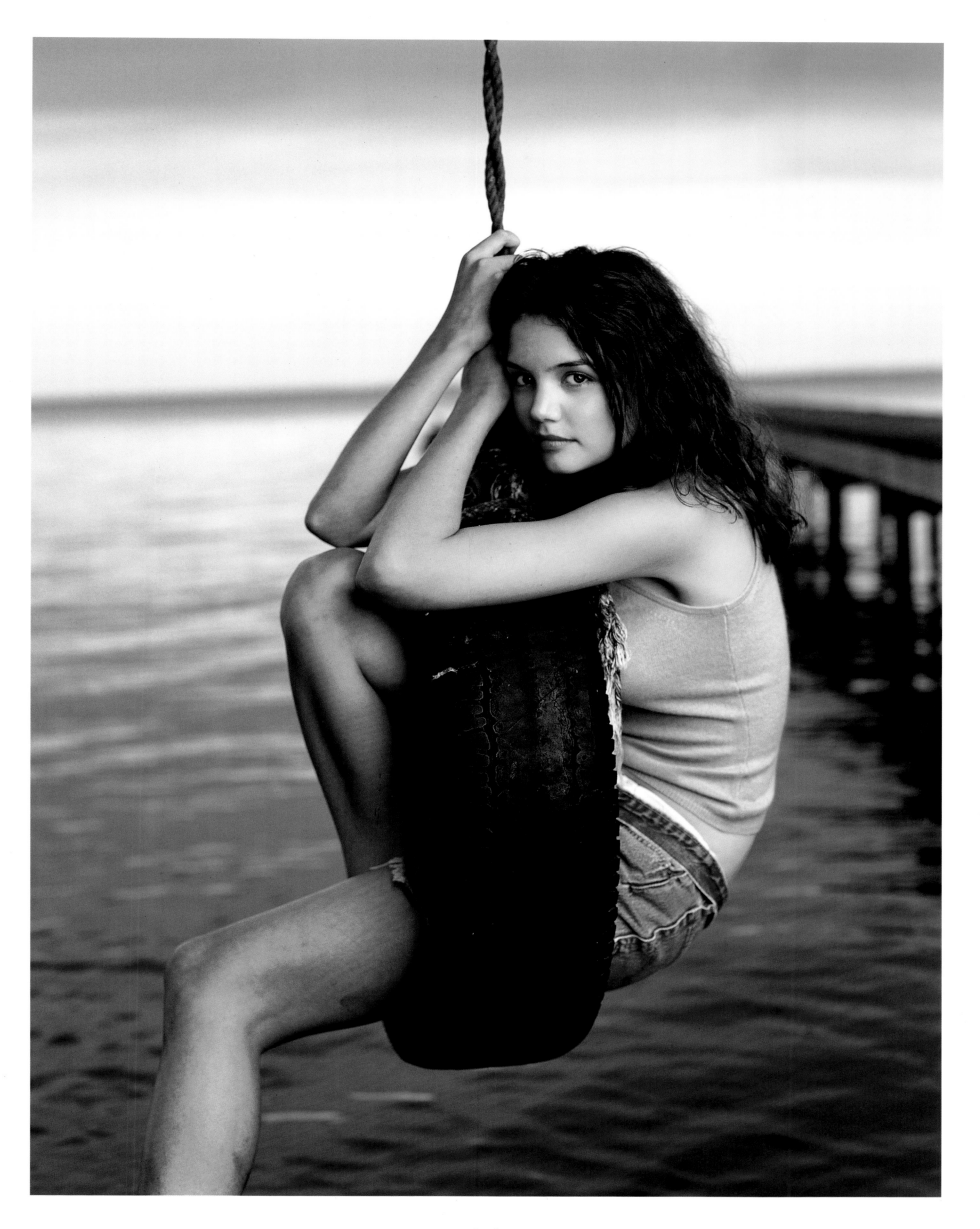

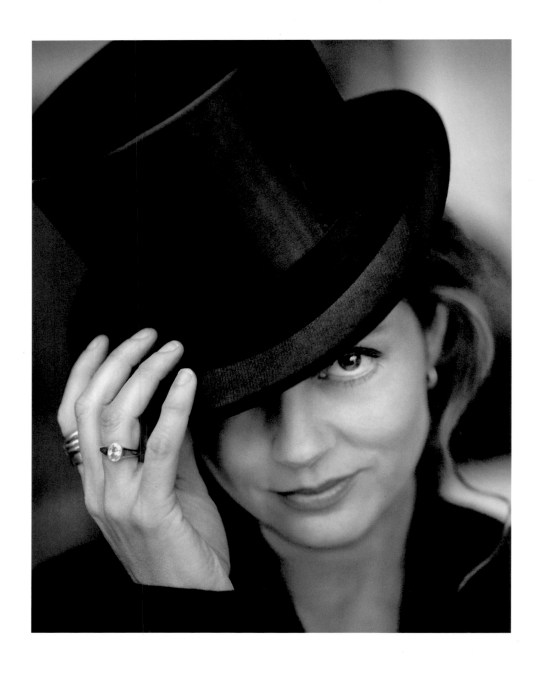

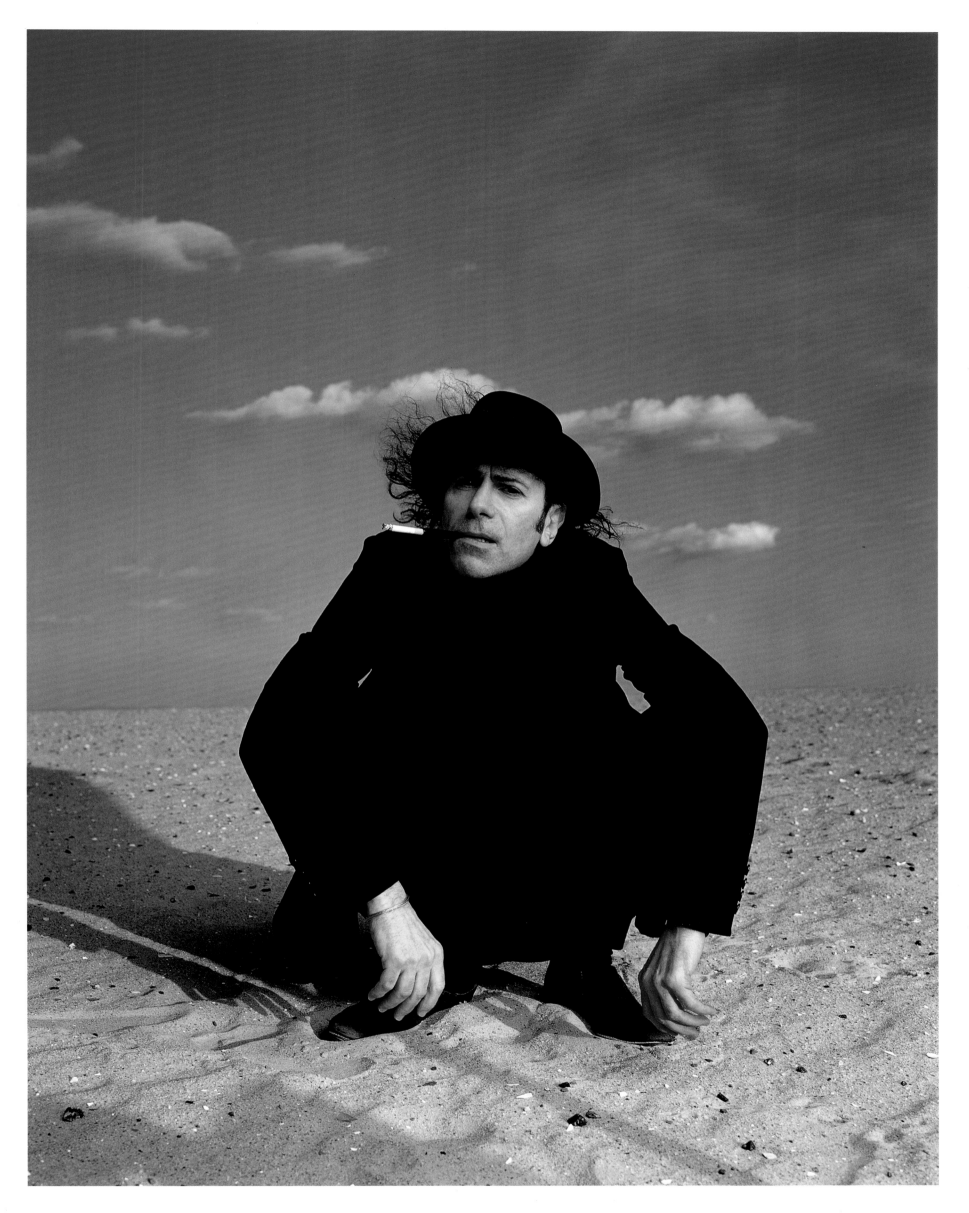

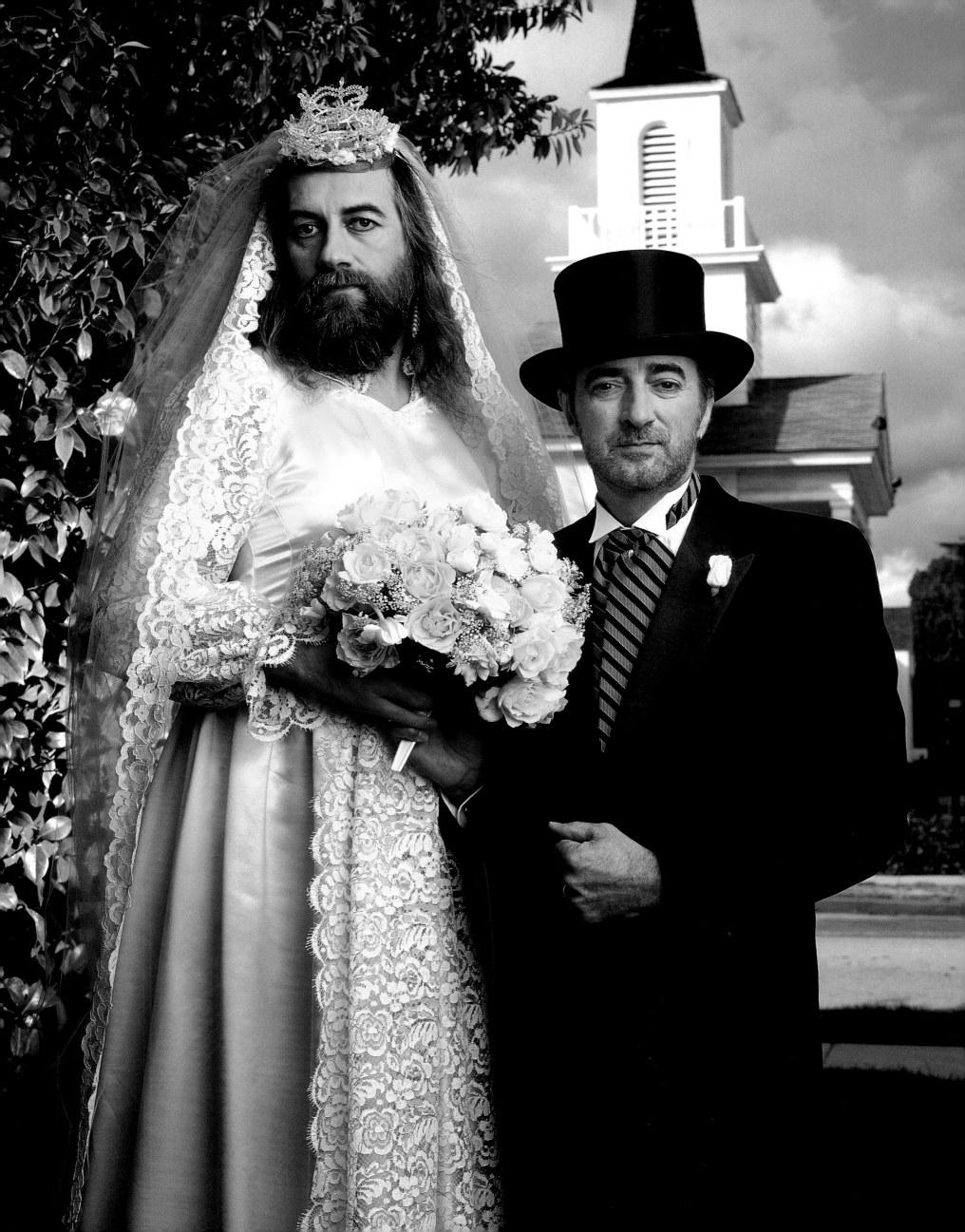

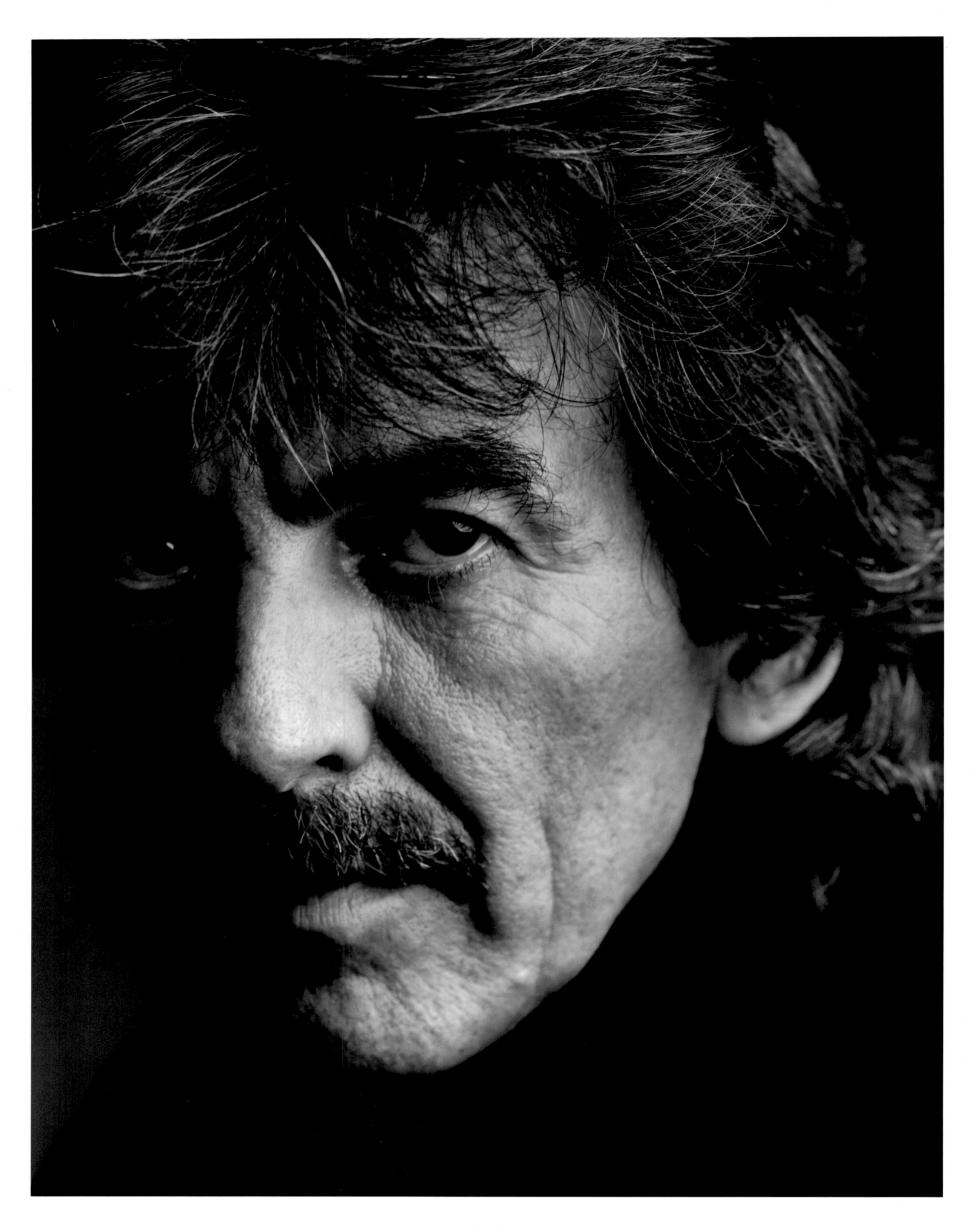

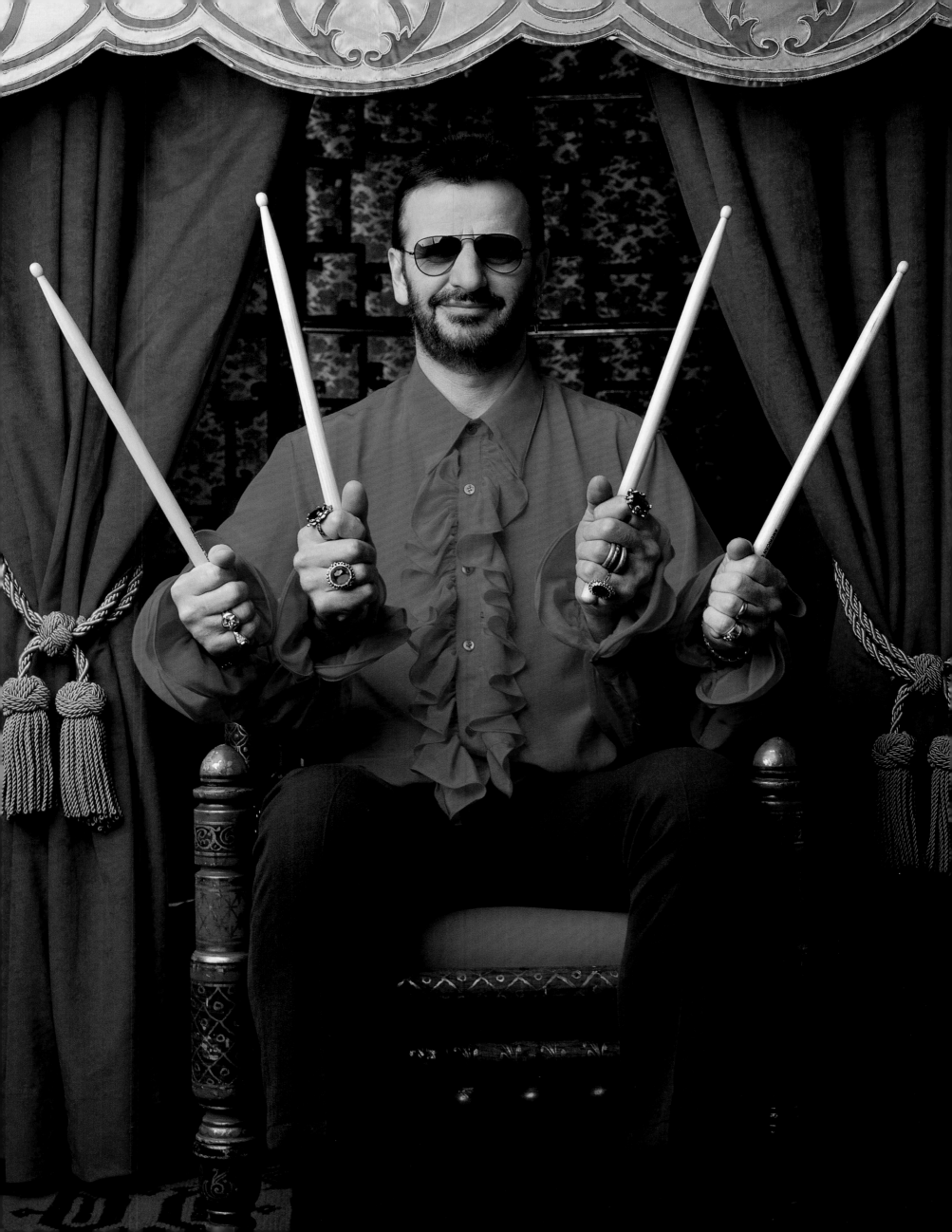

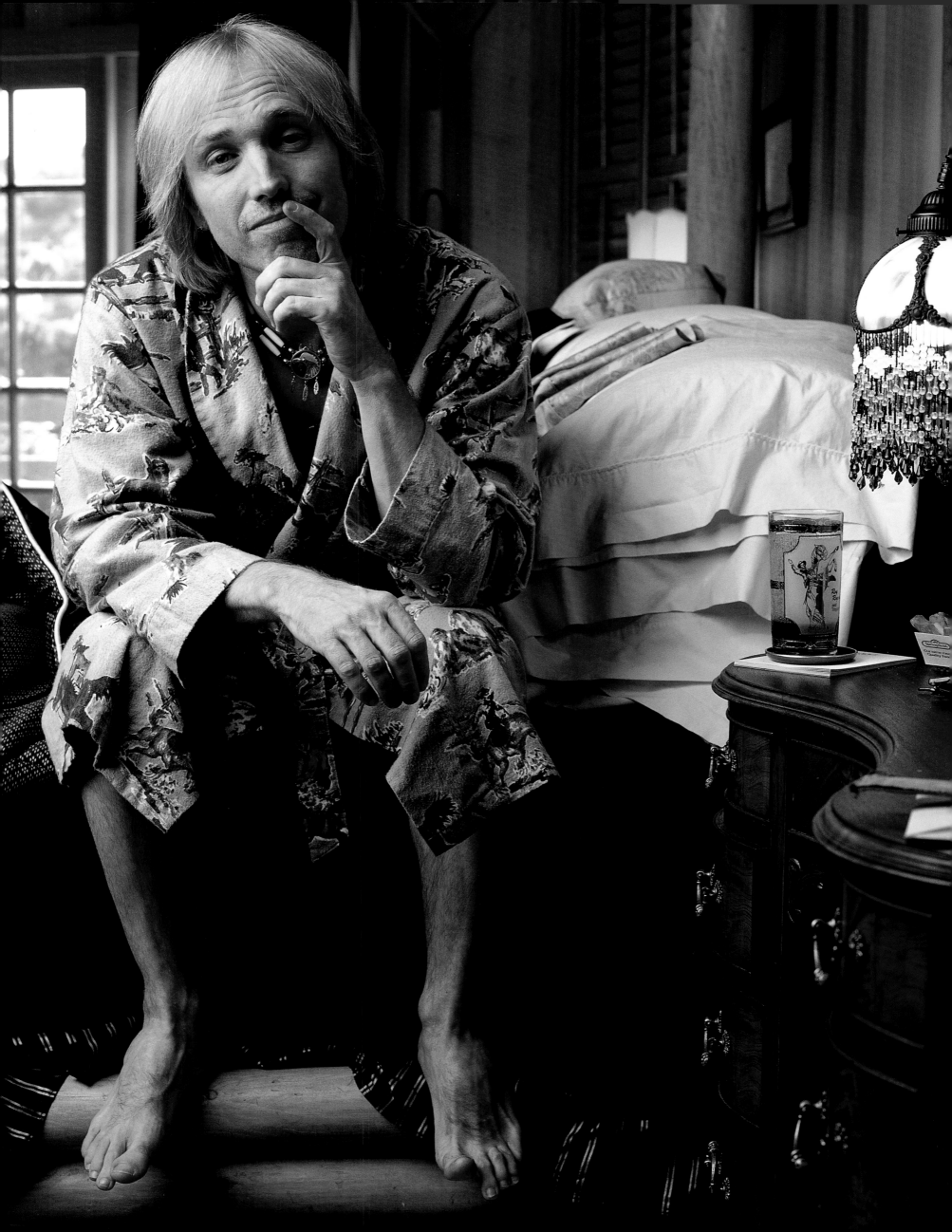

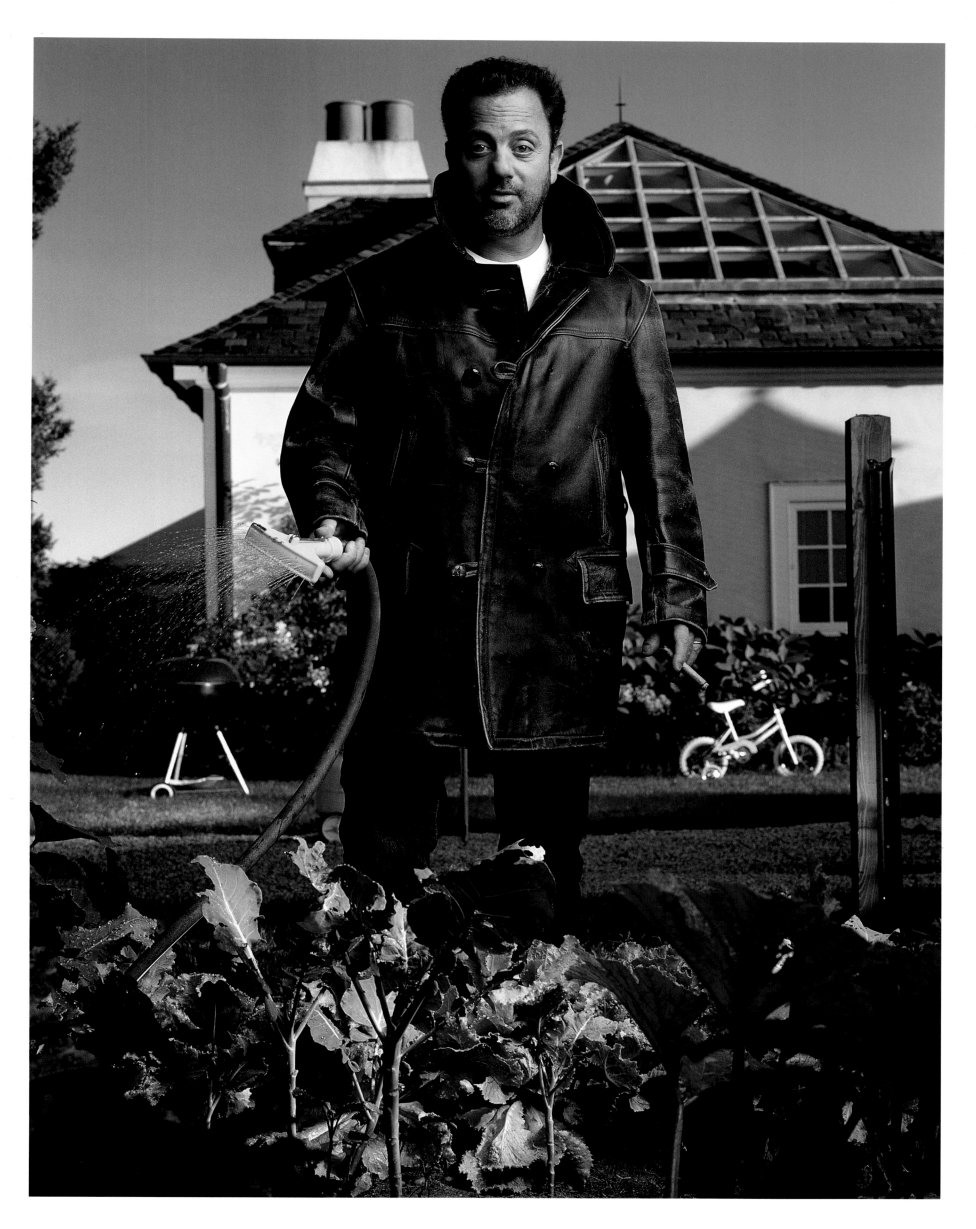

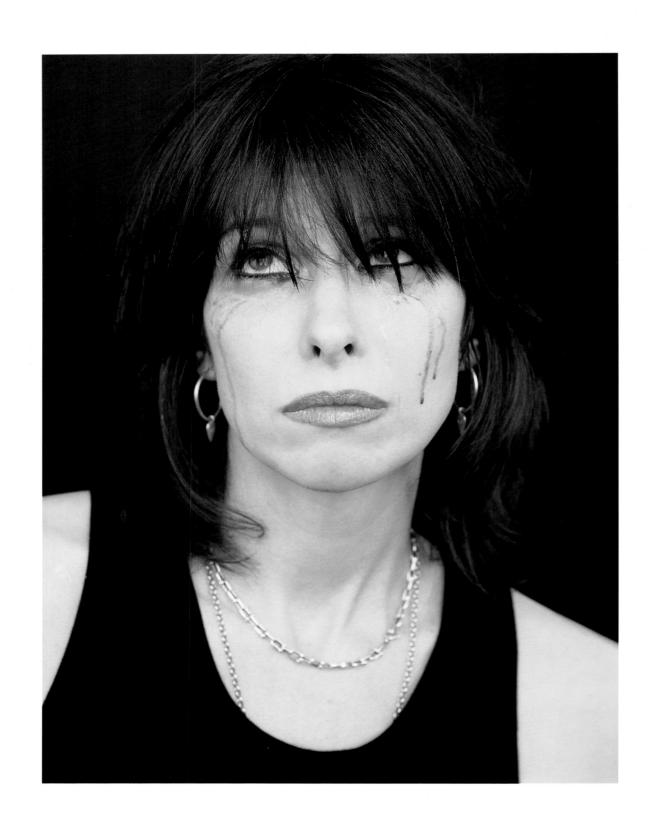

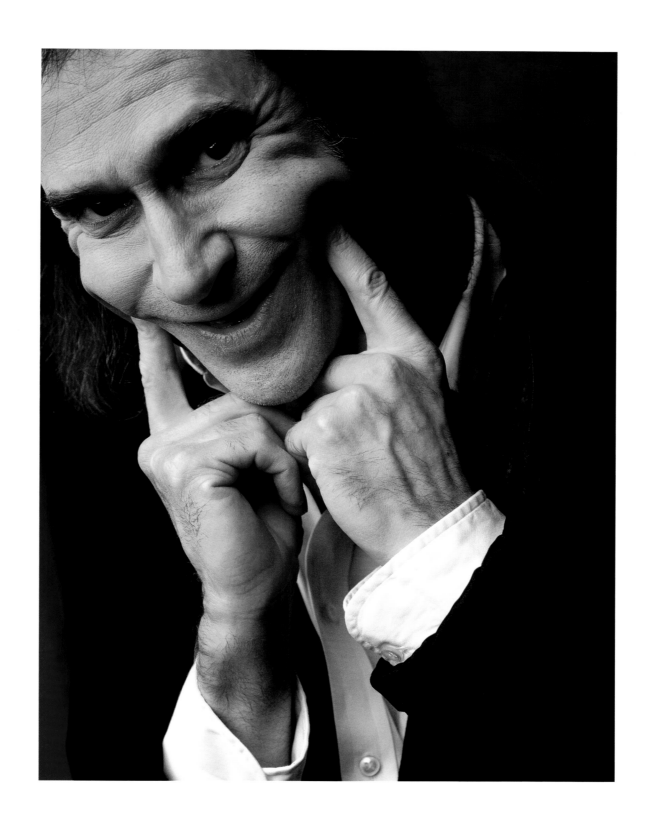

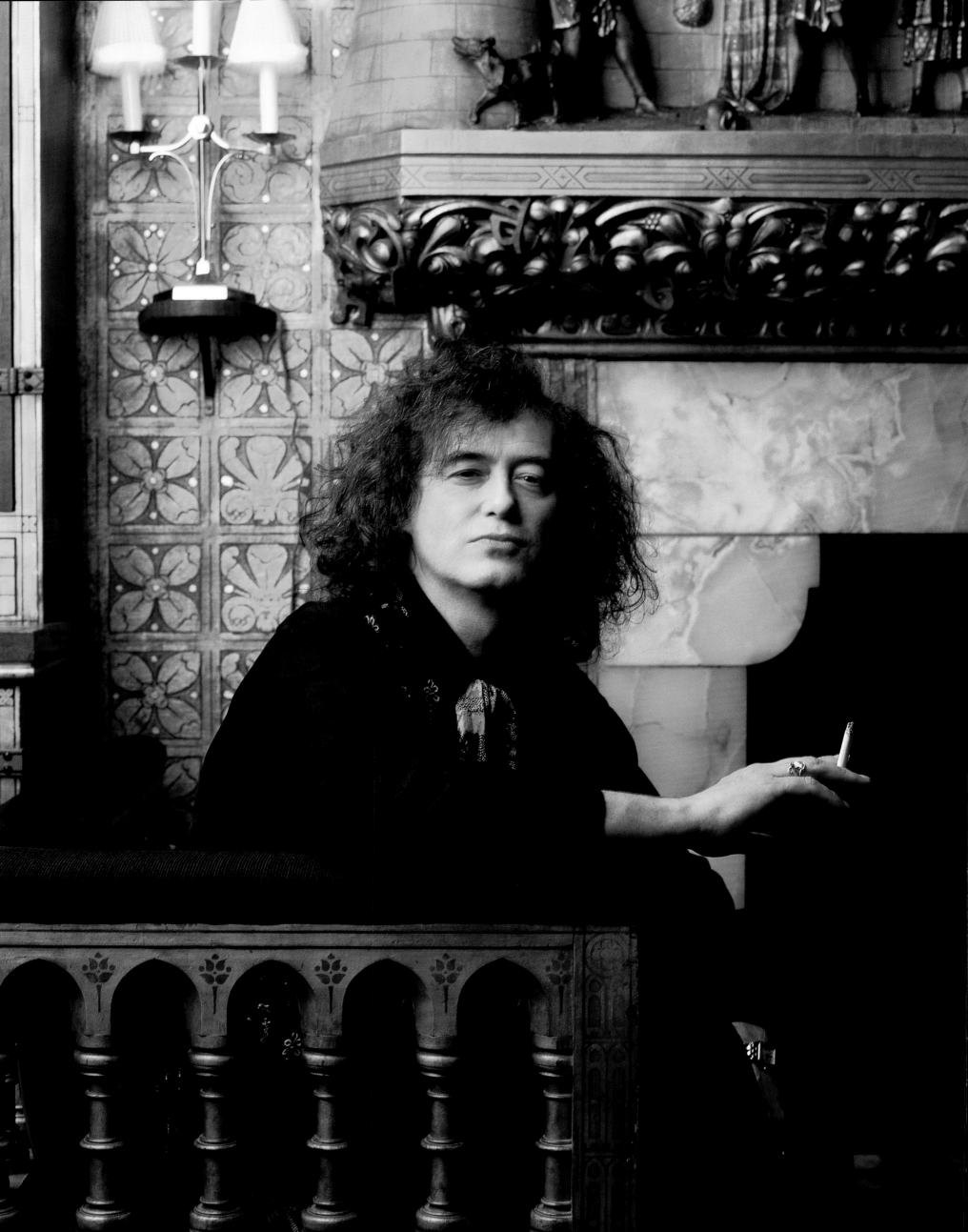

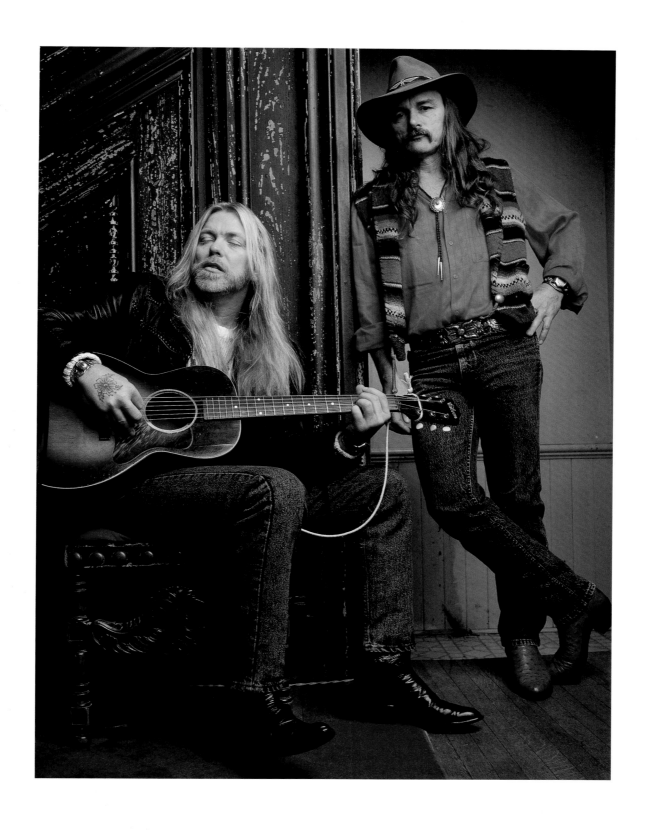

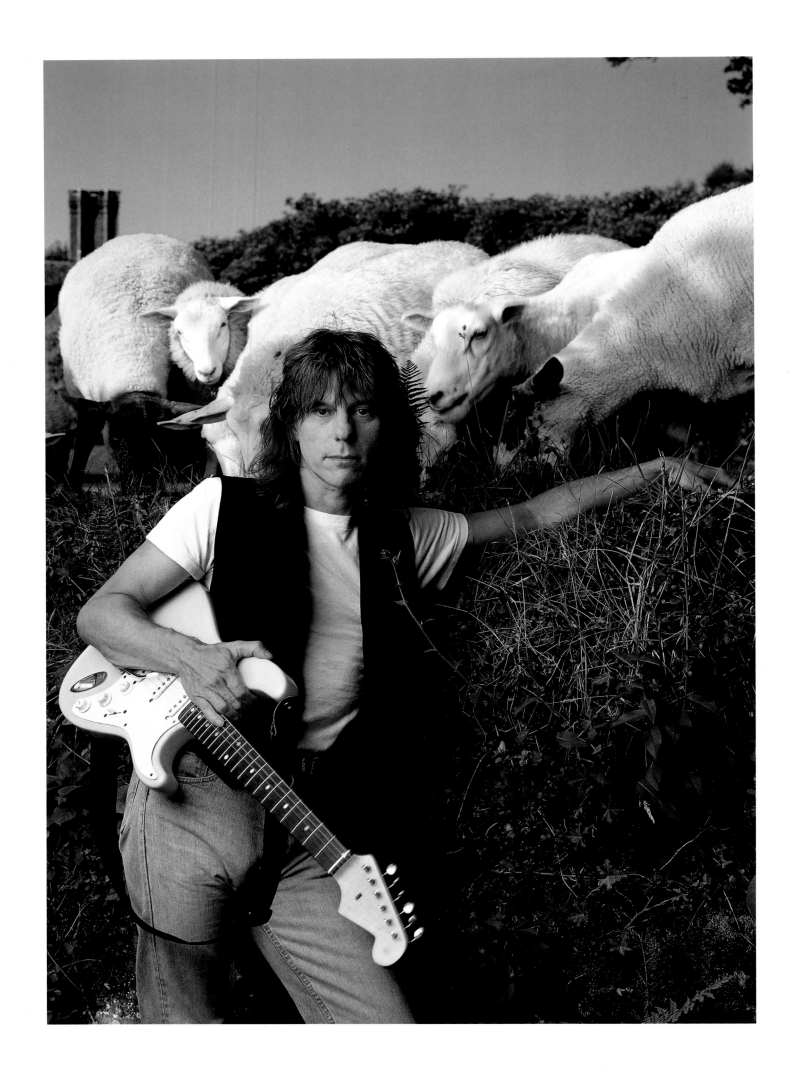

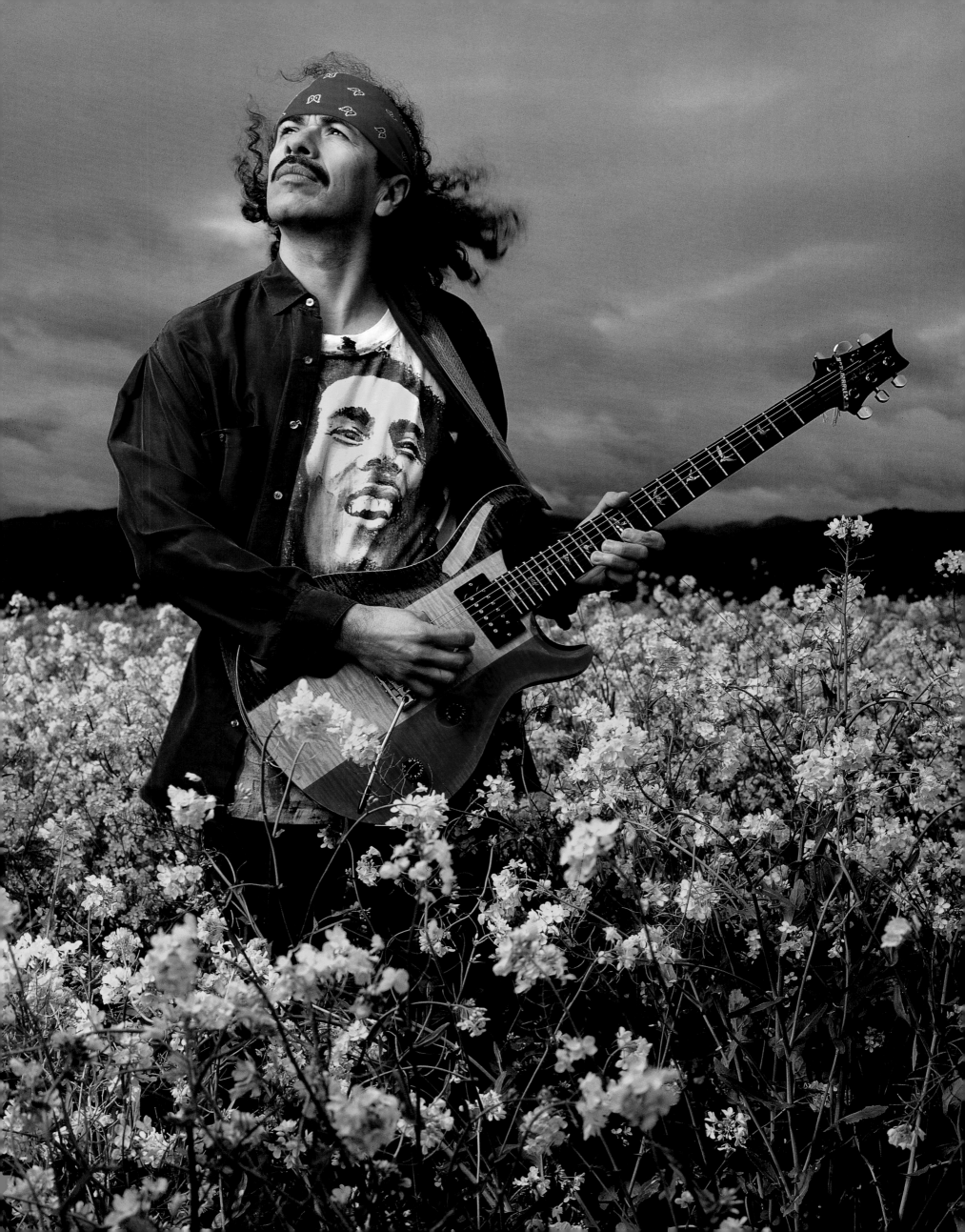

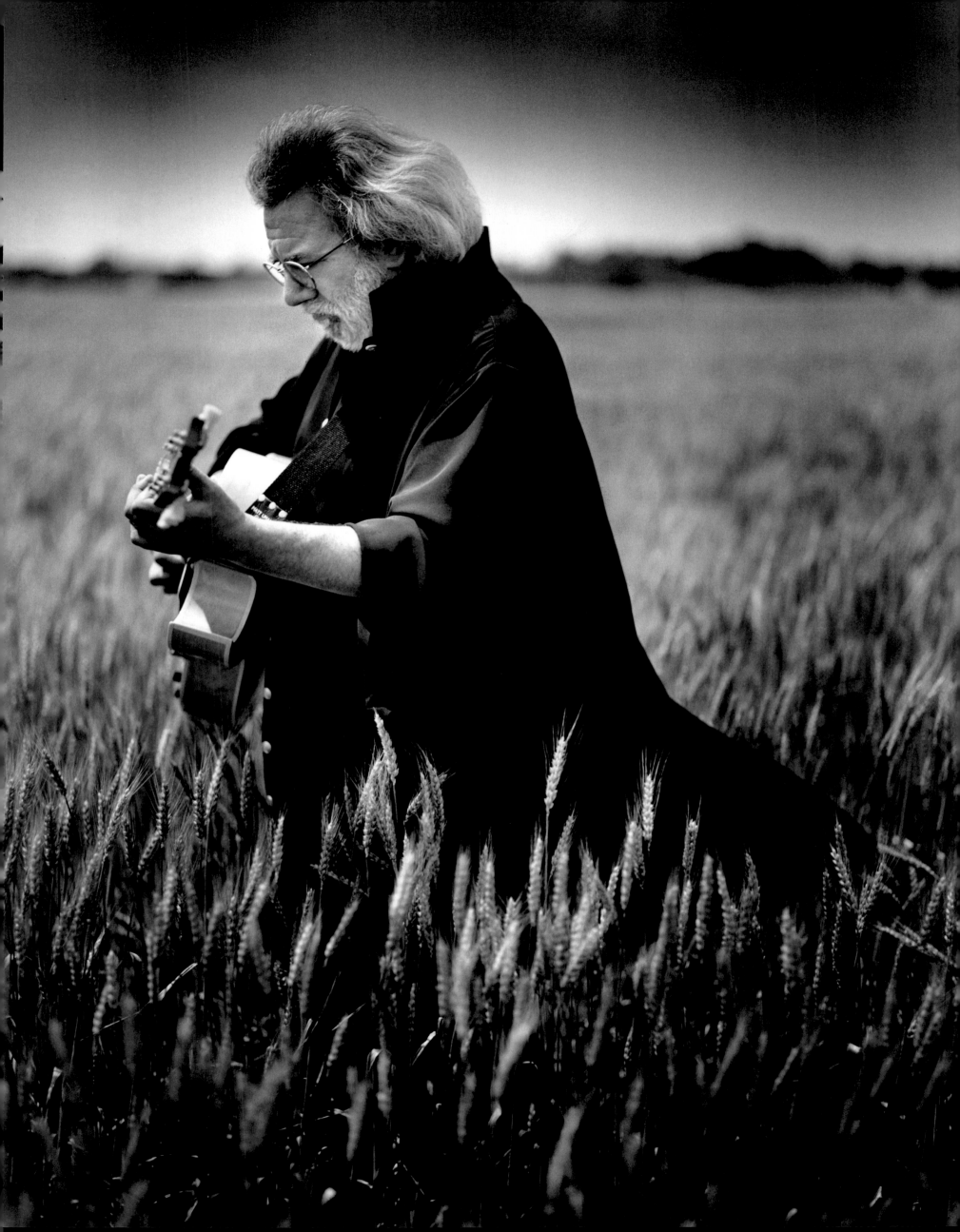

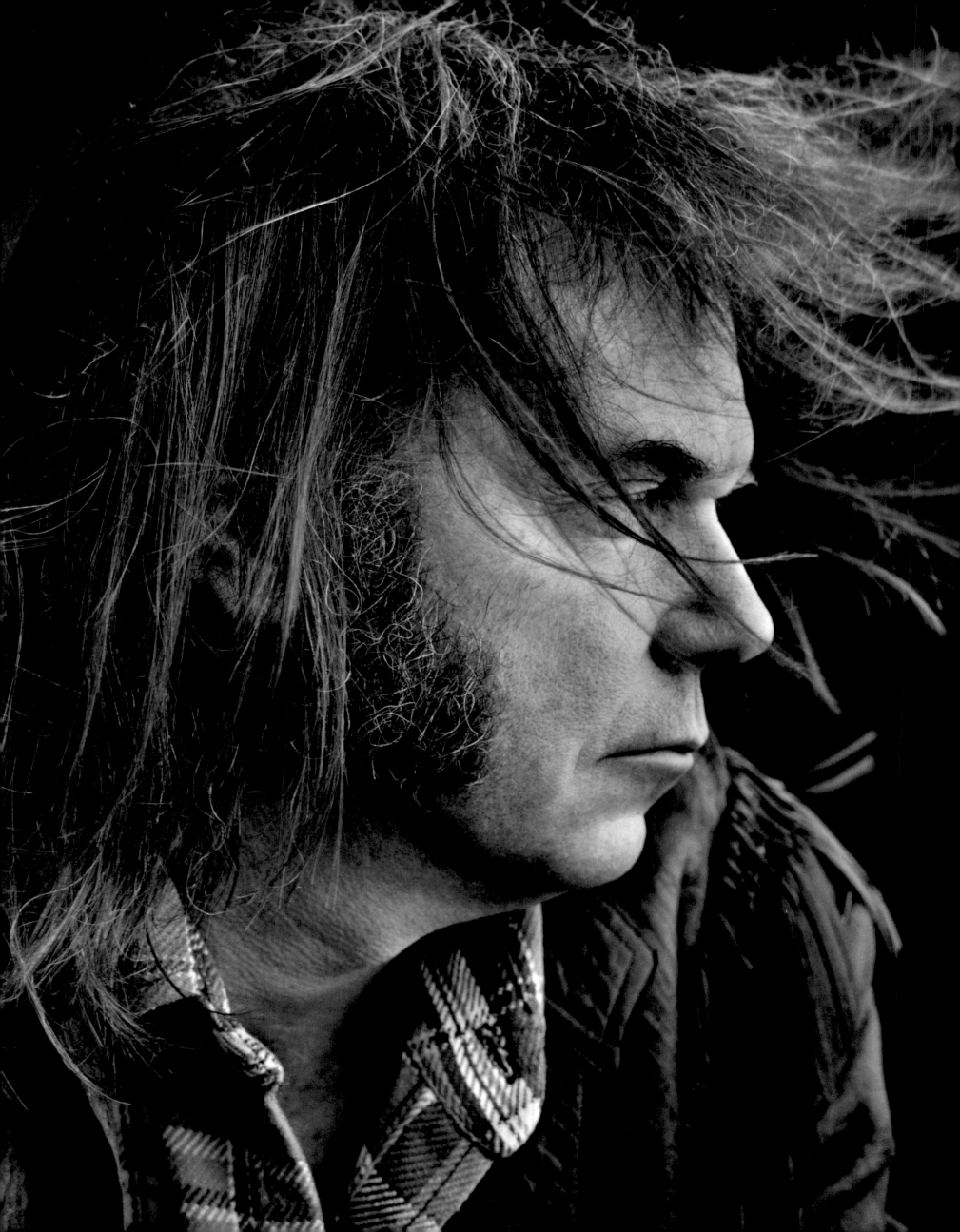

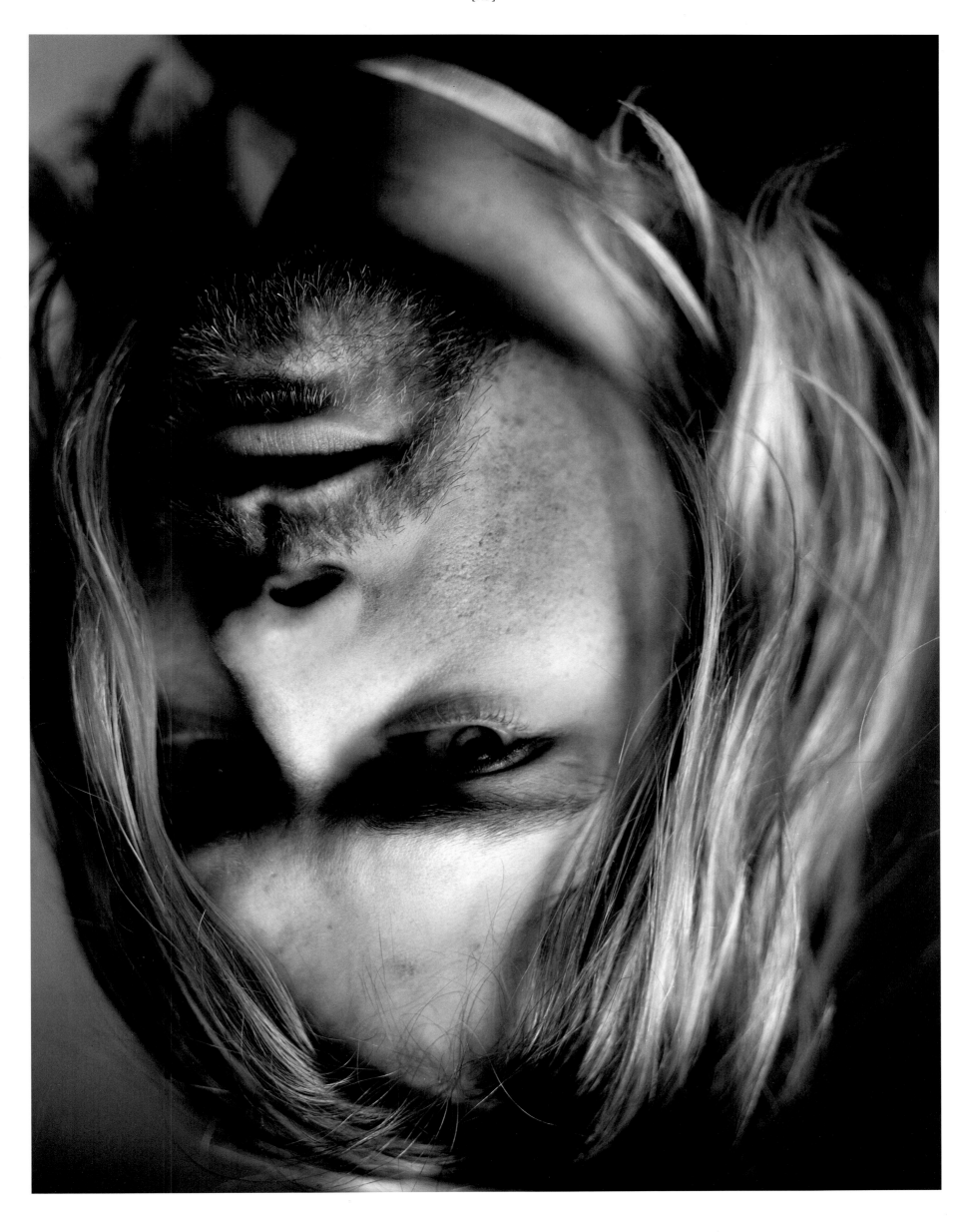

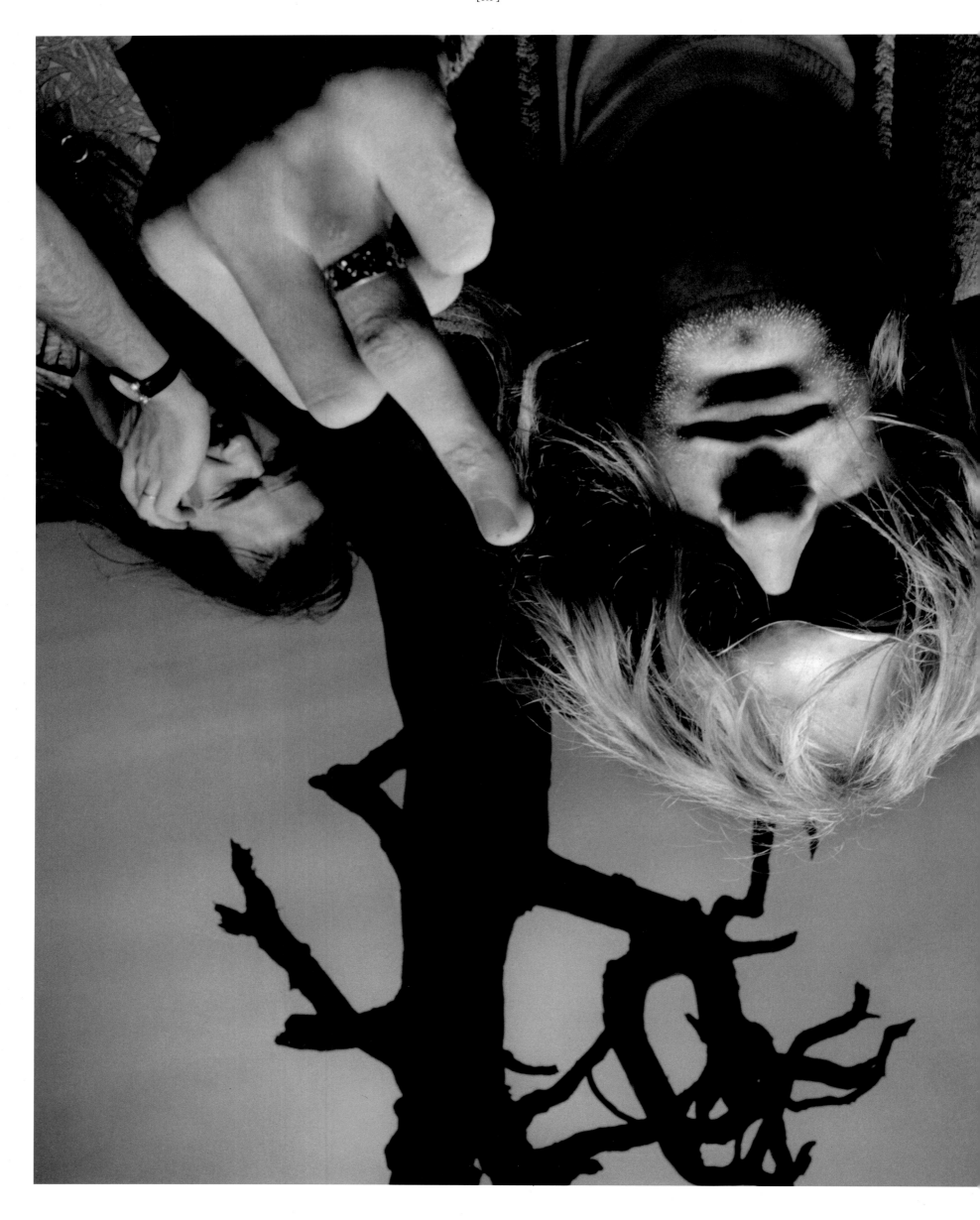

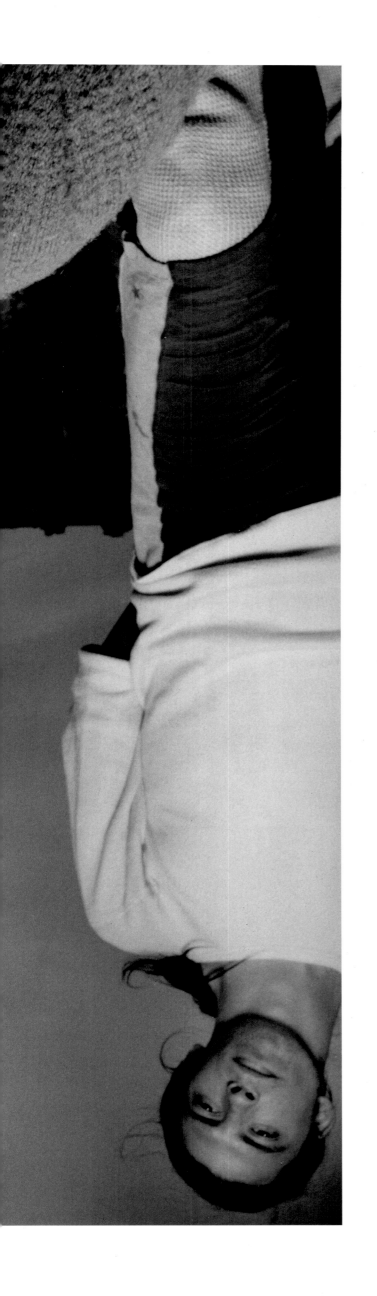

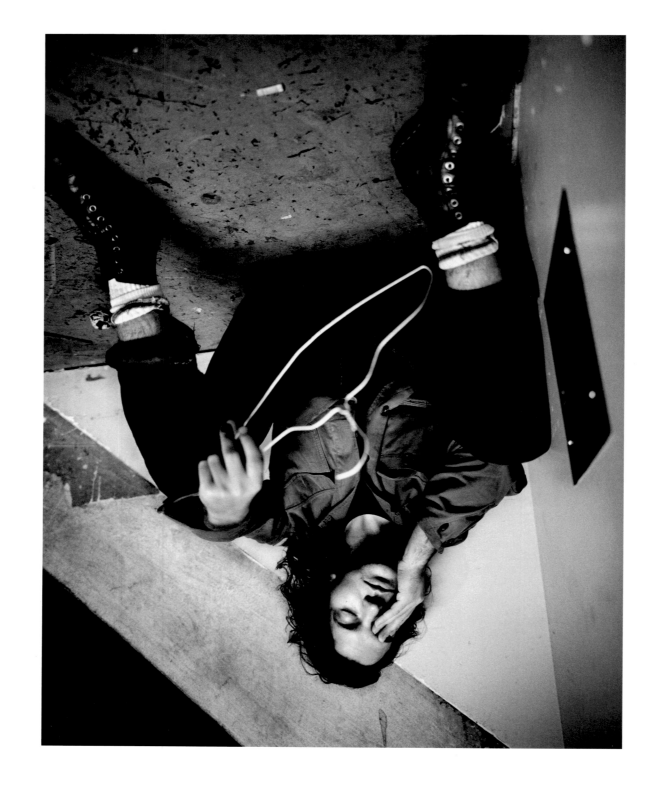

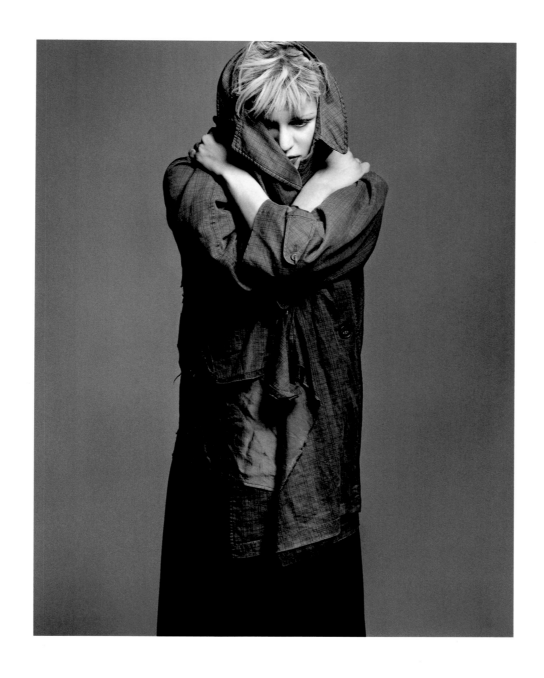

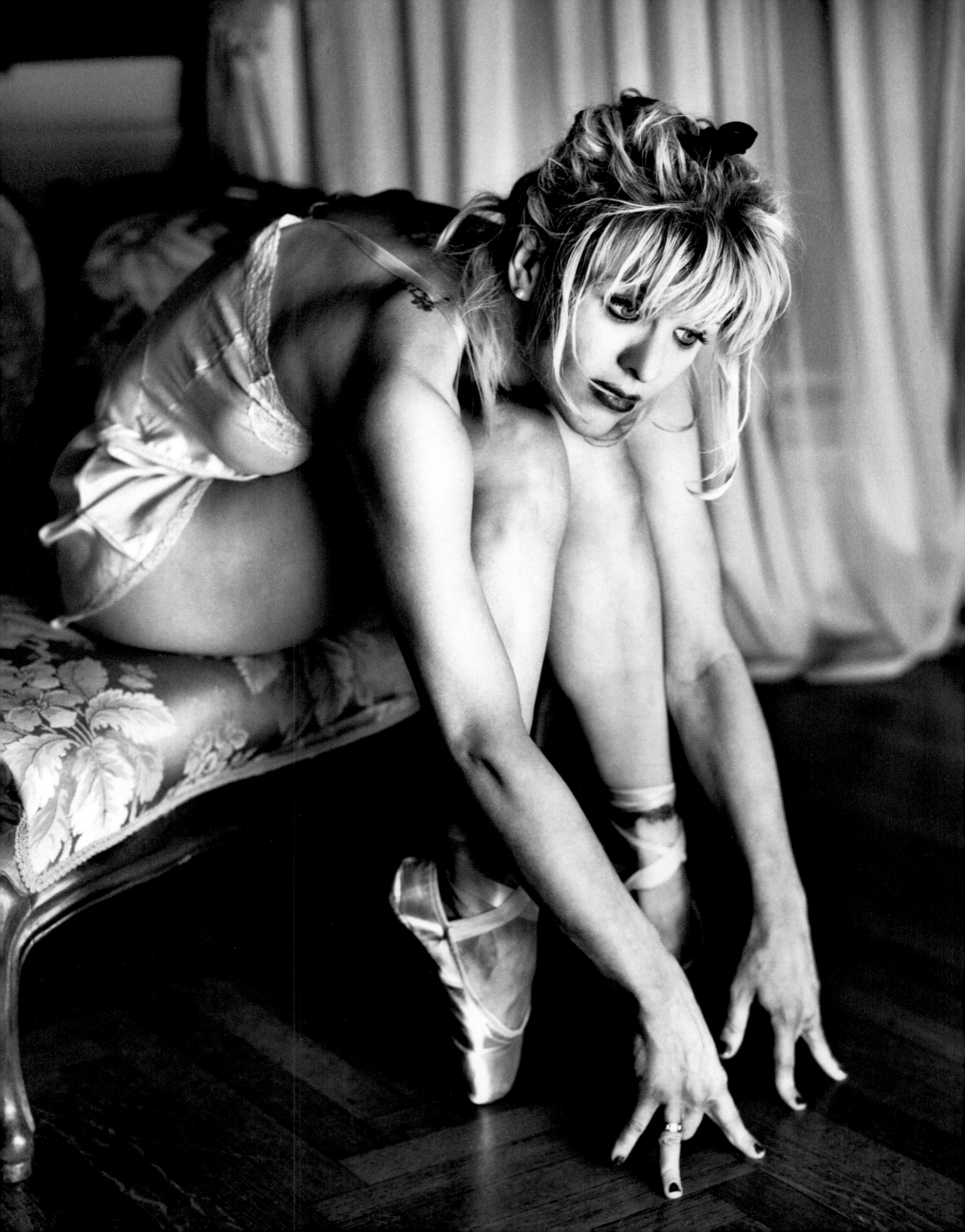

It came to me

as an epiphany of sorts, spurred by an Arnold Newman portrait of Igor Stravinsky: the composer's elbow on a grand piano, his hand on his face, this arrangement echoing the architecture of the piano, which resembles a large musical note. My college professor James Newberry had been passionately elaborating on this photo in my Environmental Portraiture class. Just weeks before, he had singled me out during one of his first tough critiques of the class's work, driving home the point that not all of us had the talent to become photographers. Humbled and discomfited, I'd bowed my head and left class early. But now, during this history of photography lecture, fireworks went off inside me as I realized I wanted to photograph artists – writers, musicians, painters, dancers, sculptors. I wanted to figure out a way to capture human emotion. I needed to connect.

My best friend at East Texas State, Tom Connors, and I would lie out on top of his LeSabre under the big night sky drinking beer and fantasizing about one day publishing our own books of photographs. I told him what Rob Lawton, my graphic-arts professor, had explained in class: "Ideas are the foundation of the art, and technique is the process used to illustrate the idea."

After graduating from college and then working a brief stint in Houston as an assistant to corporate photographers, I was persuaded to move to New York by my sister Lori, who had visited once and felt the city had an energy I would love. I moved into my brother Yoel's apartment in Crown Heights, Brooklyn, in a Lubavitcher community, a neighborhood that was home to Hasidic Jews, Haitians, Jamaicans and Puerto Ricans. I'd never experienced such diversity – it set me free.

Each morning I ventured into Manhattan with my fresh roll of dimes and cold-called every photographer I could, occasionally interrupted by others waiting to use the phone at the Twenty-third Street Woolworth. It became my Manhattan office for the first three months I was in New York. Eventually I found work assisting a plethora of talented photographers who worked for *Rolling Stone, Time, Musician* and *Esquire,* before deciding that if I was going to work that hard for other people, I might as well do it for myself. I stopped assisting and jumped into the fire. I moved to upper Manhattan, and for six months my days were spent dropping off my portfolio to various magazines, going to the local bodega on 104th Street for *café con leche* and obsessively checking my answering machine or just staring it down when I got home. Then I started to get work.

Ellen Madere of *Esquire* generously gave me my first assignment – taking a photo of Bryant Gumbel wearing a Cubs cap, shot against a gray seamless backdrop I had set up in his office. I'd assisted Ellen's husband, John Madere, for a year and had become close friends with him, so she threw this dog a bone. Most of my portraits for the next year were for *Business* magazine, and then I got a break. Jane Clark, the picture editor for a photo-driven business magazine called *Manhattan Inc.,* gave me a series of assignments shooting businessmen. A popular trend in the 1980s was for businessmen to look like rock stars. So, somehow, in some perverse way, shooting them for *Manhattan Inc.* became my training ground. I had the opportunity to carve my own portrait style while testing on some pretty willing subjects. If I could make these guys look cool, I thought, then the music and art world would be a breeze.

For me, the editorial pinnacle was *Rolling Stone,* which had a well-known history of providing an especially creative environment for photographers. Laurie Kratochvil, my first photo editor there, soon became my mentor. She started me off with what seemed to be a simple assignment: photographing a group of New York University film students for the 1987 Hot issue. Procrastinating, I couldn't seem to commit to a due date. I realized that the professor in Texas who used to contemptuously jab me with, "Seliger only works under pressure" must have been right.

I finally scheduled the shoot, and on January 10, 1987, three NYU students posed outdoors for me in minus-ten-degree weather for eight hours. Just moments before we all froze to death, I decided I had gotten my picture and released the weary subjects. In an attempt to save money on the project, I had borrowed a friend's Toyota and now loaded my gear into it. Seconds before I closed the door, having finished adjusting my bags, a bus slammed into the driver's side door, spinning me and the door onto the icy street. In retrospect, I think I may have been in hypothermic shock, because I jumped up and chased the bus for what seemed like a mile, getting just close enough to read the license plates, but arriving there too exhausted to focus on the numbers. I gave up and headed back to the car, taped the door on and drove uptown, dreading the inevitable explanation to my friend. The Toyota's repair bill came to twelve hundred dollars, so my first *Rolling Stone* shoot cost me around fifteen hundred bucks. It all became worth it, though, when Laurie left a message on my machine saying how happy she was with the pictures I'd turned in and informing me that there would be plenty more assignments to come. The eagle had landed.

Perry Farrell was the first person I shot for *Rolling Stone* who qualified as a rock star, though he wasn't as well known in 1987 as he's since become. At the time, though, Jane's Addiction was *the* new West Coast band. I flew out to L.A., went to Perry's house, and we hung out together for two days. I shot him at a show; I shot him with his girlfriend; I shot him at his house in his backyard garden; I shot him at his rehearsal space. I did portraits of him and of the group, which made me realize how much I enjoyed shooting bands. Then, after all that, only one quarter-page picture ran in the magazine.

A few months later, my first *Rolling Stone* cover assignment came from associate photo editor Jim Franco on the spur of the moment: Paul Simon and Ladysmith Black Mambazo. I had only four hours to prepare to photograph this great songwriter and the ten-member South African group on a backdrop of white seamless, and then, as if I wasn't nervous enough already, Paul Simon called, saying, "We need to do this quickly, okay?" "Sure, Paul." "Good, I'll be over in fifteen minutes." By that time, Ladysmith Black Mambazo had started filtering into the studio, and I panicked. How the hell was I going to group all of them plus Paul Simon together on one page? It was like solving a jigsaw puzzle, and luckily I discovered I had a flair for it. After I'd shot a couple rolls of film, Paul and the gang started to sing, and I got my first real taste of the kind of perks that come with being a music photographer. Everyone working on the session suspended animation, transfixed by the a cappella voices.

After the shoot was finished I called my folks in Texas and shared my day with them, swearing that I could care less if I ever shot another cover for *Rolling Stone,* that just having done this one was enough. But I was a damn liar – shooting the covers became an addiction.

Rolling Stone kept me plenty busy, and I had a great time working on its covers, stories and photo essays. Then, in 1991, Laurie and *Rolling Stone* art director Fred Woodward asked me if I wanted to be involved in the magazine's Twenty-fifth Anniversary Portraits issue. I was flattered and honored, but I knew the other photographers on the project were hard acts to follow. It was a scary prospect: "Oh no, another test! I'll surely fail this one!" I had four or five subjects assigned to me initially; that turned into ten, and then the number just kept on growing. Among the first was a portrait of Mick Fleetwood and John McVie. The results pleased me so much, I started a series of images bent toward the surreal and unusual. Before the shoot, I talked to Mick Fleetwood's publicist, and he said, "You know, I want to warn you that, for Mick, the kinkier the better." So I called up Mick, and he spoke to me from his studio. He said, "What do you have planned for this little photo shoot?" I said, "Well, what I really want to do is this photograph of you and John McVie – I know it's gonna sound crazy – but as a bride and groom." He goes, "Oh, good! That sounds terrific. We're celebrating our twenty-fifth anniversary as a band. It'll be perfect. I want to ask just one

little favor." I said, "What?" He answered, "I want to be the bride."

After the Twenty-fifth Anniversary portfolio was finished, Laurie, Fred and I met for a drink and they asked me if I'd be interested in working full-time for *Rolling Stone*. My duties would be shooting half the magazine's covers and bringing the visual approach that I used for them to *US* magazine, *Rolling Stone*'s sister publication. After my subsequent meeting with editor and publisher Jann Wenner, I became Chief Photographer of both magazines.

All this changed my life substantially and presented a huge challenge. It was daunting to know I was now going to be shooting all types of people. For instance, I had always been interested in photographing women, but had never actually done it. At first I found it difficult, because dealing with feminine beauty requires a whole different set of technical rules, the details of which I'd been previously unaware. I now had to rethink lighting; I had to rethink how I would approach my subjects.

In that regard, photographing Drew Barrymore for an *US* magazine portfolio proved a breakthrough for me, for together we experienced an absolute, instant mutual trust. We spoke briefly on the phone before the shoot, and it was as though we'd known each other for years. A shoot usually requires me to put my subject at ease, but in this case Drew was the one who did that for me. When I started to explain what I wanted to do for her session, she stopped me in midsentence and said, "Whatever you feel like doing is fine – I totally trust you." It was like when you ask a pretty girl out on a date expecting her to say no, and, astoundingly, she says yes – I kept yammering on, as if she had said no. She repeated: "I totally trust you, whatever." That kind of reaction from subjects is rare and welcome, but it also creates a lot of pressure not to let them down. During that first session, we shot Drew as a "naughty" Alice in Wonderland, and we shot her in a boxing ring in South Central L.A. wearing only boxing gloves and a fighter's cup. After seeing the day's results, I felt we had captured her like nobody had before. I'd revealed that little dark edge of the cute, familiar Drew Barrymore. She truly has the ability to be a chameleon – Drew is my original muse.

One of the challenges and benefits of working for *Rolling Stone* and *US* is having the opportunity to capture artists just as they're breaking through. That was the exciting aspect of photographing Brad Pitt for the first time – it gave a sort of naive quality to the entire session. Uncompromising and unpredictable, Brad is true to his art. Each of the four sessions we've done together has turned into a sort of adventure. Our sessions have always been uninterrupted and concentrated, truly collaborative. As a result, we've created a journal of time and place. Our work together perfectly embodies my philosophy of photography.

During our first conversation, in 1994, while planning a cover session for *Rolling Stone*, Brad proposed that we do his shoot in a Los Angeles barrio. I took his lead and suggested Mexicali, in Baja California, Mexico. At the time, he and I were at similar places in our careers. We both realized the artistic value of putting ourselves outside our usual element in order to push our individual envelopes and create work that was truly different for us. *Rolling Stone*'s new photo editor, Jodi Peckman, and I met Brad for our shoot in San Diego, a town where he could still feel completely anonymous. Each morning we drove for two hours to get to Mexicali. We'd cross the border and go into town and start walking along the streets, taking pictures. We were just a couple of gringos coming in, shooting photos of a buddy. We'd see a group of kids, and Brad would start playing soccer with them, or we'd be on the street and he would have a taco. We documented it all.

On the second day we happened upon a dry lake bed that was absolutely magical. As the sun started to drop low, and while Neil Young's *Mirror Ball* cranked on my boom box, the sky became a mixture of deep blue, purple and orange. We shot picture after picture, knowing this would be our only chance to capture that idyllic tableau. Since then, whenever Brad and I work together, we try to recapture the spirit of that first shoot.

Photographing Nirvana resulted in some of my favorite pictures also. At the time of our first session, which was shot in Australia, the last thing Nirvana wanted – particularly Kurt Cobain – was to be on the cover of *Rolling Stone*. The day before the session I had specifically said to the band, "Tomorrow, if you don't mind, could you wear plain shirts without any writing on them? It'll photograph better." The next day Kurt showed up on location wearing a T-shirt on which he'd written CORPORATE MAGA-ZINES STILL SUCK, and he refused to take off his sunglasses. Though I tried to negotiate with Kurt, he wouldn't budge. He wasn't angry at me – he was just happy to be standing there making his statement. It was very important to him not to be seen as selling out.

I photographed Nirvana for the second time when *In Utero* came out. I imagined they thought I was the devil – the *Rolling Stone* photographer who had helped change their status from underground to mainstream. But instead, the opposite was true. Letting Nirvana do as they wished during the first session had worked in my favor. This time when I saw Kurt he was warm and talkative. My concept was for Nirvana to wear Brooks Brothers suits, as a play on their first cover, and Kurt was cool about the idea. He thought it would be funny, so we did that for Nirvana's second *Rolling Stone*

cover. Kurt had been open to doing an individual portrait as well, and though he had seemed quite happy during the session, in the resulting photos his face conveyed a real sense of melancholy. A few months later I was in Paris photographing Counting Crows when I got the devastating call from *Rolling Stone* that Kurt had shot himself. He had seemed to be in such a good place when we had done those last photos. One portrait we did together became the cover of a special memorial issue of *Rolling Stone*.

About six months after Kurt died, I photographed Courtney Love for the cover of *Rolling Stone*. She was still very emotionally raw at that point, but we'd developed a comfortable, close relationship while doing a photo shoot together the year before. We did this session in Chicago, from five in the evening till four in the morning. She was spirited and lucid as we photographed her in several different setups. Then, while waiting for us to adjust some lights, she threw on a tattered, gray-plaid raincoat to keep warm in the drafty room. When we resumed the session with Courtney still in the coat, I could see her begin to withdraw, overcome by sadness. Within minutes she was lying quietly on the floor, entirely wrapped in the garment. The coat had belonged to Kurt, it turned out, and after the session, she asked me not to publish those photos in the magazine. I agreed.

* * * * *

I used to write

compulsively in my journal after every photo session I did – either on the plane or back at the studio – dissecting what had gone right or wrong with the shoot. One day I accidentally left my journal on a plane and became obsessed with the idea of a stranger finding it and learning the stories behind my work. Since then, I've stopped making notes afterward, but continue to write down my ideas and sketches for sessions beforehand. I've learned, though, that what happens during a shoot is completely unpredictable. Nine times out of ten, once I get an idea and proceed with it, the concept changes anyway – subjects want to do something different, or it's raining, or the location's not exactly right. As a photographer, you have to be open to adjustments. You have to be willing to put yourself into uncomfortable situations. It may mean falling on your face, but my experience has been that my work has always benefited from facing the unknown.

When I return home after being on location, I drop my bags in the hallway, beneath my framed print of Newman's Stravinsky. It reminds me that the one constant in photography is that you should always strive to please yourself. And to this day I still marvel at how incredibly perfect that portrait is.

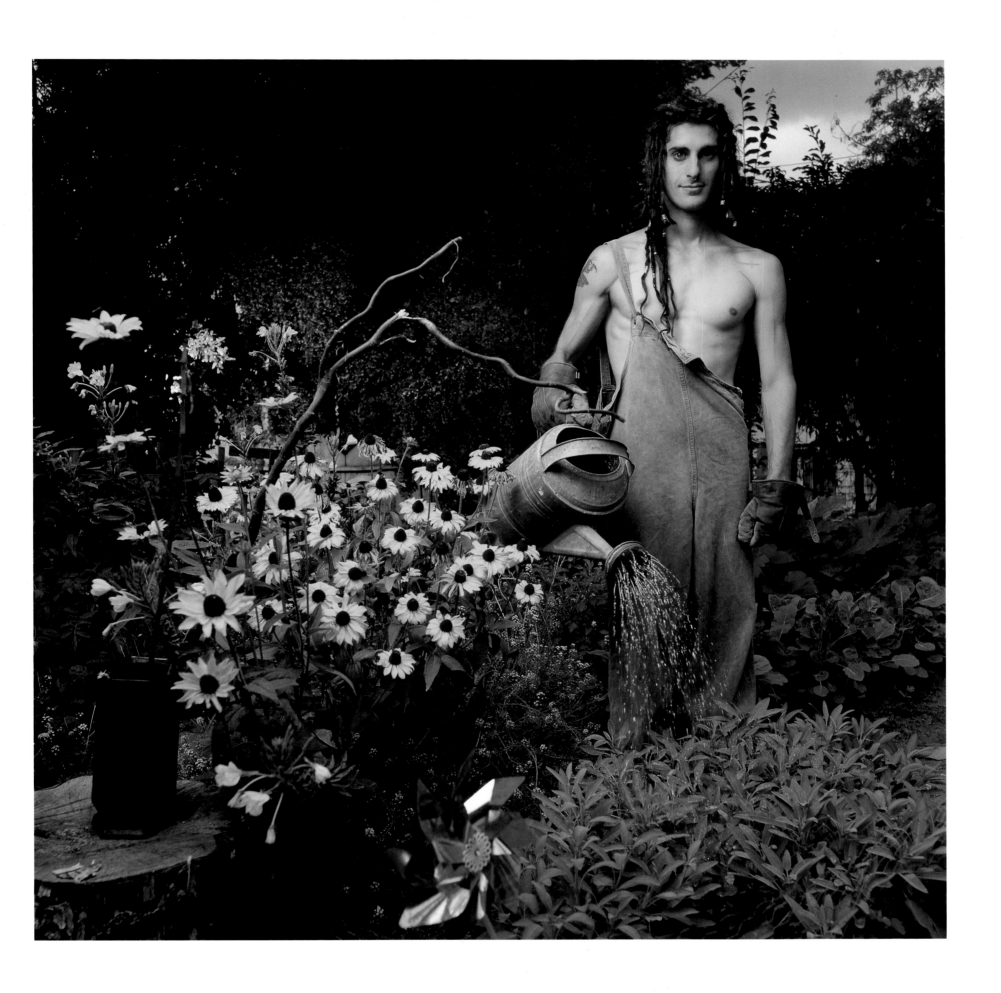

[*The* PLATES]

[3] Tom Hanks
LOS ANGELES, 1994

[5] Ben Stiller
NEW YORK CITY, 1998

[11] Howard Stern
NEW YORK CITY, 1997

[13] Rob Zombie
of White Zombie
YONKERS, NEW YORK, 1998

[14] Fiona Apple
LOS ANGELES, 1997

[15] Slash
LOS ANGELES, 1990

[17] Brad Pitt
MEXICALI, MEXICO, 1994

[18] Brad Pitt
MEXICALI, MEXICO, 1994

[19] Brad Pitt
LOS ANGELES, 1998

[21] Sean Penn
LOS ANGELES, 1992

[22] Mick Jagger
NEW YORK CITY, 1994

[23] Keith Richards
OKLAHOMA CITY, 1994

[24] Hunter S. Thompson
LITTLE ROCK, ARKANSAS, 1992

[25] Keith Richards
WILD BLUE YONDER, 1994

[26] Dr. Dre &
Snoop Doggy Dogg
LOS ANGELES, 1993

[27] Burt Bacharach
& Elvis Costello
LOS ANGELES, 1998

[28] John Lee Hooker
VALLEJO, CALIFORNIA, 1991

[29] John Lee Hooker
VALLEJO, CALIFORNIA, 1991

[30] Bob Dylan
LOS ANGELES, 1998

[31] Bruce Springsteen
COLTS NECK, NEW JERSEY, 1998

[33] Joni Mitchell
LOS ANGELES, 1998

[34] David Byrne
NEW YORK CITY, 1994

[35] Stephen Dorff
LOS ANGELES, 1996

[36] Slash
LOS ANGELES, 1990

[37] Michael J. Fox
BURLINGTON, VERMONT, 1993

[39] Merle Haggard
LAKE SHASTA, CALIFORNIA, 1994

[40] Buck Owens
BAKERSFIELD, CALIFORNIA, 1994

[42] Loretta Lynn
HURRICANE MILLS, TENNESSEE, 1994

[43] Tammy Wynette
NASHVILLE, 1994

[44] George Jones
BRENTWOOD, TENNESSEE, 1995

[45] Kitty Wells
& Johnny Wright
KINGSTON SPRINGS, TENNESSEE, 1994

[46] Willie Nelson
NEW YORK CITY, 1995

[47] Bill Monroe
NASHVILLE, 1994

[48] Johnny Cash
HENDERSONVILLE, TENNESSEE, 1992

[49] Lyle Lovett
HOUSTON, 1998

[50] Dwight Yoakam
LOS ANGELES, 1993

[51] Billy Bob Thornton
TORONTO, 1997

[52] Bill Clinton
LITTLE ROCK, ARKANSAS, 1993

[53] Elisabeth Shue
PALM SPRINGS, CALIFORNIA, 1995

[54] Me'Shell Ndegéocello
NEW YORK CITY, 1996

[55] Jakob Dylan
NEW YORK CITY, 1997

[56] Sean Lennon
ATLANTIC CITY, NEW JERSEY, 1998

[58] Marilyn Manson
LOS ANGELES, 1998

[59] Marilyn Manson
LOS ANGELES, 1998

[60] James Iha
of Smashing Pumpkins
CHICAGO, 1995

[61] Shirley Manson
of Garbage
LONDON, 1996

[62] Bob Dylan
NEW YORK CITY, 1995

[63] Adam Duritz
of Counting Crows
PARIS, 1994

[64] Paula Cole
NEW YORK CITY, 1997

[66] Green Day
*Billie Joe Armstrong,
Mike Dirnt & Tré Cool*
NEW YORK CITY, 1995

[67] Sinéad O'Connor
NEW YORK CITY, 1992

[68] Sheryl Crow
NEW YORK CITY, 1996

[69] Pat Conroy
CHARLESTON, SOUTH CAROLINA, 1995

[70] Ralph Fiennes
LONDON, 1996

[71] Johnny Depp
MOJAVE DESERT, CALIFORNIA, 1993

[72] Dr. Dre
LOS ANGELES, 1993

[74] Cameron Diaz
NEW YORK CITY, 1996

[76] Tom Jones
SARATOGA, CALIFORNIA, 1994

[79] Robin Williams
NEW YORK CITY, 1991

[80] Uma Thurman
LONDON, 1998

[81] Quentin Tarantino
NEW YORK CITY, 1994

[82] Christian Slater
LOS ANGELES, 1994

[83] Ethan Hawke
ELGIN, TEXAS, 1997

[84] Arnold
Schwarzenegger
LOS ANGELES, 1994

[85] Leonardo DiCaprio
NEW YORK CITY, 1994

[87] Bill Murray
LOS ANGELES, 1996

[88] Alicia Silverstone
NEW YORK CITY, 1997

[89] Djimon Hounsou
LOS ANGELES, 1998

[90] Glenn Danzig
NEW YORK CITY, 1994

[91] Melissa Etheridge
CHATSWORTH, CALIFORNIA, 1995

[92] Charlize Theron
NEW YORK CITY, 1997

[93] Garry Shandling
LOS ANGELES, 1994

[94] Jerry Seinfeld
LOS ANGELES, 1998

[95] Jason Alexander,
Michael Richards,
Julia Louis-Dreyfus
& Jerry Seinfeld
LOS ANGELES, 1998

[96] Will Smith
LOS ANGELES, 1997

[97] Julia Louis-Dreyfus
& Jerry Seinfeld
LOS ANGELES, 1993

[98] Perry Farrell
of Jane's Addiction
LOS ANGELES, 1994

[99] Mark Spitz
NEW YORK CITY, 1990

[100] Lauryn Hill
NEW YORK CITY, 1998

[101] Maxwell
LOS ANGELES, 1998

[102] Sandra Bullock
ANGUILLA, 1996

[104] Claire Danes
BORREGO SPRINGS, CALIFORNIA, 1996

[105] Mel Gibson
LOS ANGELES, 1993

[106] Rich &
Chris Robinson
of the Black Crowes
MACON, GEORGIA, 1992

[107] Chris Barron
of the Spin Doctors
POUGHKEEPSIE, NEW YORK, 1992

[108] Dave Pirner
of Soul Asylum
NEW YORK CITY, 1993

[110] Jodie Foster
PASADENA, CALIFORNIA, 1994

[111] Ashley Judd
MALIBU, CALIFORNIA, 1995

[112] Kennedy
NEW YORK CITY, 1994

[113] Elvis Costello
NEW YORK CITY, 1998

[114] Jackson Browne
NEW YORK CITY, 1996

[116] Lenny Kravitz
NASSAU, BAHAMAS, 1998

[117] Lenny Kravitz
NASSAU, BAHAMAS, 1998

[119] Curtis Mayfield
DUNWOODY, GEORGIA, 1993

[120] Winona Ryder
NEW YORK CITY, 1997

[121] Timothy Leary
BEVERLY HILLS, 1996

[122] RZA
of Wu-Tang Clan
NEW YORK CITY, 1997

[123] Zack de la Rocha
of Rage Against the Machine
NEW YORK CITY, 1997

[124] Michael Stipe
of R.E.M.
LOS ANGELES, 1994

[125] Peter Buck
of R.E.M.
LOS ANGELES, 1994

[126] Mike Mills
of R.E.M.
LOS ANGELES, 1994

[127] Bill Berry
of R.E.M.
LOS ANGELES, 1994

[129] James Hetfield
of Metallica
ST. PETERSBURG, FLORIDA, 1993

[130] Red Hot Chili Peppers
Chad Smith, Anthony Kiedis,
Flea & John Frusciante
LOS ANGELES, 1992

[131] Metallica
Kirk Hammett, Lars Ulrich,
James Hetfield & Jason Newsted
PARIS, 1991

[132] Axel
NEW YORK CITY, 1990

[133] Siegfried & Roy
LAS VEGAS, 1991

[134] Jerry Seinfeld
LOS ANGELES, 1994

[135] Jerry Seinfeld
LOS ANGELES, 1994

[136] Chris Rock
LOS ANGELES, 1997

[137] Chris Rock
NEW YORK CITY, 1997

[138] Michael Richards
NEW YORK CITY, 1993

[139] Dana Carvey
LOS ANGELES, 1993

[141] Phish
Page McConnell, Jon Fishman,
Trey Anastasio & Mike Gordon
WESTFORD, VERMONT, 1995

[142] Lucinda Williams
NASHVILLE, 1998

[143] Richard Ashcroft
of the Verve
LONDON, 1998

[145] Jenny McCarthy
LOS ANGELES, 1996

[146] Nicole Kidman
NEWPORT PAGNELL, ENGLAND, 1996

[147] Liam Gallagher
of Oasis
NEW YORK CITY, 1997

[148] Claire Danes
BORREGO SPRINGS, CALIFORNIA, 1996

[149] Benicio Del Toro
& Parker Posey
NEW YORK CITY, 1995

[150] Christina Ricci
LOS ANGELES, 1998

[151] Vince Vaughn
LOS ANGELES, 1997

[153] Drew Barrymore
BELL, CALIFORNIA, 1993

[154] Drew Barrymore
NEW YORK CITY, 1995

[155] Drew Barrymore
NEW YORK CITY, 1995

[156] Drew Barrymore
NEW YORK CITY, 1995

[157] Drew Barrymore
LOS ANGELES, 1993

[158] Dave Navarro
PASADENA, CALIFORNIA, 1998

[159] Mark Wahlberg
MALIBU, CALIFORNIA, 1997

[160] Meat Puppets
Derrick Bostrom, Cris
Kirkwood & Curt Kirkwood
NEW YORK CITY, 1994

[161] Ice-T
LOS ANGELES, 1992

[163] Marilyn Manson
LOS ANGELES, 1998

[164] Gillian Anderson
& David Duchovny
VANCOUVER, CANADA, 1997

[165] Gillian Anderson
& David Duchovny
VANCOUVER, CANADA, 1997

[166] Tom Waits
NORTHERN CALIFORNIA, 1999

[169] The Beastie Boys
Mike Diamond, Adam
"MCA" Yauch & Adam
"Ad-Rock" Horovitz
NEW YORK CITY, 1998

[170] Danny DeVito
LOS ANGELES, 1996

[171] Robin Williams
NEW YORK CITY, 1991

[172] Billy Corgan
& D'Arcy
of Smashing Pumpkins
CHICAGO, 1995

[175] Jennifer Aniston
LOS ANGELES, 1996

[176] Jennifer Aniston
LOS ANGELES, 1998

[177] Liv Tyler
LOS ANGELES, 1996

[178] John Travolta
LOS ANGELES, 1995

[179] Emily Watson
LOS ANGELES, 1997

[180] David Letterman
NEW YORK CITY, 1993

[181] Conan O'Brien
NEW YORK CITY, 1999

[182] Phil Hartman
LOS ANGELES, 1996

[184] Gillian Anderson
LOS ANGELES, 1997

[185] Gillian Anderson
LOS ANGELES, 1997

[186] Whoopi Goldberg
PITTSBURGH, 1994

[187] Steven Tyler
of Aerosmith
BOSTON, 1990

[188] Ice-T
NEW YORK CITY, 1993

[190] Fiona Apple
LOS ANGELES, 1997

[191] Nicole Kidman
NEWPORT PAGNELL, ENGLAND, 1996

[192] Blind Melon
Brad Smith, Rogers Stevens,
Glen Graham, Shannon Hoon
& Christopher Thorn
AUSTIN, TEXAS, 1993

[193] Katie Holmes
WILMINGTON, NORTH CAROLINA, 1998

[194] Susan Sarandon
NEW YORK CITY, 1994

[195] Peter Wolf
CONEY ISLAND, NEW YORK, 1998

[197] Mick Fleetwood
& John McVie
of Fleetwood Mac
TOLUCA LAKE, CALIFORNIA, 1992

[198] George Harrison
LOS ANGELES, 1992

[199] Ringo Starr
LOS ANGELES, 1992

[200] Tom Petty
LOS ANGELES, 1991

[201] Billy Joel
LONG ISLAND, NEW YORK, 1992

[202] Chrissie Hynde
of the Pretenders
NEW YORK CITY, 1995

[203] Ray Davies
of the Kinks
NEW YORK CITY, 1992

[204] Jimmy Page
LONDON, 1992

[205] Gregg Allman
& Dickey Betts
of the Allman Brothers Band
MACON, GEORGIA, 1991

[206] Jeff Beck
TUNBRIDGE WELLS, ENGLAND, 1992

[207] Carlos Santana
SAN FRANCISCO, 1992

[209] Jerry Garcia
INDIANAPOLIS, 1993

[210] Neil Young
CHICAGO, 1992

[211] Eddie Vedder
of Pearl Jam
MISSOULA, MONTANA, 1993

[212] Nirvana
Dave Grohl, Kurt Cobain
& Krist Novoselic
MELBOURNE, AUSTRALIA, 1992

[214] Kurt Cobain
KALAMAZOO, MICHIGAN, 1993

[215] Courtney Love
CHICAGO, 1994

[216] Courtney Love
CHICAGO, 1994

[221] Perry Farrell
LOS ANGELES, 1987

[ACKNOWLEDGMENTS]

A ROLLING STONE PRESS BOOK

EDITOR: Holly George-Warren
ASSISTANT EDITOR: Ann Abel
EDITORIAL ASSISTANT: Carrie Smith
EDITORIAL CONTRIBUTORS: Shawn Dahl, Andrea Odintz, Janet Wygal
PHOTOGRAPHIC ARCHIVIST: David Sokosh

DESIGNER: Fred Woodward
ASSOCIATE DESIGNERS: Siung Tjia (*Sr.*); Yoomi Chong, Andy Omel

WHERE WOULD I BE WITHOUT JANN WENNER AND *Rolling Stone*? Thank you for adopting me into the family and allowing me to play a small part in the magazine's incredible history. I can never repay Jann for his encouragement and support over the years.

I'm especially grateful to Fred Woodward for adding another dimension to my work at the magazine over the past decade and for his beautiful design and editing of *Physiognomy*. I treasure his honesty, patience and, above all, his friendship.

Laurie Kratochvil believed in me enough to get me started at *Rolling Stone* and then gave me a place to grow up. I will always cherish her guidance and wisdom. Jim Franco gave me the ability to stand back and enjoy the ride and gave me my first chance to exercise my *RS* cover legs. Thanks also to my dear friend Jodi Peckman, who for so many years was my most reliable sounding board and confidant. The most important ingredient in all our work together has always been friendship.

Rachel Knepfer always laughs with me at the end of the day and has collaborated on some of my finest moments. I'm indebted to Richard Baker and Jennifer Crandall for reinventing *US* magazine and creating a host of new opportunities. To the staffs of *Rolling Stone*, *US* and *Men's Journal*, past and present, especially Fiona Woodnagh, Kathy McCarver, Kristin Dymitruk and Angie Wright, thank you. In addition, thanks to Bob Love, Sid Holt, Barbara O'Dair, Terry McDonell, Rina Migliaccio, Linn Tanzman, Bob Wallace, David Wild, Mary MacDonald, Patti O'Brien, David Amario, David Fricke and Joe Levy.

I'd like to thank Eric Bogosian for his ingenious and generous introduction to *Physiognomy*. No other voice could have captured this period of time so perfectly. And I am extra thankful to Jerry Seinfeld for gracing the cover.

David Sokosh methodically and patiently organized this project. It could not have happened without him. Ivory Serra works like no one else I know, using his incredible stamina and talent to bring my work to life. I also appreciate my past assistants, Brennan Cavanaugh, Eric Delphenich, Ramak Fazel, Todd France, John Gilhooley, Jay Gullixson, Ben Hills, Rocky Kenworthy, Kevin Knight, Tom Legoff, Brian Long, Simon McArthur, Samantha McCormick, Karjean Ng, Steven Pan, David Peterson, Jonathan Ragle, Nikolaus Ruechel, David Safian, Martin Schoeller, Wendy Schwartz, Anthony St. James, Jeff Strauss, Brian Velenchenko and Wayne Wakino, whose patience and endless energy have made me look good for years. Alex Martinengo and Ramon Perez have tirelessly contributed their artistic sensibilities in printing my work for this project. To Ari Phillips, thanks for giving me style.

I can't thank enough my first studio manager, Cathy Weiner, for her wonderful attitude, generosity and tireless efforts. She kept me sane amid chaos. (Also, I really appreciated that free cup of coffee every morning.) Samantha Schwartz courageously took over the day-to-day operation of the new studio. She's the first person I see each morning, and it feels good to know I'm in such reliable hands. Thank you to Jessica Brown and her predecessor, Sofi Dillof, for offering their incredible input and for assembling the talented stylists, hair and makeup artists, prop stylists, set designers, location scouts and caterers that make these monstrous shoots a reality. Those contributors include Vaughn Acord, Vaughn Allen, Walter Barnett, Gabe Bartalos, Christy Belt, Oscar Blandi, Tara Charne, Tim Considine, Cookie at Allstar Coach, Lysa Cooper, Cathy Dixon, Rick Elden, Cathy Eng, Brenda Farrell, Dan Halprin, Ralis Kahn, Steven Knee, Julian Laverdiere, Robert Molnar, Patrick Parkhurst and Scenario, Kathlene Persoff, Maital Sabban, Screaming Mad George, Tim Smith, Tracy Warbin and Cindy Warlow. And many thanks to the rest of the family at my studio both past and present: Flint Adedoyin, Maria Avitabile, Leigh Brown, Albina Campos, Dannielle Coenig, Lorna Faverey, Natalie Flemming, Abby Gennet, Lauren Guerra Heuwetter, Ann Lichtenstein, Sheryl Olson and Loni Weiner.

A huge thank you goes out to everyone at Bulfinch Press who has made *Physiognomy* into a physical reality – Terry Hackford, Karen Dane, Sandra Klimt and especially Carol Judy Leslie.

Thanks also to Holly George-Warren at Rolling Stone Press for her enthusiasm, knowledge of book publishing and patience in steering me through the hard parts, and to inexhaustible assistant editor Ann Abel and editorial assistant Carrie Smith. Dan Cooper, Shawn Dahl, Andrea Odintz, Janet Wygal, Ashley Kahn, Roo Reath, Laura Sandlin, Emily Shur, Tom Soper and Karen Winter also made important editorial contributions. Design associates Siung Tjia, Yoomi Chong and Andy Omel gave much of their time and energy to the project. Wenner Media's production department, including Janice Borowicz, Patrick Cavanaugh, Robert Cohen, Lucy Elghazoly, Betsy Hill, Dylan Jones, Hubert Kretzschmar, Les Lawrence, Richard Leefook, James Lenick, Jack Mittman, Brian Popkie, Chris Raymond, Tim Reitz, Vincent Romano, Paul Rouse, Kilian Schalk, Tevi Schwartz, Alan Sikiric, Peter Walker, Dennis Wheeler, Tom Worley and especially Peter Rosen and Rich Waltman, made invaluable contributions to this book and consistently give my work its finishing touches in *Rolling Stone*, *US* and *Men's Journal*.

This book wouldn't have been possible without Wenner Media's Kent Brownridge, John Lagana and Evelyn Bernal or literary agent Sarah Lazin.

I'm grateful to Howard Greenberg and Marla Kennedy for their counsel and willingness to represent me. I'm thankful to Yancey Richardson for exhibiting the photographs of *When They Came to Take My Father*. Thanks as well to David Fahey for providing me with a place to show my work in Los Angeles. Terry Jacoby, Robert Balsam and Bob Zdon have helped me navigate those uncharted waters of money and law. Hal Goldberg and Robbie Feldman brought the world to me, and Lisa Diamond and Jim Roehrig brought my work to the world.

Thank you to the best labs on earth, who make me look great every time: CYMK, Green Rhino, Kelton Labs, LTI, Mark Markheim, Megargee Vanderlinde, Randeep Khanna at Color Edge and Zona. A tip of the hat to Shoot Digital and Phillip Nardulli for digital magic and to Chris Bishop for good ol' fashioned black-and-white retouching over the years. Thanks to Canon Copiers for their generous support.

Thank you to my incredible family, Mom, Dad, Grandma, Yoel, Frank and Lori for their respect, openness, unfailing support and unconditional love, and for giving me strength and pushing me out the front door. Thanks also to Ruth, Malka, Tzvi-Leib and Devorah-Leah Seliger, Judy and Gary Liberson and Matthew Asner. Thanks to Josh Liberson for his inspired prototype and his brotherhood.

Thank you to my teachers in life and art, James Newberry, Don Lawson, Rob Lawton, Lindsey Clennell, Andrew Tatarsky and Danny Martin.

Thank you to Stephanie Pastor for her love, her support and her infectious smile.

Peter Himmelstein has given me years of friendship and built me a home. Only we know what a strange road it has been. And thanks to the other friends who have helped me on that road: April Barton, Tim Baskim, Danny Bennett, Julian Broad, Mona Chan and John Lombardi, Gerik Cionsky, Jane Clark and Peter Wilkinson, Pat Coakley, Brian and Beverly Coats, Tom and Jodi Connors, Katy Damon, Patrick Daughters and Karen Tanaka, Jenny Freeman and Walker Stevenson, Hovik Dilakian, Andy Gibson, Julie Gold, Emily Greenberg, Leilani Hill, Joseph Himmelstein, Paul Huber, Tamara Jenkins, Mark Johnson, Leora Kahn, Chuck and Bettina Katz, Ed Keating, Gary Laufman, Frank Lipman, Michelle Litvin, Woody Lowe, Lutz, Shana Mabari, Matt Mahurin, Ben Mandel, Gary Marcoe, Mary Ellen Mark, Kurt Markus, Jim Marshall, Kevin Mazur, Scott McDonald, Rob Morea, Chip Morton, Graham Nabarro, John Perez, Menachem Prus, Gary Robertson, Kim Schutza, Peter Sekel, Chris Shinn, Kerry Simon, Chip Simons, Andy Slater, Robin Sloane, Maryolive Smith, Matt Smith, Anna Sui, David Van Taylor, Manon von Gerkon, Albert Watson and Stuart and Jane Weil.

I appreciate the efforts of Kelly Bush, Mara Buxbaum, Steven Huvane, Molly Madden, Cynthia Pett, Cari Ross, Jovar Andrews and Cindy Guagenti.

Thank you to Ellen, John, Charlotte and Jared Madere – my New York family. And thanks to my Brooklyn family, the Lieblichs. For a place to hang my hat in Los Angeles, thank you to Jakob and Paige Dylan.

I'm grateful to Brad, Drew, Jennifer, Perry, Courtney, Lenny K., Elisabeth S., Elizabeth B., Ashley, Conan, Stephen, Jerry, Tom, Lyle, Ben and Elvis for sharing with me their time, talent and incredible ideas. They are all truly partners in this book.

And I'd like to send out an enormous thank you to all my incredible, talented and beautiful subjects, without whom none of this would have been possible.

M.S., MARCH 1999

phys·i·og·no·my

\ˌfi-zē-'ä(g)-nə-mē\ *n, pl* -mies [fr. *physiognōmōn* judging character by the features, fr. *physis* nature, physique, appearance + *gnōmōn* interpreter] **1**: the art of discovering temperament and character from outward appearance **2**: the facial features held to show qualities of mind or character by their configuration or expression **3**: external aspect; *also*: inner character or quality revealed outwardly